Tangled Journeys

Tangled Journeys

ONE FAMILY'S STORY AND THE

MAKING OF AMERICAN HISTORY

Lori D. Ginzberg

The University of North Carolina Press Chapel Hill

For Karin —
with
affection!

Set in Miller and HTF Didot by codeMantra
Manufactured in the United States of America

Cover art: Leaves © naphoart naphoart / iStock; photographs of Sarah Ann Sanders
and Julia Sanders Venning courtesy of the Library Company of Philadelphia.

Library of Congress Cataloging-in-Publication Data
Names: Ginzberg, Lori D., author.
Title: Tangled journeys : one family's story and the making
of American history / Lori D. Ginzberg.
Other titles: One family's story and the making of American history
Description: Chapel Hill : The University of North Carolina Press,
[2024] | Includes bibliographical references and index.
Identifiers: LCCN 2024020857 | ISBN 9781469679952
(cloth ; alk. paper) | ISBN 9781469679969 (paper ; alk. paper) |
ISBN 9781469679976 (epub) | ISBN 9781469679983 (pdf)
Subjects: LCSH: Saunders family. | Sanders, Sarah Martha, 1815–1850—Family. |
Cogdell, Richard Walpole, 1787–1866—Family. | Racially mixed families—
Pennsylvania—Philadelphia. | African Americans—Pennsylvania—Philadelphia—
Biography. | Freed persons—Pennsylvania—Philadelphia—Biography. |
Slaveholders—South Carolina—Charleston—Biography. | Enslaved women—
South Carolina—Charleston—Biography. | Charleston (s.c.)—Biography. |
Philadelphia (Pa.)—Biography. | BISAC: SOCIAL SCIENCE / Ethnic Studies /
American / African American & Black Studies | SOCIAL SCIENCE / Slavery
Classification: LCC F158.9.B53 G56 2024 | DDC 306.850748/11—dc23/eng/20240523
LC record available at https://lccn.loc.gov/2024020857

For my parents

CONTENTS

ILLUSTRATIONS

ACKNOWLEDGMENTS

This book, like everything I have written, has been shaped by collaboration. But *Tangled Journeys* reflects a particularly explicit engagement with historians, theorists, places, and events outside my usual purview. I am certain that I have left out people with whom I had conversations that found their way into this book, and for that I apologize. I am also grateful to numerous scholars, journalists, and novelists whose writings, though part of my ongoing education, do not appear in the bibliography. To everyone whose activist commitments and intellectual passions inspired this book, many thanks.

Let me begin with librarians and archivists. I wrote this book during both a global pandemic and right-wing attacks against the kind of history it reflects, and so I am reminded more than ever that those who manage, protect, and share books and archives are our heroes. My first debt is to Krystal Appiah, now at the University of Virginia, who, as the curator of African American history and reference librarian at the Library Company of Philadelphia, introduced me to the Stevens-Cogdell-Sanders-Venning-Chew Collection and, so, inspired this book; I hope she's pleased with the result. At the Library Company, Connie King was as knowledgeable and helpful as always, as were Max Moeller, Jasmine Smith, Sarah Weatherwax, Erika Piola, Emily Smith, Max Margolies, and Linda Kimiko August. I am especially grateful to Erika for her prompt and kind responses to my many queries about how to locate, identify, download, and move photographs. I am so grateful to the Library Company for digitizing this vast collection of photographs and granting permission to reprint them. And, like countless other scholars, I thank the late Phil Lapsansky for nurturing the relationships that led to the Library Company of Philadelphia

acquiring and making available this family's papers, as well as so many other resources in African American history.

Numerous other librarians, archivists, and local historians went beyond their usual duties to do research and send me digital versions of sources I could not access in person. It is a pleasure to thank Virginia Ellison and Brandon Reid at the South Carolina Historical Society; McKenzie Lemhouse and Edward Blessing at the University of South Carolina's Caroliniana Library; Wade Dorsey and Sarah Moore at the South Carolina Department of Archives and History, Columbia; Timothy H. Horning, public services archivist at the University of Pennsylvania; Elena Popchock at the National Constitution Center in Philadelphia; Alex Bartlett at the Germantown Historical Society; Mary Jo Fairchild at the College of Charleston; Alex Japha at the Lehigh University Library; Tricia Moore of St. Philip's Church in Charleston; Camille Wish at the Bethel Methodist Church in Charleston; Aaisha Haykal at the Avery Research Center for African American History and Culture at the College of Charleston; Amanda Holling at the Charleston County Public Library; Sheila Jones at Historic Eden Cemetery; and those who made available the resources of the Historical Society of Pennsylvania, the City Archives in the Philadelphia Department of Records, the Schomburg Center for Research in Black Culture of the New York Public Library, the New York Historical Society, the Winterthur Museum, Garden, and Library, and the Huntington Library. Librarians at Penn State, most notably Eric Novotny, have been unfailingly generous with their time and expertise. I thank Gerald Carver of the Grand Lodge of Ancient Free Masons of South Carolina for permission to reprint a portrait from its library, although it turned out not to be of Richard Cogdell but of his brother John—and Woody Holton for helping solve that small mystery when he went to take the photograph. I am also grateful to Penn State for the privilege of easy access to numerous online resources; it is hard to remember how we did our work before Ancestry, Readex, Newsbank, Accessible Archives, JSTOR, FindaGrave, and other internet databases existed. In particular, Ancestry provided access to federal and state censuses as well as other vital genealogical information. More information is being put online daily, including by the new International African American History Museum in Charleston.

Nicholas Butler is in a category of his own: both archivist and historian, he oversees the Special Collections at the Charleston County Public Library, where he also produces the enormously valuable podcast

The Charleston Time Machine. Whether by email, in person, or on audio, he has been unfailingly generous in sharing his vast knowledge—and insightful critiques—of Charleston's history. Franklin D. Williams, founder of the "Frankly Charleston" Black History Tours, was a great guide through that once majority–African American city.

Funding from various institutions allowed me the space and time to range widely before actually writing the book. In addition to Penn State's generous research leave policies, the Departments of History and Women's, Gender, and Sexuality Studies, as well as the Richards Civil War Era Center, made funds available for research on numerous occasions. I am honored and grateful to have been both a John Simon Guggenheim Foundation Fellow and a Mayers Fellow at the Huntington Library. The McNeil Center for Early American Studies at the University of Pennsylvania has welcomed me as a research associate for many years, offering access to libraries and to its vibrant seminar series.

I am extremely fortunate in having friends and colleagues with expertise in areas in which I was, and still am, lacking. It is my enormous good luck to include among them Scott Wilds—Charleston expert, genealogist, and fact-checker—who really can find anything. On the Philadelphia side, Donna Rilling helped me navigate that city's historical sources and shared leads that only someone as relentless as she could have uncovered; it was Donna as well who led me to Joshua Cohen and Aaron Wunsch, whom I thank for their guidance in researching nineteenth-century streets and houses. In an effort to address my ignorance about the Civil War draft and the US Colored Troops, Judith Giesberg lent me mountains of books and then tried to answer my questions about what their authors left out or could not know. Iver Bernstein, William Blair, Brian Luskey, and Rachel Shelden were patient with my Civil War questions, no matter how trivial. Both longtime and new colleagues at Penn State, as well as my (now mostly former) graduate students, offered company, encouragement, and advice.

A number of scholars read this book at various stages and offered welcome criticism and support. Judy Giesberg and Alexandra Finley provided particularly close readings and detailed comments as well as timely enthusiasm. I am extraordinarily lucky to count among my friends Anne Boylan, Courtney Morris, Mrinalini Sinha, and Nan Woodruff, who read chunks of this book in a very early form and offered characteristically encouraging and challenging feedback. My decades-long conversation with Nan, my "other-half other half," was once again key to getting me started on a project and reminding me why it

mattered. Others may not realize how much our long-ago conversations, emails, quick chats, or long walks mattered: I thank Dan Beaver, Christopher Clark, Nancy Cott, J. Marlena (Janelle) Edwards, Thavolia Glymph, Kerri Greenidge, Steve Hahn, Emma Hart, Chris Hayashi-da-Knight, Charles Holden, Martha Jones, Carol Lasser, Deirdre Cooper Owens, Alison Parker, Helene Quanquin, Shari Rabin, Nicholas C. T. Rogers, Bryant Simon, Nicole Myers Turner, and Christine Walker, who listened, supported, loaned books, or guided me to sources that I would not have otherwise found. When I was first considering the ideas that shaped this book, I spent some time at the Frei University in Berlin. For sharing their space and opening their seminar to my early musings I thank Michaela Hampf, Gudrun Löhrer, and Catya de Laczkovich.

Thomas LeBien of Moon and Co. was more important than he may realize in visualizing my scattered thoughts as an actual book. It is a pleasure to publish another book with the University of North Carolina Press, and I thank Debbie Gershenowitz, JessieAnne D'Amico, Madge Duffy, Erin Granville, Elizabeth Orange, Lindsay Starr, Iza Wojciechowska, and others for their attention to matters large and small.

The papers that lie at the core of this book, the Stevens-Cogdell-Sanders-Venning-Chew Collection, was a gift to the Library Company of Philadelphia of descendants Cordelia H. Brown, Lillie V. Dickerson, Mary Hinkson Jackson, and Georgine E. Willis in honor of Phil Lapsansky in 1991, with additional gifts made since. I have cited the SCSVC Collection throughout the book as scrupulously as I can, but notes cannot do justice to its intricacies and breadth. Nor can the formalities of academic attribution account for the valued relationships I have gained among the descendants of this family. I was privileged to spend a day with the late Cordelia (Betty) Hinkson Brown when she was ninety-six years old and to have several follow-up conversations before her death in 2022. I am grateful to her family members who have shared stories and meals, read my drafts, shared their own writing, and corrected factual errors. Beverly Brown Ruggia in particular has become a rare friend, ever willing to "nerd out" with me at a moment's notice.

For several decades my small West Philly block has provided an essential community, and I look forward to many more years of porch wine and wide-ranging conversation. I thank them all, as well as far-flung friends too numerous to name, for distracting me with topics unrelated to history and for nodding patiently when I mention that there's no such thing. Yvonne Smith read this manuscript when it was in an embarrassingly rough state and talked me through particular

challenges of interpretation, voice, and language. Lindsay Ahlman devoted valuable porch time to discussing the frustrations of history and punctuation, and I am grateful for her compulsiveness about these and other important matters.

My family—a sprawling assortment of sarcastic but helpful individuals—are my closest people, my past, present, and future. I thank them all—parents, children, siblings, and niblings—for their love, support, and diversions. I am delighted to dedicate another book to my parents, Shirley and David Ginzberg, who have tried to be patient about how long this one has taken; sadly, I could not finish it in time for Francine Steiker to read it. Janet Ginzberg, my favorite sister, came through yet again as an active and intellectually curious reader, chief grammarian, and member of our mutual admiration society. Other family members took on particular tasks, explaining specie payment and inflation calculations, deciphering nineteenth-century estate settlements, calligraphy, and legal cases, seeking out Colored School No. 1 in Brooklyn, navigating illustrations and technology, and offering advice on narrative and design: you know who you are and that I owe you.

No acknowledgment can fully express my appreciation for Kate and Eli Steiker-Ginzberg, although, except for Eli's design input, they did not speed up the process much, nor was their advice always relevant. But they enrich my life and work every day and I hope they—and their partners, Lucas Iberico Lozada and Sarah Baehr Schrading—know how much I admire and enjoy the adults they have become. Finally, I am as always beyond grateful for Joel Steiker's well-known, not to say infinite, patience and for the many critiques he offered on drafts of this book. He also, once again, read microfilm, a reminder that, even in Charleston, being a historian isn't always as much fun as it looks. Although I squirm at his frequent query—"What's the next project?"—I am sure that when I figure it out, he will be my principal booster and my companion on all our journeys.

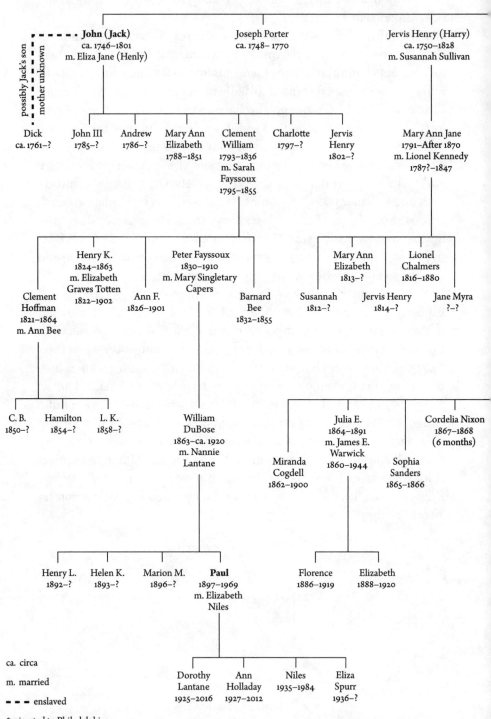

John Stevens
ca. 1720–1772

possibly Jack's son
mother unknown

Dick
ca. 1761–?

John (Jack)
ca. 1746–1801
m. Eliza Jane (Henly)

John III
1785–?

Andrew
1786–?

Mary Ann
Elizabeth
1788–1851

Clement
William
1793–1836
m. Sarah
Fayssoux
1795–1855

Charlotte
1797–?

Jervis
Henry
1802–?

Joseph Porter
ca. 1748– 1770

Jervis Henry (Harry)
ca. 1750–1828
m. Susannah Sullivan

Mary Ann Jane
1791–After 1870
m. Lionel Kennedy
1787?–1847

Clement
Hoffman
1821–1864
m. Ann Bee

Henry K.
1824–1863
m. Elizabeth
Graves Totten
1822–1902

Ann F.
1826–1901

Peter Fayssoux
1830–1910
m. Mary Singletary
Capers

Barnard
Bee
1832–1855

Mary Ann
Elizabeth
1813–?

Susannah
1812–?

Lionel
Chalmers
1816–1880

Jervis Henry
1814–?

Jane Myra
?–?

C. B.
1850–?

Hamilton
1854–?

L. K.
1858–?

William
DuBose
1863–ca. 1920
m. Nannie
Lantane

Miranda
Cogdell
1862–1900

Julia E.
1864–1891
m. James E.
Warwick
1860–1944

Sophia
Sanders
1865–1866

Cordelia Nixon
1867–1868
(6 months)

Henry L.
1892–?

Helen K.
1893–?

Marion M.
1896–?

Paul
1897–1969
m. Elizabeth
Niles

Florence
1886–1919

Elizabeth
1888–1920

ca. circa

m. married

- - - enslaved

* migrated to Philadelphia

bold frequently mentioned

Dorothy
Lantane
1925–2016

Ann
Holladay
1927–2012

Niles
1935–1984

Eliza
Spurr
1936–?

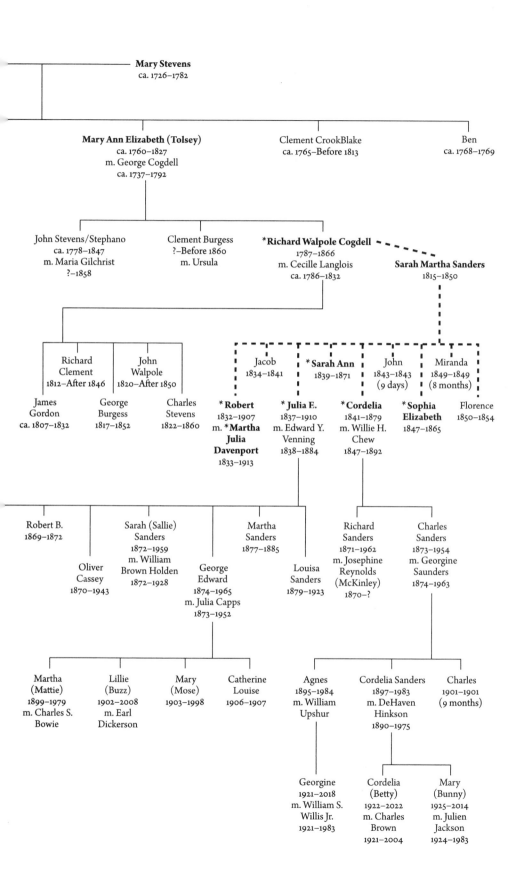

Tangled Journeys

INTRODUCTION
Making American History

This is what happened: Beginning in the 1750s and continuing through the 1760s, a family named Stevens—John, Mary, and their children— migrated from London to Saint Kitts to Georgia to Charleston, South Carolina. In addition to the usual dislocation of a transatlantic move, events in Georgia in particular made John despair of his ambitions: fires, bankruptcies, and people who fled their enslavement all thwarted his attempts at entering the planter elite. Along the way, one son moved to Jamaica, and another went to sea; others were born, and some died. Things looked up in Charleston, a city whose grandiose self-image fit well with John's own. John, encouraged by local merchants and eager to promote himself, bought and sold goods of all kinds across the Atlantic; Mary was able to open her own coffeehouse that offered her protection from John's debts, if not from his hubris; their "clever" daughter, Mary Ann, would become a teacher of girls, and their son Harry played organ at St. Philip's Church. The Stevenses established themselves as members of the urban, slave-owning merchant class in Charleston, where their family remained for generations.

Here is what also happened. In 1830, a Stevens grandson, Mary Ann's son Richard Walpole Cogdell, a rather ordinary member of that urban middle class—a husband, father, bank employee, and slaveholder— purchased a fifteen-year-old enslaved girl, Sarah Martha Sanders. Over the next twenty years, Richard and Sarah Martha had nine children, five of whom lived to adulthood. In the eyes of Charleston slave owners (and, perhaps, the enslaved), such a relationship, founded on rape or acquiescence or negotiation or words we don't yet have, was all too common, barely worthy of comment, although Richard's wife's abandonment of her home and sons surely raised eyebrows. Nor was

Sarah Martha Sanders's death—of childbed (puerperal) fever at age thirty-five—a matter for much remark except, of course, by her grieving children. Under the laws of antebellum South Carolina, Cogdell could not have emancipated Sarah Martha or their children if he wanted to. What followed, however, was remarkable indeed, the result of a conversation that is nearly impossible to imagine: In 1857 Richard Cogdell and his enslaved children, Robert, Julia, Sarah Ann, Cordelia, and Sophia Sanders, moved to Philadelphia, where he purchased a house that he immediately signed over to them. While some of John Stevens's other great-grandsons would fight and die for the Confederacy, the Sanders children and their descendants entered Philadelphia's African American middle class and remained in that house, at 1116 Fitzwater Street, for nearly half a century. Neither they nor their white father would ever live in Charleston again.

Within Philadelphia's aspiring and bustling African American middle class, the Sanderses were a tightly knit family of siblings, aunts, uncles, and cousins well through the twentieth century. Alongside others in their community, many of whom had also migrated from Charleston, they were tailors, barbers, and teachers. Miranda Cogdell Venning, Richard Cogdell's first grandchild, born in the early years of the Civil War, would become the first "colored" graduate of Girls' Normal School, later the Philadelphia High School for Girls; her cousins and brother would enter Philadelphia's integrated public schools in the wake of a victorious lawsuit brought by their fathers. The Sanderses were not famous people, nor were they prominent reformers, but together they navigated their migration from Charleston; the Civil War and the hopes and traumas that followed; the illness, death, and debts of their white Southern father; and births and deaths of babies and children whose names recalled both long- and recently dead siblings. In their basement sat the boxes holding the papers of the Stevens-Cogdell-Sanders-Venning-Chew family, including those of John Stevens.

This book tells the story of the Sanders family, of their ancestors and their descendants, of their collective decisions and, to the extent possible, their individual characters. It contains entirely different and competing stories, both traumatic and prosaic, unique and ordinary. The challenge here is to tell these stories together, while also telling them apart. They touch, as the Sanderses' lives did, upon nearly all the standard themes of the American narrative. Immigration, the market revolution, transatlantic connections, and the Civil War and Reconstruction all shape this narrative. Racism, sexual abuse, and

slavery are, of course, woven throughout. So, too, are traits Americans from the nation's founding to the present claim to embrace: freedom, independence, and opportunity. The lived experiences of race, gender, and class—the tangled interplay among these often abstract concepts—are front and center, demanding their due alongside hapless husbands, competent wives, and unflinching children. Central to this story are the ways that actual people—parents, children, and siblings—experienced their membership in a family that remained committed to one another against all odds, laws, and logic. So while slavery, freedom, and ambition play competing roles, and economic change, war, and racist violence make dramatic appearances, so, too, do loyalty, pride, and love.

In addition to telling a centuries-long story of one family's place in the making of American history, this book also asks readers to grapple explicitly with the process of history-making: what historians encounter as evidence, how we interpret its tiniest shards, and how stretching those sources nearly beyond recognition can offer unexpected insight into our past. "History," Marisa Fuentes reminds us, "is produced from what the archive offers."[1] The archive on which this narrative rests offers an abundance of noise as well as enormous empty spaces. What was once a jumble of papers in a Philadelphia row house has been organized chronologically by archivists and curators, filed in numbered folders, and put in boxes that generally conform to topic or writer. They contain thousands of words by one rather cranky white immigrant to Charleston but not one by the enslaved woman who bore nine of his great-grandchildren. The archive itself has no edges; almost every detail in this book emerged from wide-ranging searches outside its boundaries, underscoring that writing history is far more random than we would like to believe. Those who interpret archives remind us that any effort to put the documents of the past in an order reflects biases and assumptions and is ever-changing; indeed, I have sometimes scrupulously footnoted a scrap of paper or letter only to find that an archivist had reconsidered its placement, and it had migrated to another box. Archives are far from rigid or permanent, though they often reflect institutions—states, churches, universities, bureaucracies—that hope through their culling and cataloging to establish and reinforce their own historical stability. Even the efforts to democratize archives—to rethink what counts as important, to enhance previously neglected voices—require that we remain skeptical of the archive itself as having the last word about anything.

All historical accounts are full of silences and omissions, infuriating gaps that, whether by intent, accident, or the very nature of what gets recorded and preserved, shape and limit our understanding of the past. These silences scream loudest in the histories of women, African Americans, enslaved and Indigenous people, and people marginalized on the basis of their gender or sexuality. What literate chroniclers and bureaucratic gatherers of historical sources thought mattered offers little insight into how the people they captured, enslaved, or sold shaped their own lives and identities. Where the archives allow it, I use a wide array of such documents to make informed interpretive arguments, framed by what scholars past and present have uncovered and argued. But in this book, I have placed (*in italics*) what I call "whispers" to address questions that those sources do not allow me to answer but that I simply cannot leave alone. I have always been intrigued by what is "out of the question" or "impossible to know" and then tempted to see what happens if we ask it, or imagine it, anyway. This family's story fueled my tendency to poke at things, intellectually speaking, and try to figure out why things remain, or are kept, invisible. When I cannot fill these gaps with facts, I suggest some possibilities the silences themselves offer. Readers who dislike or distrust the word "perhaps" will take issue with this, but this book invites people to explore how historians travel through the past and to interrogate what we feel able to say about it. It begins with the conventional sources of literate people, such as account books, letters, deeds, and wills, and asks readers to share the joys and frustrations of unraveling history's many threads, to listen closely to the silences themselves, and to try to imagine what lies there.

This book, like history itself, is therefore a translation of sorts. The stories I am able to relate, and the ones I struggle to imagine, seek to interest readers in how archival contradictions shape our research, by placing the detective work of history alongside a fascinating and particular historical saga. Scholars and artists who write about archival practices—whether conducted in the academy, in established libraries and historical societies, or in community archives—express explicitly what historians of women and African Americans do of necessity: read sources at a slant, imagine sketching in the spaces, speak aloud into the silences. There are compelling reasons that those who focus on the nature of archives should communicate with readers who want an interesting account of the past. Like Fuentes, I am "drawn to these people by the loss of their histories and my unfulfillable desire to recuperate something about them" but also, equally, because of the astonishing

good fortune that a family held on to "archival fragments" that no one else might have considered important. This book takes seriously Peter Fritzsche's appeal to "make the incompleteness of the story the story itself, to acknowledge the strain of and the limits to a common past, and to produce archives of loss."[2] It invites readers along on the many spurs and side trips of the historian's journey without losing sight of what the trail itself teaches us about American history.

This book and the story it tells are limited only by the kinds of historical sources it examines and the limits of our historical imagination. Geographically it ranges from Charleston to Philadelphia, with side trips to Saint Kitts, Georgia, Jamaica, and Bristol, England. Its cast of characters includes white slaveholders, urban people of color, and members of Philadelphia's African American middle class. It travels between eighteenth-century transatlantic merchants and their twentieth-century descendants. There are no heroes here: the people who occupy this book's pages committed acts of violence and trauma, made complex and sometimes inexplicable choices, and surely had regrets, passions, and distresses that we cannot uncover. None became radicalized by their experience, however courageous, of leaving one community and settling in another, or established themselves as bold leaders, or spoke out against the forces of slavery, racism, and sexual exploitation that had shaped their lives. Even their most dramatic actions were shaped by the most ordinary—and perhaps most universally shared—of ambitions, those that encompass family, security, and self-respect.

How we understand people's actions is also, inescapably, shaped by the questions we ask. Take one tiny example. Paul Stevens, a Northern-born white man who lived in the mid-twentieth century, had a deep interest in (what he understood as) his Southern roots. He wrote with vigor and imagination—and a great deal of pride—about his male ancestors' roles at sea and war. In a typescript about one Henry K. Stevens, he named every ship on which the young midshipman and navy man served, the types of arms he carried, his battles on behalf of the Confederacy, and his 1863 death "with a rifle bullet through his heart." When he donated his papers to South Carolina's flagship university, he was proud of that legacy, and certain that his family contributed to the central narrative that the South Caroliniana Library should pass on to future generations.[3]

Yet about Henry's aunt Mary Ann Elizabeth Stevens, "spinster," Paul Stevens notes only this: that she left her widowed mother in Jamaica in the early nineteenth century and settled in England with a female

companion "for no reason that I have ever been able to determine."[4] Stevens's historical imagination could not fit these women into the questions that mattered to him. Like all historians, he missed things that might change the shape of the narrative. My own historical imagination, like Paul Stevens's, is limited and partial, and I have surely missed things too. Indeed, I expect my readers to read some of the evidence that follows differently than I do; enlarging and transforming American history is most assuredly a collective project. At the very least, I do hope they, like me, can imagine some reasons that Mary Ann Elizabeth Stevens—young, unmarried, and well-off—decided to move to a midsize English city far from her family's Jamaica plantation.

This book is shaped by a rich and unusual archive, by my love for the detective work involved in research, and by the questions and intellectual commitments that I bring to my study of history. My own path into and through this story has, unlike Paul Stevens's, been a professional one. It began with the extraordinary collection of papers held at the Library Company of Philadelphia, which I came upon through sheer luck. I'm not the first to read these documents, nor am I the most knowledgeable about the people and places whose lives they trace. Other scholars—notably Wendy Gonaver, Amrita Chakrabarti Myers, and Nazera Sadiq Wright—have looked at the lives of the Stevens-Cogdell-Sanders-Venning-Chew clan through various lenses and have fleshed out aspects of their history. Still others, descendants of those families, know far more of the human details and oral traditions than I ever can.[5]

And when I say "came upon"—well. Historians are reluctant to admit this, but sometimes we sit in the archive or hang out on websites with little apparent purpose, meandering through documents written long ago. Sometimes we take a note. And sometimes we have a fantastically lucky day. In July 2016 I asked Krystal Appiah, then the curator of African American history at the Library Company (now a curator at the University of Virginia), what she was working on. And she told me about transcribing the little journals kept by a nineteenth-century African American girl. And about that girl's family's story. And I became swept up in, addicted to, and absorbed by the Stevens-Cogdell-Sanders-Venning-Chew family and the collection of papers that had sat in their descendant's Philadelphia home. I was hooked; getting out of the weeds of this research has been much harder than getting in.

I used to be a historian who focused on white, middle-class Protestant women in the nineteenth-century United States, among them abolitionists, supporters of woman's rights, and activists of various

stripes. But when I dove into these family papers, my intellectual world exploded. What might seem a narrowing process—an intense focus on the story and archive of one family—expanded into a transatlantic, multinational, multiracial journey. My bookshelves reflect this disorder: books about slaveholders in South Carolina sit alongside those about the enslaved in Jamaica; books about the Civil War crowd next to monographs about African American education; biographies of Black teachers rest uneasily on the shelf with those of Confederate soldiers; memoirs of families migrating across oceans and centuries are sprinkled among books about the nature and practices of archives themselves. Charleston, South Carolina, and Philadelphia, Pennsylvania, reside together in perfect amity, and then in war. And books about men take up space, manspreading across my study in ways they never did before. I no longer know what I'm a specialist in; I no longer know enough about anything.

I have previously written about women who were largely invisible to the historical record. In particular, I spent a great deal of time weaving together the story of the six women in Jefferson County, New York, who, in 1846, petitioned their state's constitutional convention for full civil and political rights. The glimpses of these white, middling-class individuals were frustratingly sparse. Still, they had written something, had owned and inherited property, had appeared as mothers, wives, widows, and landowners in the records of a community of farmers.[6]

But this book's central character, Sarah Martha Sanders, is largely invisible within the very archive that makes her story known at all. She epitomizes what Fuentes calls "the fragmentary, disfigured bodies of enslaved women" and what Avery Gordon calls "the traces of a ghost."[7] We know about her because she bore nine children with the man who enslaved her. We know about her because those children, and their descendants, held on to the papers (often, literally, pieces of scrap paper) of their father's family, papers that included immigrants, slave owners, enslaved people, free white and Black Americans, and Jamaicans among them. Sarah Martha Sanders herself appears here—*we know she existed*—because the people who enslaved her kept records of sales and wills and because her children carefully placed each of their names, birth dates, marriages, and dates of death, including hers, in a family Bible. That Sarah Martha Sanders has a known birth date—February 8, 1815—is perhaps the most mundane, and the most extraordinary, fact in this story. Still, for all the details that we do have, the silences in her family's story take up far more space than the noise I am used to or that

readers generally prefer. They represent some of the "archivally invisible horrors" that Fuentes points to in the study of enslaved women.[8]

So now that I've read everything I can get my hands on, now that the typed notes are printed out and proofread, now that I've been to Charleston and Columbia, South Carolina, and Washington, DC, wandered cemeteries, scoured church archives, spent more time on Ancestry than can be healthy, picked the brains of historians, descendants, archivists, and genealogists—basically followed every lead in my toolbox to find more about these folks, to walk their streets, to listen in on their conversations—what now? Do I compress the cacophony into a story about one family's history? How many strands do I follow, and which ones do I let go? How do I keep in mind Elsa Barkley Brown's dictum that *all* lives, *all* histories, are relational, that no one is entitled to escape, or look away from, the complexities of the whole past?[9]

What kinds of alternative structures might tell this story? This is the sentence I have stared at the longest and that has delayed this book by several years. We might begin with the dramatic themes of American history and see where the family "fits." This is the choice that Paul Stevens made, devoting his attention to his family members' military service under the Confederacy. I could tell this as vignettes—embrace the incoherent moments in which real people live their lives, without trying to fit them, or twist them, into a larger picture. Or I could abandon chronology altogether, dipping into stories randomly and asking readers to do the work of putting it all together. There are additional challenges I have tried to face, if not resolve. How can I, a white scholar, address the inconsistencies and failings of enslaved and free African Americans in light of their extremely limited choices? How, conversely, do I, a feminist historian, square a middle-aged white man's sexual relationship with an enslaved teenager with, as all the available evidence suggests, his love for and loyalty to their children? I have chosen simply to tell the biggest story I can, insert "whispers" where I feel I must, and invite readers along on the journey.

For all my efforts to reimagine how to structure a story like this one, I remain a historian by training and mind-set. So, since any story's beginning exposes our assumptions, our concerns, and our focus, I have to start somewhere. Wendy Gonaver, whose 2001 master's thesis explored this archive, begins in 1899, when W. E. B. Du Bois, living among and researching Philadelphia's Black community, met a descendant of the Sanders family. Amrita Chakrabarti Myers, writing about women's lives in antebellum Charleston, enters with Cecille Langlois Cogdell and

Sarah Martha Sanders, respectively the wife and enslaved mistress of Richard Walpole Cogdell. Nazera Sadiq Wright, who writes about the material culture of African American girls' lives, begins with two autograph books, the 1877 one that fifteen-year-old Miranda Cogdell Venning received from her uncle Richard DeReef Venning and her sister Sallie's from 1886; both were filled with the names and wishes of their schoolmates, friends, and mentors.[10] The Stevens-Cogdell-Sanders-Venning-Chew Collection itself begins, chronologically, with a white man, John Stevens, whose letter books offer a rich and idiosyncratic portrayal of an immigrant, husband, father, merchant, slave owner, and social climber in mid-eighteenth-century Charleston. His story highlights the silences that are present from the start and demonstrates by its very existence the path the archive more or less forces us to enter. As I wrote some years ago about another context, every story is a beginning, a middle, and an end, so all these beginnings are valid, though each frames the story we tell and the lessons we draw.

For all the context this book offers, it is important to note what it is not. It is not a comprehensive account of the eras and places it touches upon. It offers few conclusions but illuminates signposts to paths not taken, lets threads dangle, and openly addresses the lapses in what we can know. Like every single history book that has ever been written, it leaves out immeasurably more than it includes. Nor does it pretend to be neutral in its commitments, for this book asks readers to join a many-decades-long project by historians of women and African Americans: to rethink the grand narrative of American history with usually marginalized human beings at its heart and to take seriously the moral complexity of people who occupy positions both of authority and of enslavement. Finally, it purposely employs the double meaning of the "making of American history" in describing my own exploration and interpretation of history alongside one particular family's complex journey through American history itself.

If a starting point is essential for every narrative, so too, as for every life, is a name. When I have been asked the name of the family I've been studying for so long, I stumble. The archive that resides at the Library Company of Philadelphia is called the Stevens-Cogdell-Sanders-Venning-Chew Collection, and surely that is the most truthful and inclusive title. It is also impossible to say. So among the many things I've tossed around are which of these names best conveys the story.

None is complete. Every one involves silence, and erasure, as well as patriarchal traditions and the practices of enslavement. This narrative is replete with mysterious last names and false endings: a white Stevens descendant's assertion that the Cogdell family line has "long since been extinct" offers an especially poignant clue to how memory, and history, are made.[11]

Let us place the name that is most mysterious and most jarring at this story's heart. We do not know how Sarah Martha Sanders, an enslaved child, got her last name. None of the people who claimed ownership of her was named Sanders. No local man, Black or white, emerges who might have been her father and given her his name; it seems impossible that she assumed a husband's name before she turned fifteen, and in any case none has surfaced. Nor does the name appear among the friends and associates of Richard Cogdell, the man who purchased Sarah Martha Sanders. I have no way to know whether she simply chose it for herself or why. But every one of her children carried the name, and her daughters used it as their children's middle names. (Sarah Martha Sanders's only surviving son, Robert, had no children, so the surname died with him.) Its usage did not end until 1962, when her grandson Richard Sanders Chew died, although it was his niece Cordelia Sanders Chew's middle name until she married DeHaven Hinkson and dropped it. It is the name that occupies the tiniest sliver of history; it is a matrilineal name; it becomes invisible as it began. It disrupts how we think about American, and family, history if we see the Sanders family as its heart.

Once we have settled on a name, this family's place in making American history is daunting simply as a matter of chronology and breadth. I have been heartened by Gordon's reminder that "a different way of knowing and writing about the social world, an entirely different mode of production, still awaits our invention," but that hardly invents it for me. But I am a historian, neither a novelist nor a genealogist; telling a story more or less in order is the only way I know how to manage and interpret the past, to explore how "the intricate web of connections that characterizes any event or problem *is the story*."[12] So let us begin.

Introduction

I

STEVENSES' JOURNEYS

John Stevens would surely think it appropriate to begin this story with him. Indeed he, along with his wife, Mary, and their children, seemed to embody European transatlantic migration itself. His story is one of failed aspirations, an industrious wife, recalcitrant sons, and an Atlantic urban world of trade, communications, and self-promotion. Leaving John's various business failures behind in London, the Stevenses landed in the mid-1750s in Saint Kitts (Saint Christopher), moved five years later to Georgia, and then, in 1767, moved to Charleston (called Charles Town until 1783), South Carolina. Although, as Richard Dunn points out, "each of the Caribbean islands settled by the English . . . has its own distinct personality," all were tightly bound together by British imperial ambitions: by the time of the Stevens family moves, the British post office moved mail regularly among the West Indies, England, and Charleston; the same ships carried cargo of many kinds, including goods traded on the account of John Stevens himself. Indeed, many of the earliest white settlers of Charleston, as well as the people they enslaved, arrived on ships not from England but from Barbados, Saint Kitts, and Jamaica. The "quest for riches" that marked all this movement surely dominated people's decision to resettle, as it did their commitment to enslavement, plantation culture, and urban opulence.[1] But that list of locations—an unexceptional migration pattern in the expansive, nebulous world that was the transatlantic merchant's domain— gives little sense of the lived experience of the travelers themselves, of how it felt to be caught up in the transformations that marked British expansion into the western Atlantic world. I do not know why, exactly, Stevens was motivated each time to pick up and move, how he decided

on the new location, or what his family members had, or were allowed, to say about it.

Perhaps more than many in his circumstances, John Stevens faced a series of sometimes astonishing setbacks and recoveries. He was fortunate in his wife, for Mary Stevens opened a coffeehouse on East Bay Street in Charleston that provided both an income and the opportunity for much name-dropping. Their eldest son, Jack, established himself as a planter in Jamaica; a younger son, Jo, went to sea, argued with his captain, and was lost; only their son Harry shared his father's ambition to become a respectable Charlestonian. Mary Ann Elizabeth Stevens, John and Mary's only daughter, "showed an energy of character peculiarly her own"; she married the much-older George Cogdell at seventeen, was widowed in her early thirties, and raised her sons (John, Clement, and Richard Cogdell) by keeping a small school for girls.[2] An enslaved child, Dick, likely the son of John and Mary Stevens's oldest son, Jack, was sold to pay some debts and, like so many enslaved children, vanishes from what we know of the family's story. But John Stevens's self-absorption and whining ("Sure no man was ever born to such misfortunes as I have undergone," he moaned repeatedly) isn't why he can lay claim to being this narrative's starting point.[3] We begin with John—father, husband, merchant, slave owner, man-about-town, postmaster, and church organist—only because he was literate, he wrote things down, and his African American descendants did not throw it all in the trash.

Even this most conventional story, based on the most standard historical documents I have on hand, demands that we be less distracted by Stevens's chatter and attend to silences. The Stevens family's path was characterized from the first by disappointing sons (the oldest, Jack, gave his father "no hopes of seeing you aspire to a more Amiable character") and some remarkable, if historically barely visible, women. Stevens may have aspired to be a planter, with the glitz and stature he thought he deserved, but his family's stability—and that of his descendants for generations—was firmly based in urban life, among those who constituted Charleston's (and, later, Philadelphia's) wage-earning middle classes. It was also supported to a large degree by the waged labor of white women, in addition to the work of enslaved people. And while American historians tend to focus on expansion west or north, the Stevenses lived in an Atlantic world, with sailors, migrants, merchants, and tourists—male and female both—crossing from Saint Kitts to South Carolina to Jamaica to England

and back, buying and selling material goods, foodstuffs, and human bodies at every step. I am, Stevens wrote in the early 1770s, just before the Anglo-Saxon world would be fractured by men born in Britain's overseas colonies, "a brother Creole," and in some complicated sense this was true.[4]

John Stevens made a great deal of noise, working hard to insert himself at the center of every story, but we know this only because his descendants retained his two large, bound letter books, where he kept copies of all his letters. As a merchant and postmaster he carried on an extensive business correspondence; as a household head he reflected on his ability to support his family; and as a father he commented frequently on his children's accomplishments and failings. By piecing together those letters with other, more public sources, we can track his family's migrations and their tribulations.

But if John and Mary Stevens's family origins are vague, another family's arrival in American history is entirely unknowable. It was because of an enslaved woman, Sarah Martha Sanders, born some forty years after John Stevens's death, that we know anything about his life. Yet her own story has no satisfactory beginning. Some of her ancestors were kidnapped in West Africa and taken by ship, via several possible routes, to South Carolina; others may have been European slaveholders, slave traders, or Native Americans. Sarah Martha's mother, Juno, and her grandmother Sarai were enslaved by Sabina Hall, presumably living in the same household where Sarah Martha spent most of her childhood, but their other kin and the fathers of their children are unknowable, their relationships not included in the records of their enslavers, their original languages muted.

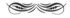

The most basic of the historians' tools are sketchy even in the white, male, property-owning Stevenses' story; dates simply do not match up. Either printed records are wrong or fathers misremember their children's ages, but in any case neither is consistent. Jack Stevens, for instance, was born sometime between 1741 and 1746. In 1771, the elder John Stevens and his wife, Mary, had been married for twenty-six years, so the later date seems more likely. But John Stevens's assertion in 1769 that his eldest son was twenty-three years old (born in 1746) fails to match Jack's 1801 obituary, which claimed that he was fifty-nine (and so born in 1742). Similar confusion arises for Jack's siblings; one would think that the father remembered correctly that his son Harry was two

years older than Jo, though sources, including the formal records on which historians must rely, report the reverse.

The elder John Stevens himself was born in about 1720, but there is no evidence about where in England he or Mary Stevens were from or where they met and married; Mary's unmarried name is lost. John was, by his own account, not a child of privilege and had perhaps been orphaned. "I have since I was 11 Years of Age," he wrote, while pointing out his oldest son's relative advantages, "never had one days Schooling." He worked instead in his uncle's countinghouse in London, with "no fond father" "constantly Soliciting to Instruct" him. That he had a brother in Madeira emerges in the record only because Stevens corresponded with him late in life.[5]

Stevens came to adulthood and pursued his early pleasures in London. Inquiring of an old friend there, he asked, "How does the Crown & Anchor go on, who presides—what new Singers of Solo's & c; Oh! friend Wm I remember when you & I were wont to cut no Small figure both as Boys & Men." Such memories of club life and male camaraderie were strong, because once he had pulled himself together after all his troubles to reconnect with old friends, he declared, "After so many years absence from my Native Country . . . you may have forgot me;—In order therefore to assist your recollection, remember the Crown & Anchor Concert, yours & my most worthy friend the late Mr. J. P. [Joseph Porter], *Persian Luxury* at Mortlake, and then read my name." Between musical and other entertainments, he found time to marry, became a merchant, and was "ruin'd by the [1755] Earthquake at Lisbon & the loss of my Ship & Cargo at Barbadoes." (These two events were not necessarily linked. Years later, writing to an old supporter, Sir Edward Walpole, Stevens claimed that his London "misfortunes were principally owing to the fatal Seizure of my Ship & Cargo at Barbadoes under Gov. Greenville.") Despite possible financial ruin, he seems always to have had connections who were willing to help him scrape together the resources to start again, in at least one case leaving some valuables with a friend as collateral in exchange for money. Stevens recalled in detail the inventory of that small cache of jewelry, watches, and other "trinkets." But as to what happened to his "Cargo," which surely included enslaved Africans who ended up on Barbados's sugar plantations, there is no trace, and Stevens remained silent about it.[6]

John and Mary Stevens had been married for about a decade when John lost his fortune for the first time. Sometime in the late 1750s, they left for Saint Kitts, the first British colony in the Caribbean, where they

Chapter One

likely had contacts through trade. While the Stevenses did not have the resources to consider leaving Mary and the children behind in England, as other West Indies–bound merchants did, I would love to know how she felt about the move to a distant island colony. Whatever her role in the decision, and whatever other options they considered, they shipped off in 1758 with three sons between the ages of eight and twelve in tow. Their only daughter, Mary Ann Elizabeth (Tolsey), was born in Saint Kitts in about 1760. There Stevens, now a colonial merchant, made his second fortune, acquired enslaved Africans as his family's servants, and aspired to a life among the landed gentry, wherever in the English colonies that might be. Whatever his initial intentions, and whether because he was overly ambitious, a bad businessman, a delinquent borrower, or simply unlucky, they did not stay put. Over the course of a decade, the family would move to three different colonies, each time with the hope that John would finally achieve the status that eluded him and that, he believed, he deserved.

In April 1765 the Stevenses sailed for Georgia, carrying enslaved people and material goods as well as the considerable sum of £4,000.[7] John Stevens barely mentions why the family left Saint Kitts, except that, "having acquir'd a genteel sum," he "thought it adviseable to settle something for my family which occasion'd my going to Georgia with my Negroes & family." Clearly they did not go empty-handed. His "Negroes" included thirteen enslaved Africans, though what families he broke up in the process no one mentioned. John acquired land, Mary had another baby, Clement CrookBlake, and they settled on "Little Fresh Marsh," a 500-acre grant of land near Josephstown on the south side of Turtle River, some forty-five miles from Savannah. It was, a traveler reported, "one of the finest countries in the world . . . the soil the nicest I ever saw, (tho' born in Old England) the oak, hickory, cedar, poplar, and beech, remarkably large." Both John and his son Jack had some talent as musicians, offering the family an easy entry into the sparsely populated white community; in November 1765 one of them (it is unclear whether it was father or son) debuted the church's new organ and was appointed the town's organist. He, or they, continued to play for the duration of their time there. Six months later, a "Concert of Musick" on the occasion of the King's birthday raised money "for the benefit of" John Stevens Jr. (Jack) followed by a "Ball, Tea, Coffee, Cards, &c. &c."[8]

But much as John Stevens aspired to membership in, and acceptance by, the planter elite, the Georgia sojourn was replete with troubles. Within months of their arrival, John Stevens took out two ads

in the *Georgia Gazette*. "Run Away from John Stevens's plantation in Josephstown," declared the first, "a NEGROE MAN named CATO.... He had on when he went off a blue jacket, is a stout young fellow, and has a scar on his right arm." Twenty shillings' reward was offered.[9] Stevens's woes did not end with Cato's escape. Soon he ran another ad:

> Whereas the house and wine room belonging to the subscriber at Josephstown was, on Friday night last, broke open by some negroes, who took from thence a quantity of rum and Madeira wine; and whereas it has been a common practice for trading boats and others to land their people, and remain whole nights and days on the plantation . . . this is therefore to give notice to all trading boats and others, that . . . any negroe or negroes who shall be found landing, or within the fences of the said plantation, not having a proper note from their owners, shall be whipped according to law, if in the day-time: And, for the better securing my property by night . . . I shall lay two spring-man-traps near my landing and dwelling-house, and keep fire arms ready in case of the least attempt.[10]

"Man-traps" were a system of metal claws commonly used to catch trespassers and poachers. No evidence remains as to whether Stevens caught anyone breaking into his house. But surely Cato, as well as other enslaved people on Stevens's plantation, recognized that, man-traps notwithstanding, all the comings and goings of "trading boats" offered opportunities for more than rum and wine.

Things went from bad to worse, from Stevens's unfailingly self-focused point of view, as "many of my Negroes died, & every thing I attempted prov'd unsuccessfull." Then, in January 1766, ten months after they had arrived, the Stevenses' house burned to the ground, destroying much of their wealth although not, as far as we know, killing anyone. Although Stevens, who had been visiting friends eight miles away at the time, later suggested that "my House was sett on fire by a party of Runaway Negroes," at the time it had been merely a "Stroke of Providence."[11] Indeed, the *Georgia Gazette* failed to mention the fire at all and no contemporary evidence corroborates his suspicion. Either way, it was bad luck indeed.

They tried to start again. Stevens took an appointment as a third lieutenant in a troop of the Georgia colonial military called Rangers, where he taught music to boys and girls "at the Guard house, where he

now lives." "5M[onths] were scarcely elaps'd before orders came from England for [the Rangers] being Disbanded." After this humiliating blow, Stevens did what financially strapped enslavers commonly did: he sold enslaved people to pay his debts. Over the next year the advertisement section of the *Georgia Gazette* provided blunt clues to the family's reduced circumstances—although it only hints at the trauma and upheaval faced by the people they enslaved. A public sale by John Stevens on October 7 offered "A FEW VALUABLE NEGROE MEN and WOMEN," including "a remarkable good squarer, sawyer, stave-maker, and rough carpenter; an exceeding good cook, house painter, barber, baker, and in every respect a useful negroe man; some good sawyers and stave makers; some house wenches who are capable of all kinds of household business and field work also."[12] Like most enslaved people in the North American colonies, many of these people had come from the Caribbean, and so they would be again uprooted from familiar places and kin. Their names, except for one, were never recorded. And that it was their labor that had built Stevens's house, farm, and fortune seems not to have entered his mind.

Soon, there would be a public sale of Stevens's land; clearly he had acquired more than his original grant and had achieved some affluence: "As valuable a PLANTATION as any in this province, very pleasantly situated at a well known place called Joseph's-Town, on the river Savannah . . . containing about 300 acres of choice river swamp, about 400 acres of fine high land, inferior to none for indico [*sic*], corn, or other provisions, 140 acres of which is in excellent pasture and well fenced, and the remainder is well timbered with oak and hickory; Also, about 700 acres of pine land . . . in the whole about 1400 acres." There was a "completely finished" sawmill and "convenient out-houses of all kinds." The "dwelling house," unfortunately, had been lost in the fire, but the sale included cattle, tools, and other signs of the Stevenses' wealth and decline. For now, John Stevens controlled the terms of the sale and the terms of payment, but not for long. The next summer an ad for a sale at the guardhouse of "some household furniture, the property of Mr. John Stevens, seized in execution," signaled a pattern that would trail him after he had departed the place, for his "lands, tenements, goods, chattels, monies, debts, and books of account" were soon "attached" by the provost marshal. That provost marshal, Matthew Roche, placed the final ad regarding the Stevenses, the proverbial last straw, in the *Georgia Gazette* on November 9, 1768, with only two days' warning: "TO BE SOLD" on November 11, "ONE MULATTO BOY, about seven years of age,

named DICK, the property of Mr. John Stevens, and seized by virtue of a mortgage."[13] We will return to this child.

The Stevens family was not there to witness these sales or to suffer the humiliations of seeing their goods and human chattel auctioned off. The previous November, the family had moved again, fleeing debts, broken friendships, and other failures of wealth and ego. In addition to Dick, now about to be sold, two sons did not accompany their parents, reinforcing the family's transnational reach: Jack, then in his twenties and understandably eager to be on his own, went to Jamaica. Jo, still in his teens, went to sea in 1767 ("Silly Boy," his father grumbled, though he did not have much to offer him) and died far from home three years later.[14]

Moving to Charleston was a decidedly urban move, and the Stevenses adapted easily. For the senior John Stevens, Charleston seemed to offer the warm embrace he had felt cheated of in Georgia. From the first (he insisted), gentlemen recognized and rewarded his gifts. Only a year earlier, the elite of Charleston had formed the St. Cecilia Society to promote music, and declare their own cultural sophistication, in their growing city. By the time the Stevenses arrived, the music scene was well established and well known; it may have been among the reasons Stevens chose Charleston as his family's new home. The St. Cecilia Society's "robust and long-term effort to replicate Old World models," like the city's boast of its "assemblies, balls, concerts and plays, which were attended by companies almost equally brilliant as those of any town in Europe of the same size," surely appealed to Stevens's desire to live amid wealth and refinement. The city's pretentiousness seems to have matched John Stevens's own. The musically inclined merchants, some of whom had known Stevens since his London days, "immediately proposed a Concert [to raise funds for the family] which was had, & the profits were Genteel." It was in Charleston, Stevens gushed, that "I have been as uncommonly successfull, as I was uncommonly unfortunate in Georgia. For soon after my arrival here, the Generous hearts of the Carolinians (warm'd with my misfortunes) proposed a Benefit Concert" that helped fund the Stevenses' initial stay. This was, he always recalled, "the first Instance of humanity, which I had experience'd from the Benevolent hearts of this Hospitable place."[15] Soon, Stevens would be hired as a church organist, help Mary Stevens open a coffeehouse (apparently also on the musical gentlemen's suggestion), and take on the responsibilities of deputy postmaster. Charleston seemed a place a white man of ambition could rise.

　　　　　　　　　　　Chapter One

John Stevens traded a wide variety of merchandise, although a reader of his correspondence may be forgiven for thinking that the exchanges served more as excuses for his storytelling than to provide an actual income. For all his losses and complaints, he relished being at the center of a bustling, even frenetic, center of trade. If something could be acquired, sold, purchased, bartered, or promised in the trade between Charleston and anyplace else in the Atlantic world, John Stevens expressed great willingness to find it. Garden seeds, leather, wine, Jamaica rum, Carolina rice, ducks, limes, and a turtle—not to mention packets of mail—all traveled on his account. Wealthy South Carolinian planters turned to city merchants to supply their households with goods both essential and extravagant, things that, in one merchant's inventory, included "silks, patterned linens, India calicoes, woolens, and Hollands; manufactures such as playing cards, buttons, bundles of violin strings, and of cloth umbrellas; an assortment of patent medicines . . . as well as more mundane items like pewter kitchen ware and workmen's tools." Friendships of long standing—in London, Saint Kitts, Jamaica, and elsewhere—served both personal and business needs: Stevens was obliged to an acquaintance in the Bahamas for a "very acceptable present of Growing pines," which had put it "in our power to oblige a most worthy friend, who is a man of Large fortune & intends from these buds to found a Hot House at his Country Seat."[16] One person might need liquor; another returned jewelry and purchased other goods for Mary Stevens; still another sought or found employment for Stevens's far-flung sons. He traded as well in enslaved Africans, buying and selling individuals on behalf of friends from Philadelphia to Jamaica.

As a merchant in London, John Stevens had profited from the trade in enslaved people before he owned any himself. While London merchants were less involved in actual slave trading than were those in Bristol, Africans were present and visible on London streets, in coffeehouses, and in runaway advertisements half a century before Stevens's time, and human trafficking, a "significant foundation of England's rising empire," was well established in the Caribbean trade.[17] In any case, Stevens adapted quickly, even seamlessly, to slave ownership. When they left Saint Kitts for Georgia, the family took enslaved people with them; they may not have taken any Africans to Charleston in 1767, having sold them to fund the family's move, but Stevens soon purchased more. In 1771 he wrote a contact in London "in regard to a Negro Boy named Cupid of yours who has been with us some time past at the request of Mr Vanderhorst in order to keep him out of mischief, he really

is a little Idle fellow & continually running away." Having slyly minimized Cupid's value, he went on, "However tis at the request of my son Harry (who I am anxious to oblige on every occasion) that I apply to you to know if you are Inclinable to sell him. If you are & will fix a moderate price on him, I will purchase, in order to make Harry a Compliment of him."[18] Enslaved people were the uncounted and unnamed occupants of the Stevens household and probably Mary Stevens's coffeehouse. Could you possibly, Stevens wrote his son Jack in Jamaica, find me "a good Negro fellow a Cook . . . on cheap Terms.—I mean a Cook, not a Blockhead who is only a pretender." "If by accident," the father continued, "some french fellow" were available, that would be best. When "the sore throat & fever attack'd both Whites & Blacks," he reported that in his own household "two small children & four Negroes remain Ill" while others had recovered.[19]

Another source of income happily united John Stevens's devotion to trade, letter-writing, and being a busybody—all while protecting his family from his debts. Typically, the laws of coverture—which placed a wife legally under the "cover" of her husband—forbade married women from doing business in their own names; nearly a century later, reforming these restrictions would be among the first demands made by middle-class woman's rights activists. In South Carolina, John Stevens, hounded by his Georgia creditors, found a loophole. With the stroke of a husband's pen on a legal contract, wives could assume the status of feme sole, or a single woman, and so protect their businesses from their husbands' debts or, to put it bluntly, their inadequacies. Thus on August 2, 1768, Mary Stevens opened her coffeehouse in the middle of Charleston's lively harbor area, on East Bay.[20] It provided an income in Mary's name while offering her husband a stage for his self-esteem.

The history of colonial-era coffeehouses is a fascinating one, linking the purchase and sale of goods, the trade in human beings, and the exchange of news and companionship. These were the physical spaces—about 3,000 of them in London by 1700—where transatlantic alliances and commerce took place on a daily basis. That they were named the "Jerusalem Coffee House" or the "Pennsylvania Coffee House" did not indicate their location but the focus of their trade. Thus when John Stevens addressed a letter to "the Carolina Coffee House" in 1770, it was to a place on Burchin Lane in London. There, shipping deals were made, connections sustained, and newspapers and mail sent to and from South Carolina. Each mail packet performed numerous functions: Stevens's 1770 missive enclosed additional letters to be passed on to a

mutual friend as well as a request to have newspapers delivered to his wife's coffeehouse.[21]

Mary Stevens's coffeehouse was "on the Bay" near Longitude Street, a street bustling with shops and wharves. When in 1775 Arnoldus Vanderhorst sold "lot . . . number 5" to Samuel Legare, the "southernmost part" of the property was "occupied by Mary Stevens widow, and the same where the Coffee House is now kept."[22] The Works Progress Administration guide to South Carolina may have conflated two spots, referring to an "OLD CAROLINA COFFEE HOUSE, 120 E. Bay . . . a pre-Revolutionary meeting place for citizens who indulged in political and social gossip over their coffee cups." "On early maps," the guide continued, "the name is also given as Old French Coffee Shop and as Harris Tavern, but it cannot be determined if the present building is the original structure."[23] But historical photographs of this address labeled it Coates Row, whose construction began in 1788, and it only later became the French Coffee House or Harris Tavern.

Whatever the coffeehouse's precise location, Mary Stevens, John's companion in all travels, entered this transatlantic and Charleston world on her own account, although not in her own words. She had been, her husband asserted, "so fortunate to have a credit given her as a Sole Trader, in order to enable her to provide for her family."[24] A year later it became the official post office, "a kind of Lloyds coffee house," her husband boasted, where mail and newspapers were delivered, ship captains gossiped, and networking for a vast array of trade goods proceeded. Characteristically, John took full credit: "Since I have been appointed postmr, I have all the Early News of the place, & am the person Apply'd to on all occasions," something that could only occur (he reminded Jack) because of his own "Dilligent & close attention to Business, & the utmost regularity." Whatever his role in its success, the coffee room, if not quite Lloyd's (the English coffeehouse founded nearly a century earlier) became, on a smaller scale, "a meeting place for people in the maritime occupations: ship captains, shipowners, merchants, insurance brokers."[25]

John Stevens, for all his privileges, kept a clear focus on the persecution and misfortune he faced from all sides, but he lucked out in his choice of a wife, whose achievements simply shored up his own self-regard. Thus, when he requested that newspapers be sent from Jamaica, he instructed his son Jack that the agent "must direct to Mrs. Stevens at the Coffee House on the Bay Charles Town, as the House is in your Mother's name in order that I may be disengaged for any advantage

which offers." This technicality, he explained to another correspondent, reflected his own virtue; he had "bound myself not to apply any moneys that may come to my hands, but to the Discharge of her Debts; what she is possessed of is not even hers till the Debts she owes are paid; I have no property, nor shall any Torture force me to Commit an Act, that I look upon as Dishonest or Dishonorable." Leaving aside the question of what debts Mary could have owed, John Stevens, with some justification, credited this turn of fortune to his own backslapping: "In short the friendships which I experience Daily, from the Inhabitants of this hospitable Place, is not to be express'd, I am as extremely happy here, as I was extremely miserable in Georgia. Not a man of any consequence in the Town (or who passes) but come to the C[offee] R[oom]."[26] Indeed, male travelers, among them officers of the army and navy, found it a place of great interest. Josiah Quincy Jr. of Massachusetts began his Charleston sojourn on a Sunday evening in 1773 by stopping at "the Coffee-house, where was a great resort of company as busy and noisy as was decent."[27] Much name-dropping ensued.

We hear nothing directly from Mary Stevens (his "deserving unfortunate Wife"), or of what she considered a "decent" level of male noise, but she did well. Charleston represented a different kind of new start for her, and she (not unlike other women in this story) may have preferred urban life to their rural sojourn. Certainly she faced new labors, another pregnancy, and the additional heartache of losing sons to death or emigration. But living and working in the very heart of this vibrant and growing city, Mary found a permanence and perhaps a purpose that had eluded her thus far. Indeed, John Stevens briefly contemplated joining their son Jack in Jamaica—assuming he could be assured of paid work as an organist—but his wife seems not to have considered accompanying him. He would make his decision to go to Jamaica, he assured his son, only with the "consent" of the gentlemen who had helped them establish the coffeehouse, for "it would be ungreatfull was I to move, at least till Mrs. S. is well fix'd. . . . However I may be able by the Spring so to settle Mrs. S. that my Absence will be no Inconveniency, provided I could make an Advantage by coming down, As I shall ever be ready to take any step, for the Benefit of a deserving unfortunate Wife & family."[28]

Whether she considered the prospect of John's absence an "Inconveniency" or not, Mary Stevens may well have enjoyed running the coffeehouse. The labors, which included renting upstairs rooms for up to eight lodgers, expanded her domestic chores but also gave her

opportunities to socialize, to hear the news, and to be a person of note. Perhaps she heard less whining there than at home; surely she accepted a compliment or two on her own behalf. Clearly she appreciated the "warm heart" and "most tender manner" with which friends and customers welcomed her new business. Money worries persisted: John Stevens frequently griped about debts men owed her or expressed outrage at slights they had proffered "a woman, who had been a Mother to you Ten Fold." On occasion, young men to whom John Stevens owed lingering Georgia debts exhibited the "most Brutal Behavior to a helpless unfortunate woman Mrs. Stevens . . . with such Indecent Language, as you Sir would blush to Read, & I should be almost distracted to commit to paper."[29] Fortunately, Mary Stevens enjoyed the assistance of their son Jervis Henry (Harry) in running the business, leading John Stevens to boast that "as Mrs. S & my Son have a considerable Business in the Liquor Trade & with reputation," a correspondent purchasing his rum, brandy, and port might "depend on their goodness."[30]

And she sustained the business after her husband's death. In 1778, a revolution was underway; her son Harry and her son-in-law, George Cogdell, were both serving on the American side. One son, twelve-year-old Clement CrookBlake, remained at home, and her daughter, Mary Ann, was about to have her first baby. A terrible fire raged through Charleston that year, destroying some 250 buildings. Among them, according to historian Nicholas Butler, was the brick house on the corner of East Bay and Longitude, which may well have been Mary Stevens's coffeehouse. That same year, Mary Stevens purchased Nos. 1 and 2 on Saint Michael's Alley from another widow for the princely sum of £10,000. Whatever her views about the migrations she and John had undertaken, and whatever she thought of his social ambitions, when Mary Stevens had independence and money she stayed put.

For all of Mary Stevens's apparent stability, a reputation in bustling, status-conscious Charleston was under constant threat and required work to uphold. His wife's success as a businesswoman and his own activity in trade brought the family material comforts, but John Stevens never realized his aspirations to be part of, or at least liked by, "the upper echelons of Low Country society."[31] Among his other troubles— debts, fire, the exhausting effort of being ingratiating to gentlemen all the time—there were his sons. Ambitious fathers expected their sons to improve upon their own lot and hoped to be proud of them. They

gave them land when they could, or a trade, and taught them, through their own example, how to be members of communities and heads of households. If nothing else, they provided them with a name, in all the meanings of that word: they had a reputation to uphold and a legacy to establish. But his sons, as John Stevens grumbled, did not quite live up to those expectations and followed unexpected paths for continuing, or closing off, a family's name; daughters, however accomplished, barely figured in a father's accounting of his own success.

Most likely John Stevens loved his children; clearly he hoped— anxiously, doubtingly—for the best. But his oldest son, John (Jack), who had absconded to Jamaica, was "my thoughtless boy," whose (in his father's opinion) "most unintelligible Letter" only showed that "you write worse & worse." He couched his disappointments in terms that surely made Jack wince: "If I could be sure of finding you entirely Divested of your Boyish flights, I should with Comfort even now lend you all the assistance of a Fond Father. But oh! friend Jack look well upon your past unwarrantable behavior, at a time when this heat of passion (upon examination) will appear clear to you to have arose from my Affection to you & my family."[32] Clearly they fought.

What exactly Jack's "unwarrantable behavior" was is hard to say, though we have clues. At the very least he did not uphold his father's often-asserted standard of industriousness and filial devotion, but neither did his brothers at times, whom Stevens declared "All good at heart, but with such Chimerical heads, that they are not to be depended on, nor have I ever yet been able to convince either of them for their real good." Jack seems to have inherited from his father a habit of getting himself into debt, for goods purchased in Georgia remained unpaid for, and although John Stevens tried to blame "a Handsome Mulatto wench [who] . . . took up these Articles," it was hard to escape the implication that Jack was involved. But Jack may have done more than simply been lazy or too free with his father's account; he was likely the father of the "Mulatto Boy nam'd Dick" who had been advertised for sale in 1768. His father scolded Jack as "that Rough, Impolite Swaine (as you confess by your own words) you ever was," capitalizing a word that connotated sexual or romantic behavior. Clearly there was some drama. In 1770, still sorting through his debts in Georgia, John Stevens raged to his now-estranged friend Clement Martin at "the unjust & cruel circumstance of your taking the mulatto Boy from my wife, & selling him at public Vendue."[33]

John Stevens's outrage went deeper than the unauthorized sale of one enslaved child. He had heard (one wonders how) that "the Good people of Georgia, have done me the honour to proclaim me the Father." Such gossip struck John Stevens at his very core: "—know Sir I am the Lawfull Husband of a Woman I Love.—that the small Education I have recd & the Religion I profess has ever taught me to live above so gross—so mean an Act; as that of placing a Negro Slave on a footing with a Virtuous Woman.—I hold such an Act in so horrid a light; that I would not (even to be master of Ten provinces) wear such a crime about me." If Stevens's moral indignation sounds overwrought, there is a twist: he was entirely able to accept being *related* to the boy, which may explain both his anger at the child's sale and his impatience with Jack. That "I believe him to be the child of my Son, I have already own'd to you, when I look'd on you as my friend, & I now repeat it." Historian Wendy Gonaver suggests that the child Dick was Harry's son, but given the brothers' ages, and the suggestion that Dick was as old as seven in 1768, he was more likely the child of "honest Rough Jack."[34] The child may have been among those enslaved people that the family brought to Georgia from Saint Kitts; perhaps Dick's mother moved with them. Perhaps she was the "Handsome Mulatto wench" who was the subject of John Stevens's only comment about someone's appearance, or she may have been among the "house wenches who are capable of all kinds of household business and field work also" who were sold—separately from Dick—when the Stevenses left Georgia. The circumstances of Dick's birth may well have been part of the "past unwarrantable behavior" that led to Jack's flight to Jamaica; in any case, Jack seems to have had no problem leaving the child behind.

Whatever John Stevens imagined would happen to the child in the family's absence, he wanted the boy back. "Send me the Mulatto Boy you seiz'd & Sold without the least Colour of Justice," he pleaded. Perhaps Mary Stevens urged her husband to retrieve the child out of a grandmotherly affection; maybe he resembled Jack, whom she might not see again. Neither of these would preclude the possibility that she also desired Dick's labor, for a small child could be a valuable worker in the coffeehouse, a setting that entailed countless errands and small exchanges. But even if Clement Martin had access to the child, Dick was never recovered by the Stevens family, and, like so many thousands of enslaved and sold children, he is lost to the historical record. Which part of this story was shocking to Stevens and his community—the rumor

that John Stevens had had sex with a "Negro slave," his acknowledg-
ment that his son had, or the apparent attachment Mary Stevens held
for the boy—must be left to our own imagination and judgment. Still,
although he regretted separating the child from his wife—apparently
without giving a thought to the boy's own mother—John Stevens's at-
tention remained fixed on his own reputation:

> Under the many misfortunes & Villainies which have been
> practic'd on me, & which (I bless God) I have waded through; I can
> challenge you, Sir, or any man living to stand forth, & with Justice
> accuse me—wretches & underhand Rascalls have taken advantage
> of my misfortunes & have endeavour'd to stain my Character.—But
> Truth is a Spark; to which Objections are like Bellows, that only
> serve to blow it up into aflame, & make it shine the brighter. I
> now Glory, That I am environ'd by Men of Sense, Discernment,
> Uprightness, Humanity, & Learning.—many of them have been
> your Intimates, who now Shudder at the recital of this most
> shocking story.[35]

I have read a great deal about the white men of "Sense, Discern-
ment, Uprightness, Humanity, & Learning" in mid-eighteenth-century
Charleston. I doubt they shuddered at the "most shocking story" nearly
as much as Stevens did at any criticism of his character. Indeed, such
behavior was common among Charleston's enslavers, and Jack, if he
had in fact left an enslaved son to be sold to strangers, would have fit
right in.

Stevens's financial woes, his troubles with his sons, and his outrage
continued unabated. Ever the victim, his indignation waxed high. Thus,
inadvertently, his correspondence offers a rare window into how a man
might enhance and protect his own reputation: "Can any thing be more
Comfortable to a Man, than to know he is well spoken of," he asked Jack
rhetorically. Stevens was a social climber, delighted to have been so
warmly welcomed in Charleston and highly attentive to his role as pur-
veyor of information; if not for his job as secretary to the deputy post-
master, we might just call him a gossip. "Whenever I hear of any new
matter, I have it publicly canvas'd in the Coffee Room particularly by
the first people of the Town," he boasted to a Georgia acquaintance. His
previous failures came about, he was sure, through no fault of his own:

the 1755 earthquake in Lisbon, followed by "the loss of my Ship & Cargo at Barbadoes," something that went wrong in Saint Kitts, and then the fire in Georgia. "Sure no man was ever born to such misfortunes as I have undergone since I wrote you last," as he repeated, endlessly, the tales that "I believe, are scarcely to be equal'd in any mans History."[36] Everything, he complained to friends and associates around the world (and, no doubt, to anyone who would listen in Mary's coffeehouse), had gone wrong, and he begged for assistance, for support, for sympathy, for opportunities to trade goods, and for a chance, once again, to try his luck and make his name.

On occasion, John Stevens could seem unhinged; one wonders how those he considered his friends viewed him. He could, after all, be rude, was nearly always self-aggrandizing, and exhibited a short fuse toward those he felt betrayed him. Not surprisingly, some of his correspondents grew exasperated. To John Holmes in Georgia, he wrote sarcastically, "You do me the honor to approve (what you very politely & Learnedly call) my 'knack of letter writing' & 'method of telling my own story;'—I claim no other merit than that of writing & speaking plain honest truth; & to such I will ever dare to subscribe my name." He was not above personal attack, warning that "when you hold the mirror of reflection— remember, I left Savannah privately —to avoid Persecution.—you left Dublin & Jamaica privately—to avoid Prosecution—oh! thou fool." Later letters continued in this vein. "Your Letter . . . is Inhumanly Gross—false—pitifull— untrue in every instance—&c. &c—I am very sure a Man who can be capable (for no cause) to write such falsehood; particularly to a person he had formerly stiled his friend, ought not to be forgiven." Yet Stevens felt sure that he was "above such base Malice" and asked only "that we never more Correspond, or Claim the smallest Acquaintance." Signing his letter, "Your much Injured former friend," Stevens left behind yet another piece of his Georgia tribulations while feeling quite confident of his own integrity.[37]

By our standards, and perhaps even those of his own time, he could be utterly oblivious. In 1770, writing to Jacob Jacobs, a member of a Jewish family in Savannah, he expressed his "astonishment" at news-paper stories Jacobs had passed along that concerned Stevens's debts. I have no idea what "Hellish Scheme . . . to gett my Lands into their own hands for a trifle" Stevens was ranting about. Apparently Jacobs was also confused, so Stevens used terms he thought his "Most Esteem'd friend" would understand: it was exactly like "the 4th act in the play of the Jew of Venice." "In every respect tis similar, my Debt to this Jew, is

not for Value rec'd of him in goods, Money, or other real property, but for becoming Security for a Man, who is since Dead, & whose Effects this Jew seized upon like another Jew of Venice."[38] Casual antisemitism was common in Jacob Jacobs's world. Still, I would have liked to have seen his face—the one known Jew in all of Stevens's correspondence—as he read this.

John Stevens's epistles to his oldest son made no attempt to veil his own self-praise: "Can any thing on Earth give greater pleasure than I at present enjoy. I converse with Gentlemen. —Am on all material occasions sent for to [So. C. M.?]—my opinion frequently ask'd in matters of moment—treated with the highest respect by every Body." Jack remained unmoved by his father's recitals, which were always intended to contrast with the son's own shortcomings; he may have wished his father meant it when he promised, "If these Facts will have no weight with you, I'll leave preaching." But this he did not do, instead throwing back Jack's words with his own interpretation. "You know friend Jack, when I read a man's Letter, I likewise read the Man:—Give me leave therefore to tell you, your last lettr to me, contains many contraritys—Great want of Stability—No Settled Theme—Tough, Tough, Tough—Superlatively Rough Mettle Indeed.—You own I always knew you so; I am concerned to find you give me no hopes of seeing you aspire to a more Amiable character."[39]

Jack had a different idea of what a "more Amiable character" consisted of, though his words are filtered through his father's disappointment. Luckily for us, the elder Stevens quoted his son's most pointed—and astonishingly crude—barbs. John Stevens objected mightily to Jack's stated ambition to "get a living without sucking." He even considered not writing ("from this hour I give over preaching, this you may depend on") but the temptation to criticize was simply too great. Sometimes, he despaired of the "three young Fellows (sons of mine) who have look'd upon me, on many occasions as a hard hearted father." Eventually, John Stevens did leave off writing to his eldest son, remarking to a Jamaica acquaintance that "Jacks health & good spirits give me satisfaction" and asking, "When you see him present my Love & good wishes to him." But father and son had not been in touch: "When he does me the honor to write me I answer him—tis all I can do," remarked John.[40]

To others, he played the proud father; after all, his sons' behavior reflected on his own reputation. But his boasting could only have confirmed the views of a son disgusted by his father's "sucking": "John Stevens, my Elder Son 23 years old . . . is respected by every Gentleman, &

I have the Satisfaction to hear him call'd a Valuable Young Man by his Employer, & every Gentleman who comes from that Island." There is nothing here about Jack's own accomplishments; that others (actual "Gentlemen") spoke well of him gave all the satisfaction John Stevens needed. What mattered to the father was that he had, as he put it, "carefully & constantly attended to the framing [of] their morals, & have the unspeakable pleasure to see them remark'd for young Men of Strict Honor & Virtue."[41]

What of Jack himself? The young man's decision to move to Jamaica made sense for an eldest son with no deep roots, no prospect of inheriting land, and a father who carped. In their business, Jamaica, the largest and richest of England's West Indian colonies, was one of the centers of the world. Jack would have had many of the skills a man needed to succeed there. In Saint Kitts he had become familiar with island life, with slavery, and with trade throughout the Caribbean and Atlantic. With his family's move he gained ties to South Carolina. Most important, he had the connections that greased a new start. His father's contacts in the British colonies went back not only to his years in Saint Kitts but to when he had done business with Barbados in the 1750s, had traveled to Antigua in 1763, and had formed acquaintances in Jamaica as well.

In the early years of English settlement, colonists considered the island of Jamaica "the most fascinating of the Caribbean islands." Newcomers from England found its tropical heat and frequent hurricanes — not to mention bugs — deeply disorienting. But Jack Stevens had been an adolescent when his family moved to the Caribbean and so was familiar with island life. It was a likely place for a young man who wanted to be outside his father's immediate presence but well within his orbit. For a London-born colonial with experience abroad, the ties between Jamaica and England were strong and profitable. As John Stuart Mill later put it, "The [English] trade with the West Indies is hardly to be considered an external trade, but more resembles the traffic between town and country."[42]

By the late 1760s, when Jack arrived, Jamaica was no longer "England's most lawless colony" or a "bad joke" within the empire, but it was a hard place.[43] Following the much smaller Barbados, the island had become the center of British trade decades before Jack sailed there; Kingston had long been "poised to become the largest transshipment depot for enslaved Africans in the Atlantic world." Indeed, sugar and slaves (as Richard Dunn named his pioneering book) propelled British

expansion and dominance of the Caribbean. Sugar's ever-rising demand among all classes of British consumers ("Like tea," writes Sidney Mintz, sugar "came to define English national 'character'") kept it largely untouched by European trade wars. A labor-intensive crop, sugar's production combined agriculture and industry, growing and processing, and storing and shipping. It made some people incredibly wealthy, "far richer than their cousins in the North American wilderness": "They lived fast, spent recklessly, played desperately, and died young."[44]

The vast majority of Jamaica's population—nearly 90 percent by the middle of the eighteenth century—were African slaves, who died far younger and without either wealth or a stake in their own productive labor. From West Africa to Bristol to the Caribbean, ships brought thousands of enslaved Africans to work and die on island plantations; over the course of a century, some 662,400 of them landed in Jamaica.[45] Jack's brother Jo likely served as a crew member on one of those ships, since he was thought to have sailed both to Guinea and Bristol; surely he stopped in Jamaica. Slave rebellions were frequent and violent; unlike the smaller islands, the mountains offered ample places to hide and opportunities to align with the Maroons, descendants of fugitives from Spanish enslavement. The biggest of these, Tacky's War, had ended but a few years prior to Jack's arrival, shaking up the white residents and resulting in ever-harsher restrictions on the enslaved workforce. Most observers agreed that Jamaica exemplified "the sugar and slave systems in its starkest and most exploitive form."[46]

It took Jack a while to settle down on his own land, to establish the plantation life that matched his father's own dreams, to purchase slaves, to marry, and to have a family. He took a series of jobs—apparently as a manager of other men's estates—but we can only follow his travels through his father's lens. He left one job (why, his father griped, had he "absolutely quit an employment which procured you even Bread"), but a Dr. William Mann helped him acquire a happier one, on the Liguanea estate of a Mr. Charles Seymour.[47] Characteristically, John Stevens viewed Jack's new position as a favor to himself. He had, he wrote to "My Good Friend" Dr. Mann, heard from Captain Todd that "thro your kindness he is settled in the House of a most amiable & worthy man. how I shall express my thanks for such kindness I am at a loss to know. I'll wear you next my heart." The elder Stevens did not yet know Charles Seymour but enclosed a letter of thanks—and some parcels of garden seeds, "said to be of the best kind," that Jack had mentioned—in the same bundle of mail. Quick to boast, John Stevens reported to a friend

that his eldest son was the "Sole Manager of a Large Estate 5 miles out of the Town of Kingston in Jamaica where he has been these 16 months past." A few months earlier John Stevens had understood "by your Expression—'that you are extreamly engaged with your plantation Business—that 'you are endeavoring to get enough to be able to sett you down hereafter Easy & Quiet—which you hope to do in a Few Years'—I judge you have a Plantation of your own, & that your former Situation when you went to Mr. Seymours is quite forgot," but that was probably wrong; months later he was still addressing Jack in the care of Charles Seymour. At some point Jack must have raised the possibility that he join the family in Charleston. His father squelched that idea with a mean twist: "For my part tis with great difficulty I am able to support the family I have with me—would you come to this place to make yourself & me miserable."[48]

John and Jack Stevens engaged in a wide range of mutually beneficial business exchanges—though it is always hard to sort out the father's requests from his criticisms of Jack's work ethic. "If you can spare time," he pleaded, "order the New[s]papers of Jamaica to be sent me by the printer regularly, & the response shall be remitted punctually, or paid to any Gentleman here; I have them already from Philad, New York &c. I therefore beg you'll find time when you go to Kingston to do this for me; & desire the Printer to write me a line that I may keep a Correspondence with him." In another he thanked him "for the [Matt?] & Coffee; No Cayon pepper, or Castor Oyl, they say you knew they were destroy'd. Many Vessels from Jamaica since 4th last, yet no papers for your mother." Exchanges were frequent: "I have the first credit in Town for Good Madeira & Old Jamaica Rum," John Stevens wrote his son, "& am getting fast to the Sale of those two articles. Is it possible to get a fine Hogshead or two of Old Rum from you, but unless 'tis the thing it will not do. You shall have a remittance in cash, Rice, or any other way you choose." Frequently they exchanged goods rather than cash, as when the senior Stevens, grateful for a shipment of rum, wrote, "In return I send you 74 Hydes of exceeding good Leather." And they bought and sold human beings, as when Stevens requested a cook "on cheap Terms" from his son.[49] As was the case with most West Indian planters (as, indeed, with most so-called self-made men), Jack's family and business ties blended seamlessly, literally making his success in Jamaica possible.

Jack did make a place, and acquired significant wealth, in Jamaica. Like his father, he played the organ in Kingston and hoped to make some money that way, though no evidence remains that he succeeded.[50]

More important, he acquired an estate in Montego Bay as well as holdings in the mountains, thus achieving the status of planter that eluded his father. In May 1782, some fifteen years after he arrived in Jamaica and now in his late thirties, Jack Stevens married Eliza Jane Henly (or Henley), the widow of Francis Henly; it may have been she who drew Jack to Montego Bay in Saint James Parish, about 100 miles from Kingston. Possibly Eliza already owned enslaved workers and their plantation, Save Rent. But their mountain property was named Stevenage, suggesting that Jack acquired and named it as his own. Together the couple were said to have had nine children, though only the names of the six who lived to adulthood have survived.

As Jack's family grew, so did his property; when he died in 1801 his estate included two plantations and some fifty enslaved people.[51] One can imagine how gratified (or envious?) the elder John Stevens would have been to read the Charleston obituary notice that called his son "a man of unblemished character, honest and industrious, an affectionate and indulgent husband, a kind father, and an agreeable companion; to know him was to respect him." His widow, Eliza Jane Stevens, pregnant at the time of Jack's death (Jervis Henry was born in 1802), would already have managerial skills gained in her first widowhood. With help from Jack's brother Clement CrookBlake, the estate grew, numbering 100 enslaved people in 1817 and then gradually declining until Britain ended slavery in 1833. At that point, a different kind of historical record, and a different silence, makes note of the family, for Eliza Jane Stevens applied for compensation for eighty-two formerly enslaved people; six adult children are listed alongside her as co-owners of Save Rent and Stevenage. There is no record that she or her children received a share of the £20 million that Britain paid to slave owners.[52] As was typical, none of the enslaved people are named in their claim. Perhaps Jack and Eliza, like many wealthy white colonists, sent some of their children to be educated in England; certainly their ties there remained strong. In any case, the estate was large enough to allow their daughter Mary Ann Elizabeth Stevens to leave home and support herself comfortably in Bristol. Indeed, the Jamaica holdings would leave Jack's heirs far more wealthy than any other branch of the family.

Jack Stevens kept close ties with Charleston, though newspaper obituaries were mistaken in declaring that he was "formerly of this city."[53] His much younger brother Clement CrookBlake, now "a lawyer of respectability & refined manners," remained in Jamaica until his own death.[54] I do not know what Clement's plans were; he may have arrived

just after Jack's death, traveling with his nephew Richard Cogdell, and simply stayed. When Clement died in 1812 or so, he left a life interest in his property to his sister, Mary Ann Cogdell, but apparently he had no other heirs. Decades later, piecing together some family history for an inquisitive relative, Richard Cogdell noted that "since the troubles in Jamaica & the emancipation of the slaves then [in 1833], I have never heard a word of the family." This was not entirely true—he knew that his cousin Mary Ann Elizabeth Stevens had died in Bristol, England, in 1851—but by then these ties to family and property in Jamaica had weakened considerably.[55]

I have no idea what the first Mary Stevens thought of her eldest son, Jack—or of much of anything else. Her husband reported to a newly married friend that "my Old Woman & I, have been, jogging on these 26 years; & on my faith, are at this very moment as happy as any two upon the face of the Globe. May this be your Lot." Each of us will have to judge whether to trust his assessment. Certainly she suffered along-side her husband as they lost their homes, their communities, and their material goods ("my House, Furniture, Apparall, money . . . my favorite Organ & every other my property," John Stevens bleated after the fire). They also lost children, both to death and misadventure. We cannot know how leaving the enslaved (grand)child Dick behind in Georgia, and then hearing that he had been sold, affected her, though her husband indicated that she was fond of him. Then, in May 1769, within a year of opening the coffeehouse, Mary and John Stevens "bury'd our little Benjamin" and John noted tersely, "Mrs. Stevens has been unwell, but I thank God she is now recovered." And there was Jo, off at sea, to worry about. I do not know whose decision it was—if it was one at all—that they had had enough children, but in 1771 John Stevens noted that he and his wife had four living children: "But no more coming friend."[56]

That she missed her first two sons is certainly plausible, as is that (as John told Jack) "she loves you past expression," but we only have her husband's morose word for this: "Your Mother desires I'll tell you this last letter of yours comforted her; she says till then, you have forgot to bestow even one poor thought on a mother, whose first care has ever been her Children, & whose heart continues to Yearn for their Wel-fair.—I am commissioned to tell you she loves you Affectionately." The three children at home were doing well enough: "Harry is diligent, & Steady to his Business,—& begins now to find the good Affects of it in the profitable way.—Tolsey plays the Harpsichord, Dances, Reads, Writes, Works, & is clever; she is now ten years old—Clem, acquainted

with every body, & a play thing for the Gentlemen who come to the House." Jo remained a worry; the "Silly Boy" had gone to sea, quarreled with his captain "in a very dirty manner," and more or less vanished, causing his parents much grief. In a rare reference to someone else's emotional state, John Stevens reported to his eldest son, "No news of poor Jo. the loss of him almost distracts your Mother," while John himself sought to "wait with patience the will of God." A letter from Jo himself, which John Stevens read as proof that "his not having follow'd my directions, has ruin'd him," caused Mary Stevens to be "unfitt for sevl hours . . . [and] near being totally lost with joy."[57]

The few glimpses of Jo allude to the more adventurous and dangerous side of this transatlantic life his father had chosen. After several years at sea and on "his Second Voyage to the Coast of Africa . . . he has suffer'd Ship Wreck, & in another instance has been plunder'd by the Spanish thieves who attack'd the Vessells as they were passing near the W. end of Porto Rico." At one point Jo visited Charleston, "naked . . . & this at a time when I had no other method to cover him but by sharing my own poor Stock of Cloths, which consisted only of a Second Shifting. I gave my child one & sett him forward to Sea a Second time; & now hope to see him every hour." In early 1770 Jo was, perhaps, "on the coast of Guinea" and had been spotted in Bristol as well. John Stevens beseeched acquaintances in Bristol to "consider a fond Father, & if you can hear of him, do my good old friend, send him home." Later that year, word came that Joseph Porter Stevens had died in England, leaving his father to "hope he is happy." Still, no word from the woman he referred to until the end as his "most industrious, Affectionate Good Wife."[58]

Harry, at least, joined his father on the straight and narrow, working alongside his mother in the coffeehouse and playing music at church: "A Capable good Dispos'd Youth, Understands Business, & a True Votary to Apollo," the older Stevens sighed contentedly. Certainly there were setbacks—an "unfortunate accident of the P[ost]. O[ffice] being Robb'd" in 1771 afflicted both Harry and his father with anxiety and ill health: "Poor Harry has been in the utmost danger, his Life dispared of for sevl days, therefore conceive my anxiety."[59] Whether John or Harry Stevens behaved inappropriately or carelessly—or whether it was Peter Delancey, who formally held the office of deputy postmaster, who was at fault—I do not know.

The post office—and John Stevens's effort to be appointed, promoted, and given more money—offered far more drama than one might imagine. Within months of the incident over the theft, Peter Delancey

was shot and killed in a duel with Dr. John Haley in a Charleston tavern. The two men, one wealthy Charlestonian reported to another, had had "a Quarrel of several Years Standing between them, which always broke out afresh under their being heated with Liquor." Before the guns had cooled, Stevens caught wind of the matter, and (he wrote privately) "I immediately sent my Son to see whether the wound was mortal—he soon return'd & told me Mr D.L. was absolutely dead.—this about 8 o Clock in the Evening." Stevens gathered himself together to express great mourning but lost no time in applying for the dead man's job. "It was then," he continued, "I began to consider whether this office came under the jurisdiction of the Govr, or not."[60] Much frantic letter-writing commenced, with Stevens breaking the news of the "melancholy circumstance" of Delancey's death and, without taking a breath, offering himself as the logical person to succeed him.[61] The appointment, instead, of a Mr. Draper ("a young man—in no way qualified for Business, & more particularly the Business of this office") led to a veritable flood of letters from Stevens that did not abate.[62]

Whatever the setbacks, Harry Stevens did well, further establishing the family as part of Charleston's urban middle class. For one thing, he eventually "served as the secretary to his Majesty's Deputy Postmaster General for the Southern District of North America, Mr. George Roupell." "Postmaster Roupell," according to historian Nicholas Butler, was "a well-established Tory placeman in Charleston [who] collected a salary from the king, but twenty-five-year-old Henry Stevens did all the work." In 1775, as tensions mounted with Great Britain, Harry was in the coffeehouse/post office when three members of Charleston's Revolutionary committee sought to intercept a letter signaling the English authorities' intentions toward the colonies. As he recalled it some forty-five years later, long after American independence had come to seem inevitable, Harry Stevens was alone in the post office; the men demanded to be let in and he opened the door; he attempted, unsuccessfully, to protect the mail. A scuffle may have occurred but it stopped short of actual violence; the men went off and Harry was left shaken. In local lore, that night's events signaled a revolutionary turning point. The three thieves congratulated themselves on revealing "the British government's determination to use force to 'reduce the colonies to a state of due obedience.'"[63] From then on, people, including Harry Stevens, chose sides.

The colonists' discontent with English rule and the coming American Revolution do not play a significant role in the family's archive,

likely because John Stevens had died in 1772 and his wife and children did not leave the paper trail he did. I do not know if John Stevens gave much thought to the colonies' growing rebellion or if he would have eventually supported independence. The evidence suggests that, like most Charleston merchants with strong transatlantic ties, he tried to keep his focus on how politics might affect his own prospects. Only once did he mention that "our resolutions have hitherto totally deprived us of all commerce, but to morrow the gentlemen of the Town & Province meet in order to settle a plan for the future." Not surprisingly, he continued, "I heartily wish the Importation may be open'd."[64] While Stevens fretted about the price of wine, and certainly in his letters to Lord Charles Montagu, an early sponsor of his, he groveled, he would likely have shifted with whatever political winds promised the most personal advantage. Clearly the rest of his family, who might have considered leaving Charleston to join Jack in Jamaica, made no such choice. Harry joined the Revolutionary army and climbed socially and economically. By 1812 or so he was the city sheriff in Charleston, his name appearing on sheriff's sales of enslaved women, men, and children.[65] Like his father and brother—and, for that matter, quite a few of his descendants—Harry played the organ, retiring as organist at St. Philip's Church in 1815 after some thirty years.[66] He also joined the St. Cecilia Society and acquired much of the polish and comfort that had eluded his father. His only child, Mary Ann Jane Stevens, would marry lawyer and politician Lionel Kennedy and thus establish one branch of the family among the middle ranks of Charleston's political leaders.

John Stevens rarely mentioned his only daughter, but he seems to have been genuinely proud of "Tolsey" and eager to let people know that she was "clever." "Your sister is to return early from Scho[o]l to write you a few lines," he told Jack, who had not seen the girl since she was six or seven, so "write her a line particularly to her Self; you know twill make the little Body happy; & any little trifle you think of, send to her; I assure you young as she is, she is clever; & I intend to bestow much care on her that she may be a credit to you when I am gone." For once Jack followed his father's instructions. "You cannot conceive how happy you made my honest little Tolsey," John Stevens wrote several months later, "by writing her a particular Letter.—O! Papa, says she, do let me go & see my D[ea]r. Br[other]. Jack when Capn Clarke goes next.—I can keep his House, mend his Linnen, & a thousand things, & I'm sure he'll be glad to see me." "I assure you the Sentiments are her own, tho you may imagine I correct some few Matters." (If I am certain of anything

in this story, it is that Jack could imagine such paternal corrections.) Still, of the ten-year-old girl, "she really is a Lady of more consequence than you at pres[en]t conceive."[67]

In the Stevenses' world of migration, trade, and travel, even a small girl was aware that ocean crossings shaped their lives and that domestic labors would shape hers; her chance to visit her brother and "mend his Linnen" could come only when "Capn Clarke goes next." Indeed, with trade goods and people making the journey regularly, Jack was not cut off from his family (except, perhaps, during the Revolutionary years, when Jamaica, dependent on the mainland colonies for much of its food, experienced the hardship of restricted trade). As for her, once she arrived in Charleston at age seven, Tolsey, like her mother and her brother Harry, made South Carolina her home. She married the forty-year-old Revolutionary army soldier George Cogdell in 1777 when she was only seventeen. George died in 1792, leaving Mary Ann, "a woman of 'remarkably strong and vigorous intellect,'" with her mother's house, her brother Harry's assistance, and three young sons. Mary Ann Cogdell, showing signs of the business acumen that characterized her mother, moved into one of the houses Mary Stevens had bought on St. Michael's Alley and opened a small school for girls. As her son John later put it, "Her talents enabled her to occupy and maintain such a position in society as to secure for her the respect and regard of a large community. To all the virtues which adorn her sex she added an energy of character peculiarly her own. In the important sphere of female education she long continued to serve her generation and the lives and characters of many still attest [to] her imminent ability and success."[68]

Mary Ann Cogdell also traveled. In his journal about a trip through Philadelphia and New York in 1808, her eldest son John noted casually that his mother, as well as his wife, were among their party. More intriguing, in declaring that Philadelphia's courtroom "by far exceeds any I have ever seen," he added, "& my Mother saw nothing like it in England."[69] As for Jamaica, even her young son Richard visited his cousins before she managed to make the trip. When Mary Ann Cogdell did get there, the world, and her world, had changed, and she traveled under less happy circumstances. It was 1815, Jack was long dead, their younger brother Clement CrookBlake had recently died, and Jack's son Clement William had moved to Charleston and left for sea. Mary Ann Elizabeth Cogdell, now a propertied grandmother herself, prepared for that voyage by writing her will.

John and Mary Stevens's grandchildren, like their sons, continued the pattern of movement and resettling, staying close to the sea, to cities, and to trade. Jack's oldest son, John III, traveled to England for business but settled in Jamaica. Mary Ann Elizabeth Stevens, named after her father's little sister, moved to Bristol, England. And there were guests. In addition to Uncle Clement CrookBlake Stevens, who had settled in Montego Bay by April of 1802, a teenage Richard Cogdell boarded a ship to Jamaica. His cousin John III was away in Bristol at the time, though Jack's widow and other children were there to welcome these Carolina relatives; Richard stayed for an entire year and Uncle Clement never left. I do not know what Richard and his cousins Clement William and Mary Ann Elizabeth, all around the same age, got up to in Jamaica, though a suggestive scrap landed in the family's papers: dated "M[ontego]. Bay" on August 14, 1802, it stated that Uncle Clement had found "the enclosed note on my return to the office on my desk, and as I am not (neither was I now) in the habit of receiving such—have returned it considering it was not intended for, Your Uncle, Clemt B. Stevens."[70] Whatever his uncle returned to Richard—a drawing? poetry? coarse words?—is long gone. The next year, Richard returned to Charleston, taking that scrap of paper and his cousin Clement with him.

Of all of John and Mary Stevens's grandchildren, only that young man, Clement Williams Stevens, passed on the Stevens name. The women who married took their husbands' names, and so named their children Cogdell or Kennedy. So let us follow the patriarchal line with this Jamaica-born Clement William Stevens. Soon after his father's death, and in the company of his cousin Richard Cogdell, he moved to the United States, living in Charleston with Uncle Harry, Harry's wife Susannah, and their teenage daughter, yet another Mary Ann. Why he, and not his siblings, made this voyage I have no idea. Unlike his father's migration, his was to a more urbane, and urban, setting, apparently with the idea of getting the boy an education. Clement, though "a fine healthy, modest boy ... [of] about 11 or 12," may not have adjusted easily. Restless or ambitious or homesick or ill-suited to urban life, by his mid-teens he had become, with the assistance of his uncle Harry and cousin John Stephano Cogdell, a midshipman in the US Navy, and so entered a military career in his adopted country.[71]

Before we continue along the Stevens lineage, let us consider what historians and genealogists call dead ends, people who, as Paul Stevens

put it, "died single." Take Jack's daughter. *This* Mary Ann Elizabeth Stevens, born around 1788, was, in her cousin Richard Cogdell's memory, "Eliza, a fine amiable girl of about 15, at that time . . . who died a few years since in Bristol, Eng." Paul Stevens, the self-appointed family chronicler, seems baffled by her. Writing in the 1950s, Stevens describes Mary Ann as a "spinster" who, "for no reason that I have ever been able to determine, left her widowed mother and family at Montego Bay and appears in Bristol, England, secure in her own establishment and means—living alone other than with an employed companion, a Miss Bagwell."[72]

Leaving aside the misreading of the "employed companion's" name (I believe it is Bagnall), we might imagine some reasons to leave Jamaica for Berkeley Crescent in Bristol, England. Perhaps, like her father, she squirmed under a parental roof. Certainly she had inherited money. And surely in addition to its other charms (Berkeley Crescent was a just-completed set of six lovely Georgian houses, now a National Historic Landmark), Bristol, and Miss Bagnall, represented a kind of independence that Montego Bay, and Mary Ann's widowed mother, did not offer. Perhaps Mary Ann Stevens knew, long before historians noticed, that a city offered greater opportunities for a woman with sufficient income and no interest in marrying, and that Bristol was more sophisticated, more private, and less burdened by family pressures than faraway Montego Bay.

Bristol was no hamlet but a common point of connection for merchants and their families. Mary Ann's grandfather John Stevens had had friends there, whom he implored to keep an eye out for his son Jo; Jo himself wrote to his father from that city, a major port for ships on his route. Indeed, Bristol was a central hub in the trade that John Stevens had engaged in throughout his life. Mary Ann's brother John was also familiar with the place, "a city produced in circuits of exchange with Jamaica," as Hazel Carby notes. "If the history of Bristol's financial dreams has been intimately tied to the enslavement of others it is also true that at the centre of this intimacy was the island of Jamaica." Ships loaded with human cargo left its port, transporting enslaved Africans and manufactured goods across the Atlantic and returning with products from the West Indies and North America. Names that appear throughout Charleston's, and the Sanders family's, history, such as Venning and Vanderhorst, had connections to Bristol as well.[73]

The abolition of the British slave trade in 1807 initiated the city's decline as a hub of trade and transport, but its residents maintained

ties with both the West Indies and the new United States. Bristol was clearly a place where a financially secure "spinster" could make a life, and Mary Ann remained there until her death in 1851. "Employed companion" is Paul Stevens's phrase for Miss Bagnall; in Mary Ann's words she was "my kind friend" who "begs I will present her best respects and good wishes to yourself and my Cousins" in Charleston. As for identifying Miss Bagnall, I considered several possibilities in the Bristol burial records. Given Paul Stevens's account, I assumed that she was Sarah Bagnall (sometimes spelled Bagnell), and not Lydia or Frances, because Sarah, four years younger than Mary Ann, died four years later, and according to Paul, Mary Ann left Miss Bagnall a life estate.[74] But in this, Stevens led me astray, reminding us of the false paths down which historical research can lead. In her will, Mary Ann Elizabeth Stevens did indeed leave sizable amounts (between £100 and £300 each) to her female friends, as well as somewhat less to several local charities, but no Bagnall is mentioned. Her estate was quite large—a "residue" of some £2,000 was to be divided among her three executors—and she left one of them various securities "during her life and after her death to transfer to my nephew Clement Hoffman Stevens of Charleston South Carolina oldest son of my late brother Clement William Stevens." Why Clement, and not his brothers, Harry, Peter, and Barnard, received this bequest I have no idea, though it does explain his eventual wealth. But however illegible the calligraphy in her will, the name of this special heir is decidedly not her old friend Miss Bagnall; as best I can decipher it, it was Jane Tozer, one of her executors and a "spinster," to whom she left the remainder of her estate "for her own absolute use and benefit."[75]

I do not know if the two Mary Ann Elizabeth Stevenses, aunt and niece, ever met. Mary Ann Cogdell visited England before 1808, and it is not clear when her niece moved to Bristol or if the younger woman ever visited Charleston. "Aunt Cogdell's" only visit to Jamaica took place after her niece and namesake had moved to England. But from Bristol Mary Ann Stevens may have been more alert to her aunt's circumstances than were her nearer relations. To her uncle Harry, she expressed the hope that "my Aunt Cogdell, will not experience much difficulty in getting the property left her by my poor uncle Clem, and that it will prove sufficient with what she has to enable her to resign her arduous employment."[76] This is how I learned that Clement CrookBlake Stevens, who would have been in his late forties, had died in Jamaica, that he had money, and that his sister, Mary Ann Cogdell, stood to inherit it. But this is also the first intimation that her niece—or, for that

matter, anyone else—recognized her work and thought it arduous. I do not know whether Mary Ann Cogdell resigned from teaching, although she did manage, finally, to visit Jamaica several years later, perhaps to view her property, to meet her sister-in-law, or just to see the place where two of her brothers had lived and died.

Buyers and sellers and inheritors of houses; merchants, coffeehouse owners, teachers, and bank clerks; owners of enslaved people and employers of others—the white people in this book hardly occupy positions that we associate with the grand narrative of American history; none is a household name even in Charleston. Mary Stevens's coffeehouse and her daughter Mary Ann Stevens Cogdell's school barely appear in the historical record; the passing of houses from one woman to another both reflected and made possible a kind of success that was too ordinary to register. Lionel Kennedy, Harry Stevens's son-in-law, became a state legislator and judge who investigated and wrote about the Denmark Vesey slave conspiracy, but even he hardly rose to the Charleston elite. John Stephano Cogdell practiced law and served as a state legislator, coming across as both unimpressive and conservative; he voted "against the outlawing of duels" and introduced legislation in 1818 "for the better ordering and governing of negroes *and other slaves* in the province." He could be an effusive observer, as when, during a visit to New York City, he happened upon the ceremonial opening of the Erie Canal, a "great and matchless celebration [which] 'tis not in man—nor his pen, his pencil nor his descriptive nor his poetic powers—to describe what was witnessed by so many thousands of spectators and actors in the Land as well as acquatic ceremonies, but will this day be remembered in N. York with pleasure and with pride." He did somewhat better as an artist who "rose from the status of an amateur painter in oils to become an amateur sculptor of reputation, talent, and ability."[77] (Whether his decision to change his middle name from Stevens to Stephano signaled any familial resentment or simply artistic pretentions, I have no idea.) There is nothing to suggest that his less ambitious younger brother, Richard Walpole Cogdell, would play a role in history, though his actions lie at the heart of this book.

2

CONVENTIONAL CHARLESTON

For all of John Stevens's aspiration to be part of the colonial planter elite, something at which his eldest son, Jack, succeeded, this story is fundamentally about city people. We are inclined to think of American history in terms of a North-South divide, and certainly that divide shaped people's status—as enslaved people, as slave owners, and decades later, as winners or losers in a Civil War. But the rural-urban divide, even in the earliest days of the Stevenses' migrations, was striking and may have been more salient in people's experiences and expectations. Surely it crossed the Jamaican-born Mary Ann Elizabeth Stevens's mind as she packed her trunks for Bristol, England, that her choice to live in a city set her apart from her brothers. Certainly her grandmother Mary Stevens and her aunt Mary Ann Stevens Cogdell built their lives, and sustained their families, within an urban economy. The notion that urban life offered more attractive opportunities for women of means may have been true for white women generally, as well as for many free and enslaved African Americans. An urban identity or, at least, the habits and customs associated with city life, surely shaped some of the Stevens descendants' decision to move, decades later, to a Northern city. As different as their legal, economic, educational, and familial lives were from one another, middle- and working-class people in Charleston and Philadelphia shared aspects of urban life: walking to their neighbors' houses, purchasing consumer goods like photographs and piano lessons, and finding work, entertainment, churches, and community close to home. And yet Charleston was a singular place, shaping people in permanent ways even as it prepared them to leave it behind.

In spite of its strong assertion of historical continuity, Charleston today barely resembles its eighteenth- and nineteenth-century counterpart. Unlike today, Charleston was a strikingly diverse city. Visitors nearly always commented on the number and proportion of enslaved Africans and the relative mobility of free people of color; in contrast to, say, New York or Boston, Black people could not be invisible to even the most oblivious tourists. A wide array of people occupied the streets, shops, and households or congregated at the annual races, where the jockeys were men of color. Nearly all visitors, eager to investigate the rumors they had heard about slavery, admitted with some embarrassment that they walked to see an auction of slaves, "a place which the traveller ought not to avoid to spare his feelings" (as Harriet Martineau insisted) "but a sorry entertainment" (in John Mackie's words); they were about equally fascinated and repelled. Margaret Hunter Hall of Edinburgh, who concluded overall that "it is a remarkable, cheerful looking place, Charleston," was disgusted by the auction, observing, "There was an expression of dogged indifference about the poor blacks, but I am told they do not at all like to be removed from the place where they have been brought up."[1]

Travelers' accounts about the Charleston John and Mary Stevens's descendants grew up in described wealthy and frivolous white elites, inhabitants of gorgeous houses and muddy streets who were accustomed to slavery and obsessed with talking about it. Having arrived in 1808 in a city rumored to be "the seat of hospitality, elegance, and gaiety," Englishman John Lambert found its social and political leaders' habits, not to mention their inattention to municipal services, troubling. He was appalled by the dirt, especially "the filthy and brutal practice of dragging dying horses or the carcasses of dead ones, to a field in the outskirts of town, near the high road, and leaving them to be devoured by a crowd of ravenous dogs and turkey buzzards." But the people, too, distressed him. "When they receive money in advance for their crops of cotton or rice," he reported, "it is immediately squandered away in the luxuries of fashion, good eating, and drinking, or an excursion to the northern states where, after dashing about for a month or two with tandems, curricles, livery servants, and outriders, they frequently return home in the stage coach with scarcely dollars enough in their pocket to pay their expenses on the road." (That very year Richard Cogdell's mother, Mary Ann, his brother John, and John's wife Maria went on a month-long excursion north; although they traveled in comfort, I have no idea

whether or not it was a foolish extravagance.) It was not only tourists who observed this. For some among Charleston's historic gentry—even in books by insiders and friends, works meant to be gentle, to honor their heritage—this seems to have been more than simple stereotyping, for their overspending both reflected and exemplified their city's pride and its fall.[2]

If they were defiant about their economic standing, elite white Charlestonians were hardly reticent about slavery. Harriet Martineau arrived in Charleston in the mid-1830s preceded by a reputation for holding antislavery views. For her part, she "made it a rule to allow others to introduce the subject of slavery, knowing that they would not fail to do so. . . . Before half an hour had passed, every man, woman, or child I might be conversing with had entered upon the question." On his first day in Charleston, Scotsman William Ferguson found, "It was not long ere I got involved with one of them in a deeply-interesting conversation upon the subject of slavery." And Frederika Bremer agreed that "there has not failed to be here conversations about slavery. I do not originate them, but when they occur, which they frequently do, I express my sentiments candidly, but as inoffensively as may be." She had met no one, she went on, "who can openly and honestly look the thing in the face." Few white travelers described conversations with enslaved people themselves, though James Stuart reported on an extensive conversation with his hired driver, a free man of color.

He gave a frightful account of the treatment to which he and all the people of colour, whether free or slaves, are subject in this state. He had been accustomed formerly to go every season to the State of New York during the period when, owing to the [white] inhabitants leaving the city, business was almost at a stand; but, by an act passed a few years ago, it is declared that a free person of colour leaving the state, though merely crossing the boundary, shall never be allowed to return; and as this person driving me has a wife and children, he feels himself really and truly a prisoner in the State of South Carolina.[3]

Free people of color were a diverse and visible community in antebellum Charleston; to say that they occupied a "middle ground" is to flatten their wide-ranging experiences. They lived in a city that was both segregated and highly mobile, worked in greatly limited job categories, and sat in separate pews in the city's most elite Episcopal churches,

St. Philip's and St. Michael's. After 1830, their options were increasingly restricted, but they had rights that sharply distinguished them from enslaved African Americans: they could own and inherit property, gain an education, and marry and protect their families from forced breakups. A few in this mostly mixed-race community—self-described "mulatto" families, highly visible, respected, and organized—achieved significant wealth in both land and slaves. Among the houses that remain from that time is Richard DeReef's; unlike the homes of elite white people in the area, there is no plaque to identify it, nor is there anything to indicate that the neighborhood of Wraggsborough was a majority-African American section of downtown through the antebellum years. It was without irony that the DeReefs considered themselves the "colored aristocracy." Richard Edward DeReef "owned fourteen slaves and real property worth $23,000; his brother and business partner Joseph DeReef owned six slaves and $16,000 worth of real estate."[4] African American neighborhoods in antebellum Charleston, DeReef Court and DeReef Park, carried their name well into the twentieth century. Members of this community formed the Brown Fellowship Society, eager to distinguish themselves from both enslaved and poorer free people of color; they were exclusive and clannish, and I have seen no evidence that they identified with other African Americans on the basis of "race." Some among these "colored aristocrats," as we will see, eagerly tied their fortunes and their futures to the ruling white elites of the Confederacy when the time came, declaring themselves loyal South Carolinians above all.

Charleston lived up to its reputation as a fiery yet insular place—the place whose sense of self-importance and resentment would smolder until it led to secession and war. Elite white Charlestonians defended their way of life—their rice and sugar plantations, their elaborate city mansions, their attachment to European material luxuries, and their utter dependence on a massive force of enslaved labor—more openly and ferociously than any other Americans. Yet this was not the Charleston society that Richard Cogdell and his friends were born into and inhabited; it is highly unlikely that the city's elite families interacted with the Cogdells, though Cogdell's friend John B. Irving knew the racehorses these planters owned. As historian Emma Hart has so beautifully shown, Charleston was also a city of middling white folks, people who were neither planters nor poor whites, whose place in building the city—literally as carpenters, bricklayers, and contractors but also figuratively as merchants, bankers, and real estate brokers—placed

Charleston squarely in the urban Atlantic world. "By the third quarter of the eighteenth century," Hart asserts, "Charleston nurtured a middling sort with an identity of its own and an emerging awareness of its distinctiveness as a group." Her depiction of that Charleston—its wharves and businesses, its shops and auctions, the availability of luxury goods and contractors willing to build houses for later sale, the practice of hiring enslaved workers alongside white artisans—is rich in detail. Her descriptions of "commercial friendships" could very well describe John Stevens's entire correspondence. Indeed, as Hart herself notes, John and Mary Stevens exemplified newcomers to this community. It was this world that John Stevens, much as he longed to rise into the planter elite (evidenced by what Hart calls his "unhealthy obsession with gentility"), entered and in which he remained. It was here that he and his coffeehouse-owning wife, Mary, as well as their children and grandchildren, made their place as members of the slave-owning, urban, middle class.[5] Indeed, while Charleston's most illustrious names do not appear in the records of Richard Cogdell and his family, other names are sprinkled throughout: Horlbeck and Toomer, both descendants of well-established bricklayers; Huger, who built and sold tenements; and Bee, who was a tradesman. As a class they represented a particular segment of urban culture, slaveholders, merchants, and professionals whose wealth was more closely tied to city properties than to agricultural land.

This by no means suggests that they were less committed to, and supported by, slavery; forced labor infused the very bricks they purchased and the homes they built, not to mention the Jamaican rum at their parties and the sugar on their tables. Charleston, founded by Anglo-Barbadian planters, had from the first wholeheartedly embraced African slavery, entirely—and uniquely among North American colonies—bypassing the largescale indenturing of European laborers. By the time of Richard Cogdell's childhood, white Charlestonians had effectively forbidden vocal opposition to slavery; in his early adulthood the state prohibited slave owners from emancipating enslaved individuals; legislators expressed intense fears of free people of color in direct proportion to their proximity to the enslaved. Reading the ordinances passed by Charleston's city council in the early nineteenth century is an exercise in watching a small group of extraordinarily powerful but anxious white men struggle to limit real and perceived threats while protecting their own comforts: regulating liquor licenses, prohibiting people of color from playing with cards or dice, suppressing "riots and

disturbances" near disorderly houses, and building a treadmill in the workhouse yard to be used for punishments.[6] Their concerns were not abstract or hypothetical. They debated and passed these local laws because someone behaved, or prepared to behave, in a way that frightened them. This happened on the state level as well, of course, and an appendix to the ordinances helpfully includes state legislation that had a particular impact on Charleston. As early as 1800, for instance, South Carolina's legislators decided that "laws heretofore enacted for the government of slaves, free negroes, mulattoes and mestizoes, have been found insufficient for the keeping [sic] them in due subordination," so they banned "all assemblies and congregations of slaves, free negroes, mulattoes, and mestizoes . . . assembled and met together for the purpose of mental instruction, in a confined or secret place of meeting, or with the gates or doors of such place of meeting barred, bolted or locked." This included meetings for religious instruction. Three years later, after "certain religious Societies in this State, have petitioned the legislature," they amended the act to allow meetings for religious purposes, provided a majority of those attending were white.[7]

But even if these men seem frantic about maintaining order— heightened after 1822 by the planned uprising, and ensuing trial, of enslaved and free people of color under Denmark Vesey—Charleston's very urbanness, the fluidity and mobility of its enslaved workforce, and its very bustle always threatened to undermine "due subordination." Thus, in an economy that depended on hired-out enslaved workers, the city council in 1818 prepared to fine anyone who employed a slave on Sunday—but, they hurriedly added, "works of absolute necessity, and the necessary occasions of the family excepted." Several years later, newly alarmed by people of color meeting in groups, the council passed "an Ordinance, to prevent Slaves or Free Persons of Colour from assembling at MILITARY PARADES or FUNERALS." The authors of the ban scrambled to avoid inconveniencing white people: slaves and free people of color were permitted near these events if they were acting as musicians or "servants attending their masters, or on a lawful errand, or business of his owner, or person having the charge of him or them."[8] No one in charge wanted to disrupt white people's (i.e., their own) parties or commercial entertainment. So they regulated disruptions near brothels but insisted that "nothing in this Ordinance, shall be construed to apply to such decent and decorous dancing at private houses, public assemblies, or at such academies, where children of both sexes are instructed in this art, but exclusively to disorderly house or houses,

place or places, which are frequented by women of ill fame, and others associating with them." These caveats and exceptions were voluminous, and if they seem absurdly twisted, they reflected a real inability to control people's mobility in the city. They express an assumption and an anxiety that none of these limitations—on card-playing, on dancing, on rambunctious drinking, on hiring musicians—should apply to *them*.[9]

In Saint Kitts, Georgia, and Jamaica, slavery brought both wealth and challenges to the Stevenses, but Charleston was different, offering them ample room to profit from the forced bondage of others in a decidedly urban setting. Enslaved Africans were present in John and Mary's story as soon as the ambitious immigrant himself appeared in the historical record, first as a London merchant who traded in the West Indies, then as a colonial merchant and aspiring planter. When John and Mary Stevens moved their family from Saint Kitts to Georgia, they brought with them some thirteen enslaved people. One enslaved child, Dick, likely their grandson, was born in either Saint Kitts or Georgia. Perhaps Mary Ann (Tolsey) Stevens, who would have been close to Dick in age, overheard conversations about her brother's relationship to the child; perhaps she, too, regretted the child's disappearance; perhaps her son Richard's name echoes his. In any case, she offered a rare opinion about white men's sexual relationships with enslaved women. In a tiny diary, Mary Ann copied from Marcus Rainsford's 1805 *An Historical Account of the Black Empire of Hayti*: "By what strange perversion of reason can it be deemed disgraceful in a white man to marry a black or mulatto woman, when it is not thought dishonorable in him to be connected with her in the most licentious familiarity." She then added, apparently as her own commentary: "The laws of a Country are imperfect allowing such familiarity with impunity, every white man having such connection, should be compell'd by the laws of humanity to marry the person, black or mulatto, with whom such familiaritys have existed.—& to have no intercourse with genteel society or to appear in any public place of amusement on an equality with other Citizens & their seats in a house of public worship in a suitable place provided for such offenders." One historian suggests that Mary Ann was disgusted by the "sexual exploitation faced by some women of color and [that she was] willing to ally with them, at least in the privacy of her commonplace book, against white men," but I read this differently. Mary Ann Cogdell wished to punish (through marriage) or shun (through social disgrace) white men who engaged in sexual relationships with Black women.[10] Whether she knew about her brother and Dick or knew that her mother

Chapter Two

wished for the child's return, she would not live long enough to know her own enslaved grandchildren. But unlike her own parents, she never experienced living in a slave-owning household as new; she was born into one, remained a slaveholder throughout her life, and left enslaved people to her own sons.

Wills offer a window into a system in which some people exercised complete control over the bodies, labor, lives, sexuality, and children of other human beings. Wills are, on the simplest level, about property—who has it and who gets it. But they also expose a writer who, in an intimate and intentional way, claims and is responsible for property in human beings. In her 1782 will, Mary Stevens distributed her human property to various heirs and singled out her "Negro Man, July," whom she "set . . . free from all bondage and slavery whatever."[11] By 1828, when her son Jervis Henry (Harry) Stevens wrote his will, South Carolina law forbade slave owners from freeing their slaves. Harry instructed that his "negroes & Mulattoes" be sold, excepting his "old Servant George," who had served him "during the Revolutionary War" and whom he left to his daughter with the "request he may be treated with kindness and attention while he lives." His sister, Mary Ann Stevens Cogdell, left her "negro Man Dumpies" to her son Clement and instructed that her other slaves either be given "a comfortable support" or, in the case of her "servant man Jack," be freed "duly and in comformity with the requisites of the acts of assembly" that he "may not serve any person as a slave after my death."[12] By the time she wrote her will, this was legally prohibited. While few wills emancipated all of an owner's slaves, individual bequests reflected enslavers' desire that most African Americans would remain enslaved but that a few might not. Deciding to emancipate a particular slave required some thought. It was an explicit justification of everyone else remaining enslaved. There is no evidence that any Stevens ever—in the West Indies, Georgia, or Charleston—contemplated the trade in and ownership of human beings as anything but a given in their lives.

Mary Ann Cogdell's sons' generation, while well settled in Charleston as property owners and enslavers, had no mansions or streets named after them. In reading about South Carolina's planter elite, the same names—Alston, DeSaussure, Motte, Ravenel, Porcher, Middleton, Manigault, Pinckney—appear over and over in friendship groups, marriages, names of historic mansions, and lists of horse breeders. But the white

people in *this* story—such as Stevens, Cogdell, Horlbeck, and Hall—are nowhere to be found in those accounts. These people were the middling elite, what we might call the professional class, sons and daughters of merchants, builders, bricklayers, and real estate developers, who had resources and houses and who enjoyed the leisure activities—theater and races and travel—that led many a wealthy Charlestonian into debt. They owned enslaved Africans but not vast wealth; their lives involved buying and selling and keeping accounts, not supervising cotton or rice plantations. Richard Cogdell and his Cogdell sons worked as lawyers or bank clerks; Richard served through the early 1820s on the city council, alongside Thomas Condy (we will return to him). These men were, socially speaking, insignificant to Charleston's upper crust. They may, or may not, have been gentlemanly, but they were not Gentlemen. No one could write a history of their lives that centered on an "ancient family homestead" or that attested to a pedigree in the city's plantation families.[13]

But if the Stevenses and Cogdells never achieved planter status in Charleston, their story is nevertheless about a sense of place, and of houses. Among the "middling sort" in eighteenth-century Charleston, as Emma Hart points out, the buying and selling of houses shaped a good part of that class's business transactions as well as contributing, literally, to the building of the city itself. Even as Charleston began to decline in the nineteenth century, city dwellers continued to buy, sell, and rent houses. Urban real estate was central to people's financial interactions, their inheritances, and their wealth; it shaped enslaved people's access to paid work as well as their proximity to their owners. For the most part, the names of enslaved residents are not recorded in public records, so we usually have no idea who lived where. Some houses held slave owners' families as well as those they enslaved, others included only the enslaved themselves, while still others sheltered a mix of free and enslaved people of color. Indeed, city houses are key characters here, not only as places where people live but in the transactions between people and between generations; they are gambling chips; they are symbols of loss as well as of stability. And, like the human participants, they are not easy to sort out.

A pair of houses purchased by one woman from another bridges several generations in this family's story. In 1778, the year a fire destroyed some 250 buildings in Charleston, Mary Stevens purchased Nos. 1 and 2 St. Michael's Alley from another widow, Rebecca Bampfield, for £10,000. When Mary died four years later, she left No. 1 ("wherein I

now live") and all its furnishings to her son Jervis Henry in trust for her married daughter, Mary Ann Stevens Cogdell, and for her (not yet of age) son Clement CrookBlake Stevens. Mary Stevens took care to protect her only daughter. She made sure that once Clement had reached twenty-one, the house should be "for the sole and separate Use of my said Daughter for and during the Term of her natural life, without being subject or liable to the control or Disposal, or the Debts, Charges or Incumbrances of her present or any future Husband, and from and immediately after her Death, To the Use of my said son Jervis Henry Stevens." No. 2, next door, was to be Clement CrookBlake's. The echoes of Mary Stevens's careful planning lasted for decades. In his own will, her grandson John Stephano Cogdell left his brother Richard his share in the trust that their grandmother had created and that had passed through their mother's estate.[14]

In addition to property, Mary Stevens also apparently passed down the lesson in protecting daughters. In the late 1820s Harry wrote his own will. His daughter—his only child—had married Lionel Kennedy, a well-regarded lawyer and judge. Mary Ann Jane Kennedy was to inherit everything, with the caveat that she was "not to be liable for the debts of the said Lionel Henry Kennedy or any future husband . . . she may have in case of the death of her present husband." He also directed his daughter to sell his wooden houses, "as all wooden houses require constant repairing and great expense to keep them in tenantable order."[15]

Mary Ann Stevens Cogdell's husband, George, named St. Michael's Alley, the property his wife had inherited from her mother, as his residence.[16] But during their marriage the couple lived some sixty miles away on a "Lott of Land in George Town No. 91" that her brother-in-law John Cogdell had purchased. This property, along with some thirteen enslaved people, ended up as part of Mary Ann's and her sons' estates, although she and the children returned to Charleston soon after George died. As for George Cogdell himself, we know little except that he was a Revolutionary War soldier and much older than his wife. Surely Mary Stevens would not have been the first or last mother to feel some doubts about the forty-year-old man who had married her seventeen-year-old daughter. Perhaps she was simply skeptical of husbands, after years of moving, running a coffeehouse, and then functioning as a widow of means. It was fairly common to protect a daughter's property from a husband's death and creditors. But Mary Stevens hinted at a greater skepticism when she directed her sons to use part of her estate "in a *suitable* and becoming Manner, [to] maintain, cloath, educate, and

support my Grand Son John Stephens Cogdell, Son of my Daughter Mary, until his arrival to the Age of eighteen Years." Mary Stevens died in 1782, not knowing that Mary and George would have two more sons before George himself died ten years later.[17]

George Cogdell left almost no shadow in the family's archive, even though it was his son Richard who gathered and kept the papers. Interestingly, none of Mary Ann and George Cogdell's sons carries their father's first name: John is named for Mary Ann's own father and brother, and Clement carries on a ubiquitous Stevens family name acquired during their Georgia sojourn. The last, Richard, is apparently named after no one, though I am tempted by the possibility that Mary Ann recalled from her childhood the enslaved child and Richard's likely cousin, Dick. After George's death in 1792, his widow returned to St. Michael's Alley, where she ran a small boarding school for girls, corresponded with her brothers in Jamaica, supervised a household of boarders and slaves, traveled a bit, and raised her children.[18]

People often write more than one will, reflecting particular changes—and fears—in their lifetimes. In 1815, about to embark on a trip to Jamaica to visit Jack's family, Mary Ann wrote her first will. Most of it describes particular items: a gold watch to her son Richard, thirty dollars and detailed instructions to her brother Harry about purchasing something for his daughter, a diamond ring to her oldest son John, her clothing to a friend.[19] The rest was to be divided among her three sons, two of whom (John and Richard), along with their uncle Jervis Henry, would serve as executors.

Mary Ann came back safe and sound from Jamaica—and probably richer, due to inheriting a share in her late brother Clement's estate. A "woman of remarkably strong and vigorous intellect," she lived and taught girls for another dozen years in the house her mother had purchased (and left for her use) in St. Michael's Alley. Her son Richard and his wife, Cecille, lived next door at least during the early 1820s, for they paid quarterly rent to Richard's uncle Harry for No. 2 St. Michael's Alley and, after Harry's death, to Harry's son-in-law, Lionel Kennedy. Richard Cogdell also paid rent to his cousin Clement William Stevens in 1822, two years after Stevens himself had married. By 1861 there are no familiar names on St. Michael's Alley.[20]

It was this urban world, this tightly packed neighborhood of slaveholders, free people of color, and the enslaved, of closely connected houses where people lived, worked, and taught, and of commerce and wage labor, into which Richard Walpole Codgell was born, married,

Chapter Two

and expected to live out his life. Unlike his grandfather John Stevens, he displayed no longing to aspire to the landed elite but remained an ordinary member of Charleston's "middling sort," the educated, urban white men and women who bought and sold material goods, enslaved people, and city houses. He did not dine with or marry into the planter class. He was probably first educated by his mother, and he may have followed his brother John to the College of Charleston, although neither is listed in its alumni records.[21] He married in 1806 at about nineteen, quite young for a man of his class. Cecille Langlois was probably pregnant; their first child, James Gordon Cogdell, does not appear in the baptismal record, but his 1832 death notice records him as twenty-six years old. Over the next sixteen years four more sons followed: Richard Clement (1812–after 1846), George Burgess (1817–1852), John Walpole (1820–after 1850), and Charles Stevens (1822–1860). I suspect there was tension between Cogdell's mother and Cecille. Certainly there is no hint that Mary Ann Cogdell felt for this daughter-in-law anything like the affection she pointedly expressed for Clement's wife, Ursula (whom she mentions by name seven times in her final will.)[22] And yet, well into the 1820s Richard and Cecille, and one or more of their sons, lived with Richard's mother on St. Michael's Alley. At some point, the couple and their children moved to a house nearby at the corner of Broad and Gadsen.[23]

The Cogdells were assuredly not poor, and they would eventually inherit a share in Richard's mother's estate, but like his grandmother, mother, and brother, Richard had to earn wages. He did so as a bank "Teller & Book-keeper" for some twenty-seven years, as well as by serving as a notary public, a grand master of the Free Masons, and for a decade as a captain in the local militia.[24] His receipt books list numerous business trades (liquor, cotton, rice, and other foodstuffs), but unlike the work of his merchant grandfather John Stevens, his was primarily salaried. Cogdell's household expenses were routine: paying rents, providing for his sons' education, purchasing some material comforts, subscribing to newspapers, and paying pew rents. There was money for small luxuries. In late March 1828, he—or perhaps Cecille—took their sons to have their silhouettes cut out by the enormously popular Master Hankes, who extended his stay in Charleston because of the demand for his work. The twenty-five-cent fee per silhouette was surely worth the memento.[25]

Richard Walpole Cogdell was what we might call a solid citizen: neither especially ambitious nor notably wealthy but behaving responsibly

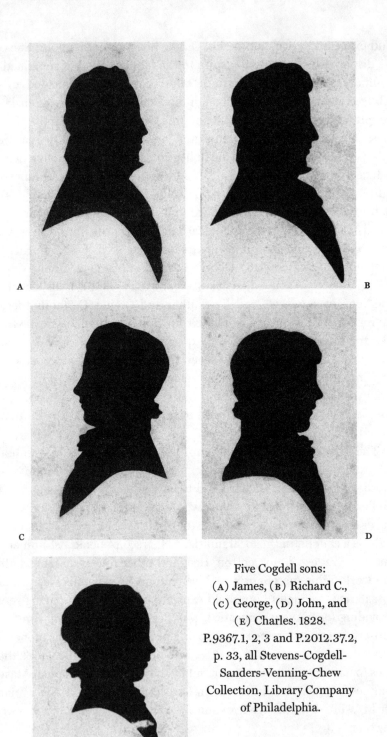

Five Cogdell sons:
(A) James, (B) Richard C.,
(C) George, (D) John, and
(E) Charles. 1828.
P.9367.1, 2, 3 and P.2012.37.2,
p. 33, all Stevens-Cogdell-
Sanders-Venning-Chew
Collection, Library Company
of Philadelphia.

on behalf of his children's security. As early as 1816, he invested $224 for four shares of the Union Bank for his two young sons as well as fifty-eight dollars for shares in the Planter Mechanic Bank; two years later he paid a hefty $2,750 (mostly in stock but also in cash) for shares in the Alabama Company. As late as 1831, with Charles still a boy of eight, Richard was buying bank shares that he held in trust for this last Cogdell son.[26] And of course, given South Carolina's refusal to establish and support public education, he paid for their schooling. From about 1815, when James was seven, Cogdell paid headmasters and tutors, including one M. L. Hurlburt, a Massachusetts transplant, as well as the South Carolina Society Academy, run by William A. Hayne.[27] As they came of age, he settled money on them. In 1828, James G. Cogdell, his eldest, now twenty-one, received $343.63 as his share of the trust that had been in his and his younger brother's name. This did not end Cogdell's responsibilities; Richard duly recorded bills for James's medical expenses. Some of his receipts, dragged from sources that are by any measure prosaic and dry, hint at his sons' own choices and behaviors. In July 1829, Cogdell spent twenty dollars for a "Navy Uniform" for seventeen-year-old Richard Clement, though he left no record of what he thought of the boy's decision to enlist.[28] Clearly provoking were their debts, a number of which lingered after their deaths: "Rec from R.W. Cogdell Esq," read one account four years after Richard's eldest son had died, "Eleven 79/100 dollars for Bal. of Acct due by the Late Cap James G. Cogdell."[29]

Before we too quickly call Richard and Cecille's sons "white," let us pause at the vagaries of historical records. No baptismal record exists for James Gordon Cogdell, born soon after Cecille and Richard married. The couple stood up at their first baptism with eight-month-old Richard Clement Cogdell on April 20, 1813, in St. Philip's Church, where his parents and other members of Charleston's Episcopal community, Black and white, had been married, baptized, and buried. He is listed there as a "child of color."[30]

Historians have wondered about this. Amrita Chakrabarti Myers suggests, plausibly, that Cecille Langlois, who claimed to be a native South Carolinian, was in fact born in San Domingue. Certainly her sister Maria, a "white schoolteacher," was from there. Possibly Cecille was passing as white; perhaps Richard's mother Mary Ann suspected and disapproved. But neither Cecille nor Richard seems to have suffered any social consequences for Richard's namesake's listing in the parish register, and he continued to live the conventional life of a white husband and father of his means.[31] And by the unspoken conventions of

Charleston, that would soon include having two families, one with a woman he enslaved.

There were hints that the Cogdell sons might not come out well, some suggestion of childish misadventures, that at first seemed nothing out of the ordinary. In March 1824 a Mr. Cummings, possibly a schoolmaster, wrote that "two or three gossips, influenced probably by some of my enemies, were whispering that I had interested myself more for your son, than became a good Christian." In what way he "interested himself" is tantalizingly unclear. Cummings's self-defense does not help: "Be assured, that if any injustice is attempted in the relation of your son's adventure, without regard to my own convenience, I will immediately do whatever is in my power, to represent correctly his mild & amiable deportment in society while among us, & his manly firmness at the crisis. You have reason to be proud of such a son; & I trust he will continue to prove himself worthy of that Roman affection which you have evinced for him."[32]

Not so fast. Things were in fact more serious than a mere prank or adventure. A few weeks before Cummings's note, Richard's eldest son, James, had been challenged to a duel by a classmate and "intimate friend," Hampden Wigfall, apparently over a trivial matter. Much pomp surrounded the affair, which would be held at "the most noted duelling ground in America." After exchanging notes, "no reconciliation could be effected," and, "with all the formalities," the two met. Wigfall (recalled decades later as a "beautiful, brave, noble, gentle youth") died immediately on the field. Young Cogdell (misremembered as "Cogsdale" by locals) threw himself by his friend's body, sobbing "Oh Hammie, Hammie!" in despair. The memoirist who relayed the tale had James's name, dates, and place of death wrong but perhaps grasped some truth in reporting that "in his 30th year, unmarried, with snow-white hair, he died in Newark, N.J., never, it is said, having smiled since the hour of the duel." (In fact James Gordon Cogdell died of "convulsions" in Charleston in August 1832, in his midtwenties.) The papers that Wigfall had sent to James—demanding restitution, declaring the terms of the duel, having witnesses deliberate about the appropriate weapons—landed in Richard Cogdell's papers, but the father left no comment about the event.[33]

Whatever "Roman affection" Richard Cogdell demonstrated as a parent, the Cogdell sons' stories became less "mild & amiable" and, indeed, increasingly disturbing and odd, and their father's patience was limited. Richard Clement, for one, was a disappointment. He joined the US

Navy at seventeen, achieved the rank of lieutenant, and was discharged in a scandal: "As I feared," Richard Walpole Cogdell fretted to the enslaved Sarah Martha Sanders, who was by then the mother of several of his children, "Richard has been ordered to be dismissed [from] the navy, and unless the President chooses to soften the sentence, he is lost forever and my peace with it." "If it was not for shame to see my old friends & enemies upon Richard's disgrace I would return immediately," he assured her, adding that he prayed for their children "and hope to see them without being ashamed of them." Apparently young Richard's misdeeds did not at first cost him his liberty or his rank, because two years later John Stephano Cogdell left his nephew Lt. Richard Clement Cogdell $1,000 in his will. But he did not, apparently, share his father's and uncle's commitment to middle-class respectability. In the winter of 1845–46, missionaries in Liberia reported on the capture of an illegal slave ship, apparently based in Philadelphia, containing some 900 kidnapped Africans, declaring it "utterly impossible for language to convey an appropriate idea of the horrors of their situation." The ship was "under the charge of Lieut. Cogdell."[34] Navy records indicate that he formally resigned that July, at which point he disappears from the historical record.[35]

In chapter 1 I suggested what a white, property-owning father— Richard's grandfather John Stevens, in that case—might have wished for and expected of his sons who would carry on, and hopefully live up to, his name. But consider for a moment Richard Walpole Cogdell's possible wishes for his (enslaved) Sanders children. Although they did not bear his name, Cogdell seems not to have been concerned about the effects of openly acknowledging these children as his own. Rather, and oddly, he believed that his reputation—his public self, his honor—depended in part on their behavior. What aspirations did he hold for them? What could they have done that would have shamed him? How did he reconcile being the father of a sailor who had embarrassed him with being the owner-father of enslaved children who, he hoped, never would? Might we consider that he invested hopes in Sarah Martha Sanders's children in part because, it was becoming clear, his other sons would never achieve them?

The other Cogdell sons fared little better than Richard Clement. John Walpole led "sometimes a busy, sometimes a migratory wandering life in the pursuit of [his] Profession" as a lawyer, but at some point (probably in the early 1850s) he committed suicide in Philadelphia, "precipitating himself from the window of his lodging, on Randolph street, in a

fit of temporary insanity jumping from a window." George Burgess had long been a worry, having demonstrated an "utter incapacity to do any thing for himself." His uncle John Stephano Cogdell "suffered" when he heard that George had not been showing up for work at the city treasury office; "I am afflicted abt your situation," he admitted to the young man's father, his own brother Richard, "but let me counsel you, that you have too much to live for, besides an ungrateful youth upon whom you have bestowed everything . . . to keep you from dwelling too much on the sting of ingratitude." And, in an extraordinarily rare appearance in the historical record, Richard's brother Clement, too, helped out; at one point Richard reimbursed him $27.90 "for monies paid by me for the use of his son George."[36] Aunt Maria Langlois, Cecille's sister, stepped in, nursing George in his final state of dementia. He died at age thirty-five in 1852 of "paralysis," leaving behind debts and resentments. Some of these burdens were borne by the youngest Cogdell son, Charles Stevens, a bank clerk. In 1853, though they lived in the same city, Charles wrote to his father "with unaffected reluctance" on the subject of funds, since "for severals years previous to the death of my unfortunate Brother George I contributed largely out of my slender means towards his support and maintenance." Hounded by creditors (a "daily and I may say hourly persecution"), Charles saw no choice but to ask his father to "relieve me from this degrading and humiliating position" by paying him back.[37] Charles's claim seems just; his father surely was wealthier and George was, after all, Richard's responsibility. Charles Cogdell, too, was troubled and ill, and apparently an alcoholic. In 1860 an old friend would inform Richard that Charles had improved "in consequence of his limiting [himself] to 3 drinks (only!) per diem." He passed away, at age thirty-eight, that same year; the attending doctor, T. L. Ogier, attributed it to "brain, softening of." Whether due to his sons' failings or his own, Richard comes across as, at best, a distant father.[38]

Richard may have wished that he and Cecille had had a daughter or, at least, a son who managed to enter and survive adulthood intact and independent. At least two of them suffered from serious mental illness; all five of them died before their father. Perhaps as he read his grandfather's querulous letters to his own son Jack, Richard felt a sympathetic pang, that "sting of ingratitude" brought on by miscreant sons. Charles Cogdell's 1853 appeal to his father's sympathy and money can only have added to his irritation: "It has pleased Providence to remove all my brothers," Charles went on, "and to leave me alone the only one who has any right to expect aid and assistance at your hands."[39] Whatever

Chapter Two

Richard Cogdell's "paternal feelings" and willingness to "snatch me from a position of such deep embarrassment," this assertion of an exclusive claim was not true, and both men knew it. Only the children Richard would have with Sarah Martha Sanders would, as the expression goes, amount to much.

Richard Cogdell's proclivities—apart from his familial responsibilities—were as an amusing companion to his male friends, not an unusual trait in Charleston. John Beaufain Irving, twelve years Richard's junior, the sometime sheriff in Charleston, a rice planter on the Cooper River, and a frequent commentator on Charleston's theatrical and racing scene, was a close friend. Though presumably his title of "doctor" came from some prior attention to his education, Irving seems mostly to have gone to the races, the theater, and parties, and he viewed his social set with great affection. In dozens of essays published in the *Charleston Courier* in the late 1850s, Irving offered anecdotes about every actor, actress, theatrical production, and source of gossip he could cull from a lifetime of such observations. Expressing great sentiment for the "*lads of the village*" with whom he shared the pleasures of the St. Cecilia Society, the Charleston stage, the renowned jockey club, and occasional drunken escapades, he recalled fondly R. W. Cogdell, the "gentleman duck, by which appellation he was known to the whole town."[40] Indeed, Cogdell's "taste for music and love for the drama" led him in 1835, still paying tuition, sons' debts, and medical expenses, to invest serious money, in installments totaling some $500, for a share in the Charleston Theater.[41] Traces of Irving's personality suggest his and Cogdell's affinity: "Trifles," Irving wrote to Richard in the spring of 1860, when, presumably, people had important matters on their minds, "make up the sum of human life. . . . Let us then, Laugh when we can, be merry whilst we may." Indeed, that same year Cogdell, ailing and aging, considered a weekend's respite but was warned that a particular hotel offered "no means of diverting attention from a dull country place not even a Billiard Room."[42] The man liked his entertainments.

I have no idea whether Richard Cogdell's carousing included women, but an 1818 correspondence with one J. M. Burgess suggests that Richard could be flirtatious and, in this instance, a bit too intimate. We only have Burgess's side of the correspondence, but her references to Cogdell's "dear saucy little letter" suggests that his epistles resembled her own. "Why did you request me to burn your letters?" she wrote on one occasion. "Do you suppose that I will ever cease to value them? Do you still desire it? Will you never write again? I won't believe it!"[43] There is no evidence as to whether he wrote again, but that he saved her letters

indicates some special affection for a long-ago female friend. Whatever the state of his marriage, Richard Cogdell comes across as playful, comfortable, and complacent, probably pompous. I assume that he expected to live in these circumstances for the rest of his life.

In the summer of 1830 much of this changed, although it may not at first have been obvious to anyone how dramatic a transformation it would be. There had long been enslaved people in the Cogdell household, as there had been in Richard's mother's and grandmother's homes, people who were hired, bought, sold, and inherited—and occasionally, when it was legal, freed. Early in their married life Richard and Cecille Cogdell hired enslaved workers: in August 1812, Richard paid James Mackie seven dollars a month for the wages of one Ben; in 1815, twelve dollars a month for Dick. Such expenses continued for decades with some names—the "Negro Wench Sylla" or Josephine—remaining fairly steady for years, accounting for some six dollars per month paid to an agent, F. G. H. Gunther. By his thirtieth birthday, Cogdell had begun to purchase enslaved people. In 1817, he paid "six hundred & sixty dollars in full for a negro man named John, bought of us at Public Auction."[44] (The next year, Cogdell paid one Thomas Cochran $3.45 for "advertising Boy John." Had the enslaved man run away? Or was Cogdell intending to resell him?) The names of the people Cogdell, or for that matter the rest of his family, enslaved have, in most cases, been lost. But sometimes, buried in the prosaic documents of antebellum life, we can extract a more complex story than the sources ever meant to convey. Very occasionally we can find a thread that, if we yank hard enough, will yield a proper, if patchy, path from one era to another.

Wills and sales of enslaved people went hand in hand, part of the paperwork of death. It was commonplace in the South to record the sale or purchase of a human being as one of the transactions of daily life. Readers and historians might grow numb, as slaveholders surely did, from the litany. But every sale was personal and extraordinary; some were particularly sordid or brutal or wrenching. Most sales of an enslaved person, like that of the child Dick, led to a deafening silence; others opened up entirely new stories. One emerges, in all its complex, contradictory particularity, at the center of this one. If we want to know how Richard Cogdell came to possess the fifteen-year-old Sarah Martha Sanders, we will have to take another tangled Charleston path among wills and financial documents. We will not learn much.

Sabina Vanderhorst Toomer Hall only appears in this narrative because in 1821 she sat down to write her will.[45] Born in about 1752, Sabina was the only daughter of William and Margaret Vanderhorst, an important name among the Charleston urban elite.[46] In her thirties she married Capt. Joshua Toomer, whose first wife, Mary Vanderhorst, died in 1786. When Joshua died ten years later, his son Anthony V. Toomer was barely of age, and Sabina found herself responsible for both her father's and her husband's estates. Joshua's will listed the enslaved people he intended Sabina to inherit, and it is both numbing and frustrating to read: "Dolly, and Children, Sary, York, Ned, and Phebe, Hager, Betty and Child Nelly, April, Joe, Peter, King, Susy, Mon, Mary and Child, Harriett, old Peter, old Nelly, Celah and Child Sally, Bristol, Israel, Deb, Amy, Big Jack, Beck, little Jack, Moriah and Children, Primus and Maggy."[47] I have no way of knowing who these individuals were, but that name Sary sticks out. We will return to her.

Thomas Hall, ten years Toomer's junior, had also lost a wife named Mary in 1786. In 1798, Sabina Toomer married Hall, living with him both at his White Hall plantation and on Broad Street in Charleston; in his 1808 will he noted that he had "put a new roof on" the house and hoped Sabina would live in it rather than rent it out. Hall's will also listed the enslaved people he intended "my loving wife Sabina" to inherit; some names—June, Beck, Betty, Hagar, Phebe, Sarah—repeat, and these individuals may well have been part of the Vanderhorst and Toomer estates.[48] Thomas Hall died in 1814.

Twice widowed, Sabina Hall now controlled several significant estates. Seven years into her second widowhood and pushing seventy, Hall wrote her own will. Why then? This was surely not the first time she considered—or experienced—the consequences of a property owner's death. Unlike her first husband, she was apparently not "very sick and Weak in body," since she lived another six years. Nor was she without some assistance since, according to his admittedly self-serving account, her stepson Anthony Toomer considered himself an enormous help. She did face financial difficulties, having both guaranteed some loans for one Jacinto Laval and deeded over much of her estate to Anthony: we learn of this only later when things fell apart. But given the will's language and timing, she clearly had in mind a state law passed in 1821 that made it illegal to free one's slaves, even upon one's death.

Consider the impact and the irony of this law. No longer could enslavers do as Mary Stevens had, directing her heirs to set her "Negro man, July" "free from all bondage and slavery whatever." Her daughter

Mary Ann Cogdell's instruction that her "servant man Jack" "not serve any person as a slave after my death" was now meaningless.[49] Men could no longer choose or promise to free the children they had with enslaved women, nor could they emancipate those women, as had been an ordinary, not to say widespread, practice. Legislators' anxieties about a growing free Black population, it turned out, outweighed South Carolina's commitment to slaveholders' absolute right to do as they wished with their human property.

Whatever her financial entanglements—and whatever her savvy or naivete in handling them—Sabina Hall explicitly attempted to navigate this new legislative reality. "Whereas I have always been Served with fidelity and integrity by my negro Slaves Sarai & Juno," she declared, "and as it is my earnest wish to provide a suitable maintenance and Support for my Coloured Slave Sarah Martha a female of the age of Six years and four months the Daughter of the said Juno & grand Daughter of the said Sarai," Hall set up an elaborate and highly unusual arrangement. Five enslaved people ("Phebe Amy Sukey and her son Peter and Myrtilla") were to be hired out, itself a common Charleston practice, and $100 of their wages per year were to be "paid & applied to the Support of the said Coloured female slave Sarah Martha until she shall arrive at the age of twenty one years." That Sabina expected these enslaved adults to find paid work suggests that they lived in or near her Broad Street house in Charleston, rather than on a plantation. But who were these people and what bound them together, aside from this document? Sary and June (possibly Sarai and Juno) appear in other family wills and likely had lived much or all of their lives in Sabina's household; perhaps Phebe was the woman mentioned in Joshua Toomer's will. With no male named (other than Sukey's son Peter) we have no hint who the child's father was; perhaps, since Sabina Hall labeled her mother and grandmother as "Negro" and Sarah Martha "Coloured," her father was white or free. But that only Sarah Martha is named for this consideration indicates Sabina Hall's special and specific intention.[50]

Who overheard or was part of the conversation in the Broad Street house and the White Hall plantation about those intentions? Who was in the room when Sabina Hall learned of the new law that forbade her from emancipating any slaves? Did she express disappointment? Confusion? Resignation? Did the enslaved members of her household—Juno and Sarai among them—inform her of the news, recognizing what this would mean for promises she may have made regarding their eventual freedom? Did her stepson, Anthony, tell her not to worry, that he would

take care of everything she had laid out so carefully? Did she believe him? Did Juno and Sarai? And what, if anything, could a six-year-old have understood about the plans that were being made for her future?

Whatever the place of finances, family, and sentiment, whatever promises had been made in light of Sarai and Juno's "fidelity and integrity," Sabina Hall explicitly tried to limit the impact of the new law against manumission. Once Sarah Martha turned twenty-one, "Phebe Amy Sukey and her son Peter and Myrtilla" were to keep their own wages; further, they should be emancipated "and set free from Slavery as soon as it may be legal to do so, or if it should not be legal to emancipate them then [the executors should] allow them . . . to depart from this state and to return to the Same if it shall be lawful." Sabina's wishes were utterly clear: protect Sarah Martha and then get out of here. Restricted by a law not of her making, she created a complex legal document that her executors (Thomas D. Condy and her stepson, Anthony Toomer) would understand as a directive to emancipate a few clearly identified people as soon as possible. Certainly the enslaved African Americans in her household understood that Sabina Hall intended to support, protect, and ultimately free Juno's daughter; surely Juno, if she was still alive, knew it as well.

None of this happened. Sabina Hall died in 1827, when Sarah Martha was twelve. But the child was not supported until her twenty-first birthday by the labors of other slaves. Sabina Hall's estate was a tangled mess of guaranteed loans and financial mismanagement; most of the enslaved people, as part of that estate, vanish from the historical record and, quite possibly, from Sarah Martha's life. Three years after Sabina's death, attorney Thomas D. Condy sold the fifteen-year-old girl to Richard W. Cogdell for the sum of $450. From that point, in every document, for reasons that I simply cannot discover, she is recorded as Sarah Martha Sanders.

The 1830 bill of sale for the fifteen-year-old Sarah Martha is clear, and legal, and filed with the State of South Carolina; it sits amid the thousands of other such transactions in the state archive in Columbia.[51] It answers not one question about that child's life. Where did the adolescent girl live, what labors did she perform, who cared for her, and what did she understand about her future during the three years following Sabina Hall's death? Perhaps she resided with Anthony Toomer at 34 or 36 Chapel Street in Charleston or, less likely, on his plantation in Christ Church Parish, while he struggled to settle his stepmother's estate; possibly she lived at Thomas and Jane Condy's house on Bee Street. Surely

State of South-Carolina.

KNOW ALL MEN by these Presents, That

[handwritten: Tho' D Condy Ext'r of Est]
[handwritten: of m'rs Edwin Hall]

for and in consideration of the sum of *[handwritten: Four Hundred]*
[handwritten: and Sixty Dollars]

to *[handwritten: me]* in hand paid, at and before the sealing and delivery of these Presents,

[handwritten: By R W Cogdell]

(the receipt whereof *[handwritten: I]* do hereby acknowledge) have bargained and sold, and by these
Presents, do bargain, sell and deliver to the said *[handwritten: R W Cogdell]*
[handwritten: a Negro Girl (Slave) named]
[handwritten: Sarah Martha]

TO HAVE AND TO HOLD, THE SAID *[handwritten: Negro]*
[handwritten: together with her future issue]
[handwritten: and increase]

unto the said *[handwritten: R W Cogdell his]*

Executors, Administrators and Assigns, to *[handwritten: his]* and *[handwritten: their]* own proper use and behoof
forever, **And** *[handwritten: I]* the said *[handwritten: Thomas D Condy Ext'r]*
[handwritten: aforesaid]

~~Executors and Administrators,~~ the said bargained premises, unto the said *[handwritten: R]*
[handwritten: W Cogdell his]

Executors, Administrators and Assigns, from and against all persons shall and will
warrant, and forever defend, by these Presents.

In Witness Whereof *[handwritten: I]* have hereunto set *[handwritten: my]* Hand and Seal .
Dated at *[handwritten: Charleston]* on the *[handwritten: Twentieth]* day of
[handwritten: February] in the year of our Lord, one thousand eight
hundred and *[handwritten: Thirty]* and in the *[handwritten: fifty fourth]*
year of the Independence of the United States of America.

SIGNED, SEALED, AND DELIVERED }
IN THE PRESENCE OF }

[handwritten: Tho' D Condy]
[handwritten: Executor of the estate]
[handwritten: Thomas N Gadsden] *[handwritten: of Edwin Hall]*

[handwritten: Tho' N Gadsden made oath that]
[handwritten: he saw the within named Tho' D Condy]
[handwritten: Sign and Seal this Bill of Sale for]
[handwritten: the uses and Purposes therein mentioned]
[handwritten: and that he witnessed the same —]
[handwritten: Sworn to before me this 7 Aug't 1830]
[handwritten: John Ward]

[handwritten: Recorded Aug't 7, 1830]

143

Bill of sale for Sarah Martha, 1830.
South Carolina Department of Archives and History, Columbia.

she knew that her future was unsettled. Even if she did not understand that the sale of her body to Richard Cogdell went against Sabina Hall's intentions, other members of her community had to know.[52] Did her mother, Juno, live to find out that her child had been sold? What happened to Phebe, Amy, Sukey, Peter, and Myrtilla, whose earnings were intended to support her and then go toward their own freedom?

One wonders where the fifty-two-year-old Anthony Toomer had gotten off to, what he thought of this transaction, and what risks he ran in disentangling himself from his stepmother's debts. Two years after Richard Cogdell purchased Sarah Martha Sanders, Hall's estate was still under dispute, and Toomer reappeared, testifying to his innocence in any monies sought from his stepmother's account. Soon he would mortgage his stately Chapel Street houses, the kinds of places Tiya Miles refers to as "mimic[king] the look of eighteenth-century plantation mansions, bringing the country into the city and declaring the owners' desired . . . planter status." His account drips with self-righteousness: I only did what was best for my beloved stepmother, it was her second husband's relations who were the problem, I managed her estate even at financial loss to myself, someone else took advantage of an ignorant widow, she gave me certain "negroes" because she wanted a particular master for them, etc., etc. I do not know what impact all this, including her guarantee of money for Jacinto Laval, had on the settlement of her estate. Nor do I know whether Sarah Martha was among the "negroes" Toomer was instructed to care for. But among Sabina Hall's creditors is R. W. Cogdell, to whom her estate owed $306.[53]

Surely Richard Cogdell knew Sabina Hall, or her stepson, or the enslaved members of her household, since she was a neighbor and in his debt. Perhaps Sabina Hall knew his mother, Mary Ann, who was a near neighbor; perhaps Cogdell and Sarah Martha Sanders had crossed paths. Certainly he knew Thomas Condy, for the two men had served together as representatives of their wards on Charleston's city council.[54] But the surviving documents, dry and spare and legal, leave no clue as to what Richard intended when he purchased Sarah Martha or whether Cecille was involved in the transaction. Perhaps Sarah Martha was already acquainted with other enslaved people in Richard Cogdell's household. In 1830, Richard Cogdell housed one other slave, a woman between twenty-four and thirty-five. That very year, in September, he bought a "family of negroes belonging to the Est. of [Mrs?] Bampfield" for $761. (Like many Charleston transactions, this involved a family of long acquaintance; it was Rebecca Bampfield who, in 1778, sold the

two houses on St. Michael's Alley to Mary Stevens, Richard Cogdell's grandmother, where he grew up.) He continued purchasing, and hiring, enslaved people for years: in late February 1834 he paid $390 "for a female slave named Jinny"; in March 1835 Richard purchased "a Negro Wench named Cornelia" for $300. The following year he paid $600 for Peggy, a year later $660 for March. June 1837 was different because he purchased a "Mulatto Boy Mama John," and the next July he purchased "a Negro Woman named Sally." None of these names are those I associate with Sarah Martha's presumed kin. Nor do I know what happened to them; emancipation preceded Richard Cogdell's death and no will or letter of his mentions the enslaved people he sold and left behind when he departed from Charleston.[55]

Whatever happened to shape this transaction, whatever trickery or greed Sabina Hall's executors employed, it is clear what happened next. In June 1831 the teenage Sarah Martha Sanders became pregnant; the following March she gave birth to Robert Sanders, the first baby she would have with the then-forty-five-year-old Richard Cogdell. Over the next eighteen years, by the time she died at age thirty-five, she and Richard would have nine children together, three of whom they buried and another who would die four years later. It is worth noting that no one, in any record, rumor, or reminiscence, not to mention in Cogdell's own wills or his children's correspondence, expressed the slightest doubt that these were Richard's children.

Richard Cogdell would be far closer to his children with Sarah Martha Sanders than to his Cogdell sons. And if we heed Nell Irvin Painter's reminder that "hierarchy by no means precludes attachment," we must note the affection that the Sanders children felt for their father and the loyalty they exhibited toward him. There is no true way, Painter notes, to apply twentieth-century standards of psychological health to people living a century ago. That said, the Cogdell sons suffered from various degrees of mental illness; none of them formed long-standing relationships, had children (that we know of), or lived to the age of forty. The Sanders children, in contrast, made stable lives, committed relationships, and tightly woven familial bonds that lasted for generations. If at the core of enslavement, as Jennifer Morgan has beautifully argued, was "the inability to convey *kinship*—to have family represent something other than the expansion of someone else's estate," then what Sarah Martha Sanders wrenched from her own commodification and abuse epitomizes resistance itself.[56]

3

"MISS SARAH"

Let us try to imagine the first time Sarah Martha Sanders entered the Cogdell house. Did she flinch or stand upright? Did she appear, at fifteen, more as girl or woman? Were Richard's sexual intentions already clear to her (or, for that matter, to him)? Did Cecille know? Did his young sons notice or care about the enslaved teenager's arrival? However her entrance into the household was negotiated, whatever violence or conversation her relationship with Cogdell involved, Sarah Martha Sanders almost immediately became her owner's mistress and household manager, and a mother. Nell Irvin Painter, writing about "soul murder and slavery," insists that we attend carefully to the psychological implications of slavery for the enslaved themselves, that we recognize that "submission and obedience, the core values of slavery, were also the key words of patriarchy and piety."[1] Indeed, there is no way to know how Sarah Martha Sanders balanced those imperatives, how her experiences shaped her personality, and how, in turn, she raised her children. We cannot know what stores of self-worth and dignity she drew upon to manage the humiliation and pain that ensued. Indeed, we literally lack a vocabulary for how Sarah Martha Sanders referred to herself or what word Richard Walpole Cogdell used among friends when he mentioned her. Physical violence, sexual abuse, and child abuse may well have pervaded the Cogdell household, and they may have done so in complicated negotiation with affection, loyalty, and trust. Even given the traumas that shaped this young woman's life, the most unusual— even inexplicable—aspect of this story is the relationship she helped forge between her children and their father. I am not quite sure that the evidence confirms Sarah Martha's "savvy tactics of negotiation," as

one historian puts it, but given white men's typical behavior toward their enslaved children, Sarah Martha surely helped make this happen.[2]

The experiences of sale, upheaval, rape, pregnancy, and bearing children who could not, under the laws of South Carolina, ever be freed were unexceptional individual and collective traumas in Sarah Martha Sanders's world. Indeed, she surely crossed paths with other Black women in Charleston who lived in complex relationships with slave owners who fathered their children. Lydia Weston, for instance, resided openly with her enslaver, Isaac Cardozo, who encouraged her to read and write, bought her a house, and educated their children. Lydia's sister Nancy, in contrast, lived with Henry Grimke, a brother of Sarah and Angelina Grimke who was a brutal man, tormenting enslaved people in his household and controlling Nancy and their children. Nancy Weston was far poorer than her sister, but she still managed, as a biography of the extended Grimke clan puts it, to live "just on the outskirts" of the "colored elite," where she "absorbed its customs, and . . . passed its pretensions to her boys." Even in the face of Henry Grimke's callousness, Nancy viewed her sons as "colored Westons whose white father would have freed them if only he could."[3] It would not be implausible or strange if Sarah Martha Sanders, who as a child must have heard of Sabina Hall's intention to free her, told her own children something similar, if she too absorbed and passed on the "pretensions" of the free Black elite.

But what followed the news of the teenager's pregnancy was remarkable indeed. That fall Cecille Langlois Cogdell moved to a house on Pitt and Routledge Streets, leaving her husband and children behind.[4] Perhaps Cecille was already ill; she would die within months. Perhaps she suffered as well from mental illness, a possibility that is hard to ignore given that two of her sons would die of what relatives called "dementia" and a third would commit suicide. Richard determined "not to add my upbraiding to an already afflicted spirit," although he is hardly a reliable source on the nature of his wife's afflictions. Surely she visited her boys in their father's home. In an extraordinary, if self-aggrandizing, letter, Richard assured her that "in your occasional visit, for I do not see how I shall be able to explain your total absence, you will find me the same—uncharming in manner or in feeling—I have not a heart that can hate because it does not love entirely."[5] Still, it is difficult to overstate how extraordinary Cecille's action was. Wives simply did not decamp because of their husbands' lack of charm; even men's most egregious behavior rarely led women—dependent financially, legally, and socially

Chapter Three

on their husbands—to leave their marriages. Nowhere was this more the case than in Charleston, a city where white men more or less openly had sex, and children, with enslaved women, in a state that boasted the most robust laws against divorce well into the twentieth century.

Cecille's action—and Richard's compliance—suggest so many possibilities, all of them unproveable. Perhaps Cecille Langlois, although not a wealthy woman, was unusually bold, or oblivious to social pressure. Much harder to imagine are any conditions that the young Sarah Martha Sanders was able to exact in her relationship with Richard, or with Cecille. One wonders what Sarah Martha observed of Richard and Cecille's relationship, which may have been particularly, even publicly, rancorous. A letter from Richard to Cecille illuminated what life in their household must have been like even before Sarah Martha entered it.

> Your injustice has at length goaded me to a sense of what I owe myself. There is not a word or action of mine upon which you have not put the worst possible construction. . . . You have furnished me with arguments, which it is evident you wish me to make use of, to free you from the necessity of continuing attentions which has become irksome to you to pay—Henceforth be free— . . . Farewell!! May the blessing of Heaven rest upon you & upon your children. May they requite you for all your domestic unhappiness. My best wishes, my warmest aspirations shall ever be yours.[6]

To what "continuing attentions" he referred—companionship, affection, domestic labors, or just sex?—is not clear; that there existed "domestic unhappiness" is. Other references are simply odd, such as his declaration, in contradiction to law or common expectation, that she "be free," his wish that she "be healed!" and his mention of "your," not "our," children. The noises in that household may have been deafening; the silences in the record are even more so. Cecille died of consumption on New Year's Day in 1832 and was duly buried in St. Philip's Cemetery; Richard finished paying for her funeral by May.[7] As a final slight she was not buried in the Cogdell family vault, where her husband and sons would end up, but on the other side of the street.

From the moment Cecille left her husband's home—with its enslaved people, Cogdell sons, and the household labors—Sarah Martha Sanders, sixteen years old and pregnant, became its manager. Amrita Chakrabarti Myers may be correct that the relationship between Richard and Sarah Martha was "neither wholly coercive nor wholly

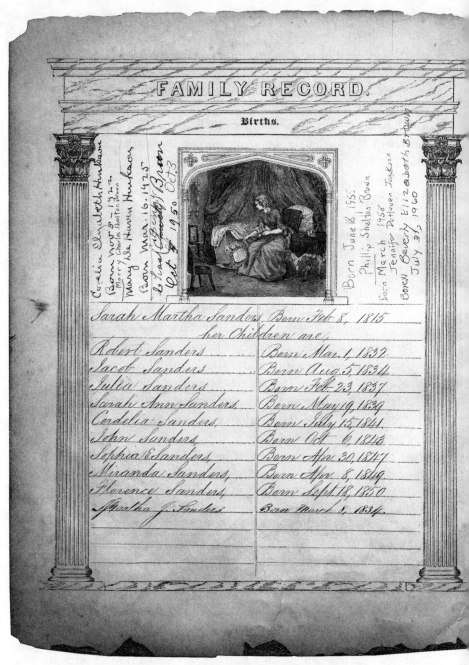

FAMILY RECORD.

Births.

Sarah Martha Sanders	Born Feb 8, 1815
her Children are,	
Robert Sanders	Born Mar. 1, 1832
Jacob Sanders	Born Aug. 5, 1834
Julia Sanders	Born Feb. 23, 1837
Sarah Ann Sanders	Born May 19, 1839
Cordelia Sanders	Born July 15, 1841
John Sanders	Born Oct 6 1843
Sophia E Sanders	Born Apr. 30, 1847
Miranda Sanders	Born Apr. 8, 1849
Florence Sanders	Born Sept 18, 1850
Martha J Sanders	Born March 8, 1834

Cordelia Elizabeth Hudson
Born Nov 5 - 1922
Marry Charles Shelton Brown
Mary Ida Haven Hudson
Born Mar. 16, 1925
6 had (Beverly) Brown
Oct 7 1950 Oct 3

Born June 18, 1955
Phillip Shelton Brown
Born March 1956
Jennifer Pittman Jackson
BORN Beverly Elizabeth Brown
July 31, 1960

Page from Sanders family Bible. *Am 1851 Bib Eng 17021.Q,
Stevens-Cogdell-Sanders-Venning-Chew Collection,
Library Company of Philadelphia.

FAMILY RECORD.

Births.

Name	Birth
Miranda Cogdell Venning,	Born 8th June 1862 at 6 O'clock A.M.
Julia Elizabeth Venning	Born Oct. 28, at 5 O'clock A.M. 64
Cordelia Nixon Venning	
Sophie Sanders Venning.	Born Oct. 12, at 8 O'clock A.M.
Oliver C. Venning.	Born Dec. 10th
Robert Sanders Venning.	
Sallie Sanders Venning	Born Aug. 13, 1872.
George Edward Venning.	Born Oct. 29, 1874
Martha Sanders Venning	
Louise Sanders Venning	Born Jan. 6, 1879.
Richard Sanders Chew	June 7, 1871
Charles Sanders Chew	June 21, 1873
Florence Irene Warwick	Born Feb. 19, 1886.
Elizabeth Venning Warwick	Born Oct. 4, 1888.
Mattie Barren Venning	Born Oct. 18, 1898
Mary Vandervoort Venning	Born Nov. 27, 1899.
Lily Capps Venning	Born June 12, 1902.
Catharine Louise Venning	Born May 9, 1906
Agnes Sanders Chew	Born Feb. 19, 1896.
Cordelia Sand Chew	Born July 20, 1899.

consensual."[8] But however it began, and however it changed over time, she remained enslaved to him. The same law that undercut Sabina Hall's intention to provide for Sarah Martha's freedom also prohibited Richard Cogdell from emancipating her if he wished. Nor could he legally free any of the children they had before Sarah Martha died in 1850; all remained the property of their father and owner as long as they lived in South Carolina. With his death, they would pass to other owners, according to the declared preferences of his will or, as in Sabina Hall's case, the realities of his financial circumstances.

What did Richard imagine would happen to them after he died? How did a slave owner/father protect his children from sale and abuse in a state that forbade emancipation even in an enslaver's will? Did he recognize the parallels between Sabina Hall's intentions for Sarah Martha Sanders and his own inability to offer his children a secure future? Here again we lack words. Pride, love, and loyalty cannot redeem relationships that were inextricable from property ownership. The most basic hopes or expectations for one's children—for financial security, for a home, for family—would have been, in his case, naive, even foolish. Any sense of responsibility he expressed toward them or their mother counted for little even in the context of their material comforts and educational privileges.

Let us name these children, before we forget how rare it is to know the full names and birth dates of enslaved people. Sarah Martha Sanders and Richard Walpole Cogdell's nine children were all given the last name of Sanders: Robert (1832–1907), Jacob (1834–1841), Julia E. (1837–1910), Sarah Ann (1839–1871), Cordelia (1841–1879), John (1843–1843), Sophia Elizabeth (1847–1865), Miranda (who died at eight months old in 1849), and Florence (1850–1854). None of these names was drawn from Sabina Hall's enslaved people, among them Sarah Martha's kin; they would, however, be common Sanders family names in the future. (Although the Sanders family Bible, along with various historians, includes Martha J. Sanders [1833–1913] as one of their children, she was actually Martha Julia [Davenport] Sanders, Robert's wife.)

Names and numbers cannot alone convey what Richard Cogdell had done or the traumas he initiated, and few documents reveal the household's mood or its timbre. With three Cogdell sons, ages thirteen, ten, and eight, in residence, the household was a bustling place, with people coming and going, meals being prepared, children being educated, and purchases being made. What evidence exists, however, suggests that

Sarah Martha and her children did not do the labors that most enslaved people performed. In March 1832, for instance, with baby Robert's arrival, Richard Cogdell bought "one of Barnes' Revolving Steam Washers." Although the "common barrel churn," a Pennsylvania product, failed to impress a writer for the *Journal of the Franklin Institute*, it was a labor-saving device not common in households that had enslaved labor, and Richard Cogdell paid fifteen dollars for it.[9]

Richard's next purchase is even more suggestive that his new family could devote time to middle-class pursuits. Although three years earlier he had paid $100 for a piano, that April he put seventy-five dollars down toward a new one.[10] Who played this instrument? Certainly Cogdell's family had a long tradition of being musical; Richard had grown up hearing his uncle Harry play the organ at St. Philip's, and his grandfather John Stevens and uncle Jack played as well. Perhaps Richard and Cecille's sons played, although no payments for their piano lessons appear in Richard's account books. Cecille left her marriage in a huff, but even if she had hired someone to move the older piano to her new house, Richard could have retrieved it after her death. If Richard himself played, we hear no mention of it, though he enjoyed listening: in Europe in 1845 he "sat opposite Liszt the great Pianist; went to his concert in the evening heard him for two hours." Might Sarah Martha have played? If so, had she learned as a child in Sabina Hall's house? Or did Richard expect his house to fill up again with children and, perhaps with Sarah Martha's input, plan ahead? Certainly Richard provided their daughters with private lessons. Seeking payment years later, a Mr. Garcia noted that "Miss Sarah will have receiv'd 29 lessons since our last settlement."[11] "Miss Sarah," Richard and Sarah Martha's second-oldest daughter, would have been seventeen.

How a word can disrupt our expectations. This "Miss Sarah" and her four remaining siblings were enslaved, owned by the father who paid for their piano lessons and everything else. Did Sarah Ann insist on that "Miss"? Did her father? Or were the Sanders daughters so obviously respectable middle-class girls that a piano teacher—essentially a tradesman—considered no alternative? Some historians have labeled such enslaved people "nominal" slaves, "irregularly freed blacks [who] behaved as free persons and [whom] city officials treated . . . as such." Myers beautifully explores the ambiguities of such labels in her study of some of Charleston's African American women, including Sarah Martha Sanders. Her words—"'virtually free' and 'quasi-free'"—may jar at first, given the bright line between chattel slavery and legal freedom and

our knowledge of what was to come.[12] But people live their lives only in their own moment: by the time Richard Cogdell and Sarah Martha Sanders had their children, the option of emancipating enslaved individuals in South Carolina had vanished. Still, much like the mixed-race and enslaved Weston/Grimke children, the Sanders children comported themselves as free and educated people of color; in some sense, whether implicitly, out of naivete, or to mislead, they passed as free. When proslavery politician Alfred Huger defended Charleston's free African American community against restrictive legislative proposals ("I believe there is not a better intermediate class in the world," he claimed), he likely included his friend Richard Cogdell's educated and yet enslaved children in that "intermediate class." Regardless, as was the case for every enslaved mother, Sarah Martha's security—and that of her children, and their piano lessons—"depended on Richard Cogdell's feelings."[13] What is most striking in this particular family's story is the degree to which those feelings remained unshaken—to the point that Richard Cogdell would give up his familiar life to offer his formally enslaved children a better future.

In a context of sexual violence, physical and psychological trauma, and patriarchal authority, we must grapple with fatherhood. Few white fathers of enslaved children openly acknowledged those children as their own. Some, like Isaac Cardozo, educated them or apprenticed them in a trade; many, possibly including Jack Stevens, left them without a backward glance; an untold number sold them as chattel. Almost none chose them openly over their other sons. As Myers observes, even men who educated and left money to their children by enslaved or free Black women—including Adam Tunno (with Margaret Bettingall) or Richard M. Johnson (with Julia Chinn)—did not acknowledge those children in writing as their own.[14] However confident Sarah Martha Sanders was that Richard Cogdell would sustain their family as essentially free people, the fact remains that Richard Cogdell's loyalty to his children long outlasted her presence in their lives. While a number of people, including descendants of the Sanders family, have wondered whether Richard Cogdell was "nice" to Sarah Martha Sanders, his loyalty was not a sign of Cogdell's particular virtue or the depth of his love but a reminder of the extraordinarily low and narrow expectations about fatherhood that enslavers had for themselves and that we have accepted as ordinary. The Sanderses' unusual relationship with their father, shaped within a system that sold and raped and exploited young women, mitigates not one horror of slavery. Rather, it forces us to confront the fact that

Chapter Three

human beings populate and enact every single lived moment in history. The abuse, rape, and sale of slaves, the tearing of children from their mothers, and the cruelty toward enslaved children were precisely as conscious, personal, and intentional—not to mention far more common— as were Richard Cogdell's acts of loyalty.

Of the many silences and gaps in this story, the years between Sarah Martha Sanders's first pregnancy in 1831 and her death in 1850 are glaring. Even the most quotidian information—such as where the family lived—is impossible to determine. Conventional sources are little help. Early federal censuses only named the household head; when they began to list individual residents in 1850, they still excluded the names of the enslaved. Nor did enslaved people appear in city directories. Therefore, I have not been able to sort out when Sarah Martha Sanders and Richard Cogdell's children lived with their father/owner, or when they lived in another house he rented or owned. At least as late as 1840, some of Richard's Cogdell sons, now ages twenty-three, twenty, and eighteen, still lived with him, but even then the count of residents is frustratingly imprecise, counting too few (if any) of his Sanders children. I do not know whether Sarah Martha supervised that household's chores, its purchases and meals, or its enslaved servants, nor can I offer evidence of who cared for her babies or how, as children, they interacted with their father or half brothers.[15]

The buildings themselves are as vague and inconsistent as the names of their occupants; addresses can tell us only so much and antebellum censuses not much more. Some—especially the wealthier ones, on Broad or on Tradd—may stand, but Charleston's leaders and census takers had a peculiar, and annoying, habit of changing the city's numbering system as they pleased; it was not formalized until 1886.[16] And as characters in a story, houses make frustratingly fleeting appearances. For example, in 1844, while traveling abroad, Richard Cogdell wrote the only letter we know of to Sarah Martha Sanders. Cogdell addressed it to her at Dutrieux Court, Bedon's Alley, a street that ran north from Tradd, just around the corner from St. Michael's Alley. Years later, in the 1861 city census, Bedon's Alley contained a house whose occupants are listed simply as "slaves," and it was considered by one wartime observer "a narrow lane of mixed repute."[17] It was surely not stylish. Another envelope arrived years later, addressed to Julie Sanders, Richard Cogdell and Sarah Martha Sanders's oldest daughter, at 101 King Street. And in 1845, Sarah Martha Sanders lived on Boundary (now Calhoun) Street.[18]

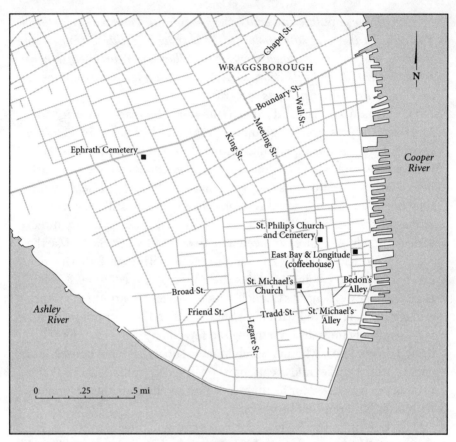

Map of Charleston

Only a few blocks' walk from St. Michael's Alley and Bedon's Alley stood other houses whose ownership—not to mention their residents—is murky. As early as 1817 Richard Cogdell owned a house on the north side of Wentworth (then Trott) Street between King and Meeting Streets. At some point he purchased or inherited a brick house at No. 5 Friend Street, which connected the larger streets of Tradd and Broad.[19] At least some of his Sanders children lived in that house for a period of years and Cogdell considered it their home. He said so in his 1856 will, directing that his children, to whom he could not leave property, should be secure in living there. That house apparently burned down during the Civil War, while Bedon's Alley was largely destroyed by the 1886 earthquake; several photographs from the early twentieth century depict the remaining brick and wood houses, with African American children playing in the lane alongside men engaged in labor.[20]

What struck me in my Charleston wanderings, what finally pierced my frustration at not being able to identify the *buildings*, is their proximity to one another. For more than half a century, clusters of houses sheltered members of the extended family—owners and enslaved alike—within a few blocks of those that Mary Stevens purchased in 1788. None was a mansion. Some we know about only because an envelope bore its address; still others because of a brief mention in a will. These houses were embedded in neighborhoods where stores, churches, banks, artisan shops, photographers' studios, dressmakers, and lawyers' offices sat side by side, with the city's central market close by. People going about their business saw one another, discussed their errands, and asked after acquaintances. "From the presence of two races," reported one traveler in 1859, "the streets of Charleston have a pepper-and-salt aspect," and although it is hard now to imagine Charleston as a majority-Black city, there was a great deal of contact among people of different races, classes, and legal statuses.[21] Buyers and sellers of slaves commenced negotiation in full view and hearing of everyone else; enslaved people, themselves highly visible as employees, peddlers, and consumers, passed others being sold, perhaps averting their eyes, perhaps not. Outside of each house's gate, or outside of the wood structures that housed the enslaved behind mansions, Charleston's streets were very public places.

Houses are property; they are exchanged, inherited, burned down, and abandoned. As in our own time, of course, these Charleston homes were shelters in which people ate and slept and bore and educated children. In them, married couples raised their children, middle-aged slaveholders impregnated enslaved girls, and wives left their marriages, leaving their sons behind. But they happened in very close relation to one another and to their neighbors. Within a four-block radius, several generations of Stevenses, as well as Sarah Martha Sanders and Richard Cogdell and their children and Cecille and Richard Cogdell and their sons, lived their lives. Whatever moves they made they could make on foot, with a hired buggy to carry their goods. Every place they strolled or shopped or visited, along residential streets that were more crowded than they are today, was familiar from childhood, reflecting an insularity that made the Sanders children's later migration all the more courageous.

Whatever Sarah Martha's daily responsibilities were, and wherever she and her children actually lived, she remained within a tight and familiar neighborhood populated by wealthy and middle-class white people, free people of color, and slaves, both those who lived with their

enslavers and those who hired out. Nearby streets, along with the shops on King and Market Streets, the churches, and the wharves near East Bay, were likely the boundaries of her entire life. She and her children would have been visible members of the community, passing friends or acquaintances, and perhaps family members, as well as tradespeople, clergy, and Cogdell's friends. Most likely she ran across people—Anthony Toomer, say, or Thomas Condy—from her earlier life; perhaps other enslaved people who had been part of Sabina Hall's estate remained in Charleston as well. Surely she, if no one else, knew why her last name was Sanders. As for her labors, at best we can extrapolate from other similarly situated women's work to imagine what she did: shopping for supplies, sewing, cooking, teaching her children. Perhaps, as historian Alexandra J. Finley shows so starkly, she participated in the care, purchase, and sale of other enslaved people, performing labors that "cast a harsh light on the value of work traditionally performed by women." Any evidence of her personality, her interests, the parts of her life she relished or those she hated, or the skills of which she was most proud, is lost: Was she shy? Sharp-tongued? Devout? Sentimental? Did she sing along when her children played the piano? That Richard Cogdell inscribed on her gravestone that "she was loved by All who knew her for her gentleness of character" tells us nothing at all.[22]

Occasionally a tiny hint emerges of the nature of the bond between her and Richard Cogdell, though mostly by implication. Actions speak loudest here, but Cogdell's few words are illuminating as well. Richard continued to work in a bank, attend the theater and the Charleston races, and educate his remaining Cogdell sons; perhaps he attended the famous soprano Jenny Lind's Charleston concert just months after Sarah Martha died. He was in his forties when he impregnated Sarah Martha and his marriage with Cecille Langlois disintegrated; he seems not to have considered remarrying. In 1844, away from home, he declared to "My Dear Sarah" that "I am almost always in my apartments and take no pleasure abroad. No person has had the power to charm me be assured. Women I never think of."[23] Apparently Sarah Martha Sanders had expressed some concern (Was she teasing? Anxious? Nagging?) about the temptations he would meet on his travels. Strange as it may seem to us, she apparently felt a right to "be assured" of his faithfulness. Stranger still, he complied.

Richard Cogdell's extended trip may have been the first time he had sailed to Europe since 1800, when he had traveled with his older brother John. Now, with his youngest Cogdell son, Charles, turning twenty-two,

Richard may have felt free to travel the world on his own—perhaps hoping to escape, if only for a time, the ongoing debts and behaviors that bound him to them. In April he resigned after twenty-seven years at the Bank of the State of South Carolina, apparently with "the intention of spending some years in travelling about Europe."[24] Nearing sixty, Cogdell felt comfortable leaving Sarah Martha and their four children behind. (They would have three more babies in quick succession after he returned.) Perhaps he moved the family temporarily, since only this letter mentions a house on Bedon's Alley. More jarring was Richard's personal concern. "It only remains for you to play false to make me abandon all hope of comfort in returning home," he fretted. "Keep pure and all will yet go well." And finally, "Yrs affectly, R.W.C."[25]

Could Sarah Martha Sanders read? Myers assumes that she was illiterate, but I am not sure. The tone of Richard Cogdell's letter is a bit more intimate than one meant to be read aloud. Certainly Robert, who was twelve, could read, but would his father have wanted him to know about his recreant navy son or about the possibility that his mother might "play false"?

Setting aside the question of what it meant for an enslaved mistress to "keep pure," where would Sarah Martha Sanders have found the time, energy, or motivation to "play false"? How could she have exercised the freedom that such a notion suggests, finding another lover, say, or taking her children away? In 1844, her oldest child was twelve, and Julia, Sarah Ann, and Cordelia were seven, five, and three, respectively. And whatever his flaws and his self-absorption, and whatever coercion their relationship entailed, Richard provided for a comfortable upkeep— apparently without involving his Cogdell sons George and Charles or his brother John Stephano in their care. Instead, he reminded Sarah Martha, "Call upon Mr. Whitney for any thing you may want & I will write to him to pay the same."[26]

Such an ordinary exchange. Any traveling husband might have thus assured his wife that his agent would cover her domestic expenses. But marriage, even at its most patriarchal, did not structure his obligation here. Sarah Martha Sanders and her children were entirely dependent on Richard Cogdell's goodwill; it is impossible to overstate how utterly powerless they were. No law protected them from sale, abandonment, or abuse; they had no legal claim on a minute of Cogdell's time or a cent of his funds. But for whatever reasons, and however Sarah Martha managed it, she felt entitled to Richard Cogdell's loyalty, and he agreed. However "special" her previous owner, Sabina Hall, told her she was,

no one planned the life she ended up living. Indeed, while Richard was away, Charleston's *State Free Negro Capitation Books* listed—and then crossed out—one Sarah Sanders on Boundary Street. I do not know who made this error, or who corrected it. Sarah Martha Sanders presumably knew she was enslaved; was there an advantage to calling herself free? Or did she simply appear enough as a free woman of color that the tax collector was uncertain and so made an honest mistake?

When Richard Cogdell returned home from Europe, it was to Sarah Martha Sanders and their children; soon they had three more. One day after giving birth to Florence, thirty-five-year-old Sarah Martha died of puerperal (or childbed) fever. It is in her death that we learn that Sarah Martha Sanders considered her own and her children's futures, as far as she was able. By 1843, Sarah Martha had borne five children; one, seven-year-old Jacob, had died two years earlier. On October 6 she gave birth to her sixth, a boy whom she named John and who died at just nine days old. Three days later, she became a "full subscriber" to the "Black and Colored" cemetery on Boundary (now Calhoun) Street, assuring that she and her minor children would be properly buried in the Ephrath plots; a formal document attesting to this rests in the family's papers. When Sarah Martha herself died, standing at her graveside were Robert (age eighteen), Julia (thirteen), Sarah Ann (eleven), Cordelia (seven), and Sophia (three), as well as the newborn Florence, who would die four years later. Sarah Martha's gravestone read, "Sacred to the Memory of Sarah Martha Sanders Who departed this life Sept. 20, 1850 Aged 35 years 7 months. Leaving 6 children to lament their loss. She was loved by All who knew her for her gentleness of character. Her infant daughter 'Miranda' lies in the same grave. 'Thou Art gone to the grave, we no longer behold thee nor tread the rough paths of the world by thy side. But the wide arms of mercy are spread and enfold thee and sinners may Hope since the sinless has died.'" Her grave, like countless others in the Ephrath Cemetery, is long covered over by asphalt; her stone is not among the dozens that rest against the fence around the Bethel Methodist Church parking lot.[27] (I've looked, wishing hard.) Indeed, we only know what it said because of a scrap in Cogdell's papers. Sarah Martha left behind a family of not-yet-grown children; all were enslaved, with no prospect of being freed. We have no way of knowing how indulgent or strict a mother she was, whether she was literate, talked about her childhood, or had a sense of humor. Nor, except for providing for their cemetery plots, can we know what plans or expectations she held for them. What kind of protection did

she believe she could offer? What words did she and Richard speak that made her confident of their survival? Would she have considered herself among "slave mothers [who] lived in a shadowland of constant, scathingly rational fear," as Tiya Miles puts it?[28] Whatever her hopes, she left behind a group of siblings who would remain deeply bound to one another for the rest of their lives—and to their father for the rest of his.

Historians can debate how to label these children and how much to consider legal enslavement the most salient fact of their lives; we might ask, as Hendrik Hartog does about wives who lived under the rules of coverture, whether people were "what the law said they were."[29] But we have to peer at the existing evidence on a pretty steep slant to imagine how they thought of themselves. Indeed, I have mused at great and frustrating length about what the Sanders children actually knew about their own legal status. Among the oddest bits of evidence about their Charleston lives is that Robert and Julia Sanders (and, later, Sarah Ann) appear in the *Free Negro Capitation Books*, suggesting that either they believed they were free or the tax collector who knocked on the door on Friend Street did.[30] Or perhaps they lied in the hope that it would offer future protection, a paper trail as it were, that might persuade the authorities that these young adults were in fact free. At the very least, combined with an inexplicable city treasury receipt in the family's records ("Received of Julia Sanders, Three Dollars 'in full for Corporation Tax for the year 1852, as per Return'"), there remains a whiff of ambiguity, of aspiration, that may have also been confusing to the young Sanderses themselves.[31]

Most of us assume, largely without question, that people of color knew whether they were enslaved or free. The sharp line between slavery and freedom has been blurred by historical investigations of how tenuous "freedom" was in what Angelina Grimke famously described as the "nominally free states." But it seems impossible that people could be unaware of their own legal status in the very heart of the slave South. No enslaved person, a friend of mine insisted when I raised this issue, could have been confused; no enslaved mother would be less than crystal clear when she spoke to her children. Another friend wonders whether telling the truth or telling a lie was the better, safer, choice. But the question haunts me: Is it possible that some or all of the Sanders children did not know, or only learned after their mother died, that they were enslaved? Would Sarah Martha Sanders have misled her children about the fact

that their father was, in fact, their owner, and that he could do nothing to protect them after his own death? In a city bustling with free people of color, a majority-Black city, is it possible that the Sanders children behaved so much as free people of color that they believed themselves to be free? We know of other instances of parents and guardians who lied to keep their children safe: European children who found out decades after the Holocaust that they were Jews or, more recently, US-raised children who discover that their parents' immigration, and thus their own, was undocumented. Did Sarah Martha Sanders and Richard Cogdell gamble that if their children believed they were free, no one would notice that they were not?

Regardless of their legal enslavement, or what they knew about it, the Sanders children behaved as free and educated people of color: Recall the piano teacher referring to "Miss Sarah." Tiny hints suggest wider connections, including friends in, or visiting, the North. A frilly Valentine's Day card ("Look at the one I love best") sits in the family papers, its envelope addressed to "Miss Julie E. Sanders, No. 101 King Street, Charleston, S. Ca." Its postmark, dated only February 12, says "Williamsburgh, N.Y." Certainly Julia and her siblings were educated; along with their piano lessons and their own assumptions of respectability, their later letters indicate both erudition and a middle-class attention to penmanship.

Even more telling is a photograph that sits in the family's archive. In it, a teenage Cordelia Sanders sits formally, even regally, hair tightly braided and her dress elaborate. No one smiled in nineteenth-century photographs, and Cordelia is appropriately serious. But there is no deference or shyness here. She gazes directly at the photographer, one hand lightly touching her chin, a confident glint in her expression, perhaps even a hint of a smirk. The picture—both its pose and the very fact of it having been taken—is an assertion of her class standing, as well as of teenage self-assurance. She was, in this portrait, the age her mother had been when Richard Cogdell purchased her. For all her poise, Cordelia does not look nearly old enough to comprehend what awaited her mother in his household, but neither, most likely, did Sarah Martha herself.

Whose idea was it to pay for this photograph? Who joined Cordelia at Tyler & Co., a Massachusetts-based company that, for a short time, kept a studio at 233 King Street? Did Julia or Sarah Ann accompany her and have her own picture taken, which was then possibly misplaced or discarded across migration and time? Did Cordelia—or her father, or her siblings, or her husband and their sons—simply like this beautiful

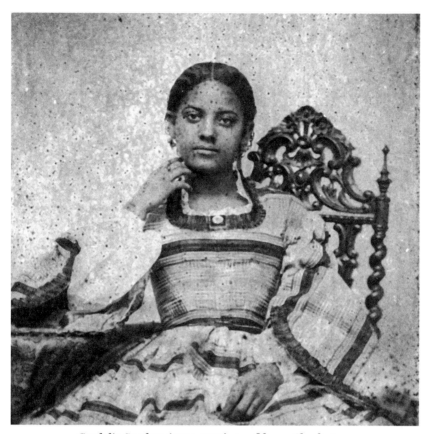

Cordelia Sanders (1841–1879), age fifteen, Charleston.
P.2014.51.2, Stevens-Cogdell-Sanders-Venning-Chew Collection,
Library Company of Philadelphia.

print more than the others and kept it as a special memento? Years later, Cordelia Sanders would muse about the difficulties of finding men of "our class" to marry. But even at fifteen, she, and presumably her siblings, communicated a sense of class and place and dignity that she must have learned from her mother, who died when Cordelia was nine, as well as from her white father and the life he provided.

As they entered adulthood, the Sanders children took chances on their future. Robert acquired a trade as a tailor, an occupation dominated by free African Americans in Charleston, which he would practice for the rest of his life. And then, on April 18, 1857, at twenty-five years old, he married Martha Julia Davenport in St. Philip's Church. Surely he

knew of his father's family's history with that church. There his great-grandfather John Stevens and great-uncle Harry had played the organ, his half brothers had been baptized, and much of Charleston's free African American elite, as well as the Cogdell family, had worshipped. There, too, hung John Stephano Cogdell's ornate relief of Mary Ann, Robert Sanders's grandmother, being mourned by her three sons. However imposing the place, however solemn the occasion, he must also have known, or discovered, that his marriage would not appear in the records of the State of South Carolina, that it had no sanction of law.

But the law did matter in Robert's choice of a wife. Martha Davenport was a free woman, born to a free African American mother and a white father. Her father, Charles Davenport, a native of Mendon, Massachusetts, appears in the Charleston papers in the late 1820s as a merchant receiving shipments of goods. Ten years later, he had returned to Massachusetts. Martha and her mother, Phillis Barron, a forty-four-year-old "mulatto," resided on Motte Lane in Charleston. Perhaps Phillis had known Robert's mother, Sarah Martha Sanders.[32] Both mother and daughter paid their taxes as "Free Negroes." Surely Robert and Martha discussed the similarities — and differences — in their families. But whatever discussions they and their families had about this, it mattered that Martha Davenport Sanders was a freeborn woman; any children she had, under the laws of South Carolina, would be free.

Perhaps Robert Sanders's courtship with a free woman of color sparked a conversation about his sisters' futures, possibly hastening the family's decision to leave Charleston. Clearly something dramatic happened. One historian, seeking to explain the family's move north, claims that "Richard's complacency was shattered; his reputation suffered; and he was forced to flee with his mulatto children to Philadelphia." But it is unclear what could so threaten a white man's standing as to force him, at seventy years old, to uproot so completely. There is no hint in his correspondence that he hid his children from public view, that they affected his reputation, or that he had lost friends. Certainly there were those who found Cogdell less than charming. "I can not say," sniffed Frederick Porcher, "that he was either much liked or respected in Charleston."[33] Still, no evidence remains of any falling-out among his friends. Indeed, what tiny hints there are suggest that it was something about his children — most likely his daughters — that shook him up. Years later, a friend of Cogdell's, writing to the Sanders children, referred in passing to his having been "forced on your acc[oun]t to leave the city," though he considered no further explanation necessary.[34] Whatever Sarah Martha

Sanders had told her children about her own past, and whatever hopes she expressed about their futures, perhaps it only now dawned on Richard Cogdell that his daughters' courtships and marriages offered a dramatically different prospect than it did for their new sister-in-law. Any children they had would be enslaved, and he, and they, could do nothing about it. Perhaps he mentioned this; perhaps they did.

But if we do not know who first spoke the idea out loud, or when the decision was made, we do know it was sudden. In the fall of 1856, Richard was seeking to protect his Sanders children's future in Charleston, drafting a will that guaranteed their right to live undisturbed at 5 Friend Street. Just six months before Robert's wedding, the family showed no sign of leaving. And then they did.

I have spent a great deal of my life trying to imagine conversations among friends and families around kitchen tables. Those exchanges, almost never documented, nudged ideas onto political agendas, shifted the ground on which people stood, and caused entire families to uproot their lives—to move to cities, to the West, to the North. Still, it is nearly impossible to imagine the conversations that led to the Sanders family's decision: Richard Cogdell, a slave owner and man-about-town at the very epicenter of US slavery, sitting at a table with his enslaved children, ages twenty-four, nineteen, seventeen, fifteen, and nine (would a nine-year-old have been part of this?) to talk about their future. Cogdell's ties, his investments, his family's burial places, his son Charles, and his friends were here; so, for that matter, were his children's.

Rooted as they all were in Charleston, Richard had traveled. Surely he had visited Philadelphia, a familiar stopping point. His mother and his brother John Stephano had toured the city, and his old friend John Irving had, like many Southerners, gone to medical school there; Richard's son John Cogdell had lived in Philadelphia before committing suicide a few years earlier.[35] Even before his 1844 trip, Richard had traveled to Europe with his brother as a teenager and to Jamaica with his uncle and later vacationed in such places as Saratoga Springs, where he stayed in 1828. He had also been to New York, where in 1845 he had "put up as usual at the American," adding parenthetically, "Good Heaven."[36] Cogdell had long subscribed to the *Albion* of New York ("a journal," it boasted, "that has to appeal to town and country, North and South, England and America, Whigs and Tories"), which closely followed New York's and London's cultural scenes.[37] He thought of himself as a cosmopolitan sort. But there is no evidence that he had inherited the rebellious spirit of his uncle Jack, who had moved to Jamaica, or

the independent streak of his cousin Mary Ann when she moved to England. Richard Cogdell enjoyed a good party, but he hardly comes across as a risk-taker, except for this one familial act. It was not the least unusual for Charleston-born African Americans to consider moving to Philadelphia or for wealthy white Carolinians to spend time there. But Richard Cogdell joined no well-worn path of white men when he undertook this journey.

If the children initiated the conversation, what could they have expected from their owner-father? What did they feel entitled to propose? Julia Sanders's flowery card from Williamsburgh suggests that she at least knew people in Brooklyn, but it is unlikely that either Sarah Martha Sanders or her children had traveled outside the state; what did they know about life in other cities? Did they raise the topic casually, or did it take nerve? Did they discuss it among themselves first? Did one of them remark boldly, or gently, or in anger that Richard was no longer young and that he could not protect them when he died? Did they promise to care for him only if they all moved north? One wonders what alternatives they considered. Perhaps one of them—Robert, most likely, about to marry Martha and equipped with skills—considered moving without the others. But never in all their lives would Robert and Martha Sanders live alone together, and it is hard to imagine them leaving his sisters behind. Could these comfortably brought-up young adults have contemplated striking out on their own, essentially becoming fugitives, leaving Richard in Charleston? Were there tears or tantrums? Declarations of affection? Appeals to a dead mother's wishes? But whoever first uttered the words, and however the negotiation took place, the family decided to stay together and leave those familiar places behind.

Such family discussions happen, of course, only in a particular time, with newspapers read aloud, rumors shared, and debates held over what it all meant. It is hard to consider the late 1850s in Charleston without peering ahead to firebrand secessionists and the Civil War. At the time, what African Americans knew was that South Carolina was becoming more dangerous. The Sanders children grew up at a time when the status and mobility, the relative autonomy, of Charleston's free, "quasi-free," and enslaved African Americans was shrinking. The 1821 law that had guaranteed their mother's lifelong enslavement—not only once, in Sabina Hall's will, but arguably twice, when she lived in a complex arrangement with Richard Cogdell—was only the beginning. In 1834, by which time Sarah Martha and Richard had two sons, it became illegal for free African Americans to teach Black children to read,

a law sponsored by Richard Cogdell's cousin-in-law Lionel Kennedy. Richard Cogdell likely hired tutors for his children (he had, he later wrote, "educated & brought [them] up as efficiently as circumstances would permit"), but their options were limited.[38]

However secure or vulnerable the Sanders children may have felt before, in the years following Sarah Martha Sanders's death, things got decidedly worse. Free people of color may have breathed a sigh of relief when the legislature failed to *enslave* them, but that politicians were even discussing this signaled how tenuous their freedom was. Ironically, the Sanders children, who were formally enslaved, did not face a serious threat from any new legal restrictions, but at least the older ones must have recognized that the growing harassment against free African Americans boded ill for them as well. Even the most elite of free African Americans, as Michael Johnson and James Roark have shown, who believed themselves protected by their own respectability, reputations, and wealth, watched anxiously as the South Carolina state legislature threatened to displace them from their familiar middle ground.

Some enslaved Charlestonians, Johnson and Roark argue, "had managed to turn their masters' loose supervision into *de facto* freedom," and this was likely the case for the Sanderses. But loopholes were disappearing. Such once-popular mechanisms as a "deed of trust" could, in theory, circumvent the law against emancipating a slave, but I have no evidence that Richard filed these for his children, and in any case they were increasingly disregarded. Other policies that had long been ignored were now being enforced. For some fifty years enslaved people who hired out (a significant part of the Charleston economy, a bane to white laborers, and a common practice in Richard Cogdell's household) had to wear a "slave badge," paid for by their master. New enforcement of this practice put enslaved workers and their family members on notice. Perhaps hundreds of them "rushed to acquire slave badges" after years of no one caring whether they carried one.[39] If Robert Sanders was an apprentice at a tailor shop—there were several owned by free African Americans right in the neighborhood—this might have threatened his mobility, his dignity, and his sense of himself as a son, a worker, and soon the husband of a free woman.

Would Richard Cogdell have purchased a "slave badge" for his son? Could the suggestion that he do so constitute an event where his "complacency was shattered"? No such item remains in the family's collection. Perhaps the badge never existed. Maybe it was lost, washed away like most everyday objects, or left behind as a relic best forgotten. Elite white

Charlestonian D. E. Huger Smith, born in 1846, recalled the numbered brass licenses, issued by the city of Charleston, to those who hired out. "A most ridiculous trade is to-day carried on in the curiosity shops," he scoffed, "which sell the very ordinary bits of brass as 'slave-badges' at high prices. . . . Doubtless many have been dispersed over the North as curiosities of slavery."⁴⁰ Huger Smith did not consider the different associations these "ordinary" badges might have had for the descendants of the enslaved themselves.

These changes underway in Charleston were not abstract. They posed real threats to actual people, who responded in a variety of ways, exposing not only the legal differences between enslaved and free but the chasms of class and color within Charleston's communities of color. Loyalties were tested, with sometimes surprising results. William Ellison Jr., oldest son in a family of wealthy African American slave owners, sent his children away to Margaretta Forten's school on Lombard Street in Philadelphia, a veritable hotbed of antislavery sentiment. His father, William Ellison Sr., eager to protect his family's freedom and security, formed a local "Kansas Association," which raised money and soldiers to send to that territory's *proslavery* fighters. White "guardians" had been required of all free African American men since 1822, but now, faced with stricter enforcement, free men of color often confronted guardians who possessed dubious legal documents, erratic memories, or callous attitudes. The yearly "capitation tax" that the Sanderses (erroneously) paid became more rigorously enforced as well, carrying the threat of enslaving free people who were behind on, or unable to pay, the fee; individuals who could not provide freedom papers found themselves, and their children, enslaved or in flight. Many free Black and brown families, especially those less tied by wealth to the land or their customers, simply left. By the time Robert Sanders and Martha Davenport married, growing numbers of Charleston's enslaved people managed to escape, even though they were faced with the Fugitive Slave Act, which required all Northerners to be slave catchers. After Lincoln's election, as white South Carolinians led the cry to secession, hundreds more African American refugees seceded in reverse, many to Philadelphia.⁴¹

If the "middle ground" between slavery and freedom was increasingly precarious, what would the Sanders children have faced if they had remained in Charleston? What kinds of pressures came to bear on Julia, Sarah Ann, Cordelia, Sophia, and their brother? With one eye on the war and emancipation to come, we can muse abstractly about growing restrictions, about the *Dred Scott* decision and the distant

fight over Kansas, but the daily choices were frightening, and we cannot know what people thought "the worst" might be. It is impossible, reading about this time, not to consider Jews in Germany in the late 1930s, the combination of disquiet, disbelief, and denial that shaped decisions about whether to cut and run, sell businesses, and leave relatives and friends for a dubious security. Indeed, Johnson and Roark label Charleston's transformation, the "crisis the free colored aristocracy had been confident would never come," as "an antebellum *Krystalnacht*."[42] Financially stable free African Americans in Charleston may have thought, with each new restriction, that the worst had passed. But none of them could have missed the chill in the air, the growing unease among young people who had likely felt, if not free, safe enough.

Whenever the Sanderses understood that they were enslaved, they also knew that their father could neither free them nor leave them property. Evidence from a later time suggests that Sarah Ann, at least, had a keen sense of business and was savvy about their rights. If they knew about the will Richard wrote in the fall of 1856—indeed, if they had urged him to write it—they knew that their father hoped to protect them from his white extended family and would also have known his limitations. For that matter, if they knew about Sabina Hall's intention to protect their mother, they would have understood how flimsy a legal shield a will could provide in the face of an estate's financial distress. However much they identified with free people of color—and as educated, piano-playing Episcopalians, how could they not?—it remains striking that there is barely a whisper in any of these records of their legal status or of how moving north would transform it. Only much later, and then only implicitly, did any of them acknowledge that emancipation affected them directly. Two years after the war, a handwritten note signed by a minister "certif[ied] that, on the 18th of April 1857, I united in marriage, according to the ritual of the Protestant Episcopal Church, in St. Philips Church Charleston, Robert Sanders and Martha Julia Davenport, in the presence of divers witnesses."[43] Only an awareness of their changed condition would have led Robert and Martha to request written assurance that their marriage had been proper, if not, at the time, legal.

What finally made the Sanders family leave Charleston? None of the possibilities are good and some are terrifying. Might Robert Sanders have been asked to produce papers or a badge? Is it possible that he, like the tax collector, believed he was actually a "Free Negro"? Given its abruptness, the decision might have been motivated by one of his

sisters. In 1856 Julia was nineteen, Sarah Ann seventeen, Cordelia fifteen, and Sophie nine. Certainly some of them were old enough for suitors, though I do not know who had received a fancy Valentine's Day card ("All my love shall flow to thee") dated "Charleston, 1856" or who had sent "Miss Julia" hers.[44] However they comported themselves, however much confidence or deference their mother had taught them to exhibit, however naive about or sharply attuned to their own vulnerability—and however deeply they trusted their father—any of them could have been harassed, assaulted, or insulted on the street. These young people together navigated a complex adolescence and young adulthood; they would have told one another if an alarming or violent or merely unpleasant incident had taken place that winter. Perhaps they approached their father with a story he could neither dismiss nor offer protection against.

One hypothetical scenario requires little stretch of the imagination. During an evening of drinking and theater, a younger male acquaintance might have made a casual or suggestive or disgusting remark about Richard Cogdell's daughters. Everyone knew that Richard had had sex with the teenage Sarah Martha Sanders; what would stop another white Charlestonian from assuming that Julia or Sarah Ann or Cordelia was similarly available? Surely his gossipy friend John Irving, inveterate writer about Charleston's social scene, would have reported hearing such a remark. A lewd off-the-cuff comment, an indecent proposal, vulgar words that would have led to a duel if they had referred to a white wife or daughter—any of these could have brought home to Richard Cogdell that he was getting old and that he could not protect his children.

Whatever the catalyst, things moved quickly. That spring, only weeks after Robert and Martha's wedding, Richard Cogdell paid $1,375 for a house at 1116 Fitzwater Street in Philadelphia. Almost immediately, he transferred ownership of the house to his children. Leaving his Charleston property in the hands of his lawyer friend Daniel Horlbeck, he loaded up his children and Martha, arranged for the shipment of boxes of family papers—including the letter books of his grandfather John Stevens, a number of old deeds, and some family mementoes and diaries—and left Charleston. He wasted no time gathering the rest of his belongings. Within a week, he received a letter about what ships would be leaving Charleston for Philadelphia that included the query whether "the piano is to be covered by Insurance when shipped by me."[45] This was no temporary move. Richard Cogdell took up residence in the La Pierre House a few blocks away from his children, and they all settled in.

4

THE SANDERSES' PHILADELPHIA

Why Philadelphia? Once, long before the chasm brought about by the Civil War, Charleston and Philadelphia had been close kin. White South Carolinians were a distinctly aristocratic presence in early nineteenth-century Philadelphia: "Carolina Row" on Spruce Street nurtured shared class, political, and familial ties that gave "Philadelphia high society the southern cast that so impressed travelers." Residents, among them Sarah Grimke's sister Anne, were, as Kerri Greenidge writes, "characterized by their pretentiousness and insularity, as well as their fabulous wealth and their ability to circumvent state laws in keeping enslaved people in their homes."[1] After sections of downtown Charleston were destroyed by fire in 1796, Philadelphians raised funds for what was effectively their sister city. Indeed, travelers often began their accounts of Charleston by comparing it to the larger—and cleaner—Philadelphia. The admiration went both ways. As one visitor from Charleston reported, Philadelphia was "the only genteel place I have seen since I left" home.[2] Richard Cogdell's brother John praised Philadelphia's art scene, its poorhouses and prison, and its bridges—though he sniffed at the courthouse's lack of "distinction as to white or black, all are Witnesses, all occupy the same Bar & are indicted & tried in the same manner just as they come, white & black."[3]

It was not only tourists who established the deeply worn path between the two cities: medical students, merchants, parents seeking to educate or marry off their children, fugitives from slavery, and free people of color all traveled between them. Goods moved in both directions, both in trade and in more informal exchanges. When Emily Wharton of Philadelphia married Charles Sinkler, a navy midshipman,

she moved to his father's cotton plantation on the Santee River. From there she sent seeds and plant cuttings home and waited impatiently for books and newspapers—not to mention a globe and microscope for the children—to arrive, as she could not get these items in South Carolina. This was true on a larger, industrial scale as well. The South, writes Frank H. Taylor, "was Philadelphia's best customer," as ships and railroads carried manufactured goods to Southern farms and households, returning with lumber, turpentine, and cotton.[4]

As in Charleston—as in any sprawling urban area—several large and vibrant communities made up Philadelphia's population. When a daughter of Charleston's slave-owning elite, Eliza Middleton, married Joshua Francis Fisher of Philadelphia, she reversed her mother's path back to Philadelphia. The Fishers, wealthy merchants, were Quakers and pacifists. They had their religious differences and some suspicions about Southerners (Fisher assured his relatives that his intended bride was "utterly free from that indolent helplessness & languid carelessness which is usually Characteristic of [white] women bred up among slaves"), but these families were well matched as, in one historian's words, "inveterate snobs." Eliza Middleton's correspondence with her mother illuminates the strong ties between Charleston and Philadelphia networks, as well as offers a wealthy young wife's glimpse into a social life "among distinguished lawyers and doctors, political leaders of both parties, visiting literary figures, and European dignitaries."[5] Their Philadelphia (like that of Joshua Fisher's cousin, the lawyer and diarist Sidney George Fisher) comes across as entirely white, exclusively upper class, and oblivious to the strife of earning a living, escaping from enslavement, or confronting racism. Readers of these letters would never know that here was the largest free Black community in the urban United States.

Elite merchants did not constitute the only white community, of course. Quakers had long ago founded Pennsylvania, and many counted themselves among the city's prominent leaders, merchants, and well into the 1800s, slaveholders. Within the Society of Friends a small but vocal minority of abolitionists included the leaders of the interracial Philadelphia Female Anti-Slavery Society, who challenged slavery and, sometimes, racial prejudice. This was the community that many African Americans leaving Charleston—either as fugitives or as free people looking for homes, schools, and work—would first encounter when they arrived. Indeed, Robert Purvis, a leader in the Vigilance Committee's Underground Railroad work, was himself from Charleston. His father,

a wealthy, slave-owning Englishman, had sent him, his brothers, and their mother (a free woman of color) to Philadelphia in 1820, where they were educated alongside and married into the most elite of African American families, the Fortens. A "complex web of relationships" continued to link these Philadelphia families with acquaintances and kin in Charleston.[6]

At about the same time that the Purvises migrated to Philadelphia, two white Charlestonians, Sarah and Angelina Grimke, undertook the move as well; their paths and that of the Fortens and Purvises would intersect famously. Daughters of a leading Charleston family, the Grimkes grew up on Church Street, supported by their father's cotton plantations and served by a large staff of enslaved people. Sarah squirmed against Charleston society's demands for rigid conformity from a young age. Why Sarah, and not other intellectually minded girls of her class, should have resisted—why, for her, "slavery was a millstone around my neck, and marred my comfort from the time I can remember myself"—is unknowable. But her discomforts with both the racial and gender strictures of Charleston piled up. In 1819, she accompanied her ill father to Philadelphia, where she remained until he passed away and she found herself on her own, "a changed person." Two years later she returned to Philadelphia for good. By 1830 her younger sister Angelina, similarly attracted to Quakerism and even more blunt about her family's dependence on enslaved labor, had joined Sarah in exile. Together they built careers as abolitionist orators and writers. Their Philadelphia was peopled by an interracial community of reformers, abolitionists of the ultraist stripe such as Lucretia and James Mott, Sarah and Grace Douglass, and Mary Grew. In the late 1830s they helped raise the funds to build Pennsylvania Hall; in May 1838, at the second annual convention of antislavery women, Black and white women walked through crowds of angry anti-abolition mobs who burned the building to the ground. That same week, Angelina married Theodore Weld in a wedding that was controversial for its racially mixed guest list, after which the Welds and Angelina's sister Sarah traded their very public lives for quieter ones, teaching school and living simply in New Jersey. They stayed in touch with their white Charleston kin, but they were, in many ways, in a different world. "Pray, have you got no servants?" their mother wailed from South Carolina upon hearing a description of their domestic arrangements. "This, my daughter, is like some of your other strange notions."[7]

Philadelphia had, in addition to Southern aristocrats, white merchants, middle-class Quakers, white working-class immigrants, and

a small African American elite, the largest community of free African Americans of any city. Beginning in 1780, when the state undertook the gradual emancipation of slaves (carefully protecting enslavers from a precipitous loss of property), Philadelphia became a bustling transit point for fugitives from slavery and a home for thousands who decided to stay; "there even seemed to be," Tiya Miles suggests, "an invisible road leading out of Charleston straight to Philadelphia in the antebellum period." By the 1850s, although shadowed by the threat of the federal Fugitive Slave Act, runaways arrived on a regular basis as "the expansion of coastal steamship service . . . opened tremendous opportunities for fugitive slaves." Philadelphia's Vigilance Committee became ever busier in receiving, hiding, and protecting those new arrivals.[8] In addition to the large number of day laborers and domestic servants, there was a growing working and middle class of seamstresses and tailors, business owners, caterers, and barbers. Among the small Black elite exemplified by the wealthy sailmaker James Forten and his family and friends—the Douglasses, Purvises, and Bustills—were the city's earliest African American activists, lawyers, and teachers. Although they are often remembered for their antislavery and Underground Railroad work alongside white activists, the men and women of this community had also established the Colored Conventions movement, demanding and asserting full Black citizenship and collective rights prior to abolitionist organizing.[9] In many respects—in its churches, its schools, and its reform activism—Philadelphia was the nation's center for exploring what African American freedom meant and what it did not.

White Philadelphians were ambivalent at best about this African American community. Some expressed their hostility openly, with daily indignities and widespread violence against the Black populace arising in tandem. Waves of anti-Black riots alternated with anti-Catholic violence. Between 1832 and 1849, white mob violence against people of color and their institutions left some people homeless and others forced to seek refuge outside the city. The committee charged with investigating one such riot called upon African American leaders to remind their community to "behav[e] themselves inoffensively and with civility at all times . . . taking care, as they pass along the streets . . . not to be obtrusive." In 1838, soon after the destruction of Pennsylvania Hall, a state constitutional convention voted to disenfranchise Black men, whose numbers were strongest in Philadelphia. Visiting in 1841, Joseph Sturge declared that he had seen no place "where dislike, amounting to hatred of the coloured population, prevails more than in the city of brotherly

Chapter Four

love!"[10] Through the 1850s, as in Charleston, things got worse; indeed, Andrew Diemer titles his chapter about 1857, the very year the Sanders family arrived in Philadelphia, "Dark Days." The young Charlotte Forten, daughter and granddaughter of elite African American abolitionists, who expressed frequent longing to return to Massachusetts from her home in Philadelphia, mirrored Sturge's remark: the "mockery" of the Liberty Bell, and the indignity of her friend's being *"ordered* to go to the 'colored car,'" made her "better able to appreciate than ever the blessings we enjoy in N[ew] England."[11] By the time William Ellison Jr. sent his children from Charleston to Margaretta Forten's school, he had to have known he was sending them into a place only slightly less hostile to African Americans than Charleston. It may not have been "*Krystalnacht*" there, but neither was it freedom.

The Sanders children and their father likely knew of Philadelphia's reputation, however mixed, as a refuge of sorts for both elite white Southerners and African Americans. There are hints as well that they knew African American Charlestonians who had previously made the move. Perhaps they thought that their material comforts and middle-class bearing would insulate them from Northern racism. Still, whatever its familiarities, and knowing what will come next, we imagine that the bridge that spanned the two lives must have seemed immense, that even with the abutments their father provided they were entering another world. Certainly Philadelphia's Black middle and working classes had no exact parallel in South Carolina. Nevertheless, it is astonishing how quickly, having wrenched themselves from their old lives, they became quite accustomed to their new ones.

In the final paragraphs of her memoir of her escape from enslavement, Harriet Jacobs offers a classic statement about slavery, gender, and freedom: "Reader, my story ends with freedom, not in the usual way, with marriage. I and my children are now free!" Still, that freedom is incomplete: "The dream of my life is not realized. I do not sit with my children in a home of my own, I still long for a hearthstone of my own, however humble."[12] Like Harriet Jacobs's own children's, the Sanderses' early lives were defined by their mother's enslavement and her ambitions; a slave owner's sexual advances on a young enslaved woman; and a plan to find a better life in the North. Unlike Harriet Jacobs and her children's situation, the Sanderses' move began with a house, a brick-and-mortar reminder that "home," like "freedom," was no mere metaphor. Less an escape than a migration, their journey also included their white father and, most important, one another.

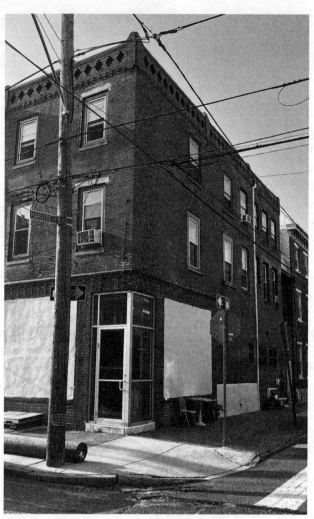

1116 Fitzwater Street in 2023. Photo by author.

The Sanderses established that new life, to an astonishingly perma-nent degree, at 1116 Fitzwater Street; more than a century later, their descendants would refer to it simply as "eleven sixteen." So if finding a place to live is the first step in any migration, let us acknowledge the role of this house. I don't know how the bookbinder John Palmer and his wife, Margaret Palmer, acquired the house or whether they ever re-sided there; I only know that in 1857 they sold it. Palmer, an Irish immi-grant, was about fifty when the transaction took place. A bookbinder at "Shields Al[ley]," he had produced "the Cheapest Catholic Prayer book

in the US." With his estate valued at $5,000, his prayer book approved by the bishop of Philadelphia, and his business well established, Palmer had done well and so could purchase at least one home and buy and sell other real estate.[13]

The house itself, eighteen feet across and fifty-seven feet deep, was a conventional three-story Philadelphia row house, some 2,500 square feet. At the end of a row, at the corner of Fitzwater and Marvine Streets, it allowed in more light than the neighboring houses. Its first-floor plan included street access to a shop, and members of the family would conduct their trades as tailors and seamstresses, as well as their family life, in that space.

Fitzwater Street was lively, if not at the center of things—a mixture of residences and artisans' shops. The Third Ward, also known as Moyamensing, had formally become part of Philadelphia only three years earlier, when the 1854 Act of Incorporation absorbed into the city such neighborhoods as Germantown, West Philadelphia, and Spring Garden. The surrounding neighborhood, with its taverns and laborers and a prison on South Tenth Street, had a reputation for unruliness: a decade later, African American observers would complain that the white Union soldiers who had been "left in [Charleston] to guard the freedmen's interest" had been drawn from "the jail birds of New York, and the inmates of Moyamensing."[14] Philadelphia was much larger than Charleston, but the very urbanness of the neighborhood may have felt familiar, with everything the Sanders family needed within walking distance of their home. The house at 1116 Fitzwater was also only a ten-minute walk from Richard Cogdell's new residence, the recently opened La Pierre House on Broad Street, where much building was going on, and a short stroll to churches and retail shops.

The Sanderses' neighbors on Fitzwater were laborers and artisans, some with small businesses on the street. Samuel Appleton, a carpenter, was across Marvine Street at 1118, with Samuel Raby to their east at 1114. John Battist, a seaman, lived across the street at 1115. John H. Neiss listed a tavern at 1117, sharing his location with S. McMullin, under "Trimmings and Variety." Small factories were scattered among the houses on nearby streets. Down the street on the corner of Fitzwater and Twelfth stood the eight-year-old "Union School and Children's House," with 110 "inmates," children who, because of "the increase of intemperance among parents, the destitution and vagrancy of children . . . and the want of domestics in families," were housed and trained there.[15]

According to the Pennsylvania Abolition Society census, some African Americans lived around the corner at "Fox's Court, Fitzwater and 12th." Most claimed to have been born free, though given the very reasonable anxieties about the Fugitive Slave Act, it made sense to lie. Most of these African American individuals were, like their white neighbors, artisans: "the wife Dressmaker," "the Man Cakebaker," "the Sister Dressmaker," or "the man brickmaker. The wife Dress & Shirtmaker & formerly taught school."[16]

But on the 1100 block of Fitzwater, all the Sanderses' neighbors, according to the census, were white, many of them, like John Palmer, immigrants from Ireland. Neither the 1856 Pennsylvania Abolition Society survey nor the 1860 federal census lists Black or mulatto residents (other than the Sanderses) on the street. A bit too far west to be at the center of Philadelphia's growing, and mostly poorer, African American community, the house's location was in some ways analogous to how the Sanderses had lived in Charleston: not among the fanciest homes, not clearly segregated by race, and walking distance to nearly everything they needed.

When John and Margaret Palmer sold 1116 Fitzwater in May of 1857, they received $1,375 cash from one Richard W. Cogdell, a South Carolinian of about seventy whom the Palmers may never have met. Did the Palmers know that he would not actually live there? Could they—or their neighbors—imagine that almost immediately after the deed was formalized, Richard Cogdell would sign over the house to "Robt Sanders et al," his children, who were, until they set foot in Philadelphia, enslaved? When Robert, his wife Martha, and his sisters Julia, Sarah Ann, Cordelia, and Sophia Sanders moved into the house sometime that spring or summer, would its former owners have cared?[17]

What a hold this house had; owned free and clear, it may have seemed the very definition of freedom and of safety (by no means synonymous). It was here at 1116 Fitzwater that the Sanders family celebrated weddings, gave birth, mourned deaths, and did the labor (as dressmakers, tailors, teachers, and barbers) that supported the household. Surely there were missteps and financial worries.[18] But with each census and each city directory, the names of 1116 Fitzwater's residents are familiar. Whatever their individual and collective aspirations—for education, for a faith community, for music, for love, for meaningful work, for independence—geographic mobility seems not to have been among them. Forays to Massachusetts, trips to the beach, and stints away at school or

to Brooklyn to teach—all these took place, but the Sanderses' paths led back to 1116 Fitzwater and to one another. After their marriages, Julia and Cordelia and their husbands and children eventually moved back; when Cordelia died, her widowed husband left his sons there while he explored new opportunities in Washington, DC.

Even when they moved, it was not forever. In 1861 Julia married Edward Y. Venning and the couple moved to his parents' house on Rodman Street. By 1870, Edward W. and Elizabeth (Nixon) Venning's home included twenty people. In addition to the elder Vennings there was Edward, Julia, and their four children. The household may have included servants, boarders, or workers in the Venning carpentry business at 420 Fothergill. Phillis Barron, Martha Sanders's mother, lived there as well, as did Richard DeReef Venning, Edward's twenty-three-year-old brother. It must have been something of a relief for everyone when Julia and Edward and their children moved a short walk away to her family home on Fitzwater. There are hints that Edward Venning once considered moving his family, for in 1880, the city directory listed him with his father and brother Richard at 337 Dean Street (later Camac). Indeed, writing to her aunt Rebecca Venning from Massachusetts several years earlier, thirteen-year-old Miranda longed "for June to come, so I can be on the cars coming home to the new house 337 Dean St. Do you like it better than 1116 Fitzwater Street? I had a letter from Julie saying she missed the old house terribly." But if the family intended to leave Fitzwater for good, they changed their minds. When he died in 1884, Edward Venning's home address was listed as 1116 Fitzwater. When Julia died in 1910 and her sister-in-law Martha Davenport Sanders three years later, they, too, resided at 1116 Fitzwater. When the next generation finally sold the house that Richard Walpole Cogdell bought for his children in 1857, it had been the Sanderses' home for more than half a century.[19]

1116 Fitzwater was more than simply a brick tenement purchased for cash. Richard himself understood that it offered a kind of stability that the house on Friend Street in Charleston, where he had once planned for his Sanders children to live out their lives, could not. In Charleston he could only hope, perhaps naively, to protect his Sanders children by threatening to disown his Cogdell son; this house, he made legally crystal clear, was theirs. It was, to refer back to Harriet Jacobs's metaphor for freedom, "a hearthstone of [their] own, however humble." Harriet Jacobs's own daughter, a close friend of Cordelia

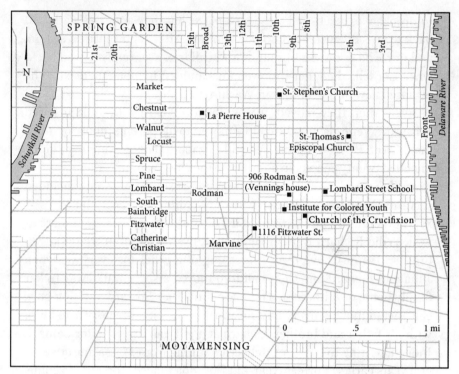

Map of Philadelphia

Sanders Chew, recognized its pull. "I have not heard from Fitzwater St. lately," she wrote a friend.[20] Throughout Louisa Jacobs's letters, the house is a character, its residents a unit, a source of news, warmth, and grief—the concrete result of a deliberate and concerted decision that Sarah Martha Sanders's children and their father negotiated and formalized and that allowed them to become independent Philadelphians, congregants of the most elite of Black Episcopal churches, and workers and artisans who owned a house that provided an underlying security for decades to come.

So, in the spring of 1857, like many other migrants from Charleston, they moved, furniture, trinkets, family papers, piano, and all. At first, whether because he was too busy or distracted or simply wanted to put Charleston behind him, Cogdell barely wrote; friends complained that he had "become as silent as the grave!" and that "months have elapsed without a word from you."[21] But while it would not be quite right to say that they never looked back, the South was never again their home.

In concrete terms, what awaited them in Philadelphia? Having purchased a house, moved in, received their shipments, and unpacked, they would have had to find schools, a church, and friends. Education would have been a primary concern; surely by September they had gotten sixteen-year-old Cordelia and ten-year-old Sophia settled at school or with tutors. Perhaps their father remained in control of their education; perhaps he left it to his adult children to care for the younger ones. (Unfortunately, receipt books that Cogdell kept in Charleston do not exist for the Philadelphia years; either Cogdell had gotten less scrupulous, his children had taken over their own finances, or the tiny bound volumes were simply lost.) Surely they talked about this, because there were choices to be made: an all-Black public school, private tutors, a small private school like Margaretta Forten's, or the newly established Institute for Colored Youth.

By the 1830s, in Leon Litwack's words, "statute or custom placed Negro children in separate schools in nearly every northern community." Only in Massachusetts did "virtual political and legal equality" exist by 1845, and even there it exempted Boston's public schools from desegregating for another decade. Philadelphia, with its much larger African American community, was no exception, although the very existence of publicly funded schools for Black children offered a dramatic contrast to Charleston.[22] When the Sanders family moved to Fitzwater Street, the closest public school for African American children was the Lombard Street School, where a half dozen white teachers taught nearly 450 children. The white principal, James Bird, was much respected by the parents (who commonly referred to it as the "Bird School"), though the walk to Seventh and Lombard placed children at risk from white gangs.[23] Many of those who would become part of the Sanderses' circle and leaders of the African American community—Whites, Dorseys, LeCounts, Bolivars, and Cattos—attended this grammar school, and it is possible that Sophia Sanders, escorted by one of her older siblings, did as well. There is another small irony here in a story replete with them. Only three years before the Sanderses moved to Philadelphia, the James Pollock School was erected a few blocks west on Fitzwater Street; it admitted only white children. Half a century later, Richard Cogdell's great-granddaughter Florence Warwick taught at that school.

Smaller schools, often founded by Quakers, existed as well. By 1857 the Clarkson Evening School, affiliated with the Pennsylvania Abolition Society and founded to teach African American adults, admitted children, though probably those with fewer resources than the Sanderses.

As at the Bird School, altercations in the neighborhood, and contact with the police, posed risks, for "one boy has been expelled for misconduct . . . by reason of white boys collecting near the school & throwing stones at the scholars which being returned by them one of the whites was badly hurt." "The name of the offending scholar was given to the police at their request," the report went on, but was not included in the minutes; nor do we know whether the police identified (or punished) the white boys who started the altercation. The association minutes do suggest that the girls studied and behaved better than the boys, leaving only for good cause, such as going to work. Still, it is a little difficult to imagine Richard Cogdell's daughters in that setting, and no Sanders appears in the student list.[24]

If Cogdell did not hire private tutors, the Institute for Colored Youth (ICY) was the likeliest school for Cordelia and Sophia Sanders. Its graduates included people, many of them from Charleston, with whom they would become friends and, later, relatives by marriage. Founded initially, and shakily, by white Quakers, the ICY adopted Sarah Douglass and Margaretta Forten's practice of hiring only African American teachers. Here Philadelphia stood apart; no other city trained and employed as many African American teachers. In 1852, with the appointment of Charles Reason as principal and Sarah Douglass as "teacher of girls," the ICY set a new standard in the classics, languages, and mathematics.[25] Tuition free, the school educated African American students from a wide range of class backgrounds. Emilie Davis, for example, born the same year as Sarah Ann Sanders, attended the ICY in her early twenties and worked as a domestic servant. The school, which later became Cheyney University, could boast that its alumni rolls, though spotty, included the leading African American educators of its day. Sarah Douglass famously taught physiology and hygiene there, advocating "a protective strategy for African American women of all classes," an early example of sex education that, as historian April Haynes puts it, "taught black women and girls to care for themselves and to speak back to scientific racism." In the face of some resistance to Douglass's work, the ICY's managers remained loyal, "desire[d] to encourage her laudable efforts," and urged her to continue to benefit her students through them. Some years later there was a bit of stir when (with the departure of Ebenezer Bassett to be the US ambassador to Haiti) the managers chose Oberlin graduate Fanny Jackson Coppin as the head of school. Her closest rival among the ICY teachers, a rising star named Octavius Catto, apparently squirmed at the invitation to

work under her.[26] Surely Cordelia Sanders, already "very familiar with Shakespeare," received some formal training as a teacher; she would later accept a job in a Brooklyn school that was headed by former ICY teacher Charles Reason. What little evidence there is suggests that she too attended the ICY.[27]

Upon arriving in Philadelphia the Sanderses joined a church that was familiar and that befitted their assessment of their own status. St. Thomas's African Episcopal Church on Fifth and Adelphi (now St. James) Streets, a half-hour walk from their Fitzwater house, was where Philadelphia's well-established African Americans gathered to pray, marry, baptize their children, and mourn their dead. Founded by Absalom Jones on land purchased in 1792, St. Thomas's was regarded by W. E. B. Du Bois as "the first Negro church in America." By the time Du Bois wrote, St. Thomas's had long gathered together "the most cultured and wealthiest of the Negro population" in Philadelphia. It may well have been where the new arrivals met, or became reacquainted with, the Vennings and Cattos, whose names appear long after their deaths as "among the many faithful" who supported the congregation.[28] Yet in one important respect St. Thomas's was strikingly different from St. Philip's Church in Charleston. Whereas in St. Philip's people of color, both free and enslaved, sat in segregated pews, St. Thomas's was an entirely African American institution. By no means was it a bastion of radical or abolitionist thought; well into the 1850s, its sermons "had no relation to the vital questions" facing the nation and the congregation. Instead, the church's leaders looked inward, seeking the right to send African American delegates to the statewide diocese meetings, forbidden since the late eighteenth century and reinforced in the 1840s.[29] Still, in striking contrast to Charleston, an African American pastor stood at the pulpit and led the service. Interestingly, while Cogdell's son Robert Sanders married Martha Davenport in St. Philip's Church, his daughter Julia and Edward Venning's wedding four years later took place in the house on Fitzwater. Whether this reflected common Philadelphia practice or a hint that Richard did not feel welcome in his children's church I cannot say, but I find it hard to imagine him sitting there on Sunday mornings while a Black man preached.

Finding a church in Philadelphia may have been tricky for Richard Cogdell. Aside from the absence of old associations and friends—he had always worshipped near his brother's artwork on St. Philip's walls

and the graveyard where his family was buried—there were starker contrasts. Some of these remind us that Cogdell was a white Southerner living in the North during tumultuous times. It was a short walk from his hotel on Broad Street to St. Stephen's Episcopal Church on Tenth, but his presence there was erratic. In November 1857, the rector, H. W. Ducachet, sent Cogdell a brief note: "I took the liberty of requesting you last Sunday, to remain for the sermon, as I have observed that you have a few times gone out after prayers, from, perhaps inability, sometimes, to remain," he wrote testily. "I desired very much that you shd hear what I had to say about public matters. Do pardon my freedom."[30]

Perhaps Richard Cogdell was not all that devout; perhaps he simply found more congenial settings elsewhere. That July, after all, he had been granted one month's visiting privileges at the "Club House," an exclusive gentleman's club on Walnut and Thirteenth Street, and he surely found companions at the La Pierre House on Broad Street, where he resided.[31] But perhaps, too, Cogdell was leery of sitting through a sermon on "public matters" that might well, in 1857, have been directed against the South. For even in the staid, and white, Episcopal Church, a place where a proslavery Southerner might have felt welcome, things were getting tense. Just the previous year, the Reverend Dudley A. Tyng had denounced the Fugitive Slave Act from his own Episcopal pulpit, launching a controversy that went on for months. And, of course, there was another factor: Cogdell's fellow congregants at St. Stephen's would not have been as accustomed to the idea of a white man having mixed-race children as his friends in Charleston's St. Philip's had been. Perhaps it was in church that Richard Cogdell felt most out of place, most like the foreigner that, as war approached, he had become.

Like migrants and immigrants everywhere, African Americans who arrived in Philadelphia maintained familiar ties and renewed old connections. To an extraordinary extent the Sanderses' new Philadelphia community was deeply and persistently bound to Charleston. Some of these connections are mere hints, but they suggest other threads that have been lost. Take, for instance, one Parris Cooper. Cooper enters this story only because in 1860, he and Robert Sanders ran a tailor shop together on South Street. Perhaps Robert, twenty years his junior, had apprenticed with Cooper in Charleston. The older man may also have known Richard Cogdell. The head of a substantial free African American household, Cooper had lived at 5 Wall Street in Charleston.

Chapter Four

By the time the City of Charleston got around to taking its 1861 street-by-street census, Cooper and his family had moved to Philadelphia, but the owner of that brick house on Wall Street was Cogdell's cousin's son Clement H. Stevens.[32]

Charleston names, whether old acquaintances or new, appear in the Sanderses' Philadelphia circle with striking regularity, and the house on Fitzwater quickly became a gathering place. A kind of clannishness may be common for migrants no less than for long-standing residents, but it nevertheless drew notice. Visiting the family at home in the spring of 1858, Philadelphia native Charlotte Forten remarked, "All were Southerners, save me."[33]

Some acquaintances were the children of Charleston-born parents, while others had themselves migrated to Philadelphia as children. Octavius Catto, born in Charleston the same year as Sarah Ann Sanders, was among them. Octavius's father, William Catto, was born free in Charleston in 1810 and did well through the 1830s, marrying Sarah Isabella Cain, a cousin of the DeReefs, wealthy, slave-owning free people of color, whom I mentioned in chapter 2. In 1845, Sarah Catto died, leaving William with four children. Soon he acquired a new calling as a missionary and found a new wife, Mary B. Anderson, with whom he would have several more children. Alarmed by the growing restrictions on education and mobility, in 1848 the family moved to Philadelphia, where they helped establish the community that welcomed the Sanderses a decade later.[34]

That Philadelphia looked like freedom to William Catto suggests how bad things were in Charleston. Just ten years earlier Pennsylvania had disenfranchised African American men and mobs had burned down Pennsylvania Hall. Still the Cattos' decision opened opportunities that were simply unimaginable back home. William combined preaching for the AME church with activism, petitioned to regain the suffrage for African American men in Pennsylvania and New Jersey, and organized against the Fugitive Slave Act. Living in the Spring Garden section of the city, he enrolled his son Octavius in the Bird School, where he became friends with other children of the aspiring African American middle class. William Catto also joined the board of the ICY, helping to transform it into a rigorous secondary school that trained African American students, including his own children, to become teachers and advocates for equality.

By 1854, when he was fifteen, Octavius Catto, along with the children of other Charleston migrants, was well on his way to fulfilling his

father's aspirations. Aside from their academic accomplishments, ICY graduates were adept at public speaking about current events. Catto's best friend, Jacob C. White Jr., for instance, offered a fiery lecture on "the Inconsistency of Colored People Using Slave Produce," and Catto himself made a passionate commencement oration in 1864. In 1859 Catto was hired by the ICY as a teacher; Jake White and the children of the Philadelphia-born coffin maker James LeCount were among his colleagues. Octavius was, by all accounts, charming and driven, what a later generation would call a "race man." In 1860, at twenty-one years old, he imagined a long future—teaching, playing baseball for the Pythians, perhaps fighting a war, maybe even voting. He also thought himself something of a ladies' man and engaged in a poetic flirtation with Cordelia Sanders, two years his junior and preparing to be a teacher.[35]

Catto's biographers claim that Cordelia "decided to marry another," but that was years in the future. For now, Catto's actions may have raised other concerns or, at least, rumors. In late 1861 Rebecca Underwood, a twenty-three-year-old "colored" servant in William Still's household, several doors away from the Cattos' home on South Street, gave birth to a daughter; Octavius Catto was the father. The baby, Elizabeth, died at seven months old, with Catto's name duly noted as her own on the death certificate. We know nothing else about this relationship: Was there coercion, even rape? Did an ambitious young man's sexual relationship with a "house maid" constitute a scandal, lead to a crisis of conscience, or involve an exchange of money? Did Cordelia and her siblings even know about it? Would they have shared William Still's unease that Catto and his friends were "inclined to frivolity"? All we really know is that Octavius and Rebecca did not get married, Rebecca moved several blocks away to 604 Middle Alley, and no one in anything I have read mentioned the matter; certainly Catto faced no consequences that slowed his rise in their community. In his biography of William Still, Andrew Diemer suggests, plausibly, that these events might have influenced the "morally upright" Still's disapproval of Catto, but we might reflect as well on what Rebecca Underwood—or Cordelia Sanders—thought of his behavior.[36]

Other migrants from Charleston, and their Philadelphia-born children, would also find their way to 1116 Fitzwater. Almost two decades before William Catto moved north, in about 1830, twenty-five-year-old Edward W. Venning, also apparently born free, left Charleston. A skilled carpenter, he valued his good reputation, and he carried with him a note that, though it dripped with condescension, his family

thought worth saving. "This is to certify," wrote one J. Laval Jr., "that I have known the bearer Edward Venning (a native of this state) for some time." "For a coloured man," the writer continued, "[he] has conducted himself with the utmost decorum; and deserves the good opinion of all who know him," and his "sobriety, honesty, civility and attention to whatever business he engages in, deservedly entitles him to a high degree of confidence and praise." (This scrap of paper offers a further hint that Vennings and Sanderses had crossed paths before. The very year that Laval had written on Venning's behalf, Richard Cogdell purchased Sarah Martha Sanders from Sabina Hall's estate, which was entangled with Jacinto Laval.) As for Venning, four years later, with his carpentry business launched, he married Elizabeth Nixon at St. Thomas's Church; Nixon's father owned a restaurant at Ninth and Walnut. Edward and his older brother, John, also a carpenter, bought and sold several properties. For the most part they and their families lived on Rodman Street, where their neighbors included James LeCount, a well-established coffin maker.[37] Decades later, William Bolivar (James LeCount's grandson and Richard DeReef Venning's close friend) would recall that the Venning family "joined the original colony and brought with them all the adjuncts necessary to meet new conditions, and keep pace with what they met, in the shape of energy, sobriety, means and trades." (Exposing the prejudice of the long-established middle class, Bolivar deemed these first waves of African Americans from Charleston "so unlike the avalanche of poverty-stricken and politically oppressed people of this day.")[38] In 1861, Edward Y. Venning, who had joined his father's business, married Julia Sanders in the Fitzwater Street house.

Even as they established homes, businesses, and families in Philadelphia, families like the Vennings exhibited persistent ties to Charleston, sometimes in ways that were symbolic, or sentimental, and that hint at complicated loyalties. In addition to Edward Y., the Vennings had a younger son, Richard DeReef Venning (often abbreviated D'R), twelve years his brother's junior. While the name Venning does not appear among Charleston's "free mulatto aristocracy," DeReef (or Dereef) does, and its appearance in Philadelphia suggests the respect their father felt for long-standing connections of marriage or business (or both).[39] I do not know what the relationship was between the elder Edward Venning and Richard and Joseph DeReef, though it seems plausible that the latter, wealthy wood merchants, played a role in the Venning brothers becoming carpenters. Like Richard Cogdell's family, the DeReefs attended St. Philip's Episcopal Church. And they were prominent in

the Brown Fellowship Society, founded by free "mulatto" members of that church. A strong sense of what a historian in 1940 called "mixed blood, free ancestry, economic position, and a devotion to the tenets of the slave system" underscored their powerful "in-group tendencies."[40]

Richard DeReef was a famous name in Charleston, but I have seen it only once in Philadelphia, in the Vennings' younger son's name. As in many upwardly aspiring families (including the Sanderses), and not unlike immigrants from other countries, the eldest Venning son followed a trade. Edward Y. Venning was both "a skilled mechanic in his chosen trade" and "an architect of considerable ability, [who] prepared plans for and constructed a large number of buildings in various parts of the city." His younger brother, Richard DeReef Venning, graduated from the Institute for Colored Youth (ICY) in 1867, giving an oration titled "Success."[41] Coming of age at a particular moment of opportunity, he became a teacher and a grocer and later worked in the Pension Office in Washington, DC. After President Garfield's election in 1880, numerous "office seekers" arrived in Washington, most of whom would "go home wiser and sadder men." But Richard D'R Venning was "among the successful applicants," his appointment duly announced in the *Christian Recorder*.[42]

Employed in a much-coveted federal position, Richard DeReef Venning boarded for more than twenty years with Charlotte Forten Grimke and Rev. Francis J. Grimke at 1526 L Street and 1415 Corcoran Street. There he surely became acquainted with the "distinctly elite, culturally conservative, yet racially activist church" that Reverend Grimke led among Washington's "light-complexioned and comparatively wealthy 'colored aristocracy.'"[43] But Venning must have first met Charlotte Forten in Philadelphia, possibly at 1116 Fitzwater, and he remained tied to Philadelphia and to the extended Sanders clan. In 1884, he was one of "several young men in government position" who came home to Philadelphia to assist with the election, "one of the *events* of this week" that included, for the first time, a Black man being elected to the city's common council. By then, "looking very well indeed," Venning epitomized a modern middle-class African American—a favorite bachelor uncle, a close friend of William Carl Bolivar, and a loyal Republican. Only that name, Richard DeReef, is a throwback, a reminder that the family had ties to Charleston that were complex and sometimes troubling and that reached back long before Richard himself was born.[44]

Overlaps abound, with familiar Charleston names popping up at St. Thomas's Church, the ICY, and in personal correspondence regularly and for generations. People with roots in Charleston—Adgers,

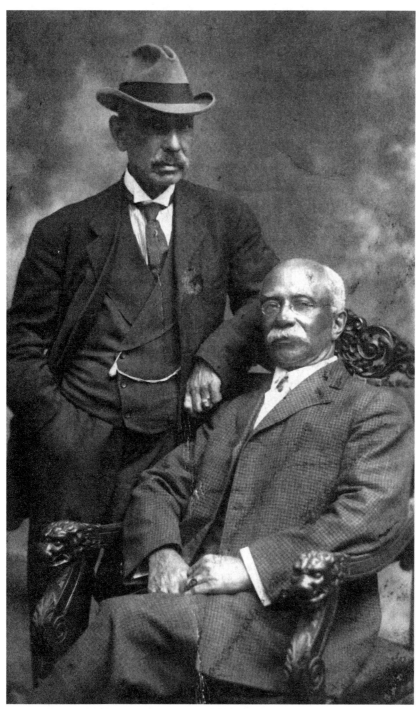

George Bolivar (*left*) and Richard DeReef Venning (*right*).
P.9367.10, Stevens-Cogdell-Sanders-Venning-Chew Collection,
Library Company of Philadelphia.

Vennings, Cattos—filled the Sanderses' circle and correspondence, attended school together, and married one another. Yet even as they remained firmly linked to other Charlestonians, sharing memories of food and friends, the Sanderses encountered people whose friendship would literally have been impossible in their old lives. Charlotte Forten, the daughter of Philadelphia's most elite Black family and an ardent abolitionist, met the Sanderses nearly a year after their arrival in Philadelphia. She found Cordelia, a few years her junior, "an intelligent, interesting girl,—very imaginative, with a great deal of freshness and originality." (Sarah Ann was, Charlotte declared, the "prettiest one" among the Sanders sisters, who "played and sang very prettily for us, accompanying herself on the guitar.") The two traveled together to Massachusetts in 1862, and it may have been Forten who introduced Cordelia to her lifelong friend Louisa Jacobs, the daughter of Harriet Jacobs.[45]

It may seem inevitable that young adults from Philadelphia's educated African American middle class would meet and socialize; it was not, after all, so large a group. But one glimpse into this new friendship challenges our assumptions about African Americans' shared beliefs. If Charlotte Forten inherited many of her views from her family, so did the children of Richard Cogdell; the young Sanderses were no radicals. "She is from the South," Forten noted about Cordelia Sanders, "and needs to be converted to Anti-Slavery." To that end, Forten gave her new friend a copy of Whittier's antislavery poems "for a beginning," but left no further evidence of how it went. Still, the notion that a recently enslaved African American was not an abolitionist, that she had to be "converted" to antislavery, is jarring. Several months later, an oblique comment in Forten's diary, which I believe referred to the Sanderses, underscored the point: "Passed the eve. very pleasantly with the S. family. Talked about poetry, music and foreign lands. Their father is an educated man who has travelled a great deal, but he's much too conceited, besides being a pro-slavery southerner." It is no stretch at all to picture Richard Cogdell as a snob, one who, in Frederick Porcher's estimation, "looked for elegance, where others sought only utility, a very nice observer of small proprieties." He was not modest about his tastes, having, on his European tour, fussed that the "Swisse table pretty good, but the servants too free & allowing the fish to remain on the table until all the meats are removed."[46] It is amusing to consider whether he minded being counted as part of the "S. family" in a teenage girl's diary. But what is harder to imagine is that this "pro-slavery southerner" spent an evening chatting with Charlotte Forten, the African

Chapter Four

American daughter and granddaughter of outspoken abolitionists, in his children's house. This was 1858; antislavery talk was impossible to avoid, pervading school, church, and newspapers. Richard Cogdell and his children must have been secure indeed—in themselves, with one another—to welcome such views (not to mention Charlotte Forten) into their parlor.

I have wondered how being "from the South" and being Richard Cogdell's children shaped the Sanderses' views. The baggage that the Sanders family brought with them from Charleston included, in addition to memories of trauma and loss, a sense of middle-class privilege, reflected less in their actual occupations than in their attitudes and expectations. Did their Southern ties include sympathy with proslavery Southerners? How did they introduce their father to their friends or beaus? How strong a presence was Sarah Martha Sanders in their memories and their conversation? Obviously they had been raised with the confidence to express their views. Was it embarrassing for the "intelligent" and "interesting" Cordelia Sanders to admit that she was not an abolitionist, or did it reflect the influence of her father's "conceit"? To put it another way: In what ways did moving to Philadelphia and becoming part of its African American community transform the Sanderses, and in what ways did it not?

Clearly the Sanderses, with or without their father's explicit instruction, considered themselves part of a privileged class. Class was, then as now, a complicated stew of wealth, homeownership, education, and that most fragile possession, "respectability." Certainly the Sanderses took for granted their material comforts, as they had in Charleston. One daughter, who I believe is Sarah Ann, could almost laugh at herself for this: "I am comfortable here and enjoy the delightful sea-air and all that," she wrote her father from a visit to the beach, "but I cannot reconcile myself to the deprivation of my own morning bath—oh, I suffer really in consequence."[47] The men in their circle were accomplished members of their trades: Robert Sanders was a tailor, Edward Venning a carpenter, and Willie Chew (whom Cordelia Sanders would marry) a barber. But the Sanderses had, and knew they had, a jump on others. Richard Cogdell had bought and furnished the house and left stocks and other property to his children and, for the most part, provided equally for them all. One exception offers a window into the kinds of material objects the family enjoyed. In May 1858, Richard Cogdell handed over the following "articles given to my daughter Sarah A. Sanders, with an injunction, that they are not to be taken from her by

any one." While not financially trivial, these items were more important emotionally, and he listed them with care:

A gold watch
A diamond Ring which was mine for many years
A piano, made by Worcester
My music Box, made for me in Geneva
My Cameo miniature taken in Rome
My garnet breast pin
gold stock Buckle
Venetian album
new opera glass[48]

A complex awareness of class emerged in the family's attitude toward prospective husbands. Parents often tried to protect their daughters' property from husbands, real or hypothetical; Cogdell's grandmother Mary Stevens had done so for his own mother many decades before. Richard Cogdell addressed this openly in his 1860 will, written after Charles, the last Cogdell son, had died and less than a year before Julia would marry Edward Venning. "It is my wish and my solemn direction to my children whom I have educated & brought up as efficiently as circumstances would permit, & for whom I have made great personal sacrifices," he wrote, "that they should in case of marriage have their little property (which I have accumulated & preserved with great care) secured to them and their children by a proper and discreet marriage settlement or deed of any other kind previous to marriage."[49]

No such prenuptial agreement lies in the family's papers. Did Julia and Edward follow her father's "solemn direction" by having one drawn up? Did they—with or without Richard—have a conversation about his instructions? Did they openly discuss Cogdell's role in their lives, their migration, and their standard of living? Did Edward or, several years later, Willie Chew get annoyed at this request?

When she was twenty-six years old and newly independent, Cordelia Sanders expressed her own concerns. Writing from Brooklyn, she confided to her sisters that she found "W" "preferable to me than all men I have ever associated with and I regret exceedingly the difference in years but otherwise I would be content." Still, she remarked, "you must remember how few among men of our class there are—how difficult— among those few you could trust me to marry, how few would or could make me contented now or ever could love." Cordelia recognized that

she held high standards: she would marry only "providing a man is honourable and of good birth these two things I dwell upon and intellect, knowledge in a man is a very weakness of mine." When she married Willie Chew (who was, in fact, six years her junior) she chose someone who had, like her brother-in-law Edward Venning, followed his father into a trade that established him securely among the "men of our class." That he was also "of good birth" reflects both Cordelia's explicitness about her family's standing *and* the complexities of what it meant to be part of Philadelphia's African American elite. Cultural historian Richard Bushman described the Black community's "pursuit of refinement" as follows. "The black elite," he wrote, "were primarily barbers, carpenters, and other artisans, plus ministers and teachers, who managed to accumulate property. . . . They purchased houses, sent their children to school, organized societies, and ran churches." Further, they "emphasized education, moral restraint, industry and frugality, the development of skills, and religious faith, all standard middle-class traits. They also paid heed to manners and parlor furnishings, the marks of prevalent vernacular gentility."[50] He could have been describing the Sanders family, both in Charleston and in their new Philadelphia lives.

For all the suddenness and drama of the Sanderses' move, the change in their legal standing, and the challenges and opportunities that Philadelphia offered, Richard Walpole Cogdell's migration might have been even more wrenching than his children's. At home in Charleston, he was a quite ordinary example of his sex, race, class, and community. His affection for his biracial and enslaved children was unusual but not unique. But in moving with them to Philadelphia, he undertook an extraordinary act, one that balanced his expectation of familiar comforts with his hopes for his children's future.

Cogdell's leisure pursuits, his circle of friends, and his faith community underwent a sharp change in the move to Philadelphia. Much like his children, he forged a new life that was firmly defined by race and by his Southernness. But there were subtler differences as well that speak to their choices and their mutual loyalties. In Charleston, the Sanderses were known as the children of a white father; here in Philadelphia they were part of the African American middle class. That their father had had children with their enslaved mother, and that he remained central in their lives, set them apart more in Philadelphia than it had in Charleston. In Charleston, ironically, Richard Cogdell might have

considered hiding that these were his children. In Philadelphia the question may have been the reverse: Should the Sanders family hide their father? Did they consider this? If so, none of them appears to have made that choice.

Richard Cogdell did not live at 1116 Fitzwater, except, perhaps, in his final year, a time characterized by illness and debt. Did he and his children discuss this or simply assume it? Since we don't know precisely what their arrangement was in Charleston, especially after Sarah Martha Sanders's death—when the children resided on Friend Street while Cogdell lived nearby—it is hard to know if this was a change. Instead, Cogdell took a room or rooms at the La Pierre House, a splendid five-story hotel that had opened on Broad Street in 1853, only minutes from the new Academy of Music. An entire front page of Boston's *Gleason's Pictorial* displayed the building and offered a description that must have made the nineteenth-century equivalent of Philadelphia's tourist board proud. The hotel was fabulous, on a street that was "rapidly becoming the grand central point for elegant mansions and costly public buildings." Ninety-eight feet wide, the La Pierre boasted a "main" and a "ladies'" entrance, as well as a rear entrance for servants; twenty-five bathhouses with hot and cold water; and a barroom, barbershop, and underground storage for "wine, groceries, ice and coal." "Marble wash basins" were available to the "male guests"; a large laundry and "the kitchen, bake-house, pastry-room and chief cook's apartment" were tucked under the north wing. Up-to-date equipment (including a range, "superior, it is said, to any before used in Philadelphia") guaranteed the most luxurious setting and promised that "no heat or offensive smell arises from the cooking."[51] I have no idea if Richard Cogdell's children visited him here, whether the hotel staff knew who they were, or what entrance they were permitted to use.

Richard Walpole Cogdell must have been comfortable indeed, having found in Philadelphia a suitable and seemingly luxurious retirement that mirrored his life in Charleston. But this is not to say that he never looked back. For Richard Cogdell was missed, even loved, in South Carolina, and he kept up a lively correspondence with friends back home. Two years after moving, depressed and ailing, Cogdell wrote his Charleston friends of his suffering. In response, Alfred Huger scolded him firmly not to "allow your depressed spirits to gain ground! It is said that brave men are often <u>beaten</u> but never <u>defeated</u>! & so let it be with yourself. I know that your manhood will never yield & that your courage is invincible!" Come visit, he urged: "Consult your physicians

as to a winter's sojourn in your native land! Some quiet house with a room down stairs, with that faithful Horlbeck to do your writing, & see to your business matters. Vanderhorst & myself to be your constant attendants! We speak of you daily, & we value you, as we ever <u>did</u> & <u>Ever shall</u>."[52] How sweet and how tempting. But in all this—longing for an old friend, promising familiar company, insisting that his health would improve over a Charleston winter—there is not one word of reproach, no whisper that Cogdell had made a bad or immoral or even unfathomable decision. His friend never insinuates that Cogdell should return home for good—"a winter sojourn" only—or that he should regret moving with his children to Philadelphia. Nor did Huger suggest that Cogdell's children return with him; he likely understood that Philadelphia had become their better option.

Richard Cogdell lived at the La Pierre House, but we catch glimpses of him in the family home. White friends—slave-owning Southerners all—visited Philadelphia, the La Pierre, and Fitzwater Street. Daniel Horlbeck and at least one of his brothers stayed at the La Pierre, leaving letters uncollected. Cogdell's old friend John B. Irving was a familiar presence there, asking Richard Cogdell to "tell my good friends the Wards to keep a room for me." Indeed, a friend recalled that Cogdell "drew Southern custom to the House of the Wards [at the La Pierre] and was a kind of Supernumerary who was good company for the Wards & his boarders." Irving, too, brought his infectious party mood with him, entertaining friends at the La Pierre with "an account of the Race [that] had charms for the one party, and my description of the <u>young Gallant</u> in Chestnut Street [that] afforded amusement to the other." But although 1116 Fitzwater Street was legally Cogdell's property for only a matter of weeks, it remained a home to him and his friends. Irving understood full well who was in charge of the household and its hospitality: "Dont make any arrangement for me," he wrote Cogdell, "further than to beg Sarah to 'Pity the sorrows of a poor old man whose trembling limbs have borne him to your door,' and let him sleep, upon the Sofa, in the drawing Room!" "I often think of you, and the children," he wrote Cogdell in July 1861 and fretted that the Civil War would result in "such bitter hatred . . . towards the mad Fanatics of the North, that I question whether any of the present generation of the Southern people will ever be found on the other side of our Confederate boundaries. I confess this grieves me when I consider its effect upon our <u>social relations</u>. . . . For instance . . . my <u>pleasant Evenings in Fitzwater Street</u>, I fear, I must remember only, as things of <u>the Past</u>, not of the <u>Future</u>!"[53]

The war did not, as it turned out, end those "social relations," nor did Irving hesitate to go to the "other side of our Confederate boundaries," happily accepting the American Jockey Club's offer of employment in New York soon after the South's defeat. Nor did war's end fully dampen his spirits. Indeed, upon seeing him in Brooklyn in 1867, Cordelia found Irving "looking remarkably <u>well</u>. And more aristocratic from <u>dressing</u> than I ever knew him. I judge, he keeps up with the class among which he <u>moves</u>. And he has John <u>his son</u> to <u>guide him</u>."[54] Indeed, once he replanted himself in the North, Irving had trouble leaving New York, planning to go to Charleston only to visit friends "& return with Mrs Irving"; his wife, Emma Maria Irving, died soon after.[55]

The correspondence between the Sanderses and their father's friends went both ways, although often only one side, as far as we know, survived. Garcia, Sarah Ann's piano teacher in Charleston, remained in communication with Cogdell, concluding his own chatty letter, "My kind regards to Sarah, I will send her something in a few days." Just after the war, in the fall of 1866, rushed by business, John Irving answered a "charming letter" from Sarah Ann by describing his plans to sail to Charleston: "I promised myself the pleasure & satisfaction of passing a night with my old friend on Fitzwater St, ere I went South, but find I cannot do so. I shall be gone a month probably. I wish you my dear Sarah, to write me word early next week, telling me how <u>your Father</u> is." A week later, his travel delayed, he responded to Sarah Ann's "affectionate note" by promising that he looked forward "to passing a day with you all, in Fitzwater St before I go." Although he wanted to "judge for myself of the condition of my dear old friend," he was in Charleston when Richard Cogdell died two days before Christmas.[56]

Irving's relationship with the Sanders children continued after their father's death. Their correspondence was more familiar, and Irving more avuncular, than we might expect. "Of course R.S. has told you that Dr. Irving has been in to see me!" Cordelia wrote cheerfully from Brooklyn. "I wrote to him last Sunday—got a note from him on Thursday telling me to expect him the first fine day. And <u>he</u> followed the note on Friday." Apparently Irving, taking for granted his old friend's comfortable lifestyle, was out of touch with the family's financial realities. "He wants to know if twas too far for me to go home every Friday afternoon, <u>he</u> did not think of the expense; but I soon <u>brought it</u> to his recollection That the distance did not matter, but the <u>price</u>."[57]

The meeting between Cordelia Sanders and John Irving in a Brooklyn parlor ("I did not take him up stairs!" Cordelia assured her family)

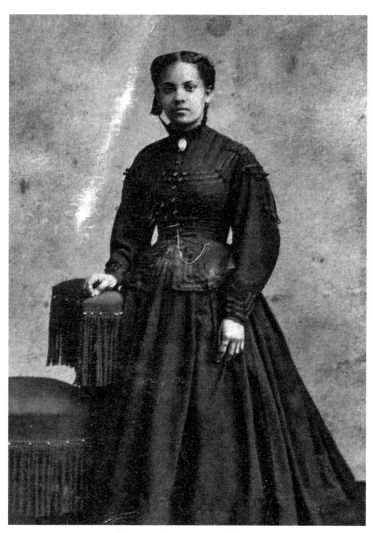

Cordelia Sanders in Brooklyn, 1866.
P.2022.47.1, p. 9a, Wood-Webb Family Collection,
Library Company of Philadelphia.

was noteworthy as family chatter. But that it took place at all was less astonishing to them than it is to us. Irving, boasting a "beautiful striped scarf," was his usual convivial, busybody self. "He inquired after all, and about every thing, thinks I am very thin and petted me a good deal much to the wonder of Putnam and children." Indeed, Georgina Putnam, the vice principal of Colored School No. 1 and Cordelia's boss, may have found Irving's presumption of intimacy—this "aristocratic" white man and her "colored" teacher!—somewhat disconcerting. "P was

actually pale after his visit," Cordelia chortled. "You know the Dr. he began immediately upon being introduced to tell her how he and father were friends of a lifetime, and that she Putnam must take good care of (me) 'his little daughter' &c &c. And then bade her go on with her class, as he would like to see the system of teaching etc." Cordelia reported further that Irving "bade me write him often and consult and send for him if I should want anything or need him. And that he will come over again when business permits. Well! I cannot tell you all he said—who could recount all the Dr. might say? Ah! But it all brought father before me and has saddened me ever since. I found myself in tears, in the cars this morning to N.Y. thinking over the last night of my father's life." A kind of PS follows: "Of course you are wondering whether 'Delia' was dressed decently when the Dr. came? Yes 'she' was."[58]

Of all the conversations I struggle to imagine, this one is especially hard. That phrase—"You know the Dr."—bespeaks a friendly intimacy, a teasing familiarity between generations. It sounds like many a twenty-something talking about her father's garrulous friend; might she have rolled her eyes? Yet the siblings tolerated Irving's attempts at charm, his petting, and his appearing "more aristocratic from dressing . . . [since] he keeps up with the class among which he moves." They welcomed him to their home, corresponded warmly, and asked for his help negotiating with other white Charlestonians. For his part, Irving's friendship, however unexpected, was consistent: "God bless you, my dear Delia, & all the children of my old friend," he wrote upon hearing of her sister Sarah Ann's death.[59]

I am, throughout this narrative, disciplined by my discipline. As a historian, I cannot make stuff up, however tempted. But I am also bound by the limits of my imagination. Nothing I thought I knew about intergenerational deference, the relationships between Southern whites (older and male, no less) and African Americans (younger, female, and free), or the nature of the post-Emancipation North prepared me to picture this relationship. It should be stilted, or patronizing, not casual. My imagination has little room for casual.

That casualness characterized the Sanderses' interactions with their father as well. Richard Cogdell's daughters fretted over him in small things. "Take care of yourself," one chided gently, "and if you must come to the parlour, do be careful about your clothes—your pants falling about, etc. Don't sit at the window in your night-cap and put your suspenders on etc., etc."[60] That they instructed him about maintaining

appearances—that the state of his clothing mattered—is another irony in a story that is replete with them.

So what do we learn from peering into 1116 Fitzwater, an ordinary Philadelphia row house that a father handed over to his children? What was the nature of what Richard Cogdell called his "great personal sacrifices"? Everyone from Charleston—Richard Cogdell, his son Charles Cogdell, his friends Irving, Huger, Vanderhorst, and Horlbeck, the piano teacher Garcia, and all the Sanderses—knew what Richard's intentions were. The date of the Fitzwater house deed is clear, and clear as well is that the children moved in and out of the house freely, that their father visited (and likely died) there, that John Irving passed "pleasant evenings" and was welcome to nap on the sofa, that it became home. Marriages and births, funerals and friendships, courtships and political discussions all took place there. Perhaps the most extraordinary part of this story is that no one seems to have objected, except for retired state legislator and South Carolina Historical Society president Frederick Adolphus Porcher, who grumbled that Cogdell, "finally abandoning his family . . . went to live in Pennsylvania."[61]

While he hardly "abandoned his family"—only his adult son Charles remained in South Carolina—Cogdell chose his Sanders children over his white Charleston kin and warned the latter not to interfere. Charles Cogdell understood this. In the fall of 1856 he'd "been informed by our mutual friend Mr. Daniel Horlbeck" that it was "your Special desire that I should allow your children by Sarah Sanders to occupy the house belonging to you and now occupied by them as a residence situated in Friend Street, during their lives. I hereby declare that they shall continue to occupy such house as a residence during my life on whatever terms you may please to suggest."[62] Charles's early death—not to mention his father's move north with those children six months after this correspondence—made all this irrelevant. But through all the tumult, no one suggested that Richard had planned anything short of establishing a new life in Philadelphia or that he should or could be prevented from doing so.

For all the continuities between Charleston and Philadelphia—social evenings where nearly everyone was from the South, visits from old friends—the leap the Sanderses made was enormous. Their conviction that their new roots would take was inescapably helped by Richard

Cogdell's material support and by the labors of adult siblings to provide an education for the younger ones. Still, their faith in themselves, their father, and one another is astonishing. How could they have known that this would work? How much confidence must these young Sanderses have had to undertake this journey and not consider reversing course? How did becoming Philadelphians change them in ways that they themselves could not predict? Quite unlike the most traumatic moments in their story—including the most devastating, Richard Cogdell's purchase of and sexual relationship with Sarah Martha Sanders—their journey to Philadelphia involved choice, collaboration, and comfort more than coercion. As they settled in and settled down, remaking themselves amid old connections, we are left to imagine the sacrifices they must have made, the concessions they agreed upon to keep their family intact, and the steps they took or avoided to keep their father at the center of their lives.

5

BATTLES BIG AND SMALL

Along with life changes both traumatic and prosaic, the Sanderses' first years in Philadelphia took place amid growing national turmoil underscored by a seemingly endless series of crises: the *Dred Scott* decision, Bleeding Kansas, John Brown's raid and capture, the election of Abraham Lincoln, secession, and the Civil War. In some circles, politics and talk of war was all the buzz, and it must have infused the Fitzwater Street house; as with all dinner table conversations, little evidence remains of the Sanders family discussions. Richard Cogdell, for one, eagerly "desired that [his Southern friends] give him the earliest intelligence" about secession, but there are precious few letters from that time.[1] Surely the rest of the family listened for any bits of news of acquaintances, friends, and relatives back in South Carolina, all of whom faced challenges quite unlike their own.

However decisively the Sanders family had established themselves in Philadelphia, they had lived in the North for only four years when the war began, and memories were fresh. What turmoil and ambivalence did they express as they watched Charleston become the epicenter of secessionist passions? Did they feel divided loyalties? Were they concerned about their father's white Southern friends and kin, finding their circumstances wrenching or frightening or just sad? Did they have to convince Martha Sanders's mother, Phillis Barron, to join them in Philadelphia, or had she already decided to leave? How did they feel about African American acquaintances who chose to remain in Charleston at this pivotal, fiery moment? Which choices did they consider reasonable as war became inevitable, and which, if any, did they judge harshly?

Not all those choices were simple, and some seem, at that historic juncture, incredible. To take one example, as the lives of Charleston's free people of color became ever more restricted, and as war loomed closer, even the wealthy DeReefs, members of the "colored aristocracy," felt twinges of concern. Yet, like wealthy people in many circumstances, they found the idea of uprooting unfeasible, and in any case they trusted their white Charleston connections. In January 1861 Joseph and Richard DeReef, along with dozens of free self-described "mulattoes," expressed that trust by signing their names to a memorial to South Carolina's governor and other politicians. In it, they declared themselves loyal "citizens of South Carolina," and wagered their property (in land, businesses, and enslaved people) on the side of secession. "In our veins flows the blood of the white race[,] in some half[,] in others much more than half white blood." "Our attachments are with you," they assured the leading white men of the state, "our hopes of safety & protection from you. Our allegiance is due to *So. Ca.* and in her defence, we are willing to offer up our lives, and all that is dear to us." Thus Richard and Joseph DeReef and their friends chose sides, allying with slaveholding and secession.[2] Barred from actually fighting—not until very late in the war were Black men allowed to fight for the Confederacy—they took little risk by aligning their, and their sons', bodies with what turned out to be the losing side. And, in contrast to most white Southerners who gambled on the Confederacy, their wager paid off, for the war did not ruin them financially. Like other African American men of his class, Richard DeReef found a leadership role in the postwar South by accepting an appointment to Charleston's city council. Even then, he stood out as devoutly conservative, "the sole black who voted with the whites to invalidate the [1868 municipal] election and to delay the installation of the city's first elected Republican administration." Unlike the vast majority of African Americans in the Reconstruction South, he was a member of the Democratic Party.[3]

Others made choices that seem more explicable, even inevitable, in their context. Although Richard's youngest Cogdell son, Charles, died before the war began, there remained white kin to keep abreast of, people whom Richard Cogdell, and perhaps his Sanders children, had known all their lives. For them, a military tradition was paramount. Richard Cogdell had long ago been close to his cousin Clement William Stevens, the "fine healthy, modest boy" who, as I noted in a previous chapter, had sailed with him from Jamaica to Charleston in 1803 and become a midshipman and naval officer. After Stevens's 1836 death in

Osceola, Florida, his wife, Sarah Fayssoux, and their children settled in her family's home in Pendleton, South Carolina.[4] Their sons, under the exigencies of Civil War and with varying degrees of enthusiasm, would follow their father into military service.

Like his father, Henry K. Stevens enlisted in the US Navy as a midshipman at fourteen. For a US Navy officer, secession offered a stark choice. The Confederacy had no navy to speak of and Henry (according to a descendant) "knew that the South could not win." Thus it was "with heavy hearts" and a "fierce tireless sense of duty" that naval officers like Henry Stevens resigned their commissions and joined the new Confederate navy (in Henry's case, after a brief stint as a prisoner of war in Massachusetts). Henry died aboard the SS *Cotton* in 1862 "with a rifle bullet through his heart."[5]

Henry's older brother, Clement Hoffman Stevens, like Richard Cogdell, worked at a Charleston bank. He married Ann Bee, had three sons, and achieved a level of prosperity that surpassed the rest of his family.[6] (In one of his three city houses, we might recall, lived Parris Cooper, the African American tailor with whom Robert Sanders briefly established a business in Philadelphia.) This Stevens may have preferred a less martial life than his brother Henry, but "he was quick to abandon his business affairs and become a civilian soldier as South Carolina seceded." At first, he designed and constructed the ironclad battery on Morris Island in Charleston Harbor, only later joining the Confederate army. He died a brigadier general ("in glory," according to Paul Stevens) in 1864, at the battle of Peachtree Creek. A plaque in the Episcopal cemetery in Pendleton, the only historic marker I know of that memorializes this family's place in history, honors his service.[7]

A third son, Paul Stevens's own grandfather, an engineer and later a minister and bishop of the Reformed Episcopal Church, would survive the war. But he, too, followed in his father's military tradition, acting as the superintendent of the South Carolina Military Academy (later the Citadel) when its cadets fired the opening shots on Fort Sumter. Col. Peter Fayssoux Stevens also served in battle, and here his story overlapped with that of some of the Sanderses' Northern acquaintances, though no one could have been aware of, or interested in, the connection. William Porcher DuBose, who served under Colonel Stevens, was a great admirer, forgiving his missteps while inadvertently letting us know that they occurred; DuBose's letters to his fiancée remind us that rumor and gossip offer "whispers" of another kind. In 1862, Colonel Stevens took 150 soldiers to Edisto Island, hoping to reclaim the Sea

Islands and re-enslave African Americans who were at the center of what historian Willie Lee Rose famously titled a "rehearsal for Reconstruction" and where Charlotte Forten would soon teach. There they faced not US troops but armed African Americans. Capturing eighty or so formerly enslaved people and killing several others, the mission became "punitive," and DuBose fretted that people were hearing "rather an exaggerated acc't of the Expedition." True, "some things did happen that were very unpleasant, particularly to a man of such tender feelings as our Col really has." However "unpleasant" it all may have been to Stevens, the captured African Americans faced being "restored to their owners" or hanged for shooting at Confederate troops. Months later Stevens's division was still trying to take Edisto Island, and the man's troubles persisted. "The prejudice against the Colonel was unfounded & I hope short lived," DuBose would later report to his fiancée. "The reaction has begun already. Destroy that letter in which I spoke of it."[8]

Surely some of this news from the South made its way to Fitzwater Street, but little evidence remains, and what does sheds scant light on the family's views of the war. We gain some details from Richard's friends; they were too old to fight, but they could still roar, and suffer: "What do the Black Republicans about you, who could not believe the South in earnest, think now?" chortled John Irving upon secession. "They have not seen all yet we are going to do, to rebuke them for their insolence! Our redemption draweth nigh, and their Ruin!!" Within months, though he still did not "apprehend the least doubt of the result," Irving had decided to "purposely avoid saying any thing of the present deplorable condition of the Country." Only at war's end, and in a noticeably shakier handwriting, did Irving relate "how badly I was treated by the United States troops as they passed by my plantation. They took away from me all my Horses, Mules, wagons, Carts, harness, Saddles & Bridles and after ransacking the House, removed the greater part of my Library. The negro troops then directed my own negroes to follow the example of the white soldiers & to help themselves to all they wanted which they did." African Americans in his neighborhood, he complained, "construing their freedom to mean licentiousness, & the right to take all that belonged to their former owners, [had] soon banded themselves, as a gang of Banditts, & with guns in their hands, broken open my doors at Kensington, & stole every thing that remained in the House and what they could not carry away, they broke up, & destroyed." He went on to detail his—and Cogdell's other friends'—material losses.[9]

Leaving aside whether Richard Cogdell had the slightest insight into the "Black Republicans" of the North, surely such correspondence, along with local meetings, lectures, and circulars, forced the Sanders family to confront the real-life decisions and entanglements inscribed on them by class, gender, race, and location. Perhaps their relationship with their father complicated any political certainties. Maybe they even sympathized with the DeReefs' allegiance to South Carolina or with Dr. Irving's losses at the hands of "my own negroes," now a "gang of Banditts." After the war and Richard Cogdell's death, his daughter Sarah Ann could refer, sympathetically and apparently without irony, to Richard's having spent his last years among "the enemies of his country!"[10] Still, we are left with very little evidence of their attitudes toward secession and war, their ties to people who remained in South Carolina, or their feelings about emancipation itself.

But however Richard Cogdell's children judged the choices, loyalties, and losses of the DeReefs and the Stevenses, of John Irving and their other old friends, and whatever news they gathered from enslaved friends and relatives whose experiences left no trace in the family's papers, the military drama that played out in Charleston was far from their wartime experience. Certainly Philadelphia—its parlors, its streets, its pulpits, and its newspapers—was awash with debates, and the Sanders family could not have avoided them. Many white Northerners were ambivalent about the war, either because they resisted the economic disruption it would bring, because they feared Black ambitions for freedom, or because, among some Quakers and abolitionists, they opposed war on principle. African Americans, for the most part, supported the war only to the degree that it promised emancipation, not merely to save a union that perpetuated slavery.

For all of Abraham Lincoln's talk about union and the Northern anger at Southern intransigence, everyone knew that the question of slavery was at the heart of the 1860 election, secession, and the war that followed. In Philadelphia, wealthy white lawyer and diarist Sidney George Fisher noted in early 1860, "Slavery occupies all conversation now." Fisher claimed that his cousin Joshua Francis Fisher (who was, as I discussed in chapter 4, married to a Charlestonian) "belongs to what is called the conservative class." No abolitionist himself, Sidney Fisher was nevertheless irritated by Joshua's position: "For the sake of preserving the Union and peace and order, which in reality means his own property and enjoyments, he is willing to sacrifice the right & the truth, to yield to all the demands of the South and to maintain slavery without so

much as asking whether it be not in itself a wrong and a crime." "Truth," he pontificated, "when it attacks the interests of property or power, is always derided & persecuted, as all history testifies." Months later the famous diarist concluded that "I shall . . . probably vote for Lincoln, if I vote at all." But Fisher's differences with his family and his class turned out to be minor ones; by election day he had decided that the "antislavery party" was "going too far" and so "I did not vote."[11] His elite white Philadelphia circle, its fretfulness and self-interest paramount, would have gotten along with Charleston's wealthy "colored aristocrats," including the DeReefs, just fine.

For white abolitionists, Lincoln's election and the prospect of disunion and war were by turns infuriating and thrilling. The older generation's "no-government" faction, led by William Lloyd Garrison, struggled to maintain its peace principles and certainly opposed any war that did not advocate emancipation. For political abolitionists, who embraced more modest antislavery goals, the Republican Party's commitment to stopping slavery's expansion was cause for hope. Not until the September 1862 announcement of the Emancipation Proclamation—and even then with some reluctance—did white abolitionists fully embrace the party of Lincoln and become, in effect, the Republican Party's progressive wing.

The story of African Americans—both those born in the North and those who had left, and continued to leave, the South—has been told as an unambiguously heroic narrative in behalf of freedom. But there were debates, sometimes heated ones, about whether and on whose terms Black Northerners should support the war. For most of Philadelphia's African American community, the war would be justified *only* if it ended slavery and promised to expand the full rights of citizenship; some, working as teachers and missionaries, focused on "preparing" enslaved African Americans for such a future. Charlotte Forten, for one, expressed powerful, if condescending, ideals about "the poor freed people" and practical emancipation, so she went to the Northern-controlled Sea Islands in South Carolina to teach.[12] Surely she and Cordelia Sanders, traveling that summer of 1862 in Massachusetts, discussed her plans, but neither Cordelia nor her sisters seem to have considered following suit. For the men of fighting age, of course, the choices were stark. Should they fight for a Union that did not declare itself against slavery? One that did not promise them the full rights of citizenship even if it won? Should they "prove their manhood," as the saying went, and thus "earn" those rights? Debates rang out from pulpits and in

newspapers, exposing rifts that would last until the war's emancipation goals were made explicit.

Even if they resolved to avoid talking politics at the dinner table, even if they were especially sensitive to their father's loyalty to "his country," the Sanderses cannot have insulated themselves from all this. What did they think of the free "mulatto" elite who allied themselves with the Confederacy and with slavery? Or of the African American women of Charleston's Brown Fellowship Society, surely old acquaintances among them, who supported efforts to care for (white) Confederate soldiers? Was Cordelia by now "converted" to antislavery and, by extension, to the party of Lincoln? Did the war itself distance them from their father and heighten the Sanderses' consciousness of their own racial identity and belonging? Would they have mourned —if they even knew about—the Stevens men who died in the Confederate cause? Robert Sanders was thirty-one at the formation of the US Colored Troops; did he consider enlisting? In a war that was famous for tearing families apart, it is impossible to know what even reasoned debate looked like in this one.

Once emancipation had been declared a wartime goal and the US Colored Troops were established, debate within the Black community became more muted and Black men rushed to enlist. Differences among African American leaders persisted, mostly about whether and how Black men might challenge army policies that offered them unequal pay and that refused to promote them as officers. Newspapers took sides, with the *Christian Recorder* advocating that Black men delay enlistment and the *Weekly Anglo-African* supporting unconditional adherence to the Union cause. Still, by late 1863, as Christopher Hayashida-Knight argues, "a sharp consolidation of opinion seems to have occurred" about the historical significance of joining the war effort and what victory would mean. By war's end, according to Brian Taylor, "more than 70 percent of free black males of military age living in states in which slavery had ended before the Civil War had served in the Union army."[13]

It is impossible to know how the Emancipation Proclamation and the call for "colored troops" affected the Sanders family, whether they agreed with one another about the wartime goals or whether they changed their minds over the course of the war. For many in their community, the fighting itself offered a chance for African American men to "prove" themselves worthy of citizenship, and it elicited sharp passions and heroic acts. "This is our golden moment," declared a widely distributed circular signed that June by dozens of African American men,

both well-known leaders such as Frederick Douglass and men who had surely passed time at 1116 Fitzwater: E. D. Bassett, O. V. Catto, Thomas Dorsey, Henry Minton, and Jacob C. White Jr. "The Government of the United States calls for every able-bodied colored man to enter the army for the three years' service, and join in fighting the battles of Liberty and the Union. A new era is open to us."[14]

Not everyone celebrated this "new era" as a moment of promise. Diarist Sidney George Fisher, for one, griped that "the abolitionists are trying to make what they can out of the enlistment of Negro soldiers & are likely to cause a reaction & injure their own cause & the real interest of the Negro. . . . The orators claim equality for the Negro race, the right of suffrage, &c. All this," he sniffed, "is as absurd as it is dangerous." But as scary as the prospect of radical change was to Fisher, African Americans experienced a surge, however guarded, of hope. In an immediate postwar tribute to Lincoln's authorization of Black men's military service, a writer in the *Anglo-African* recalled the moment's implications, perhaps with more optimism than it deserved: "Four years ago, a colored man would not be allowed in the Capitol unless he had a dust-pan and broom in his hand. The idea of a colored lawyer speaking in the Supreme Court, would have been preposterous, or a colored minister preaching in those halls, entirely out of the question. A colored major in the regular army would have been hooted at, as it would be placing him on too much of an equality."[15]

Even if the Sanderses felt some ambivalence about the war, Black enlistment, and emancipation, the questions raised by these debates were far from abstract. As with the African American DeReefs and the white Stevenses, there were choices to be made. Whatever their conversations about the war's potential impact, Robert Sanders, his wife, and his sisters—and perhaps their father—surely discussed who had, or had not, chosen to enlist. Some men in the Sanderses' community did seem eager to enter the fight. In June 1863 Octavius Catto and Jacob C. White Jr. enlisted some ninety men (and boys), many of them associated with the Institute for Colored Youth. Emilie Davis, their friend and fellow ICY student, thought, "To day has bin the most Exciting I ever witness [when] we went to see the boyes start for harrisburg." Less excited than their teenage friends, according to Catto's biographers, "several mothers intercepted the underage warriors and kept their sons from leaving."[16] This first group of "colored troops" was rejected by Maj. Gen. Darius Crouch and returned to Philadelphia. Emilie Davis's feelings were surely widely, if quietly, shared: "The boyes had bin sent back

i feel glad and sorry." All week the conversation continued, with Davis alternating between being proud at the "boyes"' talk about war and being "so thankful that our boyes are all hom again."[17]

There was a great deal more than war to talk about in the Sanders household, because life, of course, went on. On May 29, 1861, only weeks after the firing on Fort Sumter, Julia Sanders married Edward Y. Venning at home on Fitzwater Street; she gave birth to Miranda Cogdell Venning the following year. This new beginning, the first of Sarah Martha Sanders's descendants to be born free and Richard Cogdell's first grandchild, was a grand event. The baby was named for the long-deceased baby sister, buried alongside Sarah Martha Sanders, whom Julia had surely held and cared for during their mother's final pregnancy. (That Miranda had died at just eight months old, just before Sarah Martha Sanders gave birth to her last child, Florence, who died at four years old.) Miranda was also the only one of Richard and Sarah Martha's grandchildren who carried the middle name Cogdell. Julia kept her memories of Charleston, and her affection for her father, close at hand, even as her family and community confronted and debated the overwhelming military conflict against their former home and acquaintances.

The summer of 1863 must have been a time of conflicting passions for the young Vennings, with Miranda just over a year old and Julia again pregnant. With the draft in place and the enlistments begun, Edward Y. Venning put his name on a flyer calling a "Mass Meeting of Colored People" to support and recruit African American troops that June. Surely he, like other Black men, discussed whether to join up himself. But two months later, Edward signed an entirely different, more unexpected, document. In it he agreed to pay one John H. Diggs to be his substitute in the Civil War draft.[18] I have struggled to understand how Venning came to this decision—was it a political one or personal? Did the carpentry business he shared with his father tip the balance? Did his father-in-law, the Southern slave owner, or his wife, Charleston born and formerly enslaved, weigh in? Certainly the Vennings were comfortable, with Edward's father reporting $5,000 in real estate and $300 in personal holdings and a growing savings account to which he had given his son access.[19] But more than the ability to pay was at stake here.

Although the conscription law included African American men, both policy and implementation were vague and arbitrary. On July 31, 1863, Emilie Davis noted that "today is the eventful day they begin to Draft in the seventh ward," and that date does appear on Venning's substitute

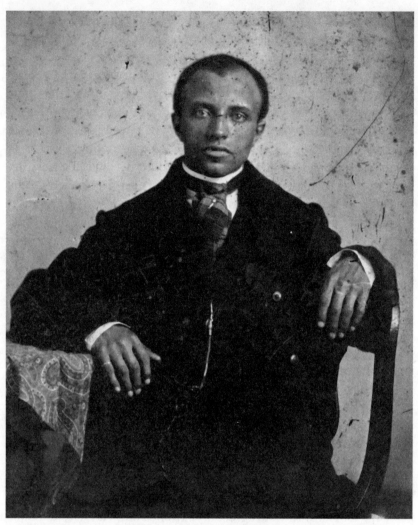

Edward Y. Venning (1838–1884).
P.9367.5, Stevens-Cogdell-Sanders-Venning-Chew Collection,
Library Company of Philadelphia.

form. Still, it seems unlikely that an official came to the Vennings' door on the first day to conscript Edward. Certainly he was not the only man in the Sanders circle who preferred to aid in recruitment rather than to actually take up arms. Octavius Catto, "ready to go to war" and active in recruiting Philadelphia's first (thwarted) African American troops, did not accompany the next (successful) local regiment. Instead, he and his friends assumed leadership roles that did not, in the end, require that they fight. Perhaps they hated the prospect of serving under white

officers; perhaps, like men in comfortable circumstances before and since, they preferred the safety of home. But although it is impossible to know how many African American men found ways to avoid fighting, paying for a substitute was an unusual, and deliberate, act.[20]

I know appallingly little about John H. Diggs, who, for $300, enlisted on August 24 as Edward Venning's substitute. The "Company Descriptive Book" of the Sixth Regiment of the US Colored Troops, Company F, offers little more than the substitute form: he had "black eyes, black hair, black complexion," was just under five and a half feet tall, and was twenty-nine years old. Diggs was a farmer, born in Maryland, although whether he was born enslaved or free the documents do not say. He left Camp William Penn with his regiment on October 14, participating in several battles throughout Virginia and North Carolina. The rest, handwritten by one J. G. Reeves, is terse: "Died in Hospital (Regtl) Chapins Farm Va. June 22 1865. Final statements forwarded July 20, 1865."[21] As for Diggs's "final statements" (to whom were they forwarded?) I have no clue. Nor do I know whether Edward Venning ever learned of the fate of the man who took his place in the US Colored Troops. As with so much of the evidence in this book, if the substitution form had not landed in the Sanders family's papers, we would not know this much.

Certainly there were reasons for young men to temper their enthusiasm for battle. And surely efforts by relatively well-off young men, especially those with wives and children, to avoid war has a long, if not always heroic, history. Still, given that a sizable majority of Northern Black men of fighting age signed up—presumably believing that this war for emancipation and, they hoped, equal rights was worth fighting—this tiny tantalizing glimpse upends our assumptions about African American men's universal eagerness to go to war. We might consider the possibility that Edward Venning's father-in-law, a white, slave-owning Southerner, influenced his thinking. Or that his own father's apparent connection to the DeReefs—still slave owners, still siding with the Confederacy—made him ambivalent about taking up arms against the South. Maybe, despite his decision to sign the call to enlist Colored Troops, his loyalties were mixed. Or maybe he just preferred, and was financially able, to stay home.

A more generous explanation of Venning's decision is that it constituted what historian Brian Luskey calls an act of philanthropy. By paying a substitute, Edward Venning contributed toward Pennsylvania's enlistment quota while subsidizing a Black man's enlistment. (In an ironic twist, white men could not be Black men's substitutes because

of the pay differential in the army.) President Lincoln himself had paid for a substitute, making his own symbolic contribution. Still, as philanthropy goes, hiring a substitute had to have been a painfully personal act. If the recruitment board followed its own rules, Venning would have met with Diggs before he went off to war and would perhaps have learned of his death. It may have been charitable, but it does not quite seem the path of principle, especially in a war that was supposed to "test his manhood" and bring about the emancipation of his people.[22]

It is impossible to know who else in the Sanderses' circle paid a substitute to take their place in battle; surely some men did. But if anyone thought less of Edward Venning for hiring a Civil War substitute, no echo of their disapproval remains, even with the hindsight that underscored African Americans' sacrifices on behalf of the war's emancipatory goals. When Edward died at age forty-nine, his reputation in Philadelphia's African American community was secure. The newspaper reported that, in addition to his carpentry skills, he was "prominently identified with nearly every movement in the interest of the colored people of this city."[23]

Women friends and acquaintances demonstrated their loyalty to the US cause through their relief efforts, but the Sanderses' names do not appear on the lists. During July 1863, just as young Black men were organizing to join the US Colored Troops, or arranging not to, fourteen young African American women formed the Ladies Union Association of Philadelphia to raise money for wounded soldiers. The women's plans for a fair, a popular fundraising practice, confronted an obstacle that was painfully familiar to African Americans in a Northern city: "After engaging Assembly Buildings we were informed that our Committee were taken for white, and the mistake being made known the rooms could not be had. After a great deal of labor and trouble we succeeded in renting Sansom Street Hall for three days, January 5th, 6th and 7th, [1864], where we opened our first Fair." That fair raised $200, which they donated to the US Sanitary Commission; the women, some of them, like Emilie Davis, in the Sanderses' circle, decided to continue their efforts, and they adopted bylaws later that year.[24]

In early 1865, as the war drew to an end, the association called for another fair "for the sick and wounded colored soldiers." Feeling that "the sacred duty of relieving the sufferings of those who are pouring out their life's blood" compelled them to act, they asked for goods and donations from the African American community. At least one member of the family thought the war promised "the elevation of our race and the

Chapter Five

advancement of liberty," for among the officers was Rebecca Venning, Edward Y. Venning's twenty-four-year-old sister.[25] Cordelia Sanders, the same age as Rebecca and related through marriage and their shared nieces, does not appear on the list.

Having white-owned spaces literally shut doors in their faces was not all the African American women of the Ladies Union Association experienced, reminding us that wartime sometimes provides openings for other kinds of public activism. At the bottom of the association's report, the secretary, S. L. Iredell, expressed the "hope that our friends will make some efforts to gain us admission to the city cars, as we find great difficulty in reaching the Hospitals." Streetcars were fairly new in Philadelphia (tracks were laid in 1857, the year the Sanderses arrived), but their use had increased greatly. As the city expanded, numerous routes took people to work, shops, and wartime hospitals, where family members and visitors attended to the needs of wounded soldiers. Privately owned streetcar companies allowed drivers to choose whether to permit African Americans aboard; individual resistance to such discrimination, on both railroads and streetcars, followed almost at once. In 1858 Charlotte Forten's friend Mrs. Putnam "was refused admission to the car in which she wished to go . . . and was *ordered* to go in the 'colored car,' which she of course indignantly refused to do." She waited for a later line "with which she met no difficulty," but frustration mounted during the war.[26] This was not a case of separate, segregated transportation; there were no alternatives for getting around the growing city. For African American women who wished to visit or bring supplies to Black troops stationed at Camp William Penn in Chelten Hills, the ban was as inconvenient as it was symbolic.

As in later movements for racial justice in urban spaces, access to public transportation drew members of this community, and especially its women, into a wider activist world. "Streetcars," Judy Giesberg writes, "became the platforms on which women of color interpreted the meaning of emancipation on the northern home front." Throughout 1864 meetings were held to challenge African Americans' exclusion from the cars, and the Sanders family was surely aware of them. Reverend Alston, a rector at their own St. Thomas's Church, lectured and wrote about the personal cost of racism. He was carrying his ill son when he saw the "Lombard and South-street cars approaching, which I hailed, and was in the act of entering, when the conductor arrested my progress by informing me that I could not enter—*being colored.*"[27]

Appeals and street-level activism continued after the war. After considerable lobbying—and only in the context of the nation's postwar experiment in civil rights—the legislature in Harrisburg finally decided to act: "The logic of the past four years," Republican judge Joseph Allison had declared while ruling on a case involving Philadelphia's streetcars, "has in many respects cleared our vision and corrected our judgement." In March 1867 the governor signed a law banning racial discrimination on Philadelphia's streetcars. Putting it to the test, however, took guts. Caroline LeCount, the Sanderses' family friend and neighbor, now a Philadelphia teacher, immediately challenged a conductor to let her onto the car. When he refused—both he and the magistrate professed ignorance of any new law—she prevailed, and the company paid a fine. The African American press exulted at this victory by a "wearied school teacher." From Brooklyn, where New York's streetcars had been integrated since the mid-1850s, Cordelia Sanders apparently missed the news: "You make a mistake," she wrote, "when you say you told me of the cars. I do not even know to what you refer. I hope you don't mean to say . . . that the fates are against our riding?" Clearly the implication that anyone would oppose "our riding" took her by surprise. Cordelia was not oblivious to the practices of racist exclusion—she assured her sister that "some one told me for a fact the other day that we can go if we will and whenever we choose to the Winter Garden"—but folks at home were talking about changes that affected them directly, and expected her to keep up.[28]

As far as we can glean from the sources, the Civil War changed the Sanderses' lives in largely quotidian ways: budgets tightened, their father's finances grew shaky, the communications that sustained friendships were erratic. Richard Cogdell likely enjoyed his small granddaughters, Miranda, Julia, and Sophia, but the war was a grim time of declining health and funds. Although he wrote mournfully of "old age, a distressing asthma, hernia and debility brot on by these maladies, and the mind much impaired by the ills which have attended this cruel war," he focused most pointedly on his financial distress. It seems likely that at some point he moved into the Fitzwater Street house, whether to save funds, be cared for by his children, or both; in the summer of 1866, one daughter, probably Sarah Ann, felt comfortable postponing her return from the beach "especially as I hear that you are so well again— shaving and washing yourself etc. etc." To the grandson of an old friend,

imprisoned in Washington, DC, and seeking his assistance, Richard bemoaned his own reduced circumstances: "I have been kindly permitted to use the table of Messrs Ward of La Pierre House, but my rooms, in an humble part of the city have afforded me little or no comfort, being obliged to ask credit for coal, Segars (necessary for asthma) and medicine at the places that I had been accustomed to get them when my means were good." Having moved, apparently, into his children's house ("in an humble part of the city"), Richard no longer enjoyed the luxuries that his prewar access to his South Carolina property had afforded him.[29]

For his children, too, the war years were remarkable in the most personal ways. When Julia married Edward Venning and moved to his parents' house on Rodman Street, Robert, Martha, Sarah Ann, Cordelia, and Sophia remained at 1116 Fitzwater. Together they cared and grieved for Sophia, who died in September 1865 at only eighteen. To friends who had remained in the South, the death of one sister seemed rather small. John Irving received "the first intimation I had of the sad event or even of her feeling ill unto death" gloomily but without much surprise, for he had "known she was a fragile flower, and might wither away, and drop from the parent stem under the influence of the first bleak wind that blew." The summer of 1865 had been rough on Irving and Richard Cogdell's old circle. "The truth is, my dear friend," Irving continued, abandoning his habitual blithe tone, "I have of late suffered so much, and can see nothing in the few short days that perhaps remain to me on Earth to restore to me the peace of mind & prosperity I once enjoyed that when I hear of a death now among the young & the innocent I shed no tear; I rather congratulate the enfranchised spirit that has become released from the trials & sufferings that inevitably await." For the Sanders siblings and their father, hearing Sophie described as an "enfranchised spirit" probably irked: "I think of Sophie (our sister) so much now that I imagine all kinds of things," Cordelia wrote in 1867, three months after their father had also died. "I can fancy I hear her in her brighter days laughing at me when I used to appear awkward to her."[30]

It is difficult to assess what direct impact emancipation itself had on the Sanders family, just as it is impossible to know what they discussed or envisioned. Perhaps their years in Charleston already seemed a lifetime ago; perhaps they talked about their mother, who would have been only fifty if she had lived. Few shards acknowledge that their own legal status had been affected. There is that handwritten certificate from C. P.

Gadsden, then the rector of St. Luke's Church in Charleston: "I hereby certify," he wrote, "that, on the 18th of April 1857, I united in marriage, according to the ritual of the Protestant Episcopal Church, in St. Philips Church Charleston, Robert Sanders and Martha Julia Davenport, in the presence of divers witnesses." Dated ten years after their wedding, the certificate makes no claim that the marriage was legal according to the state of South Carolina; it was not. But by requesting this document, Robert and Martha acknowledged that something had changed. Like thousands of emancipated African Americans throughout the South, they now wished to document a marriage that took place before it could have been a legal fact. Interestingly, that same year Edward Venning appealed to his own former minister, now in London, to certify that he had performed his and Julia Sanders's marriage ceremony in May 1861. He prodded his memory—the wedding had taken place at 1116 Fitzwater Street, and he enclosed a "publication of the marriage which I have clip[ped] from the Press"—and he hoped that the reverend would take whatever steps necessary to avoid "it being disputed to hereafter."[31] Who he imagined might dispute it, I have no idea. But Venning clearly understood that his wife had once been enslaved and for whatever reasons—political, emotional, or financial—believed that it was prudent to establish his family's legal standing.

The changes in the family's circumstances had little to do with the war itself or with emancipation but instead reflected the Sanderses' secure position within their community. In the summer of 1862 Cordelia joined her friend Charlotte Forten in Massachusetts just before Forten went to teach in the Sea Islands. After the war, Cordelia moved to Brooklyn to teach, although she remained in close touch. ("Kiss all the little girls," she wrote Julia, referring to her nieces.) New names appear in the census of their households, including newly arrived Charleston kin. Thomas Denny, for instance, was now living at 1116 Fitzwater; he, or someone in the household, told the census taker that he was Robert's brother-in-law, so perhaps he was Martha's brother. Denny's presence suggested other ties of long standing. Before leaving Charleston, Denny had rented 109 Calhoun Street from Henry Horlbeck, whose brother Daniel was Cogdell's lawyer and good friend. And, upon arriving in Philadelphia, Denny, a machinist and carpenter, opened a business at 418 Fothergill Street, next door to the Vennings' own carpentry shop. Anna A. Davenport, Martha Sanders's sister, had also moved to 1116 Fitzwater by 1870. Ten years later, listed as "white" in the census, she lived with their father, Charles, and his wife, Medora Davenport, in Massachusetts.[32]

Other African American Charlestonians moved north as well. By 1870, Edward W. Venning's Rodman Street household included not only his daughter-in-law Julia Sanders Venning and her four children but Phillis Barron, "mulatto," aged fifty-eight, born in South Carolina. Even if, as I suspect, the Sanderses, Vennings, and Barrons had known one another in Charleston, it is odd that Phillis Barron, who was Martha Sanders and Anna Davenport's mother, did not live with her daughters on Fitzwater. Perhaps the Vennings' crowded household welcomed the housekeeping labors of another adult woman. Maybe Barron and her daughters simply did not get along. But clearly the families were close, for in 1864 Julia and Edward Venning asked Phillis Barron to be their daughter Julia's godparent.

For all the changes—arrivals and departures, births and deaths—the Civil War's most profound impact on the Sanders household was financial. Richard Cogdell had set up his estate to provide his children with a measure of security; a trail of paper affirms his intentions. He had given each of them a $1,000 Memphis Railroad bond, assuming they would retain their worth.[33] He bought their house and paid the real estate tax through his lifetime. But now Cogdell faced, perhaps for the first time in his life, financial hardship. He tried mightily to remain sanguine that his privations were temporary. How far he had lived beyond his means became apparent (both to him and to his children) only after the South's defeat.

In the wake of the collapse of the Confederate money that had funded the railroad bonds that he had, he believed, so sensibly invested, Richard Cogdell was forced to confront how fragile his own—and his Southern associates'—finances had become. In what turned out to be his final year, he tried to protect his children from any future claims on his accounts. Soon after his youngest child Sophia's death in 1865, Richard Cogdell added a codicil to his will: "I give and bequeath to my two Daughters Sarah A Sanders and Cordelia Sanders . . . all my household goods Jewelry Silver China Pictures Books Piano Beds and Bedding Linen and other Furniture whatsoever and I do in all other respects confirm my Said Will." To his friend and lawyer (and, not incidentally, debtor and executor) Daniel Horlbeck, he challenged "a passage in one of your last letters that disturbs me much. You say, that one of your brothers intends that the debt $4,000 might [need] to be paid according to the value of the conf[ederate] paper loans of that time. Now, this is the very first intimation I have had, that the return of the Loan would not be made, on a specie basis! Your letters, from first to last,

have so expressed." While he understood that the Confederate blockade had made wartime trade difficult and that the decline of the Southern economy could affect his holdings, he begged for more information: "Mr Mordecai agrees with you as to the loss by the Banks being entire but thinks the R.R. bonds &c. good. He says 'twill take some time to get them into gear again, but they must prove good. The City and State stock you are silent about. How are they to do."[34]

Richard Cogdell may never have realized quite how bad things were. He died in December 1866, four days after fourteen-month-old Sophia Sanders Venning, his third granddaughter, died. However badly shaken by these losses, his children managed to protect their home, belongings, and other assets, but it took work. Sarah Ann Sanders's outrage fairly bounces off the page during the settlement of her father's estate: "Finding that this house is our own property," she noted indignantly, the creditors "are even questioning whether the furniture can be called ours." (In fact, Cogdell's 1866 codicil giving his daughters the household furniture suggests that it was not clearly theirs prior to his death.) But Richard left his children and his lawyers unambiguous instructions and, in Sarah Ann's case, the confidence to handle his estate. Indeed, it is here that Sarah Ann Sanders emerges most clearly as the household's manager: acerbic, stubborn, and principled. Horlbeck, financially precarious himself, became increasingly frantic in the face of Sarah Ann's insistence that he make good on her late father's investments. Perhaps, he admitted, he had "spoken under impulse & may have said sharp things," but he reminded her pointedly that "you know & so did your father that my property vanished with Emancipation."[35] We might pause here and consider his phrasing: the property Horlbeck had lost consisted of enslaved people, and he expected Sarah Ann and her siblings to sympathize with his troubles.

Sarah Ann Sanders did not blink. Philadelphia creditors were hounding the family, "thrusting before my eyes on every hand, vouchers with my father's signature attached for loans of money," and it was her job to protect both her household and her father's reputation. She sought John Irving's support, reminding him that both money and honor were at stake: "You know of course that during the War, when my Father's resources were cut off from the existence of the blockade and the difficulty of correspondence, etc. etc. that the Ward Bros. Mr Hassard the Druggist Mr Town the Coal dealer, and many others were kind to him; they opened their hearts to him, when every other Southern man was looked upon with distrust and in many instances with hatred." In

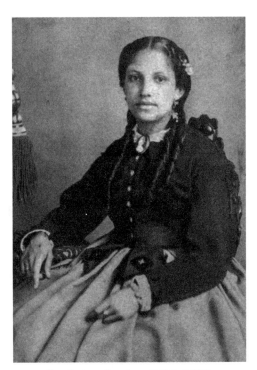

Sarah Ann Sanders (1839–1871).
p-2012-37-1-p14, Stevens-Cogdell-Sanders-Venning-Chew Collection,
Library Company of Philadelphia.

a series of long letters to Horlbeck, copied over for others to peruse, collated, filed, shared, and saved, she expressed great frustration, but never once did she question her father's integrity or intentions. Finally, exasperated by their ongoing misunderstanding, she got Irving to write to Horlbeck. "I truly sympathize with you, in your trouble," Irving assured her. "I hope all things from the truly generous nature and strictly honorable principles of your Father's old friend Mr. Horlbeck."[36] Sarah and her siblings may have felt less certain.

The complications of dealing with their father's estate, along with his debts to hotel keepers, pharmacists, and others, touch on many histories. On one level, there is deflated Confederate wealth and an equally, if metaphorically, deflated lawyer friend in Charleston. Daniel Horlbeck was essentially broke, his affairs tangled up in the South's collapse and in promises he had made to his partner-brothers. Perhaps Horlbeck had misled his brothers, and possibly he lied or prevaricated in his dealings with the Sanderses. Horlbeck was hardly a devout Confederate loyalist; he seems, like Cogdell's circle generally, to have held

his political allegiances rather lightly. Indeed, as the war neared its end, one white Charlestonian, who considered himself "among the 'hopeless hopeful still,'" "grieve[d] to say many of our citizens are very calmly anticipating the fall of Charleston and openly declaring their intention to take the oath of allegiance to the Lincoln government." He singled out one: "Daniel Horlbeck says he will write to his brothers advising their return to the city with a view to saving their property by a quick and ready adhesion to the approaching new order of things, and he stands only one of hundreds."[37] At war's end, living with a niece, Horlbeck struggled to recover both some wealth and some dignity. Cogdell, in contrast—whatever his feelings about the war, the Confederacy, slavery, or his old friends—maintained his pride in large part because his children exhibited an unwavering commitment to defending his honor.

That astonishing personal loyalty is nowhere better evidenced than in the years-long effort to settle Richard Cogdell's estate. It was an extraordinary negotiation, between savvy lawyers and untrained heirs, between Southern whites and once-enslaved African Americans, and between men and women. Like other parts of the Sanderses' history, this story, too, requires that we look not only to the noise—the words spoken, the money exchanged—but to its timbre and to the silences.

From the first, this correspondence unsettles our expectations. Sarah Ann Sanders's confidence in herself and her concern for her father's honor suffuse her letters; although she remained polite, she was neither self-deprecating nor deferential. Daniel Horlbeck did become a little testy when pressed by Richard Cogdell's daughter for the several thousand dollars he had held for his old friend. It was, he insisted, a "voluntary promise" (we might, like Sarah Ann, ask what that even means) and in any case he no longer had the money. It is difficult at times to distinguish Horlbeck's petulance from his actual losses, his insistence on being broke from his appeals to his brothers to cover his expenses. Self-justification leaks out: "I advised your Father, before the War, to sell and take his property away," Horlbeck wrote crossly, offering further evidence that Richard's friends knew that he had left Charleston for good. But "he was silly, & stood on a few hundred dollars." (In fact, more than a few hundred dollars were at stake. As late as 1860, Richard Cogdell was still paying taxes on Charleston property valued at $4,500—far less than his relative Clement Hoffman Stevens owned but not much less than what Daniel Horlbeck himself possessed.) There is much convoluted discussion about Cogdell's accounts, his credit, and his debts— even a resentful reference by Sarah Ann to Horlbeck's daring to make

his "own claims against the Estate (Debts assumed by my Father for Walpole & Charles etc.) which he said were preferred to all others, think of the debt assumed fifteen or twenty years ago, being preferred to his own debts, contracted in his old age, by poverty and privation, with the enemies of his country!"[38] Horlbeck's tone becomes beseeching and a bit pathetic, just as hers becomes increasingly sharp.

But in a lengthy exchange about two Southern white men's honor and reputation, about who promised what before the war, and about Richard Cogdell's financial expectations, Horlbeck never once referred to the circumstances of Sarah Ann Sanders's birth, her race, her sex, her competence, or the legitimacy of her and her siblings' claims to their father's estate.

Indeed, there is nothing to suggest that Daniel Horlbeck doubted the Sanderses' rights, that he thought the demands of an African American woman beneath his notice, or that he considered his own reputation, even his relations with his brothers, safe from her criticism. Although emancipation (as he termed it) erased much of his wealth, it was he who suggested that Sarah and the others "come and live in the South where are all your early friends & associates." After all, he intoned, "all are now equal before the law."[39]

Whatever temptations, excuses, and dodges Daniel Horlbeck offered, Sarah Ann and her siblings needed the money owed their father, and they knew they were entitled to it. Although the adults had worked throughout the war, and the family had the house and its furnishings, the Sanderses had been compelled to borrow for coal and medicine, and they shared their father's reduced circumstances. Their expectations were not those of the nearly destitute but of stable working- and middle-class people, long used to a comfortable parental cushion, who expected to recover money owed them and in turn to pay their debts. Clearly they discussed these troubles among themselves. Teaching in Brooklyn in 1867, Cordelia was sorry that she could not afford to travel home for weekends but she recognized that her siblings were struggling as well. She hoped to hear that "money matters" were settled soon, but only so that her sisters and brother would "not remain in want": "I am all right;" she assured them, "give yourself no uneasiness on the score of my being needful. I am patiently waiting however to learn of some home situation." "Dan," she hoped, would soon make things right.[40]

Leaving aside whether any of the Sanderses actually called their father's friend and lawyer by his first name, did "Dan" "make things right"? Horlbeck's version of Cogdell's accounts, carefully listed from

1860, is difficult to follow but suggests that he was highly attentive to financial accuracy; every payment of city taxes (five dollars), every interest check ($9.13 for "3 years 7 months"), and all bank dividends through the war years are listed. The total held by Horlbeck by the time of Cogdell's death was just over $4,200. Some $1,743 was "brot. forward" in 1868, with a complicated note about "amt. loaned in depreciated money to H. Horlbeck & Bros. by Daniel Horlbeck Agt of R. W. Cogdell from moneys received from Insurance Co (loss of house burnt), now assumed by Danl H as he agreed by letter to see if paid in Specie tho the firm insist they are not liable for more than the amt. scaled down in the end of 1863, when they tendered the money back." More follows of this nature: detailed accounting, another reference to a "loss of House by fire" (possibly the house on Friend Street), followed by tedious reminders of the depreciation of value in the postwar South.[41]

Unfortunately for Daniel Horlbeck, the estate's settlement, and all these documents, did end up in court. In November 1868, George Buist, the judge of probate, certified the accounts and found that the estate had a balance of just over $3,600. But legal accounting language obscures a great deal, and in any case much of the trail of antebellum credit and debt has vanished; let us just consider the numbers. In 1866, Sarah Ann Sanders's bank account, which may have been the family's shared funds, contained $600. The 1870 census, listing Robert Sanders as household head, estimates the house's worth at $4,000 and his (or their) personal estate at $2,000. A significant amount of money, if not the full amount that Richard Cogdell considered his due, had apparently made its way out of the financially devastated South and into the Sanderses' hands.[42]

Sarah Ann Sanders's confidence in her own and her father's integrity, and her commitment both to getting the funds he had assured them were theirs and to paying off his debts, cannot have been acquired overnight. She and her siblings were raised to believe in themselves and one another. Although they became legally free only when they arrived in Philadelphia, their legal status alone cannot account for the evidence of pride, competence, and dignity that is woven through the sources. Still, I wish I could more fully grasp the process by which these formerly enslaved Charlestonians became members of Philadelphia's African American middle class. How gradual, how instantaneous, or

how profound was the transformation? Did their migration resemble the shift in identity that others—immigrants from abroad, migrants from other regions, even their great-grandfather John Stevens and his Jamaica-bound son Jack—experienced? Did their years in Philadelphia shape a new consciousness of themselves as members of an African American community that was denied, and deserved, the full rights of citizenship? Or is it only in retrospect that such a transition, steeped in war and emancipation, seems so dramatic? However rooted or safe or transformed they felt, within a decade of leaving Charleston the Sanderses had permanently settled in Philadelphia. Only rarely did any of them refer to South Carolina. "I thought of you the other day, and wished I could have sent you home the finest Carolina Shad imagineable that was brought me by a Steward of one of the Charleston boats," wrote twenty-six-year-old Cordelia to her father, detailing how she purchased and cooked the fish, which she shared with Mrs. Putnam "to let her taste how much better our Carolina fish is than her own." Apparently Cordelia did wish to visit Charleston after the war, because their father's friend John Irving had "promised to write and inform ['my little Delia'] when it was probable I would be going to South Carolina on a short visit, that she might accompany me."[43] Irving cancelled that trip (business at the American Jockey Club in New York was always more urgent), and there is no evidence that Cordelia found another opportunity.

Only once, as far as I know, did a family member return to Charleston, and we catch this information only secondhand. Four days after Richard Cogdell's death on December 23, 1866, Daniel Horlbeck wrote to "Rob Sanders & Sisters" that he had received their telegram and stood ready to receive his friend's body and to arrange a funeral. We only know that Robert Sanders attended that funeral because, a year later, Horlbeck mentioned to Sarah Ann Sanders a conversation he and Robert had had "when he was here with the corps[e] of your father." "Things are not as when you were here," he assured the adults he had known as his friend's enslaved children. Having reminded them that "all are now equal before the law," he went on to talk of "a worthy colored man" who was now able to testify successfully in court against a white one.[44] We have no record of how they greeted this information: Did they need Horlbeck to tell them that life in the South had changed? Or to decide who was "worthy" of their new rights? And what did Robert report back? Still, while they had remained in touch with their father's

and perhaps their own "early friends & associates" and welcomed family members to Philadelphia, the break with Charleston was permanent.

I would have loved to hear Robert Sanders describe his visit through the postwar streets of Charleston and his feelings at Richard Cogdell's graveside. Twenty-first-century Charleston does not make it easy to visualize the nineteenth-century city. But less than two years after the end of the Civil War and slavery, Charleston was still predominantly Black; for all the destruction of war, it would have felt more familiar to Robert than it would to us. As in other Southern cities, African Americans from rural areas were migrating to urban spaces, seeking family members, employment, a political voice, and new lives. Into that mix, a thirty-four-year-old African American man arrived from Philadelphia with his white father's body, attended his burial, and chatted with his white friends. Perhaps Reverend Gadsden, who had known the family, attended the funeral—or else Robert stopped by Gadsden's new church, St. Luke's, to request the paper certifying his and Martha's marriage. (The document is dated January 17, 1867, the very month when Robert was visiting.) On January 1, Robert might have witnessed the second celebration of Emancipation Day, in which African Americans in Charleston marked the Emancipation Proclamation, parading with the gusto and pomp that befit their city. It must have seemed both shockingly familiar and dramatically changed. I imagine that Robert Sanders sought out his own friends and teachers (perhaps his mother-in-law, Phillis Barron, was still there, or Martha's sister, Anna), noticed the reduced circumstances of some of his father's associates, and visited the (likely burnt) remains of the house on Friend Street. Surely he walked the few blocks of Boundary Street to his mother's grave in the Ephrath Cemetery and took note of the new gravestones, including that of Charles Cogdell, in St. Philip's. Maybe he mused about where he and his wife, sisters, and nieces would be buried.

Other African Americans who had left South Carolina returned south to build new lives and communities after emancipation. After all, while people such as John Irving despaired at the looting, dislocation, and mayhem in the aftermath of the war, others experienced postwar Charleston as abuzz with new people, new activity, and new hopes, its rebuilding barely begun, its pridefulness shaken to the core. Robert Smalls of Beaufort famously returned home a war hero and assumed a position of economic and political leadership—wealthy, connected, successful. There was reason to be hopeful, even if naively so. Indeed, one white acquaintance of Cogdell's had written him a year

after emancipation and the "enlargement of the civil rights of the Freed-man" that "the idea of any antagonism between the two classes of population, will I think, in a short time, be shown as wholly pointless."[45] Still, the Sanderses made a different choice. The decision not to return to the South seems as tied up with their connection and commitment to one another as was the decision to leave in the first place. Their home was now Philadelphia, with its house and shared relationships. It is difficult to imagine any of them leaving without all of them coming along. Whatever Robert may have felt upon burying his father in Charleston, all the Sanderses' remains are in Philadelphia.

6

COLLECTIVES AND INDIVIDUALS

Such stability seems astonishing less than a decade after arriving in Philadelphia. Yet here they all were, entering their postwar lives grieving the loss of their father and their sister Sophia, but with a house, skills, a bank account, a new generation being born, and one another. The Sanderses were neither radical activists nor leading intellectuals; nor were they, as in Saidiya Hartman's dazzling exposition of late nineteenth-century African American life, "wayward girls."[1] They associated with other members of Philadelphia's educated, middle-class African American community, both in St. Thomas's Church and the Church of the Crucifixion (the newer Black Episcopal church on Eighth and Bainbridge, founded in 1847) and at charitable and musical events. That community included tailors, carpenters, and artisans like themselves; some, such as Cordelia Sanders and several of her nieces, became teachers. Sometimes they traveled—to Massachusetts or to the beach. Only rarely did they move from Philadelphia: Cordelia Sanders to teach in Brooklyn, Richard DeReef Venning to gain federal employment, Willie Chew to Washington to explore a new life after his wife died, and a generation later, Richard Sanders Chew, to California, to be an engineer with expertise in earthquake zones.

Every decision the Sanderses made—to leave Charleston, to remain in Philadelphia—they made together, reminding us, as sociologist Avery Gordon puts it, that "the intricate web of connections that characterizes any event or problem *is the story*."[2] Deliberately and in concert, Sarah Martha Sanders's children and their father negotiated a path upon which the Sanderses would become independent Philadelphians, people who owned a house that provided an underlying security for decades

to come. Indeed, the house itself is a remarkably stable character here: the Sanderses and their spouses and offspring lived at 1116 Fitzwater for half a century. It was here that the Sanderses' collective decisions took shape; the siblings' hold on one another, and on that house, was extraordinary. Indeed, their story is most compelling and revealing as that of a family. Still, like all collectives, their household was made up of individuals, and I have struggled to draw out each of their voices, to picture a cast of complex human beings. Here readers must grapple most explicitly with how different kinds of historical evidence offer— or foreclose—possibilities that might fill particular silences and must attend to how the life stories we can tell reflect the kinds of sources we have on hand.

Although the 1860 census lists him as the household's head (and a "mulatto"), we know little about Robert Sanders, the oldest child and only surviving son of Richard Walpole Cogdell and Sarah Martha Sanders.[3] His memories of Charleston were both the oldest and the most recent; he had, after all, returned to bury his father. Surely he had mourned his brother Jacob, two years younger and dead at the age of seven. Eighteen when his mother died, he would have best understood the realities of her, and his own, status in Charleston. He was likely the most attuned to his parents' interactions, had considered the nature of his mother's claims, and recognized the efforts his father made on the children's behalf. He would have witnessed whatever abuse, affection, or discord his parents were willing to show or were unable to hide. He had to have noticed that for all the education and comforts he and his sisters received, they were less than those available to his Cogdell half brothers; I have no idea whether he ever expected or imagined otherwise.

We know nothing about Robert's or his sisters' relationship with their half brothers or what feelings they expressed to their father or one another when the last of them, Charles, died in 1860. Only briefly, and dismissively, did Sarah Ann Sanders refer to "debts assumed by my Father for Walpole & Charles etc." in her correspondence; did she hesitate even for an instant before she wrote that "my," rather than "our"? Did Robert think of them as kin? Was he their pet or their pest or simply invisible? Did their father forbid the Cogdell boys from speaking rudely to his Sanders children, or did he not notice or care? Given their father's apparent affection for his Sanders children, would the older boys have considered their little brother or the babies that followed their property?

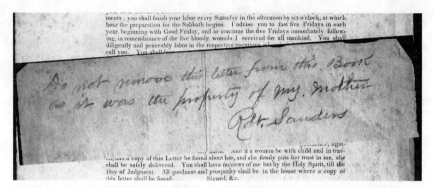

Robert Sanders's note on his mother's sheet.

Only one piece of paper exists, as far as I know, in Robert Sanders's writing. Tucked inside the family Bible (printed in Savannah in 1851, so probably brought along from Charleston) is a printed page entitled "A Letter of Jesus Christ." With it is a scrap that reads, "Do not remove this letter from this Book as it was the property of my Mother. Robt. Sanders."[4] Perhaps Sarah Martha Sanders could read after all; perhaps she was deeply religious. Either way, her son preserved this remnant simply because it had been hers.

Whatever his role in the family's decision to move north and whatever his fears and his ambitions, Robert remains a shadowy presence. He was a tailor, possibly having learned the trade in Charleston, perhaps from Parris C. Cooper. Briefly, in 1860, "Cooper and Sanders," both "col[ore]d," operated a tailor shop at 915 South Street, Philadelphia, and in 1868 Robert had a shop on South Seventh Street, but for most of his life Robert Sanders worked from home. Robert and Martha, who had no children, remained with his sisters—and later their husbands and children—for the rest of their lives. "Aunt mother and Uncle Bobbie" indulged their nieces and nephews: "They love them and will do to the last for them," noted a friend, "but not always wisely."[5]

Like most ordinary citizens, Robert would show up in the newspaper only when there was trouble. In 1890 he took on the job of enumerator for the census, working close to home in the fourteenth division of the Third Ward. The count was delayed by some five days when fifty-eight-year-old Robert's rheumatism acted up and forced him to miss work. Pressed on why he did not explain his "delinquency," the "large, portly, colored man" demurred: "I positively refuse to say whether I had

Chapter Six

a doctor or not, and will not speak to newspaper men," he declared. But an intriguing non sequitur followed, as Robert grumbled that, in his district, "most of the people do not understand the English language and know nothing about filling up census schedules."[6] The enumerator who replaced Robert Sanders was permitted to get an interpreter if necessary, but the incident, however trivial, hints at a sense both of belonging and of elitism—as well as a clue to how their neighborhood was changing—that was widely shared within the Sanderses' circle.

Census takers considered Robert the household's head, but he lived in a community of women. Julia E. Sanders, twenty when the family moved north, married Edward Y. Venning in 1861 and moved to his parents' house at 910 Rodman Street. The daily routines of her life may not have quite matched her ambitions, since her sister Cordelia once remarked obliquely, "Your life has not been what you required, I know."[7] It is numbers—the sheer accumulation and loss of people—that provide the only entry we have to her story. Only she and Cordelia had children, and only Julia lived long enough to raise—and bury—them. In that sense her life heartbreakingly resembled her mother's, with its births, infant deaths, and child raising. Fewer than half of her ten children outlived her.

Julia had been thirteen when her mother died. She surely helped with Sarah Martha's babies, grew attached to them, and grieved their deaths. She chose names for her own children that resonated with the family's ties to Charleston and their scars. Julia and Edward Venning named their first child Miranda, after Julia's little sister, born when Julia was twelve, who had lived for just eight months. Julia's adult sisters—Sarah Ann, Cordelia, and Sophia—provided names for the babies who followed. The numbers are bleak, the losses staggering. Of the ten children Julia Sanders Venning bore, two died as babies, two as young children, and two as adults before their mother; only four outlived her. Julia buried her forty-nine-year-old husband and every one of her siblings; when she died at seventy-three in 1910, only her sister-in-law Martha Sanders remained.

Sarah Ann Sanders, in contrast, two years younger than Julia, emerges in her own voice, however disciplined by duty and business. She comes across as highly educated, competent, and devoted to her father and

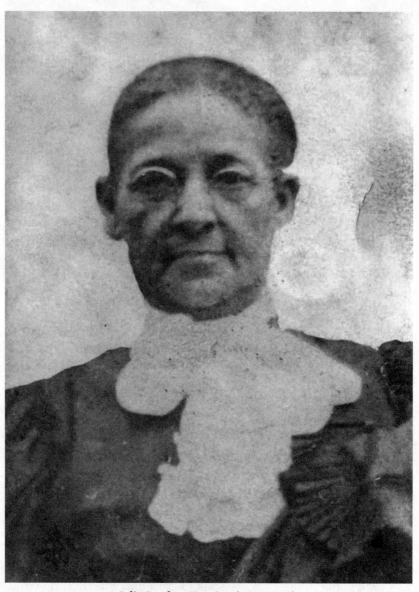

Julia Sanders Venning (1837–1910).
P.9367.26, Stevens-Cogdell-Sanders-Venning-Chew Collection,
Library Company of Philadelphia.

siblings. It was she to whom her father entrusted his prized possessions; she was, I have suggested, in charge. Perhaps she was more erudite, or more well-spoken: "You use the power of your able pen to give a colouring to your views," a self-pitying Daniel Horlbeck would gripe, complaining that "you take many positions in which I do not agree."[8] Perhaps when Julia went to live with her husband's family, Sarah Ann took on household management by default. Maybe she, too, had had other aspirations but had fallen into the work of caring for married sisters, small nieces, and an ailing father. Maybe she just had the most acute business sense. The evidence suggests that it was she, nicknamed (illegibly) "Newky" or "Minky," who wrote her father from the beach in 1866 that "I will not come home as soon as I promised perhaps a week later. . . . I am sure you do not need me immediately."[9] Once she returned late that August she stayed home through Richard Cogdell's and Sophia's final illnesses; she paid the bills, negotiated with creditors, managed her father's estate, and took on the burden of guarding his, and the family's, reputation. While the first letter from Horlbeck to the Sanders family was addressed to "Robt. Sanders and sisters," later ones were simply to "Miss Sarah A. Sanders." Her death surely left her siblings bereft and the household in disarray.

Sarah Ann Sanders's letters are, quite simply, wonderful. Significant for helping us sort through the settlement of Richard Cogdell's estate, they also offer glimpses into his second daughter's personality. Though she intended to stick to business, her feelings crept in, since her father's debts were "very strange, and excessively embarrassing to me." And she grew ever clearer, and blunter, on where the blame lay. "You asked me once, whether I wished you to recede from your claim," she responded to Cogdell's executor, Daniel Horlbeck. "I said no, nor do I wish you to do so or indeed any man—but I think now that as long as it is your own misfortune that brought about the difficulty with the firm of Horl-becks, and as you agreed to take the whole responsibility for payment of $4000, that you certainly ought to be willing to receive that in payment for the claims you have against the Estate etc." Certainly emotions were running high. "I could not half convey to you by letter, all I feel upon this subject," she admitted to John Irving when Philadelphians to whom her father owed money hounded her, "nor can I blame these people who have fallen into troubles by their kindness for an unfortunate man among strangers." Irving, in return, promised to look into the matters that "you have so feelingly and with so much ability called to my attention."[10]

Sarah Ann lived long enough to see the estate settled, but not by much. She died in 1871 at the age of thirty-two. Cordelia, who had returned from Brooklyn and married Willie Chew, now assumed her sister's role as family correspondent and executor, informing John Irving of Sarah's death and asking about some remaining issues in their father's estate.[11] Julia Venning's next baby, born the following year, would carry on the name Sarah for yet another generation.

The Sanderses barely had time to mourn Sarah Ann's death before their community was shaken by another, more violent one. However much domestic matters required their attention, they were inexorably drawn to a larger Philadelphia world. With the passage of the Fifteenth Amendment, in 1871 Black men could vote again in Pennsylvania. Surely those Sanderses who were eligible to vote—only the men, of course, Robert Sanders, Willie Chew, Thomas Denny, and Edward Venning—would choose to do so. But alongside the excitement and hopefulness, hostility ran high. On Election Day, October 10, Democrats, aided by policemen, lined voters up by race, pushed Black men out of their lines, and clubbed individuals who resisted. So blatant were these actions, even for Philadelphia, that when a number of Black men were charged with rioting, the judge declared that the police had instigated it and dismissed the charges. Octavius Catto, now a Republican Party activist in the thick of it, "beseeched the mayor to better protect the city's Negro residents"; he also bought a pistol. White men, police officers among them, shot several Black men as others ran home to lock themselves indoors. That afternoon Catto, too, headed home, greeting friends along the way. A block away from his home, on South Street near Eighth, he was shot and killed. William Carl Bolivar, Richard DeReef Venning's close friend and a journalist, described how in African Americans' homes that evening "strong men wept like children"—surely that included the Sanderses' own. In contrast, the next day's edition of Philadelphia's white press, the *Public Ledger*, reported that "the election passed off yesterday in perfect quiet" just before reporting about the riots and Catto's murder.[12]

Many white people, Bolivar reported, who had "sat quietly unmindful of things not directly concerning themselves" now "were aroused out of their seclusion and took a stand for law and order." Some now joined African Americans in "a righteous public sentiment that brought brute force to bay." However insular the Sanderses were, and however

distraught by Sarah Ann's recent death, Catto's killing was close to home. They had long known both Catto and his friend Caroline Le-Count, as well as Bolivar and Jacob C. White Jr., who was now in charge of the burial of his best friend. Whether or not Robert, Edward, and Willie voted, whether they stood their ground in those voting lines, or whether they fled police through the neighborhood, they were now part of a community in mourning. Surely some of the family attended Catto's funeral on October 16, "perhaps the most imposing funeral ever given to an American Negro." Thousands of people marched past the military armory on North Broad Street to view Catto's coffin, schools and offices were closed, and numerous clubs and Republican Party members walked in formation south to Lebanon Cemetery. Years later, a white man, Frank Kelly, was tried for Catto's and another man's murders and was acquitted by an all-white male jury.[13] There are so many parts of this story that are hard for me to imagine. This is not one of them.

It is impossible to know what impact Catto's murder had on the Sanders family, whether the trauma of his murder propelled them to confront more openly the injustices of Northern racism, whether it heightened their sense of being part of a group defined primarily by their race. But within a few years, as historian Christopher Hayashida-Knight describes so well, the plans to commemorate the nation's centennial provide a rare opportunity to glimpse both the tense relations between white and African American women *and* strains among educated African Americans themselves.[14] Several years later, the legal challenge to racially segregated public schools offered another.

It was Cordelia Sanders Chew, two years younger than Sarah Ann, who stepped out with characteristic vigor onto this larger public stage. If Sarah Ann comes across as competent, principled, and loyal, Cordelia offers glimpses of an outgoing and expansive personality. Sixteen when she moved to Philadelphia, already "familiar with Shakespeare," she quickly displayed middle-class notions of young womanhood. As a teenager she kept a scrapbook—full of romantic poetry, lacy cards, and elaborate prints cut from magazines—that Hayashida-Knight points to as "an exercise in dreaming and idealism that would serve her well in the decades ahead." Poems she wrote, poems she copied, teenage musings about love and sadness—all are pasted in, "born," as Hayashida-Knight puts it, "of [her] joy and boundless hope for a 'brighter coming day.'" Cordelia was sociable, welcoming the teenage abolitionist Charlotte Forten to Fitzwater Street, flirting with Octavius Catto, chatting in Brooklyn with John Irving, and musing about which of the men "of

our class" she would consider marrying. Through her letters and those of a close friend, she comes across as a beloved sister, aunt, wife, and mother, a civic activist, and a distinctively vivacious voice among the siblings.[15]

I do not know how the Sanders teenager might have acquired "joy and boundless hope," but she surely identified with what historian Kabria Baumgartner calls "purposeful womanhood" by becoming a teacher. Whether or not she attended the Institute for Colored Youth (ICY), she certainly knew the ICY's other young teachers — Octavius Catto, Caroline LeCount, Jacob C. White Jr. — and likely its leading teachers Sarah Douglass, Charles Reason, Fanny Coppin, and Charles Dorsey as well. After the war, and probably through those contacts, Cordelia taught at Colored School No. 1 in Fort Greene, Brooklyn. Like the ICY in Philadelphia, this school, founded as the African Free School decades earlier, had illustrious antecedents. In 1845, it had formally become the first public school for African Americans in Brooklyn. Given Philadelphia's tradition of training African American teachers, it is not surprising that the school drew upon the ICY's expertise. Charles Reason, who had taught at the ICY from 1852 to 1856, had gone to teach in Brooklyn by the time Cordelia got the job. Philadelphian (and ICY and Oberlin graduate) Charles Dorsey was the school's principal. In the 1970s the school's principal and students successfully organized to rename it the Charles A. Dorsey School to recognize Dorsey's singular contributions to African American education.[16]

In Brooklyn, Cordelia embarked on a career, explored a new city, made new friends, and considered the attentions of men. Now twenty-six, it was the first time she was recognized as a professional: the 1867 Brooklyn City Directory lists "CORDELIA A. SANDERS (col.) teacher, h 421 Atlantic," and the following year the same, though without the racial designation. She enjoyed her new independence but, luckily for us, wrote home frequently. Those letters — lively, chatty, seeking gossip — provide the most human element to the family's story since the cranky and self-pitying missives of her great-grandfather John Stevens. Cordelia's habit of underlining random words gives the impression of an enthusiastic young woman — not so far removed from the "intelligent, interesting girl . . . with a great deal of freshness and originality" whom Charlotte Forten had befriended nearly a decade before.[17]

It is in Cordelia's letters, too, that we find the most explicit displays of affection for Richard Cogdell, as well as signs that he still fretted about his adult children's well-being. "My dear father," Cordelia began,

"How are you, and where this dark miserable day?" She proceeded to discuss Brooklyn's wintry unpleasantness but assured him, "You need not be uneasy about me. I hope by Monday morning 'twill be better for one to (ride at least) to school." Certainly she was homesick: "I am wondering if you are at home, and whats doing at this time 4 P.M. You must be at dinner." And she missed her nieces, for she begged Julia for more news about those "cunning little things . . . eaten up with vanity—for I remember they had begun to tie ribbons on their head ere I left last time." Though she'd already written "all about my monotonous life here" to her sister, she chattered to her father about a new acquaintance who worked on the Charleston boats and brought her the piece of fish that recalled their South Carolina home. Monotonous her life may have been, but it is not hard to imagine her energy and enthusiasm or to picture that she gave "instructions in gymnastics."[18]

Occasional references to racial tension and prejudice waft through Cordelia's letters, always infused with the patience and moderation that would characterize her later civic activism. Surely she, too, had experienced being "refused at two ice cream saloons, successively," as Charlotte Forten had been one summer day in Philadelphia. Charlotte's response had been characteristically outraged: "It is dreadful! Dreadful! I cannot stay in such a place." But Cordelia seems to have been bemused by, and prepared to overlook, white people's ignorance. On one occasion, a Mr. Burnham visited her calisthenics class and wondered "why I do not have a regular class as he does. . . . (Of course he was thinking how nice such a thing would be for col[ored] young ladies.)" To Cordelia, such apparent ignorance about African Americans demanded patience, for Mr. Burnham "does not know, that col'd people don't understand such things" and that "his plan was out of the question." Still, she concluded, "he is just as much my friend and a perfect gentleman. I do not think he has any predjudice [sic] really."[19]

And she had a social life. Now twenty-six, she considered the prospect of marrying, both in the abstract and in terms of the persistent "W." After all, she wrote her sister, "I am no longer very young nor handsome whatever, nor accomplished, nor the most amiable. And 'tis a marvel why W. ever should so desire union although so different in himself from my standard." Tantalizingly, she referred to another conversation they had had but not recorded: "Believe me my dear sister about my marrying. It is just like my unwillingness to leave this country (were it possible) for another because I could be lifted to a higher station. I would always pine for the other happiness, lovely accustomed life."[20]

What opportunities Cordelia had had—or imagined she had—to leave the country, what examples of being "lifted to a higher station" another migration might have offered, are impossible to know.

In any case she came home to Fitzwater. In 1868 Colored School No. 1's end-of-term exercises were "marked by a feature of unusual interest, the presentation by the pupils of testimonials of regard to Miss Cordelia Sanders who is about to leave the school." The children gave her "a handsome gold chain," as well as a "set of books, comprising eight volumes of standard literature." "Poor health," the newspaper article concluded, although with a reticence that makes it impossible to know how ill, or just worn out, Cordelia was, "is the cause of Miss Sanders retirement." Delighted by the notice, she sent a copy to John Irving, who found it gratifying.[21] Whatever her reasons for returning to Philadelphia, Cordelia evidently decided to overlook the age difference between herself and "W." In 1871, back on Fitzwater Street, she married Willie Chew, six years her junior. With her husband working in his late father's "hairdresser" shop at 37 South Sixth Street (John Chew's had been one of the "best and largest barber shops," according to a later account), the young couple were surely a lively addition to 1116 Fitzwater.[22] The births of Richard and Charles Chew in 1871 and 1873 kept the house from becoming a much quieter place after the loss of Sarah Ann. A photo from that time shows Cordelia sitting with her two young sons, looking both staid and serious—but surely she had not lost entirely the enthusiasm that characterized her letters from Brooklyn.

Cordelia Sanders Chew did not teach once she married, but she found time to engage in a moment of civic activism that elucidates her racial, class, and political identities. Ten years after the Civil War, Philadelphia hosted the nation's centennial, a paean to industrial progress and unity, complete with monumental buildings and much waving of flags. From the first, divisions arose among white women seeking a role in the celebration. Elite white women sought to highlight women's accomplishments in a separate Women's Pavilion. More radical white women's rights activists, led by Susan B. Anthony, literally thrust themselves onto the centennial stage to demand that women be granted the vote and other rights—and omitted on their declaration the names of Mary Ann Shadd Cary and some ninety-four African American suffragists from Washington, DC, who had asked to be included.[23] For Philadelphia's middle-class African American women, the postwar years represented a time of promise: the streetcars were no longer segregated, federal troops patrolled Southern cities, and the Centennial fair seemed

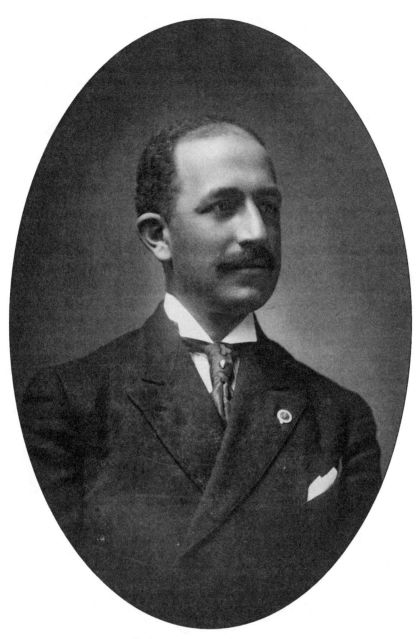

William (Willie) Chew (1847–1892).
P.2013.14.10, Stevens-Cogdell-Sanders-Venning-Chew Collection,
Library Company of Philadelphia.

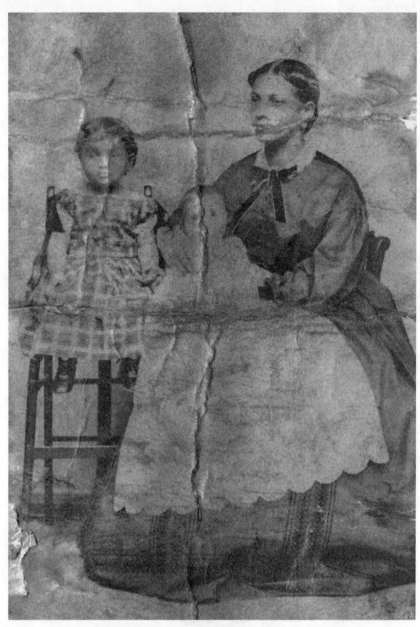

Cordelia Sanders Chew with Richard and Charles.
P.9367.25, Stevens-Cogdell-Sanders-Venning-Chew Collection,
Library Company of Philadelphia.

a perfect opportunity to remind the nation of both its founding rhetoric and its incomplete promises. The conflict that emerged underscores the layers of exclusion and entitlement that pervade celebrations of national pride.

Well organized and well connected, Philadelphia's most elite white women traipsed through the city to raise money for the Women's Pavilion. Uncomfortable with knocking on the doors of African American households, they invited Dr. Rebecca Cole, a graduate of the ICY and the Female Medical College of Pennsylvania, to gather a group of educated African American women to "assist" where (the white women determined) they could best serve. If, at the beginning, the invitation was scented with condescension, soon the odor became stronger and the white women's attitude harder to dismiss. The African American women Cole invited would differ among themselves about whether to hold their noses, how hard to push back, and how best to express their own sense of national belonging, celebration, and hopefulness.

Cordelia Sanders Chew and her sister-in-law Martha J. Sanders joined Dr. Rebecca Cole, Caroline LeCount, Letitia Still, and others on the fundraising committee. Certainly Rebecca Cole and Caroline LeCount, academic stars at the ICY and, in Cole's case, medical school, exemplified African American women's advancement, worthy, they believed, of national pride. To LeCount, the Centennial represented "the common inheritance of all" and stood for African Americans' aspirations for freedom in the postwar United States.[24]

The white women had a different, if largely unexamined, idea of what that freedom entailed. These were not the activist descendants of Lucretia Mott and Sarah Grimke, nor supporters of woman suffrage like Susan B. Anthony and Elizabeth Cady Stanton. They would have considered themselves liberals—after all, they were about to celebrate a nation that had won a war, emancipated 4 million slaves, and was experiencing expansive industrial growth—but they barely interacted with African Americans. They chose as their liaison to the Black community Mary Rose Smith. The onetime president of the Women's Freedmen's Relief Association, Smith had some experience in benevolent work among newly emancipated African Americans and had raised money for teachers in the South. Apparently her white associates believed that this provided her with some insight into Philadelphia's highly educated, middle-class African American community. They were wrong.

It didn't take much to expose Smith's prejudices. At the first meeting, Cole, LeCount, Cordelia Sanders Chew, and the others realized that the

invitation to "a colored element" to "*cooperate*" cast them in a decidedly subordinate role. The women were expected to solicit funds from Black households throughout the city but were not to speak to white people on the Centennial committee's behalf. Upon realizing this, the African American women met separately and agreed that they would participate only as equals. Smith's response to this plan, as Hayashida-Knight puts it, was "swift and hot." Insisting that the African American women had been invited only as "a courtesy" and that, in LeCount's retelling, "the celebration was not a matter that concerns our color, but only white people," Smith expressed a view that, LeCount sniffed, "needs no reply from intelligent persons." In response, thirty-three African American women signed a statement that made clear their own position. We met in good faith, they said, in an effort to work with the Centennial committee "not as 'colored Centennial women!' there being no such body in existence." Having discovered that they were to be a segregated body, they declared "our unwillingness and inability to work in any fixed sphere, being ignored in our respective wards, and we do here, and forever hereafter, protest against any such injustice, because of American prejudice, which ought to have outlived itself in this hundredth anniversary."[25] Both Cordelia Sanders Chew and her sister-in-law Martha J. Sanders added their names to the letter of protest.

It took some time for the white women's committee to realize that Mary Rose Smith's actions had given them unwanted publicity and had left a bad taste even in their own community. When they did, two of the women met with Rebecca Cole and Cordelia Chew to hear of their "real or supposed grievance." Cordelia Sanders Chew ("a lady," reported the *Philadelphia Inquirer*, "of much more than ordinary intelligence") spoke decisively, objecting that "the idea of color caste prejudice seemed to be a predominant one in the treatment of them." One of the white representatives, Mary McHenry, scrambled to explain that "personally, she did not recognize the word 'color' in its customary application to the human races," even as she defended the committee's plan for segregating the fundraising work. Chew explained patiently that she "had not the slightest objection to a proper use of the term, for, of course, anyone could see that they were colored, but it was the acting out the idea of color that wounded the colored women."[26] Offering an excuse that would endure for generations, the white women suggested that Smith had understood the African American women to *prefer* separate work. Cole and Chew graciously accepted this and, in a renewed spirit of cooperation, helped revise the rules for volunteers.

Not everyone agreed, even among friends. Caroline LeCount, along with ten others, was unwilling to accept the truce or to swallow the committee's explanation for Smith's racist remarks. They publicly "re-pudiate[d] all action which took place on the part of Miss [*sic*] Cole and Mrs Chew, so far as they claimed to represent the colored women," and fumed that anyone would "so far debase herself and degrade us" by accepting those terms. Some back-and-forth ensued. A bit haughtily, Rebecca Cole reminded the others that it was *she* whom the committee had appointed to gather African American volunteers, that she could, therefore, disband the committee, and that she was, unlike LeCount (and her "portion"), willing to work for the Centennial on the grounds of equality. LeCount took a harder line; Smith's remark that African Americans could be sent "back" to Africa was particularly unforgivable, evoking "painful associations" from when "the dealers in the bodies and souls of men succeeded in getting their prey and consigning them to interminable bondage."[27]

Cordelia Sanders Chew took a milder view than LeCount; she sided with Cole in, as Hayashida-Knight puts it, "taking clumsy white women at their word."[28] Perhaps, given her family's experiences, Cordelia had more faith that education, material security, and class standing itself could shield women like her from Northern racism, but she was not naive. Certainly she objected to Mary Rose Smith's treatment of the African American women and opposed her plan for raising funds—she had made that crystal clear in the meeting. Still, once a reconcili-ation was staged and some soothing words spoken, Chew was willing to compromise, to temper LeCount's demands for racial equality with patience, and to participate in a commemoration of national belong-ing. Again, as with her Brooklyn friend Mr. Burnham, Cordelia could accommodate, even excuse, white people's "clumsiness." How much her Southern upbringing, her long-deceased mother, and her slaveholding father helped shape that moderation in her racial consciousness is im-possible to know.

Cordelia also enjoyed some independence, surely more than her sis-ter Julia Venning did, traveling in 1875 to Massachusetts to visit her friend Louisa Jacobs and to check up on her niece Miranda Venning, a student at the Washington Grammar School. Either Cordelia or Mi-randa boarded at the home of Harriet Jacobs's widowed sister-in-law Eleanor Jacobs in Massachusetts; Cordelia paid the bills. As befit family tradition, she also paid twelve dollars for the rental of a piano.[29] Al-though she no longer taught school, Aunt Delia helped educate the next

generation; after Cordelia's too-early death, her friend Louisa Jacobs noted that "Rannie" (Miranda Venning) "told me how much she missed Delie in her lessons."[30]

For in November 1879, thirty-eight-year-old Cordelia Sanders Chew died, like Sarah Ann, of consumption. Of all the too-early deaths the Sanders family endured, this one left the most wrenching evidence in its wake. At first Willie Chew remained in the house on Fitzwater, but it must have been bleak. Surely the aunts and uncles did their best for the boys, ages eight and six, but friends worried. "The children. Poor little things!" fretted Louisa Jacobs. "They are children that have been greatly indulged, and what they need now is a gentle firm hand to lead them." Julia Venning had plenty of children already and was again pregnant. As for "their aunt mother and Uncle Bobbie," Jacobs noted, "they love them and will do to the last for them, but not always wisely. Ah me! How their mamma used to plan for their future."[31]

From her intimate friend Louisa Jacobs, we learn the most about the emotional impact of Cordelia Chew's death. I do not know how the women met, although it may have been as early as Cordelia's 1862 trip to Massachusetts. They were extremely close; Cordelia's death—and worries over her widowed husband Willie's future—suffused Louisa Jacobs's letters for years. Strangely, Louisa was not seated among the clearly designated friend and family groupings in Cordelia's funeral carriages; perhaps the event was simply too painful to bear.[32]

Surely Cordelia and Louisa recognized the similarities, and the silences, in each other's pasts. Louisa's was more widely known—her mother Harriet's 1861 *Incidents in the Life of a Slave Girl*, although published under a pseudonym, famously detailed her years of hiding from her abusive master so that she could free herself and two children from slavery—but the similarities were evident. Born of enslaved mothers and white fathers, migrating to the North before they became adults, Louisa and Cordelia shared values common to their standing. As historian Mary Maillard puts it, these women "were educated by tutors and in private schools, and they studied French, the classics and mathematics, drawing and painting, botany and physiology. They sang in choirs and played musical instruments. . . . The men in this society were barbers, caterers, carpenters, tailors, printers, and businessmen. The women were dressmakers, teachers, housekeepers, nurses, and milliners." Louisa and her mother never quite acquired the home and stability Harriet had once called the very definition of freedom, but their lives followed a reliable pattern: Washington, DC, in the winter

and New England in the summer. They hired servants and, in Louisa's case, found work at Howard University.[33]

And they wrote letters. The correspondence between Louisa Jacobs and Philadelphian Genie Webb came about because of Cordelia's death; the much younger Genie, whose family were longtime friends of the Chews, had been at Cordelia's side and, unlike Louisa, rode alongside family members at the funeral. Indeed, as she neared death Cordelia apparently suggested that Genie marry Willie. Louisa Jacobs was somewhat torn by the idea. She asked Genie whether "Delie's request of you has been regarded?" and then could not resist offering advice: "Let it not be unless your heart with true fervor can say amen to it. I loved her with a great love and yet I say this to you. I am fond of Willie, and know he would do his best for the woman he loved. It is a great responsibility marrying a man with two children." She regretted that it had been Genie, not she, who had had the "sad privilege" to spend the last days at their friend's side. For Louisa, memories of Cordelia sounded an extended cry of grief. "Yes, I loved her most dearly," she wrote her new correspondent. "It was a rare friendship, such as comes but once in a lifetime."[34]

Louisa Jacobs's grief did not fade. A year after Cordelia's death, Louisa made plans to stop in Philadelphia briefly to lay flowers on her friend's grave. From Boston later that summer she was again reminded of Cordelia, "for it was here she stopped with me a few days the last time she was in Boston. And now I sit in the very room we occupied, sleep in the same bed, dream of her but not pleasantly." "Do you know dear," she continued to Genie Webb, "there is not a spot I go to that is not, in some way, associated with her so she is an ever abiding memory." From Brockett's Bridge she recalled that "it is just five years this very month since Delie and I in this very spot looked together at the landscape before me now. Wooded hills crowned with the golden tints of autumn, and meadow still fresh and green. And days like this we would wander arm in arm until the stump of some old tree would invite us to rest, and there in the sun we would talk and dream of hopes death has sealed." When her own mother got ill in 1880, Louisa reflected on her earlier loss: "While Delie lived I felt I had a heart to lean upon should sorrow come to me." Cordelia's absence even challenged her religious faith: "I have not yet reached that place where I can resign her wholly to the other world. Nor would I for ten thousand worlds bring her back to this to suffer. Still I so often wish for her, well and happy as I knew her in the long ago. I cannot feel like you that it is sinful that I would bring her from a greater to a less happiness."[35]

Louisa Jacobs eagerly sought news about how the Sanders family was coping. "I have not heard from Fitzwater Street for several weeks," she wrote Genie. "I hope they are all well." "Do you see them often at Fitzwater Street?" she asked dolefully in March 1880 and in virtually every letter that follows remarks on whether she has, or has not, heard from them. In early 1881 Louisa reported that the children at Fitzwater Street had a Christmas tree but noted, "It would have made me too sad to have been with them on that day. I was with them on that day four years ago. Our loved Delie with her large heart strove to make the occasion happy to all—dear generous loving soul!" (I do not know what happened that Christmas of 1877, two years before Cordelia's death, but she may have already been ill.) Louisa Jacobs's pride in the Venning and Chew children's accomplishments remained tinged with that loss. "Have you been to Fitzwater Street lately?" she wrote Webb. "I was glad Rannie came all right out of her examination and Julia acquitted herself so well at her graduation. How proud dear Delie would have been could she have lived to see those days."[36]

Cordelia's death left her husband, Willie Chew, "heart sore and lonely." He did not marry Genie Webb or anyone else, nor did he turn to his own large family.[37] His widowed mother had already taken his sisters to her native Trenton, New Jersey, in 1870, when Willie, about to marry and take over his late father's business, stayed in Philadelphia. Perhaps he found his own family difficult. Or perhaps he simply thought that growing up with their Venning cousins was the best future he could offer his sons.

In spite of the stability offered by 1116 Fitzwater Street, the newly widowed Willie comes across as unmoored; apparently he considered going to sea.[38] Even the census, that most bureaucratic of sources, reflects disruption and confusion. One year after Cordelia's death, Charlotte Chew's Trenton household listed Richard Chew, age eight, the son of Cordelia Sanders and Willie Chew. Apparently, at least as far as Willie's mother was concerned, her grandson Richard now lived with her. Yet the same year's census shows both Richard and his brother, Charles, living at 1116 Fitzwater Street with their father, uncle Robert, aunts Martha Sanders and Julia Venning, and seven Venning cousins—all of Richard Cogdell and Sarah Martha Sanders's surviving descendants under one roof.

Even if she did not actually recommend a new wife to Willie, Cordelia Sanders Chew exerted a strong influence over her children's future after she died. Surely this was the case in Willie's next actions regarding

their sons' education. The Sanders family's journey north, their relationship with their father, and their security in owning their own home set them apart. But they shared a dedication to education that was typical, even emblematic, of their class. Here, too, disagreements within Philadelphia's African American community would surface, reflecting ironies that would persist in later struggles for civil rights.

The year after Cordelia died, William Chew and their brother-in-law Edward Venning initiated a lawsuit to integrate the public schools in Philadelphia.[39] Like other "colored people," one newspaper reported, they "resented the setting aside of schools particularly for their children, as an act indicating their untrustworthiness to mingle in class rooms with the offspring of white parents," just as they disliked that "the buildings were of the most wretched character," staffed with white teachers who were unsympathetic at best. Decades later, William Bolivar recalled the "celebrated case" when "William H. Chew . . . insisted on his children's admission to what had been an exclusively white school. Being denied, he had recourse to the courts, and after a good deal of contest, won out. It was Richard and Charles Chew and Oliver Venning, who were the pioneers after such fashion." "There was a great deal more liberality thirty years ago," Bolivar sighed, "than there is today, and the law was lived up to, and without any clashings at the time of the entrance of the above children in the white schools." The *Philadelphia Inquirer* reporter got some of the facts wrong—it could not have been Willie's wife who answered the door at Fitzwater, since Cordelia had already died—but surely it was correct that whoever it was (Julia? Martha?) was "intelligent [and] courteous" and fully prepared to tell the reporter that Chew "does not think it right that we should be taxed to support the public schools, and then have our children denied admission to them." "I am very glad [Willie Chew] is testing the school question for colored children and trust he has come off conqueror," wrote Louisa Jacobs. "It is just what our dear Delie would have liked him to do."[40] I am as confident as Jacobs that Cordelia would have approved; indeed, it may reflect her lingering influence that her sons (Richard and Charles Chew), but not her nephews (Oliver and George Venning), pursued their education beyond the eighth grade.

But for all their hopefulness, educated African Americans fretted about desegregation. Louisa Jacobs, for one, correctly predicted one negative consequence: white parents would not accept African American teachers for their children. "I do not doubt but Willie's agitation of the school question helped to pass the bill in the Legislature for mixed

school," Jacobs acknowledged. "We can't but be glad, and yet I fear in time it will interfere with the colored teachers. All we can do is to hope for the best—a change in public feeling."[41]

As for Willie Chew, he continued to live at Fitzwater and work as a barber for a few years after Cordelia's death. But by 1885 new ventures pulled him away from the house and his children. At first, he entered into business with South Carolinian Joseph H. Rainey in Washington, DC, where he sometimes boarded with his wife's friend Louisa Jacobs. Two years later, he found work as a clerk in the federal printing office.[42] But things never went well for him. In June 1892, Julia Sanders Venning's daughter Sallie noted in her diary, "Dick & Charlie left for Washington to see their dying father." And the next day, "Willie Chew died. Quite a shock," followed by the bleak entry, "Dick's birthday. 21 years. His father buried." Willie Chew was buried with his wife's family in Lebanon Cemetery, later to be removed to Eden.[43]

Of the youngest surviving Sanders child, Sophia Elizabeth, there is almost nothing—no childhood portrait, no album full of poetry, no letters from school. She enters the archive only with her death in 1865 at eighteen, when John Irving acknowledged that she had long been "a fragile flower."[44] Surely this loss was traumatic for the remaining siblings, as well as for their father, whose own health was declining. But other than imagining what life had been like for this youngest migrant—Sophie was only ten when they left Charleston—there is only silence, and sadness.

The Sanders family Bible lists one more name under the heading of Sarah Martha Sanders's children, and historians and family members have counted her as the tenth child. In fact, "Martha J. Sanders" was Martha Julia Davenport Sanders, who married Robert Sanders in the spring of 1857 and immediately joined him, his father, and his siblings on their trip north. She would end up as the last member of her generation, and it was her death in 1913 that led to the sale of the Fitzwater Street house.

Although she lived to be eighty, Martha Davenport Sanders is barely visible in the historical record. She was born in Charleston to a free woman of color and a white man from Massachusetts, and someone had made the highly unusual decision to give her and her sister their

father's last name. She became a dressmaker; perhaps she had sewn the fashionable dresses the Sanders women wore in their photographs. I do not know how she and Robert met, whether their mothers had been acquainted, or whether their fathers had been associated in any trade. She and Robert had no children, but "Aunt Mattie" or "aunt mother" lived, worked, and grieved alongside her sister-in-law Julia Venning, as well as numerous nieces and nephews, for her entire life. Her name appears (as "Mrs. Robert Sanders") on two 1875 committees to "benefit the colored poor."[45] And it was she who joined her other sister-in-law Cordelia Sanders Chew on the women's Centennial committee and in objecting to their ill treatment by their white coworkers. Surely her presence in the household—and in the Sanders story—was more compelling than the historical sources reveal.

However obscure her adult life, the young Martha Sanders showed guts, for she seems not to have hesitated to leave Charleston or to tie her future to the Sanders family. Was she bold, frightened, in love, or all of those? Might she have been alert enough to the changes underway in Charleston to urge Robert to talk to his father and sisters about leaving? Her mother, Phillis Barron, and her sister, Anna Davenport, had previously paid their "Free Negro Capitation Tax," but I cannot locate them in either Charleston or Philadelphia at the start of the war; were they part of the plan to move north? Martha Sanders was the oldest woman at 1116 Fitzwater; perhaps that conferred a certain authority that, especially in the case of women, left no trace in the family's papers. Her 1913 obituary suggests that Martha maintained some ties to Charleston, for it—and no one else's that I have found—concludes, "Charleston, S.C. papers please copy."[46]

There are whispers of another member of the Sanders household, one who does not appear in the family Bible, account books, or census records. According to family tradition, a woman named Clara, "nurse to children and grandchildren of Sarah Sanders and R. W. Cogdell," moved with them from Charleston to Philadelphia. Someone has written "[Clara?]" on a portrait based on a tintype taken in Philadelphia, which sits in the family's archive: an African American woman, hair tied firmly back, dressed simply in a dark dress with a lace collar.[47] Her clothing in no way resembles the formal photograph of Cordelia Sanders, with its corset and starched and fancy satin dress; nor does the woman's face resemble hers. Who first had the idea that this picture

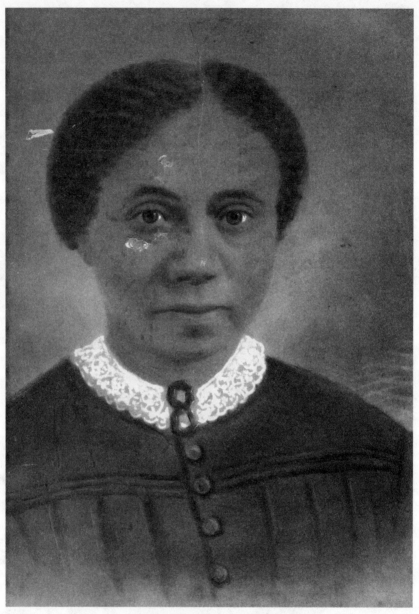

Possibly Clara, pastel portrait based on a tintype in the collection.
P.9367.32, Stevens-Cogdell-Sanders-Venning-Chew Collection,
Library Company of Philadelphia.

was of her? That she is referred to as their "nurse" and has no known last name suggests that she had been enslaved, but there is no Clara listed among the people Richard Cogdell purchased in South Carolina or living in any of the Sanders, Venning, or Chew Philadelphia households. But before we dismiss the possibility that Clara played an actual part in the Sanders story, there is that seating arrangement for Cordelia Sanders Chew's 1879 funeral cortege: the very first car held "William H. Chew, two children & Clara." In that moment we can glimpse her, now middle aged, a woman who had cared for Sarah Martha Sanders's babies, watched over them after their mother's death, and tied her future to their own, now seated with two small boys at the grave of their own mother. Her presence, if this truly is Clara, is a reminder of how little time had passed since they left Charleston, and slavery.

7
ROOTS AND BRANCHES

Having transplanted themselves, the Sanderses' roots took hold and spread. While it remains difficult to extract their individual stories and personalities from the existing sources, the next generation—Sarah Martha Sanders and Richard Cogdell's grandchildren—were deeply connected members of their class and community. Born in Philadelphia, they did not experience the enslavement, disruption, or migration of their parents. Certainly, as Nazera Sadiq Wright points out, the experiences of girlhood and adolescence were dramatically, even shockingly, different across the generations.[1] Although too-early deaths remained a constant, theirs must have seemed, from both generations' points of view, a different world. Some threads remain consistent. In general, the girls acquired more formal education than boys and became teachers, coming across as an especially competent bunch. The sons and sons-in-law finished at least eighth grade and did well in a variety of trades, businesses, and government jobs (only one, Richard Sanders Chew, attended college and became an engineer) as well as buying and selling houses. Both women and men joined clubs, played music, and participated in civic activities within the African American community. To a striking degree, the family—as siblings, as spouses, and as cousins—remained close.

At the beginning of this book I raised the question common to all historical narratives: Where to start? Now, as in any historical, and historian's, journey, it is hard to know where to end. Like all families, the Sanderses acquired branches, additional names, and individual histories that sprawl over time and place. A genealogist might track backward from the present generation of descendants, a few of whom I have

met. A historian of the twentieth century would emphasize the family's place among Philadelphia's African American elite: their children attended Camp Atwater, a private sleepaway camp for African American children; they went to public magnet schools; and the women attended prominent Northern state universities, later becoming, and marrying, teachers, businesspeople, and professionals. Scholars of labor might explore the working lives of the barbers and waiters and postal workers, as well as of the teachers, the engineer, or in the next generation, the dancer in the Martha Graham Dance Company. Historians of war might sideline the women who stayed home to raise children in favor of their husbands who served. None of these will offer a satisfactory answer to my own questions: what each of them thought of their family's past or place, how they talked about their long-ago roots in Charleston, what aspects of their history—its traumas as well as its security—continued to define them, and what motivated someone to read, sort, and paste in albums many of the family's papers. Friends have urged me to follow the Sanders family to the present day, eager to know how the story "ends." But, of course, no one ending encompasses or explains the entire journey, and I will leave that more recent history to others. As in any historical account, this one leaves out far more people than it contains; as with any historical narrative as well, what we can know is dependent on the nature of the sources that we have on hand. These sources offer only sparse evidence about the individuals in the first generation of Philadelphia-born Sanderses. Those glimpses, however, remind us that even the most ordinary lives touch on, reflect, and enrich the larger narrative of history itself.

Like their grandparents and parents—indeed, like everyone— Richard Cogdell and Sarah Martha Sanders's grandchildren lived in, and were shaped by, a particular time and place. For some, the closing decades of the nineteenth century were a time of enormous hope: massive immigration, the rise of labor and farmer movements, third parties, and radical causes reflected many people's confidence that the era would open doors to promise and prosperity, the American dream itself. In Philadelphia, the "workshop of the world," immigrants from southern and eastern Europe poured into the shops, factories, row houses, and streets, often displacing African Americans as they built their new lives. Racial tensions were rife, as most African Americans faced low wages, job segregation, and dilapidated housing, conditions that had accelerated since the Sanderses' arrival in the city. When W. E. B. Du Bois began research for his work *The Philadelphia Negro* in 1896, the

prevailing "theory" was that "this great, rich, and famous municipality was going to the dogs because of the crime and venality of its Negro citizens." Du Bois's research, he would later note, "revealed the Negro group as a symptom, not a cause; as a striving, palpitating group, and not an inert, sick body of crime; as a long historic development and not a transient occurrence." Among that complex, and decidedly non-transient, community were families like the Sanderses, who identified with Du Bois's "best class," the "aristocracy of the Negroes," who worked as "caterers, clerks, teachers, professional men, small merchants, etc." Still, the "general situation," as Elijah Anderson notes, "contributed to a profound demoralization of the black community."[2]

In many ways, the late nineteenth century was a bleak time: historians have called this period the "nadir" of civil rights, as the full implications of reestablishing white supremacy after Reconstruction took hold. I do not mean to suggest that the post–Civil War commitment to equal rights was entirely forgotten or abandoned. African American activists and thinkers organized, sometimes across racial lines, against lynching, for legal and educational equality, against the laws of Jim Crow, and for access to the vote. This era brought to prominence many of the leaders widely admired today, among them Ida B. Wells, Mary Church Terrell, Booker T. Washington, and W. E. B. Du Bois; both the NAACP and the National Association of Colored Women commenced a new era in secular, national activism for racial justice.[3] Philadelphia's own African American newspaper, the *Tribune*, began publishing in 1884; Sanders friend and neighbor William Carl Bolivar's weekly Pencil Pusher Points column appeared there, detailing their community's history within the city's Black middle class. W. E. B. Du Bois's *The Philadelphia Negro*, the first full-scale study of an urban Black population, offered a comprehensive account of the city's Seventh Ward, with topics ranging from "Conjugal Condition" and "Education and Illiteracy" to "The Negro Family" and health, crime, and politics. It epitomized the emerging conviction that scientific, industrial, and sociological studies could, and should, prepare citizens to improve American society.

But it was in many ways an insular time. As several historians have shown, women's growing visibility in the Black church and the rise of "respectability politics," which demonstrated an ongoing commitment to "lifting" African Americans as a community, stemmed in part from dashed political hopes. The "search for common ground—to be both black and American—occurred," historian Evelyn Brooks Higginbotham has written, "as the nation worked assiduously to deny this

possibility by isolating the 'Negro's place' within physical and symbolic spaces of inferiority." Given the backlash against many of Reconstruction's promises, it seemed a time to emphasize, and sometimes impose, sexual, domestic, and religious "respectability," to reflect on racial destiny, and perhaps to turn inward.[4] The Sanders family likely identified with this description of their class, place, and time; whether they gave much thought to how they had secured their place there, or whether they felt anxious about the changes surrounding their community, I have no idea. Clearly, in light of the educational aspirations and achievements of the next generation, they were confident of their abilities, their worth, and their belonging.

Let us begin, as the post-Charleston generation did, with Julia Sanders and Edward Y. Venning's daughters. Miranda Cogdell Venning (1862–1900) was a much doted-on first child and first grandchild. Her aunt Cordelia inquired often from Brooklyn about the "little girls," sending a rather lofty, if frantically underlined, poem, "To Miranda on her fourth birth-day," that sits in the family's papers. Miranda's own words echo her aunt's spirit as well as a surprising informality between generations. From school in Cambridge, Massachusetts, the thirteen-year-old wrote her aunt Rebecca Venning ("My dear Beckie") about upheavals at home: "O I am just longing for June to come, so I can be on the cars coming home to the new house 337 Dean St. Do you like it better than 1116 Fitzwater Street? I had a letter from Julie saying she missed the old house terribly." From her new worldly-wise position Miranda wrote her uncle Richard DeReef Venning ("Dear Richard") that people should not live in Cambridge "unless they had a good, strong constitution. I don't mean to be conceited of myself. I don't mean, to think that I have got a strong constitution, because I do not think I have." She commented breezily about family life, opining that "Grandma and Grandpa [Elizabeth and Edward W. Venning] ought to go away [on vacation] now but I know Grandma won't go, she would think all the time while she was away that your shirts would not be ironed good. I don't know what she would do if you ever got married, she would want you to live with her all the time." For all her teasing, she appreciated those family ties: "Very much obliged to you for the money."[5]

Miranda stood out in her studies, for she was given—or grasped— opportunities that the other children did not have. Along with her sister Julia, Miranda started at Margaretta Forten's school, to which their

mother paid $1.50 for each girl (ages nine and seven) for a month of tuition. Eventually she attended the Institute for Colored Youth (ICY), then under the leadership of Fanny Coppin. I do not know who decided that Miranda should go to Cambridge to attend school or why they chose the Washington Grammar School. Perhaps, as a later newspaper writer claimed, she was sent away from segregated schools at home—"exiled to find common justice"—but I have no idea if she shared that view.[6] Surely Aunt Cordelia's friendship with Louisa Jacobs played a role, for Miranda boarded with Louisa's sister-in-law and knew these women as friends and mentors; both Louisa and her mother signed Miranda's autograph book, a gift from Uncle Richard. "Precept is good but example is better," wrote Louisa on July 2, 1877, and that same day Harriet Jacobs wrote and signed, "Trust and be hopeful." According to her brother Oliver's later admiring account, Miranda was an "accomplished musician," who studied at the Boston Conservatory; like her long-ago (Southern, white, male) relatives, she too would serve as church organist, at Philadelphia's Church of the Crucifixion and at St. Thomas's Church.[7]

Whether exile or adventure, in July 1877 Miranda Venning graduated from the second class of the Washington Grammar School. On the back of her certificate Daniel Mansfield (possibly her first white teacher) wrote, "Promoted on Examination, & would have entered the first class if she had returned." By then, she was ready to move on and she entered Philadelphia's Robert Vaux Grammar School, whose principal was her family's friend Jacob C. White Jr. Never absent, late, or marked for misconduct (though on occasion she did recite her lessons "indifferently"), her grades ranged from "meritorious" to "distinguished," and she was soon admitted to the Girls' Normal School, later the Philadelphia High School for Girls. She would hereafter be referred to as "the first colored girl who had the courage and determination" to graduate from Girls' High, in 1882.[8]

It is hard to measure how much "courage and determination" this took, but simply being admitted involved some conflict. In 1878, a letter to the editor of the *Record* reported on "The Colored Competition" that had taken place the previous day at the Normal School. Apparently a few low scores had been used to exclude two "colored *scholars* (the children of taxed citizens of Philadelphia)," from "intellectual and respectable families, who understand scholarly attainments and averages belonging thereto, and understand perfectly the capacities of the scholars whom they allowed to go into the examination of the Philadelphia

High School." One of the two "who was passed by in this city has been a successful and appreciated pupil for several years in the 'Washington grammar school' at Cambridge, Mass., and has in her possession testimonials thereof. . . . Returning home to complete, she sought access first to a Philadelphia grammar school, from thence to the Girls' Normal, where she was led to think she might find fair play. The result has just been shown." The letter was signed "Suspicion." Miranda was soon admitted; I do not know who the other "colored scholar" was. Miranda's family followed her successes, and challenges, closely and with pride. So too did the larger African American community in Philadelphia. Indeed, her father's obituary, after detailing his accomplishments as a carpenter, further measured his legacy by noting that "one of his daughters, Miss Miranda Venning, was the first colored graduate of the Girls' Normal School. She is now a teacher in the Haines Street School, Germantown, and another daughter is teaching in the South."[9]

For Miranda Venning, debates about desegregating public education were literally close to home. In 1881, in the wake of Willie Chew's and her father's lawsuit, Philadelphia's previously white public schools became open to Black children. ("It is a singular coincidence," wrote William Bolivar in his Pencil Pusher column, "that the brother of . . . [Miranda Venning] was the first colored boy to enter a public primary school.") But just as Louisa Jacobs feared, white school boards refused to hire African Americans to teach white children. William Byrd, a longtime Germantown resident and activist, "did not want Black children to attend the new integrated Emlen School because he feared it would put the Black teachers at the Hill School out of work." Indeed, throughout Miranda's life, as W. E. B. Du Bois put it, "no Negro has been appointed to a permanent position outside the few colored schools." African American children continued to attend the Hill School, which, in the tradition of the Fortens and the ICY, hired only African American teachers. Miranda benefited from this commitment, as she was "now efficiently filling the position of principal of the Joseph E. Hill (colored) School, on Price Street, Germantown."[10] Until her death in 1900, she taught African American children in the all-Black public schools that were proud to hire her.

Miranda Venning struck quite a public presence, and her death at age thirty-seven was a great loss. She had often been ill, occasionally asking her sister Sallie to teach as her substitute. "Rannie taken very sick," Sallie reported tersely in her journal. "Sent for Dr."[11] Still, she taught and led the school, helped direct musical performances at church, and

socialized with friends and family. And her death seemed sudden. "My darling Ran," wrote William Bolivar, Miranda's own "loving cousin, Billy," "You must steel yourself so as to fight any nervousness—You never was a coward & don't begin now—if you do I'll consider you don't love me." She died three days later. The *Germantown Guide*'s obituary noted that Miranda C. Venning, "the first colored graduate of the Girls' High School," died at her home at 1116 Fitzwater Street "after a brief illness of heart disease." Newspapers as far away as the *Portland Morning Oregonian* mentioned her death when they highlighted the "Public Education of Colored Children."[12]

Julia E. Venning (1864–1891) was presumably that "other daughter" mentioned in Edward Venning's 1884 obituary, a phrase that, given her big sister's successes, may have rankled. With Miranda she attended Margaretta Forten's school and the ICY, but she did not go to Massachusetts. She received some local notice when she played a piano solo at the "Concert and Exhibition by the Sabbath School of St. Thomas' P.E. Church" in 1877. Later she sang a solo and served as secretary of the Young People's Association of the Church of the Crucifixion; Miranda was the assistant musical director. And in the spring of 1881 new ICY graduate Julia Venning was one of two winners of the English prize, gaining her fifteen dollars and yet another mention in the paper.[13] Numerous such programs remain in the family papers, evidence of the pride Miranda's and Julia's academic and musical talents elicited at home.

If Julia was teaching in the South in 1884, as her father's obituary suggested, she returned home soon after and left no evidence of her experience. Tiny hints suggest that she did not stick to the path her parents preferred, though she took perhaps a more conventional one. "You have heard of Julia Venning's marriage?" queried Annie Purvis (a Charleston native and member of Philadelphia's African American elite) in 1885. "Her Mother I hear is much grieved over her marrying the way she did." Like Purvis, I would love to know "any of the particulars" and to decide whether we should "feel so sorry for the poor Mother" and "wonder why girls act so queer."[14] But there is no way to know whether Julia Sanders Venning's unhappiness with her daughter's marriage was with the timing, the ceremony, or the man himself.

Nothing in the bits of evidence about Julia's husband, James E. Warwick, explains her mother's dismay. Born in Virginia in 1860, he, his mother, and his two sisters migrated north. In 1900 he told the census

taker that his father was born in England, but later documents suggest that Abraham Warwick, like his mother, Martha Clarke Warwick, was from Virginia. I have no idea whether his father was Black, whether his parents were born enslaved or free, or what happened to Abraham, but when Martha died in 1893 she was a sixty-three-year-old widowed homemaker living on Erie Street and was buried—along with so many others in this story—in Lebanon Cemetery. James himself would become a bookkeeper and then a postal clerk, earning $600 by 1897 and, a few years later, working alongside his sister as "stationers" on South Eleventh Street. Indeed, W. E. B. Du Bois surely referred to him when he quoted an observer's compliments about "the most tasteful and enterprising stationery and periodical store" on that street, run by a "keen-looking pleasant young man" and his sister. There is nothing in these details to explain why Julia's marrying him was proof that "girls act so queer."[15]

James Warwick probably met the Venning girls at the Church of the Crucifixion, one of the Black churches with which the Sanders family associated. In the summer of 1881, the church's Young People's Association held its annual assembly. Among the participants were a Mr. James Warwick (who sang a duet with Miss Mamie Lindsay) and seventeen-year-old Miss Julia Venning, who sang "She Is So Innocent." When he and Julia became close is impossible to know, but they married four years later. In the meantime, Warwick still sang: in 1882, as a member of the Scientific and Art Association of Philadelphia, he was part of a singing quartet.[16]

I do not know where Julia and James Warwick lived; along with many other Pennsylvanians their section of the 1890 census was destroyed in a 1921 fire. Within a year of their marriage they had a daughter, Florence Irene, and Elizabeth Venning two years later.

Given Julia Sanders Venning's practice of naming her daughters after her sisters, I had wondered why there was no child named Florence, whose birth led to Sarah Martha Sanders's death and who herself died in Charleston four years later. Perhaps, I thought, this death was simply too painful for Julia, who must (at age thirteen) have cared for her sister even as she faced the loss of their mother. Much later I realized that Julia's daughter had chosen that name for her own daughter, her mother's first grandchild. Perhaps Julie Warwick soothed her mother's unease about her marriage by naming her baby after Sarah Martha Sanders's last child. But clearly Julia Sanders Venning had passed along family memories to her children, whose own names echoed her many losses.

Whatever her mother's concerns, there was no lasting estrangement. Julie Warwick visited the Venning clan ("Julie and the children [were] here," her younger sister Sallie would remark). And in the summer of 1891, Julie and her small daughters joined the family on the Jersey Shore for a couple of weeks that Sallie pronounced "a fine time." When her husband makes a rare appearance in his sister-in-law's diary, it is rather formally as "James Warwick."[17]

But whatever the family's ambivalence about Julia's decisions, there was nowhere near enough time for resentments and reconciliations. Julia Venning Warwick was "taken sick with pneumonia" during the autumn after the trip to the beach; "Momma," Sallie reported, was "there all day." But the twenty-seven-year old died within the week. "Julie died 1 A.M.," Sallie reported tersely. "Very sad affair leave two children" and, three days later, "Buried Julie a very nice funeral." For her mother the parallels were wrenching. A dozen years earlier Julia Sanders Venning had lost her sister Cordelia, also after six years of marriage and the mother of two small children. But Elizabeth and Florence did not move into 1116 Fitzwater as their widowed uncle Willie and his sons had. Instead, they lived with their father and his sisters on South Eleventh Street, not far away; sadly, he outlived them both.[18] True to her family's long history, Florence Warwick appears as the accompanist at a "Grand Concert" to benefit the Child's Welfare League in 1918. An "accomplished pianist" who died at thirty-three, she was both a teacher at the James Pollock public school (erected in 1854 close to home on Fitzwater near Fifteenth Street) and an assistant in her father's shop. Her sister, who died even younger, was also recalled for her "musical talent."[19]

In age order, Oliver comes next. But let us stick to the girls for now.

Miranda and Julia's next living sister, Sarah (Sallie) Venning (1872–1959), offers another kind of historical source, with a sprightlier version of teenage life. In terse journal entries covering 1890–92 that listed the weather ("Fair") and the day's summary ("Sewing all day. Ironed after supper. Mamma and Aunt Mattie out" or "Helped Clara to wash"), she offers some insight into the labor, recreation, and friendships of a world closer to our own.[20]

As in many nineteenth-century journals, there is little deep emotion here. At her most effusive, and only very occasionally, Sallie Venning underlined her favorite adjective, "fine." But she offered a litany of family, friends, social activities, paid work, and household chores. Sallie

was neither rich nor leisured, but amid her ironing, sewing, teaching, and going to concert rehearsals, she fit in a great deal of visiting and attending concerts. Sometimes there was dancing school. Very rarely a personal event seemed worth a remark: "Louise had her hair all cut off," she reported of her eleven-year-old sister or "Bangs cut by Cokine. Very fine."[21] Occasionally there would be "Pictures taken" and received. Evening activities went surprisingly late: "Dancing School Sociable with Will Holden," she noted. "A fine time. Retired 3 a.m." (on a *Tuesday*!)[22] At the end of the year a "Memorandum" listed her expenses: small debts incurred and crossed off as they were paid. The journal also served as her address book: Willie H. Chew at 1790 Massachusetts Avenue and Louisa Jacobs at 1900 R Street in Washington, DC, for instance; Will Holden at 1130 South Seventh Street and Fred Dutton on Fitzwater in Philadelphia.

Like her sisters, Sallie taught, though at first not in a formal position. "Taught school for Ran [Miranda] she sick," she would note or, the next fall, "Public School opens. Taught school for Rannie," followed by days "Out to school." Early the following year, "Taught school, Rannie still sick."[23] Other times she noted, simply, "Work as usually," suggesting that she did not record all her labors, paid or not. Throughout May 1891 she referred almost daily to being "Still at School" or to an event there. That fall, at nineteen, she "Wrote application for Rannie's school," and, while Rannie was sick, "Taught day & night," seeming exhausted by the winter break. The following spring she noted that she had been at the "Joseph E. Hill School. A large time in Germantown." Perhaps she had gotten permanent employment, commuting with her sister by streetcar. She also taught, or took, millinery classes, which met on Thursdays through 1891.[24]

Sallie and her sisters attended one or more Episcopal churches as well as other public happenings—although, like much of the family, they almost never referred to religious faith or practice. "Went to Central's fair" and, with Louise, to a "Catholic fair" as well. The laying of the cornerstone at the new ground for St. Thomas's Church was "Very fine," as was the church's weeklong fair, the "boys fair," and the fair at Crucifixion.[25] Other outings were primarily social or literary. In early 1891 a group met at Blanche Songow's, where Sallie considered an "Election of officers very good," noting "Sec. Sallie Venning." The "Fern Leaf" club met again a month later at Anna Banton's house and twice in April at Addie Cooper's. After a summer break, the "Fern Leaf Social & Mystic met here. A very good meeting," although the attendance of "only 4 of us" was unusual enough to remark upon.[26] (The group's seven members

would declare the club "abandoned" on the occasion of Mabel Duncan's marriage.) Less regular comments note an "Educational Club" and a "King's Daughters meeting," which was "very large."[27]

Sallie Venning frequently "red [read] all day," though she never mentions what she read. Just that year, Thomas Hardy, Oscar Wilde, and Arthur Conan Doyle published books that we still read today; perhaps she had already gotten through the "eight volumes of standard literature" that her aunt Cordelia had received from her Brooklyn students when she left—but I have no idea where Sallie's tastes lay. In any case she was drawn to books, heading "Down to Parish Building to fix Library." A decade later, she was established as the librarian at the Church of the Crucifixion on Bainbridge Street. Arranging books one day, she smelled burning wood. She helped get all the Sunday school children out of the building, but, as the newspaper reported, the church itself "was completely destroyed by fire yesterday afternoon."[28]

In the summer, there was the Jersey Shore. "Beach in morning fun all day," she wrote during a weeklong vacation with friends and family and again, for a longer span, the next July. A free-floating group of friends from Philadelphia, Brooklyn, and the Shore itself filled those weeks. Family members came and went.[29] Sometimes friends became part of the family, as in the case of Julia Capps, who would marry Sallie's brother George Edward Venning. Fishing parties, bathing, cooking crabs, a "Yacht party"—these were pleasures and labors associated with someone solidly in the urban middle class.[30]

As in Philadelphia, African Americans at the Jersey Shore faced both opportunity and restriction, and here, too, the Sanders family, regular visitors, left behind scant commentary. As leisure and commercial activity expanded after the Civil War, several beach communities drew sizable populations of African Americans. Cape May's in particular would grow considerably by the 1920s, including many year-round residents, who owned a majority of its shops and restaurants. As early as 1869 an "Impromptu Meeting of Guests of the Banneker House" on Cape [May] Island had applauded the house's owners for offering not only splendid accommodations but "the only summer resort where we can enjoy the same rights and privileges (unmolested) as other citizens." The secretary of the assemblage was listed as twenty-year-old R. DeReef Venning.[31] It is entirely possible that this is where Sarah Ann Sanders spent her beach vacation in 1866. By the final decades of the century the Shore saw both growing numbers of Black beachgoers and frequent challenges to their "rights and privileges."

Other towns had been founded along denominational (and religiously conservative) lines. In Asbury Park, members of the African Methodist Episcopal Church, as well as workers in the town's hotels and restaurants, expanded its Black population. Throughout the 1880s, conflict over public space emerged, as African Americans asserted their right to be fully included in the resort town's spaces of commercialized leisure. Newspapers throughout the country declared Asbury Park a microcosm of the nation's—and especially the North's—struggle to grapple with the consequences and limitations of emancipation and constitutional rights. "Color Line at Asbury Park," reported the *New York Times* in 1887: "Negroes Indignant at Threatened Exclusion from the Beach." By decade's end, the *Times* had declared the issue "settled," attributing the advent of what one historian has called "Jim Crow, New Jersey," to "the presumption of some of the colored people who offensively assert themselves where they are not wanted."[32]

Most likely Sallie Sanders Venning and her friends went to Atlantic City, fifty miles north and on a direct railroad line from Philadelphia. Indeed, Julia Capps appears in Sallie's address book at 1004 Atlantic Avenue, although her family also lived in Philadelphia. Atlantic City had long attracted white and African American tourists who had the means to patronize its boardinghouses, restaurants, and shops. It was not yet in the heyday that followed World War I, when it offered middle-class tourists the "Boardwalk of Dreams." Still, the early 1890s were relatively open and carefree, and the Sanderses left no impression that anyone had suggested they did not belong. Within a decade, white hotel patrons began to complain about "the matter of colored bathers." From then until the middle of the century, de facto segregation took effect, with "Chicken Bone Beach" becoming the epithet for the Missouri Avenue beach assigned to African Americans.[33]

Sallie Venning's family ties were close and familiar. "Dick," she reported in 1891, referring to her twenty-year-old cousin Richard Sanders Chew, "tried his luck at university." In the wake of her sister Julie Warwick's death she spent birthdays with her nieces: "Florince's birthday. 6 years old. A number of presents," and "Lizzie's birthday, 4 years old."[34] Some of her silences evoke dark periods: November 1892 is largely blank except for "One year Julie has been dead." Other comments are more cryptic. "Mollie's in afternoon. Lawyer Randolph there. Trouble at Home." And, in the days after Julie's death and funeral, there were other, unnamed, concerns: "A sad house trouble with Bobby," she wrote.[35] That Thanksgiving was "a very sad one." She barely wrote again

until, in late June, she traveled to Cleveland, Ohio, by the overnight train; her companion, "Miss Chew," was likely her uncle Willie Chew's sister. There, over several months, she made an entirely new group of friends—and perhaps beaus. Their names—but so little about them— are dutifully included in that year's address book: Clarence Williams on Blair Street, Ed Williams on Grant Street, Clara Denver on Henry. Letters and packages from Cleveland pepper her entries. "The summer in Cleveland and long to be remembered 1892. Clara, Clid, Ed. & Sallie. Big 4." Sallie's months away from home were for pleasure, not work.[36]

Sallie Venning's diary offers its own whispers in the form of euphemisms. Throughout, she regularly inserts the phrase "War of Roses." Archivist (and diary transcriber) Krystal Appiah, having searched for performances or associations or anything else that would explain that phrase, finally, and brilliantly, counted its frequency. She suggests that it referred to Sallie's menstruation—especially since it was often followed by "terrable time" or "not so bad" or "very bad. . . . Sick rest of the day." It rarely interfered with her nights out or having visitors.[37]

The main tone, and pace, of Sallie Venning's diary suggests quotidian teenage pleasures amid work and family difficulties. Boys were ever-present. The seventeen-year-old's very first diary entry noted that "C. Able & W. Holden were here." "Will Holden came home with me very good" was, for her, unusual commentary, or "Will Holden here spent the evening." William Brown Holden was simply one of the young people, male and female both, floating in and through her days, a steady presence. Others appeared regularly: "F. D.," Fred Dutton, "came home with me. First time," a fairly new addition to the group. Sometimes plans changed; once she wrote, "Dancing School. Engaged to Will Holden for the evening," and then crossed his name out and wrote in its place, "Fred Dutton." Some alternating between the two young men to and from dances commenced; others, including Tom Dorsey, also regularly escorted her or spent the evening at the house on Fitzwater.[38]

Still, the gap of a decade is frustrating. In 1903, thirteen years after she began the diary, at just past the age of thirty, Sallie Venning married Will Holden at the Church of the Crucifixion, with a celebration at 1116 Fitzwater.[39] Holden, too, was born in Philadelphia in 1872, though his father was born in Virginia. By the time he was eight he lived with his mother, a Pennsylvania native, and two sisters. A bank steward and then a caterer, censuses list him variably as "mulatto," "black," and "colored." I know little about Will and Sallie's relationship, other than its length, that they had no children, and that they lived with, or close to, Sallie's

siblings and cousins. In family memory, Will Holden was one of the family's intellectuals, a holder of soirees, and an acquaintance of such notables as W. E. B. Du Bois. When he died in 1928 at age fifty-six, cards and resolutions poured in mourning his loss and giving a small sense of his own busy social and civic life. While Sallie Holden was the longtime and much-beloved "Chairman" of the southwest branch of the YWCA of Philadelphia, Will was recalled as the "highly honored president" of a men's social club, "the Henpecks," "an efficient executive, four-square at all times in his dealings with his fellow men, and ever mindful of the little niceties of attitude that make for kind feelings and courtesies."[40]

If Sallie Holden kept a journal throughout her married life, she either destroyed or lost it. But some years after Will's death, at age sixty-three, she documented her daily life in the same prosaic tone but with a greater focus on the past: "Rannie dead 35 years," she noted, or "Will's birthday" or "Mamma's birthday." Election day was "very exciting," and "Armistice Day" was a "holiday for some." By then, she took vacations at the Hotel Comfort in Ocean City, New Jersey, where, she (somewhat snootily) told her younger sister, she saw "any number of people that we knew and hundreds that we didn't know nor care to meet."[41]

Perhaps Sallie Venning Holden does offer a clue to a question I have pondered throughout this project: how this first generation of Philadelphia-born Sanderses viewed their family's journey. What had they been told about Richard Cogdell's relationship with their enslaved grandmother, Sarah Martha Sanders? Were the labels that we might use—enslaver, rapist, concubine, mistress—in their vocabularies? Did they discuss the traumas and loyalties that shaped their grandparents' story and pass on those historical memories to their own children, or did they choose silence? There are few clues except, of course, for someone's decision not to destroy boxes of their ancestors' papers; we will never know what did get tossed out along the way. But according to Sanders descendants, Sallie Venning Holden, born six years after her grandfather's death, destroyed the only picture of Richard Walpole Cogdell that was in the family's possession. Whether she did this just after learning his, and Sarah Martha's, story, whether she released a long-standing rage, or, indeed, whether the story is true, we will never know.

The last child of this first Philadelphia-born generation, Louisa Sanders Venning (1879–1923), was born the year her aunt Cordelia Sanders Chew died and may have been named for Delia's friend Louisa Jacobs.

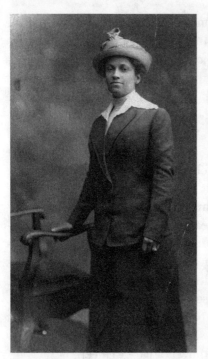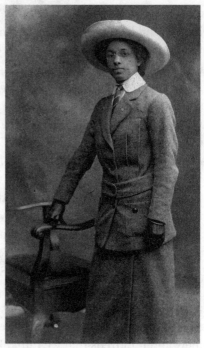

Left, Sallie Venning (Holden) (1872–1959); *right,* Louisa Sanders Venning (1879–1923). P. 2014.51.16 and P.9367.9, Stevens-Cogdell-Sanders-Venning-Chew Collection, Library Company of Philadelphia.

Certainly the chasm between the Louisa born into slavery and this postwar Philadelphian exemplified a new century. For one thing, she was the baby, a charge or a pet in her older sister Sallie's journal. "Louise goes to the Grammar School. 3rd [and] Catherine," Sallie reported in 1890. Long after the others had left home, Louisa lived with her uncle Robert, her mother, and Aunt Mattie at 1116 Fitzwater. Small calling cards indicate that she, and friends, would be "At Home" to receive visitors.[42] Like her sisters, Louisa became a teacher. Like them, too, she remained close. After the family sold 1116 Fitzwater in 1913, the thirty-four-year-old joined her remaining siblings, George Venning's family, and her uncle Richard DeReef Venning on the 2100 block of Fitzwater, about a mile west.

Louisa's life lacked the drama of her mother's migration from Charleston to Philadelphia. Nor did her entry into the South Philadelphia High School for Girls demand the grit of her sister Miranda, seventeen years her senior. Yet Louisa, too, crossed into a new era. For one thing, by the 1920s, she drove a car. Writing to her sister Sallie from

Ocean City, she told of her plans to return home after four weeks. "I am depending on Ella to come down and drive us home," she noted, offering as explanation, "I am driving very well but would not trust myself on the Whitehorse Pike as there is a great crowd there during this time of the year." Indeed, her estate's inventory included a Star sedan, built by the Durant Motors Company, along with real estate and other goods, leaving an impressive teacher's estate of some $10,000.[43]

Louisa also offers a tiny but fascinating glimpse into her community's place in the twentieth-century movement for women's rights. In 1919, now forty and a teacher, she served as an officer in an institutional relief organization's performance of *The International Congress of Women*. Set in Norway two years in the future, this fictional convention (which starred Marian Anderson) is both genteel and sardonic—and pointed in its political critique. The Great War has ended, and the women "of the civilized countries of the world" are meeting both to discuss "the peculiar problems of her own land" and to advance "liberty, equality and fraternity for women everywhere." Justice guards the door to ensure that "no one will be admitted who is not willing to give to all in her country the privilege which she asks for herself." Of all the "civilized" nations, only one group is denied admission: "The American white woman who asks for sectional Suffrage." Just in case anyone missed the point, the program went on: "Her request is denied until she brings with her the American colored woman, who joins with her in the request for the Susan B. Anthony amendment to the constitution of the United States which will give suffrage to every woman in the country without regard to section, race or creed."[44] A year later, the African American women of Louisa Venning's Philadelphia community, but not those of her mother's South Carolina birthplace, gained the vote. Although Louisa died in 1923, I like to think that she voted several times.

There were three boys amid all these Venning sisters, two of whom survived to adulthood. Edward and Julia Sanders Venning's sons remained close to home and devoted to their aging aunts and uncles. Oliver Cassey Venning (1870–1943), who had joined his cousins at a previously all-white public school, worked as a waiter and lived with his sister Sallie. A great admirer of his big sister Miranda, Oliver penned a short biography of her for Helen Lee Pinkett of the Federal Writers' Project's "Negro Unit."

Oliver Cassey Venning (1870–1943) and his new dog.
P.9367.40, Stevens-Cogdell-Sanders-Venning-Chew Collection,
Library Company of Philadelphia.

In 1910, the year their mother, Julia Sanders Venning, died, Oliver's brother George Edward Venning (1874–1965) is listed as the household head at 1116 Fitzwater; like his uncle Robert, he lived among women, including his aunt Martha Sanders, Louisa Venning, and George and Julia Capps Venning's three daughters. It would be Julia Sanders Venning's four living children, George, Oliver, Sallie, and Louisa, who decided to sell 1116 Fitzwater after Aunt Martha's death three years later. And it fell to George to deal with his grandfather Edward W. Venning's property at 910 Rodman Street, condemned in 1937 and ordered demolished, "cellar filled up and the integrity of the party wall maintained." W. E. B Du Bois offered both commentary about misguided urban development in that neighborhood and a window into the prejudices of his class. "Streets like Rodman and Juniper were nearly ruined," he noted, "and property which the thrifty Negroes had bought here greatly depreciated" by the "attempted clearing out of the slums of the Fifth Ward." It is certainly plausible that the Sanderses and Vennings—those "thrifty Negroes"—shared Du Bois's disdain for recent arrivals in their old neighborhood and agreed that "it is not well to clear a cess-pool until one knows where the refuse can be disposed of without general harm."[45] Throughout, the next generation remained close. When the census taker came by his house ten years after his mother's death, George (now a US mail carrier) lived with the extended Sanders clan, as well as their seventy-one-year-old uncle Richard DeReef Venning, at 2107 Fitzwater. More than eighty years after Richard Cogdell purchased a house on Fitzwater Street for his children, three of his grandchildren lived together barely a mile west, with another grandson, Charles Chew, across the street.

Cousins Charles Chew (1873–1954) and George Venning's relationship echoed their parents'. Born a year apart, they had nearly always lived together. After Charles's mother, Cordelia Sanders Chew, died, six-year-old Charles and his older brother, Richard, remained at 1116 Fitzwater. With their cousin Oliver (and possibly Sallie) Venning, they integrated Philadelphia's public schools. After high school Charles found steady work as a waiter for the railroad and later owned and managed a shop as a "decorator." He and his wife, Georgine R. Saunders (an inconvenient last name for anyone trying to keep track of the Sanders family), and soon their daughters, Agnes and Cordelia, lived with Georgine's sisters Agnes Saunders and Susan R. Williams and Susan's husband, John. At twenty-eight, Charles was baptized at the Church of the Crucifixion, where his parents and his brother had married. At

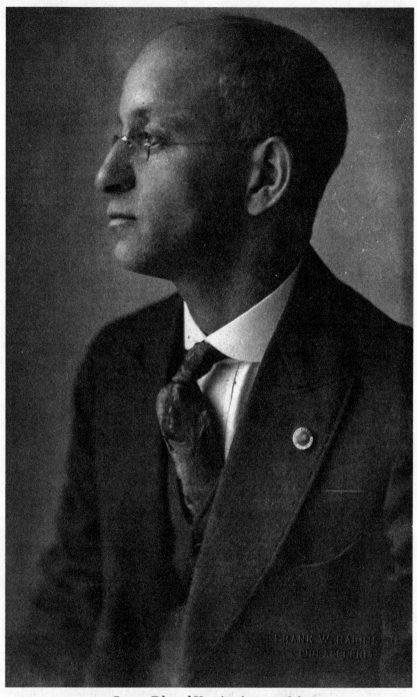

George Edward Venning (1874–1965).
P.9367.17, Stevens-Cogdell-Sanders-Venning-Chew Collection,
Library Company of Philadelphia.

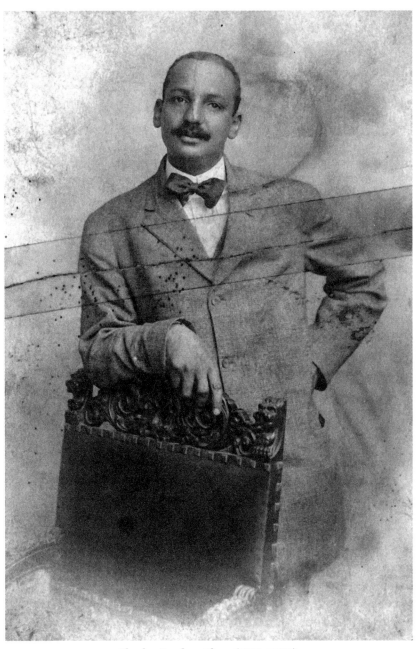

Charles Sanders Chew (1873–1954).
P.9367.45, Stevens-Cogdell-Sanders-Venning-Chew Collection,
Library Company of Philadelphia.

the start of World War I, at age forty-five, tall and of medium build, he, along with his cousin George, duly registered for the draft.[46]

The Vennings and Chews were remarkably close; when they joined in the African American community's cultural, social, and musical activities, they did so together. Programs they saved—of concerts, club meetings, and variety shows—fill several files in the family papers. Like their sisters, the men joined one another in various clubs, including the "Bachelor-Benedict Club," which was not, apparently, restricted to unmarried men.[47] George and Charles—along with Charles's brother-in-law John Williams and Sallie's husband, William Holden—served on committees for the 1921 "Triumphant Return of the Soap Box Minstrel" in Atlantic City and "O'boy! Academy of Music" in Philadelphia.[48] In middle age, they still lived across from each other at 2116 and 2107 Fitzwater. Their daughters grew up alongside one another; together each family grieved for a baby who died. Like the adults, children moved easily between the houses; in 1910, twelve-year-old Cordelia Chew was counted as living with her cousins' family when the census taker visited. These households were financially stable, with Charles and his brother-in-law John Williams making enough in selling a house to travel to Europe in the early 1930s to visit Charles's daughter Cordelia, her doctor husband DeHaven Hinkson, and their two small daughters. When Charles Chew—"Papoo" to his granddaughters—died in 1954, he left memories of Rhode Island vacations, "sitting in that chair on our porch at 'Dweedle-Dee'—drumming his fingers, thinking about what to do next."[49] When his wife, Georgine Chew, died in 1963 at eighty-eight, she still lived at 2116 Fitzwater, ten blocks west of the Fitzwater house that her husband's grandfather had purchased more than a century earlier.

Charles's brother, Richard, made another choice, one that resisted the family's, and Fitzwater's, pull. Richard Sanders Chew (1871–1962) was eight when his mother died and his father floundered. Following his father's and uncle's success at integrating Philadelphia's public schools, he excelled as a student, becoming the first in the family to go to college, an overwhelmingly white one at that. In 1895 he received a bachelor of science degree from the University of Pennsylvania; one year later he submitted his thesis and received the "technical degree" of civil engineer. I do not know if any of Richard Sanders Chew's family attended Penn's 1895 commencement at the American Academy of Music on June 11, which the *Philadelphia Inquirer* declared "more than ordinarily brilliant." But surely they recognized his achievements. When W. E. B. Du Bois listed the occupations of the surviving graduates of

the Institute for Colored Youth, alongside the 117 teachers was exactly one "civil engineer."[50]

Richard Sanders Chew was proud to have gone to Penn, for he remained in touch with his alma mater, counting himself among "The Men of Ninety-Five" in its fiftieth-anniversary booklet and donating money through the early 1950s. A respected engineer in California, his "notable treatise" on the effects of earthquakes on "framed structures" sits in Penn's alumni files.[51] Indeed, many of the letters that comprise the family papers are pasted into a scrapbook, forming an actual palimpsest, over Richard's engineering tables and drawings.

But there is another, likely intentional, silence. The University of Pennsylvania did not keep early records about the race of its students, and yearbooks did not include pictures until 1902. Still, someone attempted a tally. Labeled "*SOME* (only) EARLY BLACK STUDENTS AT UNIVERSITY OF PENNSYLVANIA," a typescript in the university archives begins with William Adger Jr.'s, Nathan Mossell's, and James Brister's enrollment in 1879. The Sanders family knew at least some of these men. (Adger was an 1875 graduate of the ICY, and when he died in 1885, members of the Sanders family likely attended his funeral at the Church of the Crucifixion.) But Richard Sanders Chew is not on the list, and I could find no other document at the University of Pennsylvania that hints at his race, suggesting that he passed as white—either purposely or implicitly. Perhaps the University of Pennsylvania was so insular that people simply did not notice that he was a local boy from a well-regarded African American family. It is unlikely that he shared the experience that his Boston contemporary William Monroe Trotter had at Harvard, where an African American student community of "future political leaders" "ate at each other's homes, danced together at private parties, and took excursions down the bay."[52] Maybe it was in college that Richard learned, by intent or osmosis, of another path for an educated light-skinned African American of his time.

Only Richard Sanders Chew was named after both his grandparents Sarah Martha Sanders and Richard Cogdell. But whether he viewed his name with pride, irony, or indifference, he journeyed far from Fitzwater Street. In 1895, the year he graduated, he married Josephine Reynolds (McKinley) in the Church of the Crucifixion, a Black church, where his parents had been married twenty-five years earlier. I know little about his wife. The 1900 census claims she was born in Mississippi in 1870 and that she was white; the one image I have seen of her makes that seem unlikely. She told the census taker that she was the mother of one

child, though of no living one; an earlier marriage would explain her having more than one last name. The possibilities of racial ambiguity—even passing—may help explain the couple's decisions, as increasingly they moved outside of the Sanderses' orbit.

At first Richard Chew considered an academic career, for he taught in 1903–4 at Lehigh University. A photograph of the engineering students of that year—all apparently white and male—includes four faculty members and a rather grim-looking department head. Among them is Richard, appearing, as an earlier generation might have said, "swarthy." Perhaps no one raised questions about his racial background. The white men who ran, taught at, and attended Lehigh saw what they expected to see, which did not include a Black, Penn-educated engineer. Or perhaps they did notice and objected, accounting for Richard's short tenure at the college; maybe Bethlehem, Pennsylvania, was just too small. The following year, the couple moved to San Francisco, where they lived in a series of boardinghouses: Richard worked as an engineer and Josephine composed music. Her extant picture, in fact, is on the cover of a score she had composed called *We Will Meet Again Some Day*.[53] They were in San Francisco for the 1906 earthquake, whose ramifications shaped the rest of Richard's career.

With its large population of immigrants and its minuscule Black community, California—and especially San Francisco—was an ideal place to reinvent oneself. Richard told the census takers that he and his parents were from Louisiana, a plausible birthplace for someone who wanted to suggest some racial ambiguity. Recorded as "black" in the 1920 census, he appears in 1930 as "white." By then, although he said he was married, there was no wife present. Richard remained in touch with his family, visiting and writing letters. One, to his grandniece Cordelia (Betty) Hinkson, almost parodies the meaning of "avuncular," advising her that "there is one attribute that the American people lack but which subconsciously they recognize and admire and that is Culture. I strongly advise you cultivate it."[54] But whatever his familial ties, Richard had moved into a white world. In 1940 Richard Sanders Chew, a "white" widower and structural engineer from Louisiana, lived in a boardinghouse on Sutter Street, whose seventy-plus boarders, many of them single or divorced women, were also listed as white. Like his grandfather and namesake, he lived in a hotel that allowed or required him to maintain several lives. Whoever filled out his 1962 death notice had the notion that he had been born in Michigan, though an obituary in the *San Francisco Examiner* believed him to be a native of

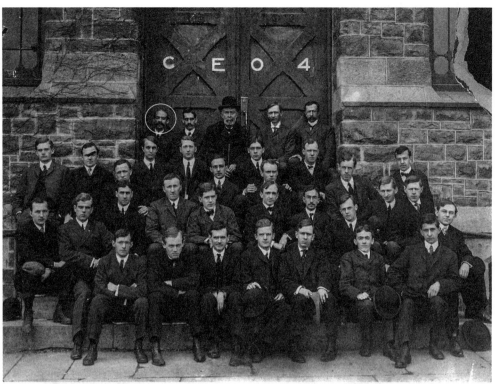

Lehigh engineering faculty and students, 1903;
top left, Richard Sanders Chew. Special Collections,
Lehigh University Libraries, Bethlehem,
Pennsylvania.

Mississippi.[55] Facts aside, California was for him, as Philadelphia had been for his mother, aunts, and uncle, a new beginning. I do not know what Charles Chew thought of his older brother, or whether he ever resented his academic achievements, but they remained close, and the family looked forward to Uncle Richard's visits. Whatever their ambivalence about his choices, they honored Richard's decision to pass, discreetly remaining in the background when he stayed in a local hotel or met with his white associates.

In her brilliantly imaginative book about the intimate lives of African American women and girls in turn-of-the-twentieth-century

Richard Sanders Chew (1871–1962).
P.9367.49, Stevens-Cogdell-Sanders-Venning-Chew Collection,
Library Company of Philadelphia.

Philadelphia and New York, Saidiya Hartman notes, "The domestic offers no refuge."[56] I think for the Sanders family it did just that to an astonishing degree. They lived collectively for half a century, the house at 1116 Fitzwater both magnet and shelter for Richard Cogdell's children, in-laws, grandchildren, and even great-grandchildren. There is no need to romanticize their relationships—disputes must have arisen about household matters, about Robert's and Martha's roles as doting uncle and aunt, about money, about space. What, after all, did the young Sallie Venning mean by "A sad house trouble with Bobby"? Perhaps family members resented one another's accomplishments, or their travels. Certainly death was a frequent and tragic presence. As the offspring of a slave owner and a young woman he enslaved, children whose mother died when they were young and whose father displaced, or released, them from their familiar surroundings, the traumas of the generation that made the journey to Philadelphia are hard to imagine, as are the role models they had in view.

Richard Cogdell's sons-in-law, though they came from large families, became part of the Sanderses' orbit. Neither Edward Venning nor Willie Chew seems to have challenged their wives' relationships to their siblings or father or exerted a strong enough pull to yank their families from 1116 Fitzwater; aside from that one (temporary) foray to a new house on Dean Street, there is no evidence that they tried. Willie moved back to the house after Cordelia's death, and five years later Edward Y. Venning died there. Perhaps Willie felt ordinary alongside Delia's splendidness or an outsider among her siblings; perhaps Edward kept his and his father's carpentry business separate from domestic life; maybe they envied the Sanders women's educational achievements or their bonds. Certainly they worked together in local educational activism. But whatever conversations or resentments these men had—about their wives, about their brother-in-law Robert, about the paths the family had taken—must be left to the imagination.

With their own family established in Philadelphia, the Civil War long over, Richard Cogdell dead, and Jim Crow firmly in place in the South, did the Sanders family give even a passing thought to what was happening back in Charleston? Given the evidence we have, it is impossible to know, though Martha Sanders's obituary notice (asking the Charleston papers to republish it) suggests she at least kept some ties there, that someone in Charleston would have remarked on her death. What

different histories can be drawn from the several strands of Stevens descendants, and what would they have thought of one another? Could they imagine, or be interested in, or relate to their very different journeys? How, finally, might it reshape American history to weave their stories together, rather than leaving them side by side?

After the Civil War, Peter Fayssoux Stevens and his wife, Mary Capers Stevens, along with their children, embarked upon a somewhat peripatetic life, living, as many white Southerners saw it, in a "world turned upside down." Even before the war, with $1,800 in real estate, Peter was far less wealthy than his older brother Clement, and he may have taken some time to recover, both from the deaths of his brothers and from the loss of his property. The couple do not appear in the 1870 census, probably because they were not settled in their own home; a year later they moved to South Santee, a small town some fifty miles from Charleston, for the winter because Mary "says it is too lonely at St. Stephens." Here the ordinary realities of life ("She has the tiniest baby I ever saw, two weeks old. It looks too little to live") and echoes of the past ("Her nurse is a tall, black woman, named Beck, who used to belong to Aunt Georgia Porcher") blended in one acquaintance's chatty letter. Stevens had by then become a minister, writing "two catechisms" that white Southerners could "use in my S[unday] school for the negroes."[57] And while I do not know whether that tiny baby lived, I do know that their son William DuBose Stevens (whose name echoes the colonel's wartime admirer) thrived. William, too, became a minister; unlike his father, he left South Carolina and moved north, likely carrying his portion of the Stevens family's papers with him. He and his wife, Nannie Randolph Lantane, had four children; the youngest, Paul Stevens, was born in Newark, New Jersey, in 1897. By 1910 the family resided on Fifth Avenue in New York City. Eight years later, William DuBose Stevens left for France, where he served as a US Army chaplain and where he died.[58]

After his father's death, twenty-two-year-old Paul Stevens left college and enlisted in the navy; he returned home to become the secretary and treasurer of the Cotton Manufacturing Company and, later, lead the Stevens Manufacturing Company. By 1940 he and his wife, Elizabeth Niles, and their children had reversed his father's migration and moved to Coble, North Carolina. This was the new South, though Paul himself preferred to view it as "the home of my ancestors, [where] I shall endeavor to maintain their honored customs and abide by their ancient precepts." For all their father's attention to his heritage, Paul

Chapter Seven

Stevens's daughters' lives, shaped by education, travel, and marriage, as well as divorce, reflected both the traditional expectations and dramatic changes underway among well-off white Southern girls in the mid-twentieth century.[59] Paul Stevens's only son, Niles, born in 1935, was not of an age to fight in a war, but he did engage in that other quintessential Southern men's activity, football. His high school team, the "Undefeated Red Devils," played, appropriately for a bustling cotton manufacturing town, in the Hosiery League.[60]

With their children grown or in college, Paul and Elizabeth Stevens settled in Myrtle Beach, South Carolina, then just emerging as a destination for retirees and tourists. There Paul wrote articles on a range of topics and published *Persimmon: His Story*, an illustrated book about life from a horse's point of view. (I have tried to read this book as something other than a parable of the Old South, but there is no getting around it. The horse, taken from his mother, sold at public auction, and abused, is rescued by his "new mistress" and "the colored man" who cares for him. Religious training—"after a good horse died he went far up in the sky beyond the clouds, and there he lived forever in great meadows"—provides the book's closing pages.) Paul Stevens also wrote newspaper articles about the Confederacy, against Russia and the Kennedy administration's "professional super eggheads," and about his fears that "a majority of the people of the United States are eager to turn the country into a socialist state." Those articles, his 1969 obituary reported, were "tart, topical, perceptive and sometimes controversial." He was "proud of his Confederate heritage . . . [although he] combined Southern and national loyalties in a manner that seems to baffle less versatile citizens nowadays."[61] Like the Sanders descendants, Paul Stevens displayed a deep interest in his family's history and wrote his family into the version of American, and Southern, history he cherished. It is thanks to him that we have information about his great-uncles' experiences fighting and dying for the Confederacy, as well as letters by his Jamaican-born great-great-aunt Mary Ann Elizabeth Stevens in Bristol. Paul Stevens told about a Southern, and Stevens, history that he believed had ended with his own line.

He was, of course, wrong. As with every historical archive, given the papers he had on hand, there were things Paul Stevens could not know. But equally, given his particular interests and perspective, there were family journeys he could, or would, not imagine. Two months after his own birth, on July 20, 1897, Georgine Saunders and Charles Sanders Chew of Philadelphia had a second daughter, whom they named

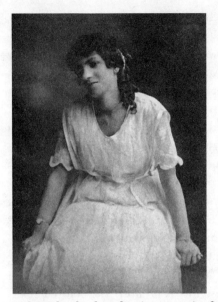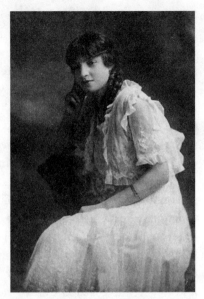

Left, High school graduation portrait of Cordelia Chew (Hinkson) (1897–1983), 1916; *right,* high school graduation portrait of Agnes Chew (Upshur) (1895–1984), 1915. P.2014.51.14 and P. 2014.51.13, Stevens-Cogdell-Sanders-Venning-Chew Collection, Library Company of Philadelphia.

Cordelia after Charles's mother.[62] That first Cordelia had come from Charleston, where she and her siblings may have had at least a passing acquaintance with Paul Stevens's grandfather and great-uncles; certainly her own father, Richard Cogdell, knew them.

This second Cordelia Sanders Chew would have made her grandmother proud. Like her father's cousin Miranda, who died when Cordelia was a toddler, she graduated from Girls' High and became a teacher. In 1921 she married DeHaven Hinkson, a graduate of Central High School and the medical school at the University of Pennsylvania, who had served at World War I field hospitals in the United States and in France. Already well established, Dr. Hinkson owned his residence and office at 329 North Fortieth Street. Soon they had two daughters, Cordelia Elizabeth (Betty) and Mary DeHaven (Bunny). In the early 1930s they all spent two years in Austria and France so that Dr. Hinkson could further his medical training. It was, family members recall, the renowned Dr. Albert Barnes—physician, educator, and art collector who established the original Barnes Museum—who funded the family's trip. "It has always seemed strange to me this matter of prejudice

against Negroes," Dr. Barnes wrote Dr. Hinkson years later. "From my earliest boyhood I never felt the slightest strangeness when in company with Negroes and I have always felt gratified when they overcame their natural feeling of inferiority and met me on equal grounds."[63]

There is zero evidence that DeHaven and Cordelia Chew Hinkson ever felt or displayed a "natural feeling of inferiority." Dr. Hinkson served as an army medical doctor during World War II at Fort Bragg, helping to found the hospital at Tuskegee Army Air Force Base, "the first military installation in the nation to be headed by a black military officer." He retired from military service as a lieutenant colonel. His obituary, prominent in a big city newspaper, reported that "D. Hinkson, Physician, Civil Rights Leader," had been Philadelphia's first Black medical examiner, the president of its Urban League, and chief of gynecology at Mercy-Douglass Hospital. He was, as befit a "race man" of his era, a staunch Republican. A card sent to "Datz" by his daughter Mary depicted a hyperstereotypical "mammy" scrubbing clothes on a washboard with the comment "Honey, Yo' Birthday's jus' like Republican votes in Georgia." Opening the card, he must have both laughed and winced: "Ain't Nobody Counts 'Em!" DeHaven and Cordelia Hinkson, who died in 1975 and 1983, respectively, are buried amid several generations of Sanders family members in Eden Cemetery just outside the city. Cordelia Sanders Chew Hinkson's death was the last time the name Sanders appears in this family's records, more than 150 years after it first materialized.[64]

The Hinksons were a cosmopolitan family, a trait surely reinforced by spending two years abroad, and they attended predominantly white schools and colleges, theaters, and music halls. But Philadelphia's professional classes rarely socialized across racial lines, and the Hinksons' closest community was among African Americans. If voter-suppression-themed humor is painfully recognizable, so are the attitudes of the few white liberals, Albert Barnes among them, whose presence in their lives signals what had not changed since the first Sanders had moved from Charleston decades before. Upon meeting these well-established, well-educated, politically moderate Black professionals, they tended to squirm. While Dr. Hinkson was serving at the hospital with "the new flying corps of Tuskegee," the author Pearl Buck visited Cordelia Hinkson at home, initiating an exchange of Christmas cards and birth announcements that would last for decades. Buck's short story "The Dark Shadow" depicted that visit as an anthropological exercise with

a political moral, in which Cordelia's young daughter was a well-bred exotic: "If she had been born in Samoa or in the Philippines, she would have been called an island beauty. But she was born in the United States of America, in the city of Philadelphia." Buck described with some satisfaction the girl's, and her mother's, integrated schooling and opined that "here is a colored American family who feels no disadvantage in their color." But Buck seems genuinely surprised that the family did not have white friends and that racism was a regular presence in their lives. As Cordelia Hinkson put it, "One doesn't want to go where the welcome is doubtful," and went on, gently, patiently, to tell Buck of the places where Black people felt they could go ("they let us come to the concerts") and where they could not. To Buck, the lesson was pointed: these respectable, middle-class women were like the refugees she had met in Germany and elsewhere, Americans who had to be "watchful continually for insult."[65]

The *Ladies' Home Journal* rejected Pearl Buck's story. It seemed, Buck explained to Cordelia Hinkson sorrowfully, that her story had "somehow conveyed the idea that there ought to be complete equality between human beings, and this the magazine does not at present feel it can advocate." As Buck understood it, the magazine's sister publication, the *Saturday Evening Post*, "got into great trouble recently over an article about the Jews and the firm does not wish to take any risks." That article, Milton Mayer's "The Case against the Jews," had caused an uproar by seeming to sympathize with Nazis; now, faced with Buck's piece, the magazines' owners seemed unable to take the risk of suggesting that racism still existed in the United States.[66]

Obviously dignity and moderation are not inherited traits. Still, when faced with both Buck's condescension and the magazine's racism, Cordelia Hinkson displayed the poise that her grandmother had exhibited— and that she passed on to her own daughters. Certainly Cordelia (Betty) and Mary (Bunny) embraced the earlier Cordelias' sense of dignity and deportment. In a lovely reminiscence, the literary critic Margo Jefferson recalls her own sister's passionate admiration for Martha Graham and her dancers: "It was possible—yes!—to be a major Negro dancer in a major white dance company." But "brown-skinned Mary Hinkson," for all her "ferocity" as a performer, had serious limitations as a rebellious girl's idol. Bad enough that Jefferson's mother, who had been her sorority sister, called her Bunny. Worse, the "shadow of Good Home Training clung to her offstage."[67]

The 1943 yearbook of the highly selective Philadelphia High School for Girls declares that Mary Hinkson's "photogenic features, her gracious manner, and excellent scholarship make her the pride of her class," and she excelled at the University of Wisconsin. Later, as a solo dancer for the Martha Graham Dance Company, she wrote effusive letters home while on tour in Europe.[68] She married Julien D. Jackson, had a daughter, and lived in New York City. Cordelia (Betty) attended Cornell University, where she appears in a photo of the Cosmopolitan Club in 1942. She studied in Mexico and later taught at an early Head Start school and was a bilingual third-grade teacher. In 1949 she married Charles S. Brown, a lawyer, and the couple ultimately moved to Detroit with their three children. Cordelia Hinkson Brown, whom I met when she was ninety-six years old, was, like Paul Stevens, highly attentive to her own family's history. She certainly knew far more than Paul Stevens how very tangled their family's story was.[69]

It is hard to imagine how the lives and worldviews of Mary Jackson and Cordelia Brown's mother, Cordelia Chew Hinkson, and Paul Stevens might have overlapped. (If it had not been for military segregation, Cordelia's husband, Dr. DeHaven Hinkson, might have crossed paths with Paul's own father, the army chaplain William DuBose Stevens, who died during World War I in France.) Indeed, in the standard narrative of American life, they should appear in two entirely separate books. Paul, a white man who remained sympathetic both to the Confederacy and to the conservative causes of the 1960s, had little in common with Cordelia, an African American woman married to a prominent war veteran and physician. All they shared, it seems, was that Paul and Cordelia's great-great-great-grandparents were John and Mary Stevens.

Historical memory, and the archives that sustain it, replicates silences and distorts our interpretation of the past. Having scoured the family papers he had on hand and written about his Confederate great-uncles' heroism in battle, Paul Stevens also declared that the "Cogdell line" of the family had ended. He did not know about, and could not imagine, his exact contemporary, Richard Cogdell's great-granddaughter Cordelia Sanders Chew Hinkson. Indeed, decades later, a Cogdell family genealogy site speculates that Richard Cogdell had "probably later married a Mrs. Sanders." How else to explain that he left all his property to "her" children? But the Sanders descendants, like other African Americans, "rarely enjoyed the privilege of ignoring history," as Kerri Greenidge puts it. They knew there was more to Paul Stevens's family story, since

they had heard and passed on stories and names, perused and pasted their ancestors' papers, and finally made the collective decision to deposit them where others would explore and rethink their legacy. These papers taught them, as they teach us, that our relationship to history is complicated and that the lives of the most ordinary Americans reflect tangled journeys.[70]

CONCLUSION
"All Together Now"

Some years ago, an image graced the cover of the *New Yorker*.[1] From the rear of a darkened auditorium, we view a lit stage, where half a dozen small children perform a play about a historical event. In between, across the middle distance, adult hands hold up cell phones, and on each screen we see one child, framed, alone, the digital star. Even the shy child—peeking from behind a curtain—is made visible by a keen parental eye. Every time I look at this cover—its truth, its irony—I laugh. *Of course* we are more interested in our own stories—our own child—than in the combined, chaotic, almost certainly boring performance. But as a metaphor for American history the image epitomizes what feminist science scholar and philosopher Donna Haraway called "partial perspectives" in scholarly work.[2] Its frame, whether digital or historical, is partial in both senses of the word: it represents and reflects a specific story (i.e., only a part of the whole) *and* it identifies with or prefers a particular actor (i.e., takes a part, chooses a side). Like the parents at a children's play, this is what narratives do. Indeed, the title of Chris Ware's *New Yorker* cover could serve for many a US history textbook: *All Together Now*. Is it possible to imagine a narrative that encompasses that "All," that observes the performance's clutter, cacophony, and individuality while still leaving room for a good story? And might we attend to the teacher's description of the process itself, to the challenges of herding all those children through their unpolished and incomplete performance? Could the children—even the shy one—give their points of view?

This book came out of a historian's desire to tackle these questions, to unravel a story from the sources we have, to stretch meaning from the silences, and to listen more closely to the whispers. Like all historical

scholarship, it enters several scholarly conversations, although at a time of unusual public attention and dispute over their meaning. It rejects from the start that history needs to be happy, or unifying, or patriotic, or that Americans in particular deserve such a story. Even knowing that bad or immoral or violent things were done in the past—here the passive voice actually does its intended work of removing responsibility—many view those issues as largely resolved. Incorporating marginalized people's experiences into the revised accounts, ironically, can reinforce this. Many readers, as well as politicians, school boards, and critics of academic scholarship, assert that past conflicts and crises were just that: resolved and done. The conservative assault against multicultural, antiracist, feminist analyses of history insists that historians who study systemic oppression and discrimination are shredding the common fabric. Whatever else it does, the Sanders story forces us to consider that there has never been a common fabric, a single narrative that encompasses all the stories that matter. It makes us face the fact that people's stories get told largely because of the sources that remain to give voice to them and the questions we ask. It makes us consider that ordinariness itself takes many forms. At the same time, as a friend of mine insists, it underscores the common aspirations that parents hold for their children—for safety, for a home, for an education—that may transcend, although they do not erase, other differences.

If there is not a single "us," there is also not a single historical conversation. This book emerged in part from my asking whether a grand narrative of US history is possible, whether we should aspire to a "master narrative," as we still insist on calling it. History is noisy, its evidence messy, and its silences urgent; as Elsa Barkley Brown put it years ago, everyone is talking at once. "As historians, we try to isolate one conversation and to explore it," she writes, "but the trick is then how to put that conversation in a context which makes evident its dialogue with so many others."[3] Scholars of women, African Americans, and people marginalized by their sexual or gender identities have strained to attend to silences amid that noise by reading our sources on a slant; we try to glimpse what those sources never intended to tell us, though they recorded data or signaled a transaction or measured a life. We take what luck or chance or intention have left us and read in the cracks. We try to imagine that past not as a tidy and continuous journey but as a collage. Collages, much like the Sanders family scrapbooks themselves, with all their overlappings and barely visible layers, are complicated and hectic, but they are not incoherent.

Those of us who are committed to incorporating the lessons of the last fifty years—to place at the center the very people older narratives considered or made marginal—need to reconsider our allegiance to the "normal" narrative form itself. According to Google, narrative is "a spoken or written account of connected events; a story," and the very nature of narrative locks us in place, provides us a with a sequence, *disciplines* us. Resisting narrative exposes the limitations of my scholarly imagination, my "discipline" itself. Yet I know that "normal" is a problem, for it refuses the complications, wishes that all those "other" voices, those demands, those *people* would just step aside. Normalcy flattens, erases, obscures, dismisses, and simplifies. In the case of Richard Walpole Cogdell and Sarah Martha Sanders and their descendants, it literally normalizes the sexual exploitation of a teenage girl. It tries to look forward from an appallingly common experience in a violent, oppressive, and tyrannical system to land at an outcome that will pacify its horrors. It puts consensus not where it may (or may not) reflect a historical process, that is, at a conflict's end, but at its beginning, where it reduces possibilities.

So how do we grapple with the noise and the silences in historical narratives? How, as sociologist Avery Gordon so brilliantly puts it, "do we reckon with what modern history has rendered ghostly?"[4] We could toy with counterfactuals, the "what-ifs" that historians studiously avoid. What would have happened, for instance, if the Sanderses had never left Charleston? From the perspective of the time, the dangers—especially in light of their father's age—seem obvious: the threat of being sold as chattel or being assaulted as their mother had been. They could not have known that emancipation would follow a war, and that Richard Cogdell would outlive slavery itself. It is also difficult to picture how they would have lived through the war: whether they would have fled to the countryside, as many of Richard's friends did, or stood their ground on Friend Street in Charleston, or, even, allied with the Confederacy. And who would they have become if they had returned to Charleston after the war, as Daniel Horlbeck had suggested? They might have found jobs as tailors and carpenters and teachers, done charitable work, and helped rebuild the city. Educated African American men found opportunities to enter politics in the Reconstruction South, though Robert Sanders does not seem to have been so inclined. Charleston offered far fewer paths for his sisters—the competent Sarah Ann, the highly intelligent Cordelia—to enter public life. Certainly an African American elite remained in Charleston, and the Sanderses might have found their way

to the Brown Fellowship Society, identifying with "the light-skinned scions of the free Negro caste [who] continued to marry among themselves, imitate the style of life of the white upper class they so admired, and boast of their white ancestry."[5] I cannot imagine that they would have shared the aspirations of the vast majority of emancipated African Americans, whose Reconstruction-era hopes lay in owning their own land; the Sanders family showed absolutely no inclination, before or after the Civil War, to become farmers.

Historians ask questions that compel us; gather evidence; sort through it; look at it from different angles; amass more evidence; bemoan what's missing or distorted or contradictory; and sit at our notebooks, typewriters, and computer screens and sigh mightily over the impossibility of fitting it all in a logical way. But history demands a story, with all the real-life people who provide the scaffolding and whose historical memories add their own layer of interpretative weight. Historians never claim to tell the *whole* story, for so many pieces of evidence no longer exist, or were never put into a form that *could* still exist, or didn't seem to be "worth" saving. Other kinds of evidence existed only in intimate spaces such as kitchen tables and bedrooms and were never meant to be overheard. In addition to noise, silence, and reading on a slant, the history I tell in this book grapples with serendipity: the awesome, against-all-odds fact that this family's papers, or the parts of it that I have been privileged to study, exist and that no one, along the way, threw them out.

There is no neat or happy ending to this journey.

Even with all the searching and stretching of sources that I offer, and the whispers I have struggled to articulate, as many paths were closed as opened, and so many questions remain unanswered. There is no trace of the enslaved boy Dick, sold to pay his (apparent) grandfather John Stevens's debts. Nor did John's wife, Mary Stevens, leave behind a single word about her transatlantic migrations, her sons' wanderings, or her husband's self-pity. We hear nothing of Sarai and Juno after they are mentioned in Sabina Hall's will as Sarah Martha's grandmother and mother; the rest of their kin, including Sarah Martha's father, are unnamed. There is no echo of the other, unnamed, enslaved people in Richard Cogdell's Charleston household, people who witnessed Richard's sexual advances on the girl, who assisted Sarah Martha Sanders during childbirth, who helped bury her babies, and who, perhaps, resented her relative privileges and authority. We do not even know whether Clara, known in Sanders family tradition as the children's

nurse, existed or whether she was the Clara who attended Cordelia Sanders Chew's funeral.

Most infuriating, our inability to picture as fully human the person at the center of this history—Sarah Martha Sanders—surely remains as frustrating to this book's readers as to its author. We do not know if she was literate or musical or talkative or vain; we do not know what she told her children about their legal status; we do not know where she got her last name. We can barely imagine why or how much she trusted Richard Cogdell or whether she thought she could do otherwise. Nor do we know how much her children reminisced about her, whether they made note of her birthday or the anniversary of her death, or what details they passed on to their own children. Only Sarah Martha Sanders's children remain as evidence of her life's work, pain, and ambition, and all we can plausibly claim is that she taught them, by word or example, to maintain a striking and stubborn dignity in the face of trauma and loss.

In addition to the lingering whispers, there are frustrations of interpretation. Everyone loves a hero: a radical thinker whose ideas changed the world or a bold actor who sets a new standard for courage. But to an astonishing degree, the people who made the extraordinary, and courageous, collective decision to leave their familiar lives behind were themselves quite conventional. Having uprooted, the Sanderses were quintessentially, even stereotypically, American: they became neither radicals nor reactionaries, continuing on the path to respectability laid out by their slave-owner father and enslaved mother. In the midst of the racial fractures of their new city and their country, they found a place as educated, middle-class, churchgoing African Americans, attentive to their own standing and moderate, if principled, in their demands. Readers who wish for a more dramatic conclusion may be disappointed that, like many other migrants and immigrants—indeed, like many of our ancestors—the Sanders family took an enormous risk to establish themselves as comfortable middle-class Americans. The point here is not whether people "succeeded" or "failed" in their individual lives but that we must attend to the remaining unknowns, be explicit about what we have and have not learned, and acknowledge why we have chosen to explore a particular history. As David Nirenberg writes (about an entirely different context), "I am not proposing that the past serve us as a model to emulate or avoid" but that we "discover in the past a stimulus to critical awareness about the workings of our own assumptions, hopes, and habits of thought."[6]

This story is part of a fabric—never cohesive, rarely shared, full of holes—that we call American history. It asks many things of us, most importantly that we not look away—from racism, from sexual violence, from the daily disregard and disrespect for Black lives and women's lives, and from the difficulties that living those lives demands. It challenges us to try to understand relationships that do not fit our preferred labels, to reimagine intimate connections even when they make us squirm or roar. Nearly everyone wants to admire their ancestors. Paul Stevens did, which he demonstrated by celebrating their service to the Confederacy. Carla Peterson stated this wish succinctly in her beautiful family history, *Black Gotham*: "I wanted my great-grandfather to be a dedicated race man, a hero of the antislavery cause," she admits. "But one can't choose one's ancestors, can one? So rather than condemn, excuse, or apologize for [his] behavior, I've simply tried to understand it."[7]

This is much harder than it sounds. It requires that we look at moments of loyalty and love among oppressors as well as complicity and compromise on the part of those they oppressed; it demands that we romanticize no one, that no one escapes being human, that we reckon with intimate connections that we abhor. The Sanders story insists that we look power relationships in the face at every moment, as each decision gets made, as relationships are forged and tested. As Richard White once noted, "The past should not be comfortable. The past should not be a familiar echo of the present. . . . The past should be so strange that you wonder how you and people you know and love could come from such a time. When you have traced that trajectory, you have learned something."[8] This trajectory, and the tangled journeys it describes, is too complex to hold in one book. Imagine others.

Conclusion

NOTES

INTRODUCTION

1. Fuentes, *Dispossessed Lives*, 146.

2. Fuentes, *Dispossessed Lives*, 145, 2; Fritzsche, "Archive," 203.

3. Paul Stevens letter [November 1959], Paul Stevens Papers, Caroliniana.

4. Paul Stevens letter [November 1959], Paul Stevens Papers, Caroliniana.

5. For one Sanders descendant's creative exploration of memoir and history, see Lora, "Our Whispering Wombs."

6. Ginzberg, *Untidy Origins*.

7. Fuentes, *Dispossessed Lives*, 1; Gordon, *Ghostly Matters*, 32.

8. Fuentes, *Dispossessed Lives*, 27. Alongside the collection of wills, letters, and court settlements—the "important" stuff of social history—sits a calling card with the name Richard Cogdell; on the back, someone, long ago, has scribbled a list of names. Now dutifully filed in an archive box, acting for all the world like historical evidence, this card was, in its day as it would be in ours, literally scrap paper.

9. Barkley Brown, "'What Has Happened Here?'"

10. Gonaver, "Race Relations"; Myers, *Forging Freedom*; Wright, "Imagining Freedom." For a beautiful pictorial essay about the Stevens-Cogdell-Sanders-Venning-Chew Collection, see Weatherwax, Piola, and Hassane, *Imperfect History*, chap. 4.

11. Paul Stevens letter [November 1959], Paul Stevens Papers, Caroliniana.

12. Gordon, *Ghostly Matters*, 21, 20.

1. Dunn, *Sugar and Slaves*, 25; Hart, *Building Charleston*, 18.

2. Quote from inscription on the relief her son (John Stephano Cogdell) sculpted, which hangs in St. Philip's Episcopal Church in Charleston.

3. John Stevens to William Savage, June 4, 1769, B1F1, SCSVC. Henceforth in citations of letters, "JS" will be used to refer to John Stevens the father, and "Jack" will be used to refer to his son. Throughout this book I have minimized the use of "[*sic*]" and have retained the misspellings, underlinings, and nonstandard punctuation that appear in the originals.

4. JS to Jack, April 29, 1769, B1F1; and to Captain Pickles, June 3, 1771, B1F2, both in SCSVC.

5. JS to Jack, April 29, 1769, B1F1, SCSVC. He had received a letter from his brother through a Capt. Pearse Ashfield on August 4, 1770; JS to "My dear brother," December 7, 1771, B1F2, SCSVC.

6. JS to Paul Whitehead, December 6, 1770, B1F2; to Walpole, July 10, 1771, B1F2; to William Savage, June 4, 1769, B1F1; and to Capt. John Harrison, June 4, 1769, B1F1, all in SCSVC. Note that Stevens's son Jo was named Joseph Porter Stevens, presumably in honor of this friend. The reference to Persian luxury at Mortlake likely refers to carpets, which were manufactured there from an early period. Henry Grenville was the governor of Barbados from 1746 to 1761, though I do not know the circumstances under which he would seize the cargo.

7. Stevens's petitions for land, which include his listing of family members and thirteen slaves, appear in *Colonial Records of the State of Georgia*, 9:325–26, 544–45. Calculating the real buying power of eighteenth- and nineteenth-century wealth is notoriously misleading; internet translators claim that this was nearly $1 million in today's money. Suffice it to say that John Stevens had accrued a significant sum when he left for Georgia.

8. JS to William Savage, June 4, 1769, B1F1, SCSVC; "Extract from a letter from a gentleman at Natchez fort to his friend in Savannah, dated 12th August last," *Georgia Gazette*, November 21, 1765, and May 21, 1766.

9. *Georgia Gazette*, June 20, 1765. This ad is characteristic of runaway ads, including in not explaining how Cato received his scar. For an in-depth analysis of runaway ads, see Block, *Colonial Complexions*.

10. *Georgia Gazette*, June 27, 1765.

11. JS to William Savage, June 4, 1769; and to George Savage, Esq., April 30, 1769, both in B1F1, SCSVC.

12. *Georgia Gazette*, November 26, 1766, June 3, 1767; JS to Dr. Wm. Mann, October 20, 1768, B1F1, SCSVC; *Georgia Gazette*, October 1, 1766.

13. *Georgia Gazette*, October 1, 1766, August 19, 1767, February 24 and March 2 (repeated), November 9, 1768.

14. JS to George Eveleigh, July 15, 1769, including in his letter a note to forward to Mrs. Willet, B1F1, SCSVC.

15. Butler, *Votaries of Apollo*, 73, xii, 9; JS to Dr. William Mann, October 20, 1768; to William Savage, June 4, 1769; and to Wm Burrows, April 11, 1769, all in B1F1, SCSVC.

16. Hart, *Building Charleston*, 41; JS to Thos Wiltshire, June 16, 1770, B1F1, SCSVC.

17. Newman (*Freedom Seekers*) describes Africans in London across the previous century. Quote on 36.

18. The business transaction itself was simple, from Stevens's point of view: "I shall be glad to have your answer," he went on, "& as Mr. Vanderhorst is your attorney here, I'll pay him the money we agree for, on his giving me a proper Bill of Sale." JS to Patrick Reilly, January 22, 1771, B1F2, SCSVC.

19. JS to Jack, July 28, 1770, B1F1; and to Peter Delancey, March 12, 1771, B1F2, both in SCSVC.

20. JS to James Johnson, July 20, 1769, B1F1, SCSVC.

21. Schivelbusch, *Tastes of Paradise*, 56; JS to Carr, August 23, 1770, B1F1, SCSVC. (Note that this letter is out of date order in the letter book.) For more on the Carolina Coffee House in London, see Butler, "Carolina Coffee House of London," which is part of an online project through the Charleston County Public Library called *The Charleston Time Machine*. While I've used the online text as my source, the series is also a podcast (www.ccpl.org/charleston -time-machine).

22. JS to Jack, October 20, 1768, B1F1, SCSVC; South Carolina Deed Abstracts 1773–78, Book P-4, 271–76, lease and release dated May 2, 3, 1775, SCDAH.

23. South Carolina Writers' Program, Work Projects Administration, *South Carolina*, 197.

24. JS to William Burrows, April 11, 1769, B1F1, SCSVC; Butler, "Woman's Progress."

25. JS to Jack, April 29, 1769, B1F1, SCSVC; Schivelbusch, *Tastes of Paradise*, 49.

26. JS to Jack, October 20, 1768, April 29, 1769; and to William Burrows, Esq., April 11, 1769, all in B1F1, SCSVC.

27. Quincy journal, February 28, 1773, in Fant, *Travelers' Charleston*, 24–25. Army and navy reference in JS to Oswald [V.?] Mile, September 11, 1770, B1F2, SCSVC.

28. JS to Charles Seymour, Esq., October 20, 1768, B1F1, SCSVC.

29. JS to William Burrows, April 11, 1769, B1F1; to John Holmes, April 25, 1771, B1F2; and to James Read, April 21, 1769, B1F1, all in SCSVC. In a letter to Thomas Savage, Esq., Stevens reported, "I am under an Obligation to pay near five hundred pounds on Monday next, which I cannot without great Inconveniency do"; JS to Savage, June 9, 1769, B1F1, SCSVC.

30. JS to Charles Tighe, October 8, 1771, B1F2, SCSVC.

31. Hart, *Building Charleston*, 143.

32. JS to Jack, October 20, 1768, B1F1, SCSVC.

33. JS to Jack, April 29, 1769; to William Burrows, April 11, 1769; to William Greene, September 9, 1769; and to Clement Martin, June 14, 1770, all in B1F1, SCSVC.

34. JS to Clement Martin, June 14, 1770; and to Dr. William Mann, April 29, 1769, both in B1F1, SCSVC.

35. JS to Clement Martin, June 14, 1770, B1F1, SCSVC. On March 14, 1770, JS wrote to James Read in Savannah asking for the details of Martin's sale of "the Mulatto Boy"; B1F1, SCSVC.

36. JS to Jack, April 29, 1769, B1F1; to James Read, April 21, 1769, B1F1; to Paul Whitehead, December 6, 1770, B1F2; and to William Savage, June 4, 1769, B1F1, all in SCSVC. In this letter he mentioned two diamond rings, apparently part of a debt.

37. JS to Holmes, May 17, June 8, 1771, B1F2, SCSVC.

38. JS to Jacobs, October 11, 1770, B1F2, SCSVC.

39. JS to Jack, April 29, 1769, B1F1, SCSVC.

40. JS to Jack, April 29, 1769, B1F1; and to William Garden, September 27, 1771, B1F2, both in SCSVC.

41. JS to James Mathias, December 18, 1769, B1F1, SCSVC.

42. Dunn, *Sugar and Slaves*, 39; Mill quoted in Mintz, *Sweetness and Power*, 42.

43. Dunn, *Sugar and Slaves*, 149.

44. Walker, *Jamaica Ladies*, 2; Mintz, *Sweetness and Power*, 39; Dunn, *Sugar and Slaves*, xiii. Walker's book offers a fascinating interpretation of the 10 percent of slaveholders in Jamaica who were female and among the "wealthiest people in the British Empire" (19).

45. Vincent Brown, *Tacky's Revolt*, 86; Mintz, *Sweetness and Power*, 53. The numbers vary, in part because of different beginning and end dates. Mintz cites the years 1701–1810. Brown writes, "Between 1661 and 1760, slave ships transported more than three hundred and fifty thousand Africans from the Gold Coast across the Atlantic Ocean," and "Jamaica took more than eighty thousand, a full twenty-seven percent of the total" (102).

46. Dunn, *Sugar and Slaves*, 151. See also Vincent Brown, *Tacky's Revolt*.

47. JS to Jack, October 20, 1768, B1F1, SCSVC.

48. JS to Mann, October 20, 1768; to Seymour, October 20, 1768; to James Mathias, December 18, 1769; and to Jack, October 9, 1769, February 10, 1770, October 20, 1768, all in B1F1, SCSVC.

49. JS to Jack, October 20, 1768, April 29, 1769, February 10, July 28, 1770, all in B1F1, SCSVC.

50. JS to Jack, July 28, 1770, B1F1, SCSVC.

51. Centre for the Study of the Legacies of British Slavery database, accessed June 11, 2020, https://www.ucl.ac.uk/lbs. The slight information I have about Jack's family is from an undated handwritten scrap of paper by Richard Cogdell, presumably written to one of Jack's grandchildren about their father's (Clement, who moved to Charleston) and grandfather's pasts. This scrap refers to the nine children and also mentions that Elizabeth Jane had a twenty-two-year-old child from her first marriage; Richard W. Cogdell (RWC), undated handwritten scrap of paper, B2F2, SCSVC. A Patrick Henly appears in some ancestry sources, but I cannot confirm that he was her child; if he had been twenty-two in 1782, she would have had her last baby (born 1802) at well past forty.

52. Mortuary notice, *City-Gazette and Daily Advertiser*, August 26, 1801; Centre for the Study of the Legacies of British Slavery database, accessed June 11, 2020, https://www.ucl.ac.uk/lbs.

53. Obituaries that use that phrase appear in *Carolina Gazette*, August 27, 1801, and *City-Gazette and Daily Advertiser*, August 26, 1801. The latter also referred to him as "a man of unblemished character, honest and industrious, an affectionate indulgent husband, a kind father, and an agreeable companion; to know him was to respect him." The mortuary notice in *Philadelphia Gazette* (September 11, 1801) refers to him as "formerly of this city" and also makes him sixty-nine instead of fifty-nine. Richard Cogdell says he died at age fifty-seven.

54. RWC, undated handwritten scrap of paper, B2F2, SCSVC.

55. George Cragg to Lionel Kennedy, December 20, 1827, accession 4066, Manuscripts Misc. (Kennedy, Lionel Henry, 1787?–1847), Caroliniana; RWC, undated handwritten scrap of paper, B2F2, SCSVC. Cragg managed the family's estate in Jamaica and, having heard of Mary Ann Stevens Cogdell's death, sought power of attorney to continue to do so for the remaining Stevens's heirs in the United States.

56. JS to John Corlet, April 17, 1771, B1F2; to Wm Mann, October 20, 1768, B1F1; to John Holmes, July 20, 1769, B1F1; and to Will Wright, May 24, 1769, B1F1, all in SCSVC.

57. JS to Jack, April 29, 1769, February 10, 1770; to George Eveleigh, July 15, 1769, including a note to forward to Mrs. Willet; to Jack, October 20, 1768; to William Savage, June 4, 1769; and to Jack, June 3, July 28, 1770, all in B1F1, SCSVC.

58. JS to James Mathias, December 18, 1769, B1F1; to his brother [Large?] Stevens, February 28, 1770, B1F1; to Mrs. Mary Willet, July 15, 1769, B1F1; to John Corlet, April 17, 1771, B1F2; and to his brother, December 7, 1771, B1F2, all in SCSVC.

59. JS to James Mathias, December 18, 1769, B1F1; and to Peter Delancey, March 26, 1771, B1F2, both in SCSVC. For more information about Harry, and his ties to the St. Cecilia Society and the post office, see Butler, *Votaries of Apollo*, 73–74.

60. Peter Manigault to Ralph Izard, August 24, 1771, in Manigault and Crouse, "Letterbook of Peter Manigault," 189; JS to Anthony Todd, August 25, 16, 1771, B1F2, SCSVC.

61. JS to Nathaniel Draper, August 20, 1771; to Henry Saxby, August 20, 1771; to Richard Oswald, August 20, 1771; and more, all in B1F2, SCSVC.

62. JS to Anthony Todd, August 21, 1771, B1F2, SCSVC.

63. Butler, "Stealing Lord Dartmouth's Mail"; J. H. Stevens to John Drayton, August 22, 1820, in Drayton, *Memoirs of the American Revolution*, 1:357–58, Drayton's description 1:309–11.

64. JS to [N.?] Pearse Ashfield, December 12, 1770, B1F2, SCSVC.

65. See, e.g., "City Sheriff's Sale," *City-Gazette and Daily Advertiser*, February 3, 25, March 3, 1812.

66. Butler, *Votaries of Apollo*, 74. See also George W. Williams, "Eighteenth-Century Organists," 212–22.

67. JS to Jack, March 13, July 28, 1770, B1F1, SCSVC.

68. Middleton, "John Stevens Cogdell," 4.

69. John Stephano Cogdell diary, [September 3?,] 1808, vol. 1, Collection 252, John Stevens (Stephano) Cogdell Papers, Winterthur Library, Winterthur, Del.

70. Clement B. Stevens, unaddressed note dated M[ontego]. Bay, August 14, 1802, B1F10, SCSVC.

71. RWC, undated handwritten scrap of paper, B2F2, SCSVC.

72. RWC, undated handwritten scrap of paper, B2F2, SCSVC; Paul Stevens letter [November 1959], Paul Stevens Papers, Caroliniana.

73. JS to Mrs. Mary Willet, July 15, 1769, B1F1, SCSVC; Carby, *Imperial Intimacies*, 188. Sometimes a name appears in the SCSVC that suggests a long-term interest in the family's ancestry. One undated clipping refers to a "Captain Arthur Venning . . . well known among seafarers for his able superintendance of African coast trade" and his son Robert, also a captain, who came back to his ship from the theater, slipped off a ladder, and drowned in the sea; undated clipping, B6F28, SCSVC. See also Vanderhorst papers in Ralph, *Guide to the Bristol Archives Office*; Elias Vanderhorst was the first US consul to Bristol.

74. Mary Elizabeth Stevens to Harry Stevens, October 4, 1809, August 4, 1812, Paul Stevens Papers, Caroliniana. Paul Stevens was not unable to imagine an unmarried woman striking out on her own. His oldest sister, Helen, was the service director of the Iran Foundation, traveling to Iran in 1950 to "study the medical program" and to assist contractors in building a new hospital in Shiraz. "Sister of Local Man Leaves for Teheran, Iran," *Daily Times-News*, September 22, 1950.

75. Will of Mary Ann Elizabeth Stevens, probated 1852, CRM:00710663, National Archives, Kew, Richmond, Surrey (digital download).

76. Mary Ann Elizabeth Stevens to Harry Stevens, [Month illegible] 3, 1812, Paul Stevens Papers, Caroliniana.

77. Middleton, "John Stevens Cogdell," 11; John Stephano Cogdell diary, November 11, 1825, vol. 4, Collection 252, John Stevens (Stephano) Cogdell Papers, Winterthur Library, Winterthur, Del.; Rutledge, "Cogdell and Mills." Both John and Richard Cogdell served in the 1820s as grand master of the Ancient Free Masons of South Carolina.

CHAPTER TWO

1. Fant, *Travelers' Charleston*, 216, 315, 98, 176–78. The literature on Charleston itself is vast. Most relevant were Myers, *Forging Freedom*; Kennedy, *Braided Relations, Entwined Lives*; Powers, *Black Charlestonians*; and Johnson and Roark, *Black Masters*. Useful older works include Rogers, *Charleston in the Age of the Pinckneys*.

2. Fant, *Travelers' Charleston*, 105, 98, 106. Mary Motte Alston, later Pringle, was born in 1803 in the Miles Brewton house at 27 King Street; her family, a largely sympathetic biographer writes, "conducted life in perennial denial of their financial reality." Cote, *Mary's World*, 174.

3. Fant, *Travelers' Charleston*, 209, 283, 254, 197–98.

4. "Archives and Library Update," 185–91; Johnson and Roark, *Black Masters*, 203.

5. Hart, *Building Charleston*, 9, 143.

6. *Digest of the Ordinances*, apps. 12, 25; *Collection of the Ordinances* [. . .] *1826*, 29.

7. *Digest of the Ordinances*, apps. 32, 34.

8. *Collection of Ordinances* [. . .] *1823*, 41.

9. *Digest of the Ordinances*, 27–28.

10. Mary Ann Stevens Cogdell Diary and Copy Book (1806–1823), B1F6, SCSVC; Gonaver, "Race Relations," 62.

11. Will of Mary Stevens, Will Book A, 1783–86, 176, Charleston District Probate Court, Will Books, SCDAH. South Carolina wills cited here are in the SCDAH and can be located both in the Charleston District Probate Court, Will Books and in SC Will Transcripts (WPA). On slave owners' wills, and women's role in normalizing slavery in the eighteenth century, see Walker, *Jamaica Ladies*.

12. Will of Jervis Henry Stevens, Will Book G, 1826–34, 240; and wills of Mary Ann Elizabeth Cogdell, Will Book G, 1826–34, 11, both in Charleston District Probate Court, Will Books, SCDAH.

13. Cote, *Mary's World*, 3. John Stephano's wife, Maria Gilchrist, and his law partner, her brother Robert Gilchrist, part of a family of merchants in Charleston and New York, probably represented their closest connection to significant wealth.

14. South Carolina Deed Abstracts 1776–83, Book Y-4, 53–55, SCDAH; will of Mary Stevens, Will Book A, 176; will of Jervis Henry Stevens, Will Book G,

1826–34, 240–42; and will of John S. Cogdell, Will Book K, 1845–51, 101, all in Charleston District Probate Court, Will Books, SCDAH.

15. Will of Jervis Henry Stevens, Will Book G, 1826–34, 240, Charleston District Probate Court, Will Books, SCDAH.

16. Cogdell is listed in "Poll Lists Charleston," 48.

17. Cogdell papers: land indentures, mostly to John Cogdell, who was George's brother, not to be confused with his son, in B1F3, SCSVC; will of Mary Stevens, Will Book A, 176, Charleston District Probate Court, Will Books, SCDAH.

18. In the 1800 federal census her household contained her three sons, another free white woman, and nine enslaved people; ten years later, in addition to her sons, several free white girls or women lived in the house, and on paper at least, there were no slaves present. Her boarding school is listed in numerous city directories, including *Nelson's Charleston Directory* [. . .] *1801*, 67; Negrin, *New Charleston Directory* [. . .] *1802*, 14; Negrin, *Negrin's Directory and Almanac* (1806), 13; and Elizer, *Directory for 1803*, 24.

19. Will of Mary Ann Elizabeth Cogdell, 1815 followed by 1827, Will Book G, 1826–34, 177, Charleston District Probate Court, Will Books, SCDAH.

20. Rutledge, "Cogdell and Mills." For instance, Cogdell paid $100 for quarter rent of No. 2 St. Michael's Alley "for my uncle, Jervis H. Stevens," and paid Lionel Kennedy fifty dollars for house rent for one quarter; see receipt books, April 1, 1820, July 12, October 23, 1824, January 8, 1825 (and beyond), B1F7, SCSVC. *Census of the City of Charleston*, 197.

21. Easterby, *History*. In the alumni lists in this book, only Richard's son George B. Cogdell, class of 1834, is listed as a graduate of the college.

22. Richard and John's brother, Clement, is largely invisible in the historical record; I do not even know whether he was the Cogdells' middle or last son. He does not seem to have joined his two brothers on their trip to Europe, nor did he go to Jamaica with Richard. As an adult he lived in Darlington, South Carolina. In 1830, his household consisted of sixteen people, twelve of them enslaved. Ten years later there were twenty-one people in residence, including sixteen enslaved people and two white girls, one between five and nine and the other between ten and fourteen. I can find no record of Clement's death, which may have preceded his brother John's 1847 will. After the war Richard Cogdell asked Daniel Horlbeck whether his brother's widow, Ursula, was still alive. RWC to Horlbeck, November 5, 1865, B1F10, SCSVC.

23. Jarrell, *1810 Charleston District*, 14; Folker, *Directory of the City*, 13. Either the numbering system was changing or they were spreading out, for they also occupied Nos. 5 and 7. *Directory and Stranger's Guide* [. . .] *1822*, 32; *Directory and Stranger's Guide* [. . .] *1831*, 65. *Directory of the City of Charleston* (25) lists Cogdell, R. W., at 65 Broad Street; this could be the same place but renumbered.

24. Several documents mention Cogdell's work: one (from 1815) authorizes him as a notary public, while another (from April 1844) offers thanks from the "Directors of the Bank of the State of SC" for twenty-seven years of service; both in B1F5, SCSVC.

25. *Charleston Courier*, March 31, 1828. Erika Piola identified the artist and confirmed the dates of the silhouettes.

26. Receipt book, October 11, 1816, August 5, 1818, April 5, 1831, B1F7, SCSVC.

27. The following are all in Cogdell's receipt book, B1F7, SCSVC. Received from RWC "twenty one dollars in full for tuition for his son James G. Cogdell, 15th May 1815." RWC paid twenty-odd dollars per quarter for George and James in the late 1820s; $5.25 "in full for the Amt of Master Cogdell's Bill"; $34.50 and another thirty dollars toward G. C. Cogdell's bill; an additional fifty dollars in 1836, then twenty-six dollars "for Schooling of Walpole & Chas." on July 8 and 22, 1835; and "in advance for schooling two boys Twenty six dollars for the quarter" (January 5, 1828). "2nd January 1829 Recd of R. W. Cogdell Twenty one dollars in advance for the quarter schooling of G. B. & J. W. Cogdell."

28. Receipt book, April 18, 1828, July 27, 1829, for twenty dollars paid in full, B1F7, SCSVC. The Register of the Navy (Ancestry.com) shows he entered the service May 9, 1829, and passed midshipman on July 3, 1835.

29. Receipt book, February 11, 1836. The sheriff's payment is dated February 25, 1832. In December 1838 Richard paid his brother Clement some twenty-seven dollars "for monies paid by me for the use of his Son George." All in B1F7, SCSVC.

30. Pinckney, *Register of St. Philip's Parish*, 15, other sons on 53, 69.

31. Myers, *Forging Freedom*, 151–53. Richard Walpole Cogdell himself had once been identified as having "short Black hair, blue Eyes, brown complexion large nose middling size mouth well made" (handwritten document upon Cogdell's traveling to Jamaica, notarized by Isaac Motte Dart, April 27, 1802, B1F5, SCSVC), which underscores Sharon Block's argument that skin color did not yet connote "race": throughout the eighteenth century, she notes, "Europeans' 'black' complexion may have suggested a sense of relatively dark coloration rather than just a specific focus on skin." Block, *Colonial Complexions*, 63.

32. Cummings to RWC, April 9, 1824, B1F10, SCSVC.

33. *Atlanta Constitution*, November 10, 1894 (misspells Cogdell as Cogsdale). Papers from Augusta, Georgia, March 22, 1824, with series of notes about negotiation, are in B1F10, SCSVC. All recorded deaths are reported in the City of Charleston Death Records, Charleston County Public Library, Charleston, S.C.

34. RWC to Sarah Martha Sanders, December 20, 1844, B1F10, SCSVC. On the Liberian report, see *Vermont Phoenix*, March 19, 1846.

35. The US Navy and Marine Corps Registries, 1814–1992 (Ancestry.com), also show that he resigned a lieutenant on July 26, 1846.

36. J[ohn] Walpole Cogdell to W. D. Howland, Esq., January 10, 1849, Cogdell files 30–04, South Carolina Historical Society, Charleston; and undated clipping, B3F6; Charles Cogdell to RWC, March 9, 1853, B1F10; and John S. Cogdell to RWC, January 18, 1840, B2F1, all in SCSVC. Clement Cogdell got this money from his brother in 1838; receipt book, B1F7, SCSVC.

37. Charles Cogdell to RWC, March 9, 1853, B1F10, SCSVC. Charles first appears in the city directory in 1859, living at 58 St. Philips and working as an assistant clerk in the Bank of the State. Means & Turnbull, *Charleston Directory*, 53.

38. Garcia to RWC, January 10, 1860, B1F8, SCSVC; City of Charleston Death Records, Charleston County Public Library, Charleston, S.C.

39. Charles Cogdell to RWC, March 9, 1853, B1F10, SCSVC.

40. Robinson, "Dr. Irving's Reminiscences," 177. (Other parts of this memoir are spread across multiple issues of the *South Carolina Historical and Genealogical Magazine*.)

41. William Ogilby to William [no last name], April 12, 1844, B1F10, SCSVC. Cogdell paid $250 for the first installment (July 8, 1835), $100 for the second (March 9, 1836), and a final $150 (March 17, 1837); all in receipt book, B1F7, SCSVC.

42. Irving to RWC, May 22, 1860; and [Ahean?] to RWC, August 25, 1860, both in B1F8, SCSVC.

43. Burgess to RWC, September 26, October 22, 1818, B1F8, SCSVC. Burgess was Richard and Cecille's son George Burgess Cogdell's godmother.

44. Receipt book, August 27, 1817, B1F7, SCSVC.

45. Will of Sabina Hall, Will Book G, 1826–34, 106, Charleston District Probate Court, Will Books, SCDAH. I am so grateful to Scott Wilds for tracking down Hall's will. Interestingly, the Sanderses' descendants whom I've met, knowledgeable about their family history, did not know about Sabina Hall, suggesting that her will, and even her name, were not part of family lore.

46. The date of Sabina Hall's birth is sketchy. Death records report that she died at age seventy-five in 1827 ("of old age"), which would place her birth at 1752.

47. Will of Joshua Toomer, Will Book C, 1796, 298–99, Charleston District Probate Court, Will Books, SCDAH.

48. Thomas Hall's will lists dozens of enslaved people, an unstated number of their children, and "the future increase of the Females." He gave specific instructions about who should be kept together on the White Hall plantation. Will of Thomas Hall, Will Book E, 1814, 422–25, Charleston District Probate Court, Will Books, SCDAH.

49. Will of Mary Stevens, Will Book A, 1783–86, 176; and will of Mary Ann Elizabeth Cogdell, Will Book G, 1826–34, 11, both in Charleston District Probate Court, Will Books, SCDAH.

50. Will of Sabina Hall, Will Book G, 1826–34, 106, Charleston District Probate Court, Will Books, SCDAH.

51. Thomas Condy to R. W. Cogdell, bill of sale for Sarah Martha, Secretary of State Miscellaneous Records (Bills of Sale) S213003, Book 5K, p. 285, SCDAH.

52. In 1850, according to the federal slave schedules, Thomas Condy owned twenty-nine slaves. By 1861, his widow, Jane (Washington) Condy, lived in their home at 2 Bee Street. *Census of the City of Charleston*, 223.

53. Miles, *All That She Carried*, 76; The Union Bank of S.C. vs Dr. Anthony Toomer, Charleston District Court at Equity, Bill 1833, No. 5, SCDAH. On Toomer's Charleston houses see Poston, *Buildings of Charleston*, 591–92. The reference to his mortgaging the houses is in Trinkley et al., *Youghal*. Toomer reappears in the historical record decades later, in 1856, when he wrote his own will. Only a few years before the Civil War the eighty-year-old set about distributing his property—land, furniture, and slaves—to his sons, with further bequests to his church. But also: "In consideration of the fidelity with which my Servant Judith alias Judy has served me and as it is inconsistent with the Laws of the land and the division of my personal estate already made to manumit her I will and bequeath to my youngest Son Anthony V. Toomer the sum of Three hundred dollars in trust for her use which sum I enjoin upon him to invest in the State Stock of this State and to pay to her the said Judy the Interest thereof during the term of her natural life." Will of Anthony V. Toomer, May 6, 1856, with a codicil on May 8, SC Will Transcripts (WPA) 47:869–72, SCDAH.

54. "City Council, 1783–1951," Charleston, S.C. (website), accessed December 7, 2022, www.charleston-sc.gov/DocumentCenter/View/19117/City -Councilmembers-1783–1951.

55. Receipt books, B1F7, SCSVC. Note that Cogdell's purchase of Sarah Martha Sanders does not appear in his receipt book.

56. Painter, *Southern History*, 34; Morgan, *Reckoning with Slavery*, 5.

CHAPTER THREE

1. Painter, *Southern History*, 18.

2. Myers, *Forging Freedom*, 167 (p. 17 refers to Sarah Martha's "astute tactics of negotiation").

3. Greenidge, *Grimkes*, 111–12, 118, 122. See also Myers, *Vice President's Black Wife*.

4. Myers, *Forging Freedom*, 155.

5. These quotes are from various of Richard Cogdell's drafts, B2F2, B2F1, SCSVC.

6. Quote from draft of letter in B2F1, SCSVC.

7. "Recd 2 May 1832 of Mr. R. W. Cogdell, Twenty dollars for Coffin furnished for Burial of Mrs. Cogdell @ Jan. last," B1F7, SCSVC. Cogdell regularly paid a Dr. Simons, including (on April 12, 1832) "for Med. Attend. To 31st Dec. last." I do not know if that was a medical expense for Cecille or for another family member, though Simons's name appears on the 1827 death certificate of Cogdell's mother, Mary Ann Stevens Cogdell.

8. Myers, *Forging Freedom*, 159.

9. Receipt book, B1F7, SCSVC; "American Patents," 74. See also the rich description of the household and its purchases in Myers, *Forging Freedom*, 158–62.

10. Receipt book, January 23, 1829, April 30, 1832 ("Seventy five dollars in Part Payments of a Piano Forte"), B1F7, SCSVC.

11. RWC travel diary, 1845, B1F7; and Garcia to RWC, September 23 [1856?], B1F8, both in SCSVC. As if to underscore their multigenerational tradition of musicality, many of the family's papers in the SCSVC collection were pasted onto blank sheets of music paper.

12. Myers, *Forging Freedom*, 12–13.

13. Huger quoted in Johnson and Roark, *Black Masters*, 192; Myers, *Forging Freedom*, 162.

14. Myers, *Vice President's Black Wife*, 143–44.

15. By 1840, George Burgess Cogdell, now twenty-three, worked in the city treasury; John Walpole, nearly twenty, practiced law; and Charles Stevens, now eighteen, would become a bank clerk. Myers, *Forging Freedom*, 157. Richard Clement had been in the navy for more than a decade. The Register of the Navy (Ancestry.com) shows that he entered the service May 9, 1829, had some leaves of absence, and resigned July 26, 1846.

16. Butler, "Street Numbers."

17. RWC to Sarah Martha Sanders, December 20, 1844, B1F10, SCSVC; Bellows, *Two Charlestonians at War*, 26. See also Poston, *Buildings of Charleston*, 54.

18. The envelope is in B2F4, SCSVC. Nearer to St. Michael's Alley, this house was owned in 1861 by John Bickley and his wife; across the street at 98 King Street lived the artist John B. Irving Jr., Richard Cogdell's old friend's son. Boundary Street is listed as Sarah Martha Sanders's address in *State Free Negro Capitation Books*, 1845, microcopy number 11, p. 37.

19. 1839 assessment of property from 1818, 576/06/88, B6, Horlbeck Brothers Records, South Carolina Historical Society, Charleston. Friend Street was later renamed Legare, thus extending that street another two blocks.

20. Cogdell was still the house's owner in 1861, with a W. T. White in residence; the property was part of the settlement of his estate in 1872. *Census of the City of Charleston*, 88. A number of photographs of Bedon's Alley are in the Photograph Collection of the Charleston Museum.

21. Fant, *Travelers' Charleston*, 314.

22. Finley, *Intimate Economy*, 4; undated handwritten scrap, B6F46, SCSVC.

23. RWC to Sarah Martha Sanders, December 20, 1844, B1F10, SCSVC.

24. William Ogilby to William [no last name], Charleston, April 12, 1844, B1F1. Ogilby to William (April 24, 1844, B1F10) introduces Cogdell and says he's planning to spend "some years" traveling. The dates of Cogdell's Europe trip are hazy but my best guess, based on bills and letters of introduction, is that he wrote from there in December 1844. In June of that year, Edward Everett offered him tickets for "tomorrow" at the House of Commons, so he was already in Europe; Everett to RWC, June 19, 1844, B1F10. When he arrived in New York in November 1845, he mentioned having found a letter "from home," which has not survived, B1F7. All in SCSVC.

25. RWC to Sarah Martha Sanders, December 20, 1844, B1F10, SCSVC.

26. RWC to Sarah Martha Sanders, December 20, 1844, B1F10. I have been unable to identify Whitney. The only reference I have is in Cogdell's receipt book, July 18, 1838, $400 "for the purchase of a Negro Woman named Sally," from Moses Jacob, the agent for [illegible] Whitney, B1F7. Both in SCSVC.

27. Undated handwritten scrap, B6F46, SCSVC. My thanks to the church archivist at Bethel Methodist Church for checking their records for information about her grave.

28. Miles, *All That She Carried*, 95.

29. Hartog, *Man and Wife*, 122.

30. *State Free Negro Capitation Books* list Robert and Julia Sanders at 5 Friend Street in 1852 and 1855. *State Free Negro Capitation Books*, 1852, microcopy number 11, p. 57.

31. Receipt from the City Treasury of Charleston, June 12, 1852, B2F4, SCSVC. I am grateful to Nicholas Butler for talking through some of these possibilities with me and suggesting that a paper trail might be a kind of insurance for their futures.

32. Phillis Barron (or Phyllis Barren) (1810–75) was born in Charleston. In 1830, she headed a household that included a white man in his twenties, as well as two young "free colored females." The ages of her daughters are confusing in the records, and in some records her name is misspelled as Barrow.

33. Gonaver, "Race Relations," 67; Porcher, "Memoirs," 91–2. (Porcher's memoir appears across numerous issues of the *South Carolina Historical and Genealogical Magazine*.)

34. Daniel Horlbeck to Sarah Ann Sanders, December 27, 1866, B2F3, SCSVC.

35. Henry Middleton Smith, handwritten account (and typescript) of John B. Irving's life, John Irving Legal Papers 30-4, South Carolina Historical Society, Charleston. Clearly John Stephano Cogdell had connections in and near New York City. His in-laws, the Gilchrists, lived there, and when John died in 1847, he owned four properties in the area.

36. RWC travel diary, November 8, 1845, B1F7, SCSVC. The Saratoga information is a perfect example of the serendipity of historical sources—and the magic of the internet. Searching for Cogdell's name, I came across a newspaper notice that he had failed to collect some mail from the post office there. *Saratoga Sentinel*, October 14, 21, 1828.

37. Receipt books, B1F7, SCSVC; "This Side of the Picture—and That," *Albion*, June 6, 1857, 271.

38. RWC, "Directions to my Executors and Children," August 17, 1860, B1F10, SCSVC. On Kennedy's role, see Johnson and Roark, *Black Masters*, 224.

39. Johnson and Roark, *Black Masters*, 240, 175. For more on the fragile autonomy of urban enslaved people, see Nunley, *At the Threshold*.

40. Smith, *Charlestonian's Recollections*, 63–64.

41. Johnson and Roark, *Black Masters*, 272–73, 149, 238–40, 274.

42. Johnson and Roark, *Black Masters*, 237.

43. C. P. Gadsden, rector of St. Luke's Church, handwritten note, Charleston, S.C., January 17, 1867, B2F4, SCSVC.

44. Venning family valentines and birthday card file, B3F4, SCSVC.

45. [John Stiegling?] to RWC, May 21, 1857, B1F8, SCSVC.

CHAPTER FOUR

1. Kilbride, *American Aristocracy*, 29; Greenidge, *Grimkes*, 31.

2. Fant, *Travelers' Charleston*, 40, 47; John Izard Middleton, quoted in Kilbride, *American Aristocracy*, 127.

3. John Stephano Cogdell diary, September 21, 1808, vol. 1, Collection 252, John Stevens (Stephano) Cogdell Papers, Winterthur Library, Winterthur, Del.

4. LeClercq, *Between North and South*; Frank H. Taylor, *Philadelphia*, 9.

5. Harrison, *Best Companions*, 20, xiii; Kilbride, *American Aristocracy*, 33.

6. Winch, *Gentleman of Color*, 119–20, 341.

7. Lerner, *Grimké Sisters*, 20, 51, 252. For an excellent critical biography of several generations of Grimkes, both free and enslaved, and the sisters' complex relationship with the formerly enslaved children of their brother, Henry, and Nancy Weston, see Greenidge, *Grimkes*.

8. Miles, *All That She Carried*, 238; Diemer, *Vigilance*, 92.

9. See Foreman, Casey, and Paterson, *Colored Conventions Movement*.

10. Litwack, *North of Slavery*, 100, quote 101. This refers to the 1834 riot. Sturge is quoted in Litwack, 102.

11. Diemer, *Vigilance*, 162; Stevenson, *Journals of Charlotte Forten Grimké*, June 18, 25, 1857, 230, 232. According to Maillard (*Whispers of Cruel Wrongs*, 67n4), Stevenson occasionally inadvertently writes *S* as *L* when referring to the Sanders family.

12. Jacobs, *Incidents*, 227.

13. *McElroy's City Directory for Philadelphia* (1839) lists John S. Palmer (192). *Catholic Herald* (1844) was published and sold by John Palmer, bookbinder at 44 Prune (later Locust) Street. Although the Fitzwater deed refers to him as being of "the Seventh Ward," soon Palmer lived in Philadelphia's Fourth Ward with six children, ranging in age from thirty-seven to one; the presence of one-year-old James suggests either that Margaret Palmer had recently died or that he had a grandchild.

14. Powers, *Black Charlestonians*, 77.

15. *Press*, August 4, 1857. The Fitzwater neighbors are listed in *McElroy's Philadelphia City Directory* (1858) as well as the 1860 census.

16. "Board of Education. Statistics of Colored People of Philadelphia, 1856," vol. 1, Pennsylvania Abolition Society Papers, Historical Society of Pennsylvania, Philadelphia. The Third Ward's listing begins on p. 9 of this handwritten document.

17. 1116 Fitzwater deeds, plan book no. 5 S, 23, Philadelphia City Archives.

18. In May 1890, for some reason, Robert Sanders, Julia Venning, and Cordelia Chew's widowed husband, William, sold the house to William Harvey, a forty-five-year-old white butcher, "by Sheriff"; two days later William and Emma Harvey sold it back to Julia Venning, and it remained in the family until 1913. 1116 Fitzwater deeds, plan book no. 5 S, 23, Philadelphia City Archives.

19. Costa, *Gopsill's Philadelphia City Directory* (1870); Miranda Venning to "My dear Beckie," January 1, 1875, SCSVC. If the numbering system is the same, 337 South Camac was built in 1800 and is just over 2,000 square feet. The family sold 1116 Fitzwater Street in 1913 to a twenty-five-year-old fruit dealer, Charles Caruso, who had immigrated from Italy; in 1920, according to the US Census, he and Teresa (Giullano) Caruso owned the house free of a mortgage. They and their children, all of whom were born in Pennsylvania, lived there until 1935, when they sold it to Italian immigrants Carmine and Licia Tempesta. It is possible that the house had been divided by then; the Tempestas (or Sampestas) are listed in the census of 1940 as living in the rear of 1116 Fitzwater.

20. Louisa Jacobs (LJ) to Genie Webb (GW), February 23, 1882, in Maillard, *Whispers of Cruel Wrongs*, 90.

21. John B. Irving to RWC, April 30, 1858, B1F8, SCSVC. It is not clear how they made the trip. Family tradition mentions taking a stage, but travel by water was more common.

22. Litwack, *North of Slavery*, 115, 143, 149. In 1854, notes Baumgartner, "1,031 black students enrolled in the public schools and 331 in the private schools, and a little under 1,000 students attended benevolent and charity schools. There was no high school for African American youth." Baumgartner, *In Pursuit of Knowledge*, 183.

23. Biddle and Dubin, *Tasting Freedom*, 96, 102. This school was later renamed the James Forten school. W. E. B. Du Bois (*Philadelphia Negro*, 86) lists the public schools that were open to Black children in 1856.

24. Clarkson Educational Association Minutes, February 13, 1862, B6F18, Pennsylvania Abolition Society Papers, Historical Society of Pennsylvania, Philadelphia.

25. Biddle and Dubin, *Tasting Freedom*, 155–58; Institute for Colored Youth, *Objects and Regulations*. I am grateful to Christopher Hayashida-Knight for providing copies of documents related to the ICY.

26. Haynes, *Riotous Flesh*, 149–62, quotes 157, 154; Institute for Colored Youth, *Objects and Regulations*, 32; Coppin, *Reminiscences of School Life*, xxxi. On Catto, see Silcox, "Nineteenth-Century Philadelphia Black Militant," 198–219; and Biddle and Dubin, *Tasting Freedom*.

27. Stevenson, *Journals of Charlotte Forten Grimké*, March 31, 1858, 297. Certainly, the values and expectations of the place, not to mention the community of which it was part, "fit" with the Sanderses' own. Institute for Colored Youth, *Objects and Regulations*, 12.

28. *A Brief History of St. Thomas' Church*, in B3F1, SCSVC. By the time of the Sanderses' arrival, the church had long been more homogenously middle class. See Nash, *Forging Freedom*, 265.

29. Litwack, *North of Slavery*, 190, 201.

30. Ducachet to RWC, November 17, 1857, B1F10, SCSVC. Sarah Ann Sanders continued to pay a five-dollar (twice-yearly) pew rent for "1 seat gallery no. 33" at St. Stephen's Church in Philadelphia through 1870; pew receipts, B2F7, SCSVC. Years later, long after Sarah Ann had passed away, her niece Miranda Venning's funeral was held at St. Stephen's; clipping on Miranda Venning's death, B3F6, SCSVC. St. Stephen's, built in 1823, seems to be the only Philadelphia church still occupying the building the Sanders family or their father attended.

31. Note from directors of Club House, July 20, 1857, B1F10, SCSVC.

32. *McElroy's Philadelphia City Directory* (1860), 1283, 182; "Board of Education. Statistics of Colored People of Philadelphia, 1856," vol. 2, Pennsylvania Abolition Society Papers, Historical Society of Pennsylvania, Philadelphia; *Census of the City of Charleston* [. . .] *1861*, 211. In 1840 Cooper, a "mulatto," headed a household on Charleston Neck that included seven free and four enslaved people of color. But sometime before the war, Cooper, his wife Susan, and their six children migrated to Philadelphia, living near the Sanderses at 1320 Catherine Street.

33. Stevenson, *Journals of Charlotte Forten Grimké*, May 13, 1858, 310.

34. Biddle and Dubin, *Tasting Freedom*, 20, see also 9–15, 24.

35. On Catto's teaching, see Biddle and Dubin, *Tasting Freedom*, 203; on Cordelia, see Biddle and Dubin, 252, 264.

36. On Catto's baby with Rebecca Underwood, see Diemer, *Vigilance*, 252, 361n48. The death certificate for Elizabeth Catto is in the Philadelphia Death Certificates Index, 1803–1915, film no. 197774 (Ancestry.com). I have not been able to locate Rebecca Underwood after she moved to 604 Middle Alley (which was possibly the street later renamed Panama) and the baby died. Donna Rilling discovered the affair while doing her research for her forthcoming book, *Foreclosed: Race and Dispossession in a Nineteenth-Century Community*.

37. Printed card of church with handwritten testimonial on back, dated April 20, 1830, B3F1, SCSVC; certificate pasted on board, certified marriage on August 28, 1834, signed Thos. G. [Album?], B3F1, SCSVC. According to the 1856 Pennsylvania Abolition Society survey, both Edward and his brother John Venning were freeborn in a slave state. It is possible that John preceded him to the North; in any case, when John died in the spring of 1863, the carpenter brothers both lived on Rodman Street with their families and Edward witnessed John's will. "Will of John R. Venning [February 1863]," June 4, 1863, no. 240, book 50, p. 370, Historical Society of Pennsylvania, Philadelphia. Thanks for this, as for so many sources, to Donna Rilling.

38. [William Bolivar,] "Pencil Pusher Points" and "A Cursory Glance at the Various Movements from Charleston to Philadelphia, for Over One Hundred Years," n.d., B4F4, SCSVC.

39. The phrase is from Johnson and Roark, *Black Masters*, 203.

40. Myers, *Forging Freedom*, 136; Harris, "Charleston's Free Afro-American Elite," 292; Fitchett, "Traditions," 146.

41. Undated obituary clipping, B3F1, SCSVC; [William Bolivar,] "Pencil Pusher Points," *Philadelphia Tribune*, February 10, 1912, says he graduated in 1865, but that may be an error.

42. "Boys Preparatory," in Institute for Colored Youth, *Objects and Regulations*, 19; LJ to GW, March 24, 1881, in Maillard, *Whispers of Cruel Wrongs*, 78; *Christian Recorder*, March 17, 1881; [William Bolivar,] "Pencil Pusher Points," *Philadelphia Tribune*, April 13, 1912, noted that Venning "has been in position for thirty-one years."

43. Greenidge, *Grimkes*, 146.

44. Maillard, *Whispers of Cruel Wrongs*, 47; *State Journal*, February 23, 1884. For more on Bolivar, see Welburn, "To 'Keep the Past,'" 165–79.

45. Stevenson, *Journals of Charlotte Forten Grimké*, March 16, 1858, 292, and on Sarah Ann, March 20, 1858, 294. According to Maillard (*Whispers of Cruel Wrongs*, 20–21), Cordelia accompanied Charlotte Forten to Salem, Massachusetts, in the summer of 1862 and may have studied there.

46. Stevenson, *Journals of Charlotte Forten Grimké*, March 16, July 15, 1858, 292, 325; Porcher, "Memoirs," 91–92; RWC travel diary, B1F7, SCSVC.

47. [Sarah Ann Sanders?] to "My Dear Father," dated only "Monday Morning" [August 6, 1866], B2F7, SCSVC. Several clues solved the issue of the

letter's date and writer. It ends, "Give my love to all and tell the children that some of them must go to Mr. Prosser's funeral." Prosser was a prominent caterer, known for "perfecting restaurant catering and making many famous dishes," in W. E. B. Du Bois's words (*Philadelphia Negro*, 34). His death date provided the information for dating this letter. A letter that fall from John Irving further suggests that the vacationer at the beach was Sarah Ann.

48. The list, with one F. C. Walton listed as witness, is in B2F7, SCSVC.

49. RWC, "Directions to my Executors and Children," August 17, 1860, B1F10, SCSVC.

50. Cordelia Sanders to "My Dear Sister" [Julia?], June 4, 1867, B2F7, SCSVC; Bushman, *Refinement of America*, 434–35.

51. *Gleason's Pictorial*, October 8, 1853, 1.

52. Huger to RWC, September 15, 1859, B1F8, SCSVC.

53. [Ahean?] to RWC, August 25, 1860, B1F8; Irving to RWC, October 6, 1859, B1F10; Horlbeck to Sarah Ann Sanders, November 24, 1867, B2F7; and Irving to RWC, May 22, 1860, June 29, 1859, July 13, 1861, B1F8, all in SCSVC.

54. Cordelia Sanders ("Delia") to Newky/Minky [Sarah Ann?], March 16, 1867, B2F7, SCSVC. Irving had undertaken this plan for employment before the war and sent Cogdell "one of the many encouraging notices that are appearing daily in the papers here in reference to the magnificent Enterprize I have embarked in [*sic*]. It is the laudable effort of such monied men as Belmont, Duncan, & others to dignify the sports of the Turf." Irving to RWC, June 29, [ca. 1859,] B1F8, SCSVC.

55. Henry Middleton Smith, handwritten account (and typescript) of John B. Irving's life, John Irving Legal Papers 30-4, South Carolina Historical Society, Charleston. Irving's plan to return to Charleston "& return with Mrs Irving" is in his letter to Sarah [Ann] Sanders, October 12, 1866, B2F7, SCSVC.

56. Garcia to RWC, January 10, 1860, B1F8; and Irving to Sarah Ann Sanders, October 12, 19, December 14, 1866, B2F7, all in SCSVC. Garcia's letter closes with a fascinating (if often illegible) political commentary, apparently about John Brown. "I suppose you are pretty well [torn] & drenched with doses of 'Old B[rown] and shall only say, that I con[torn] that we of the South ought to be [torn] to Old Brown for furnishing a [torn] supply of political capital. Just at a time when it was so much needed."

57. Cordelia Sanders ("Delia") to Newky/Minky [Sarah Ann?], March 16, 1867, B2F7, SCSVC. I do not know if "R.S." refers to their brother Robert, but if it does, it indicates that she, or Irving, had written other, now lost, letters.

58. Cordelia Sanders to Newky/Minky [Sarah Ann?], March 16, 1867, B2F7, SCSVC. Georgina Frances Putnam was an assistant principal heading the primary department of Colored School No. 1. For information about the school, see box 1 (folders 1 and 3), Colored School No. 1 Records, 1863–1891, Schomburg Center for Research in Black Culture, New York Public Library.

59. Cordelia Sanders to Newky/Minky [Sarah Ann?], March 16, 1867; and Irving to Cordelia Sanders, September 11, 1871, both in B2F7, SCSVC.

60. Newky/Minky [Sarah Ann?] to "My Dear Father," [August 6, 1866], B2F7, SCSVC.

61. Porcher, "Memoirs," 92.

62. Charles S. Cogdell to RWC, October 1, 1856, B1F10, SCSVC.

CHAPTER FIVE

1. John B. Irving to Daniel Horlbeck, December 23, 1860, B2F2, SCSVC.

2. Johnson and Roark, *Black Masters*, 293–4. Powers (*Black Charlestonians*, 67) notes that the Brown Fellowship Society supported the Ladies Relief Association efforts to care for Confederate soldiers and that Black women organized "Colored Abandoned Women" to raise money for the Confederacy as well.

3. Hine, "Black Politicians," 568, table 9; "Archives and Library Update," 185–91; Powers, *Black Charlestonians*, 17.

4. The quote about Clement Williams Stevens is on a scrap of family history written by RWC, in B2F2, SCSVC. Stevens became a teenage midshipman, later serving as a lieutenant in the War of 1812. Paul Stevens (Paul Stevens letter [November 1959], Paul Stevens Papers, Caroliniana) claims that Clement was involved, in 1804, in "the affair under Decatur . . . with the Barbary Pirates"; Clement would have been only fourteen. He fought in the War of 1812, becoming a lieutenant, serving on the brig *Epervier*, in 1815; "The Epervier," *Newburyport Herald*, October 14, 1815. Reflecting the far greater wealth accrued by his father, Jack, in Jamaica, he (and later his son Clement Hoffman Stevens) acquired considerable property in Charleston; in 1822 his cousin Richard Cogdell paid him half a year's rent of $150. Receipt books, B1F7, SCSVC.

5. Paul Stevens letter [November 1959], Paul Stevens Papers, Caroliniana. Henry's release from prison in Massachusetts was aided by his Northern father-in-law, General Totten. Henry Stevens is listed in Naval War Records Office Memoranda No. 8, in *Officers in the Confederate States Navy*, 132.

6. On the eve of war, Clement Hoffman Stevens's real estate was worth $30,000 and his personal estate, which included enslaved people, only somewhat less. *Census of the City of Charleston*, 36, 77, 211. Stevens owned his family's residence at 3 Bay Street, as well as 2 Drake Street and 5 Wall Street. The 1860 federal census was the first one that separated "personal" from "real" property, which allows historians and descendants to calculate the value of enslaved people as part of someone's wealth on the eve of the Civil War. I have not found his three children (C. B., Hamilton, and L. K., ages ten, six, and two in 1860) in postwar records.

7. Paul Stevens letter [November 1959], Paul Stevens Papers, Caroliniana. See also "Clement Hoffman Stevens," Historical Marker Database (website), accessed January 20, 2024, https://www.hmdb.org/m.asp?m=9680.

8. Emerson and Stokes, *Faith, Valor, and Devotion*, 38n1, January 3 /February 1, 1862, 40, April 28, 1862, 61; Rose, *Rehearsal for Reconstruction*.

9. Irving to RWC, April 4, July 13, 1861, October 12, 1865, B1F8, SCSVC.

10. Sarah Ann Sanders to John Irving, April 13, 1868, B2F7, SCSVC.

11. Jonathan W. White, *Philadelphia Perspective*, January 2, October 6, November 6, 1860, 17–18, 47, 56.

12. Stevenson, *Journals of Charlotte Forten Grimké*, August 17, 1862, 376.

13. Hayashida-Knight, "'Sacrifices and Sufferings,'" 58; Brian M. Taylor, *Fighting for Citizenship*, 94. See also Mendez, *Great Sacrifice*, 11.

14. Quoted in Frank H. Taylor, *Philadelphia*, 188.

15. Jonathan W. White, *Philadelphia Perspective*, July 8, 1863, 198; *Weekly Anglo-African*, May 27, 1865.

16. Giesberg, *Emilie Davis's Civil War Diary*, June 17–18, 1863, 47; Biddle and Dubin, *Tasting Freedom*, 292. See also Silcox, "Nineteenth-Century Philadelphia Black Militant."

17. Frank H. Taylor, *Philadelphia*, 188; Giesberg, *Emilie Davis's Civil War Diary*, June 20–21, 1863, 47. Spellings [*sic*]. In 1866 Emilie Davis would marry George Bustill White, Jacob's brother.

18. "Mass Meeting," *Philadelphia Inquirer*, June 24, 1863, 5. The substitution form reads: "John H. Diggs born in the State of Maryland, aged 29 years, and by occupation a Farmer Do Hereby Acknowledge to have agreed with Edward Venning jr, esq, of 7th ward Philad to become his SUBSTITUTE in the Military Service, for a sufficient consideration paid and delivered to me, on the 24th Day of August, 1863, and having thus agreed with said Edward Venning jr I do hereby acknowledge to have enlisted in this 24th Day of August 1863 to serve as a Soldier in the Army of the United States of America for the period of THREE YEARS, unless sooner discharged by proper authority"; substitution form, B3F1, SCSVC.

19. "I hereby authorize Edward Y. Venning to draw the whole or any part of the many deposits in my name"; Edward W. Venning savings fund book, B3F1, SCSVC.

20. Giesberg, *Emilie Davis's Civil War Diary*, 54; Biddle and Dubin, *Tasting Freedom*, quote 290, next regiment 293. Some Black Washingtonians paid substitutes to fight for them. See *Christian Recorder*, December 12, August 29, September 5, 1863; and *Weekly Anglo-African*, August 1, 15, September 19, December 12, 1863. "Company Descriptive Book" lists quite a few of the soldiers as "substitute," though without elaboration.

21. "Company Descriptive Book." Alice J. Gayley notes in her online listing that he was a "substitute" and claims that he died on March 11, 1865; Alice J. Gayley, "6th Regiment U.S. Colored Troops," PA-Roots, accessed April 7, 2021, www.pa-roots.com/pacw/usct/6thusct/6thusctcof.html. On the battles of the Sixth Regiment, see Frank H. Taylor, *Philadelphia*, 190. See also Dobak,

Freedom by the Sword; and Civil War Soldiers and Sailors Database, National Park Service, www.nps.gov/civilwar/soldiers-and-sailors-database.htm. The battle at Chapin's Farm, which had taken place the previous September, led to severe losses among the US Colored Troops Sixth Regiment; Private Diggs may have been injured then and lingered.

22. Brian Luskey, email correspondence with author, March 2021; William Blair, email correspondence with author, March 2021.Luskey and Blair were both helpful in describing the rules of the draft, suggesting that Venning and Diggs might have had to meet either to sign these papers or later, when Diggs presented himself at the muster. See also Luskey, *Men Is Cheap*.

23. Edward Y. Venning obituary, *Philadelphia Inquirer*, July 29, 1884, B3F1, SCSVC.

24. Ladies Union Association, *First Annual Report*.

25. "An Appeal," *Christian Recorder*, January 21, 1865.

26. Ladies Union Association, *First Annual Report*; Stevenson, *Journals of Charlotte Forten Grimké*, June 25, 1858, 232.

27. Giesberg, *Army at Home*, 98; *Press*, July 21, 1864.

28. Allison quoted in Diemer, *Vigilance*, 242; Biddle and Dubin, *Tasting Freedom*, 351–52; Cordelia Sanders to Newky/Minky [Sarah Ann?], March 16, 1867, B2F7, SCSVC.

29. RWC to Maj. James Du Gue Ferguson, April 9, 1865, B1F10; and [Sarah Ann?] to RWC, Monday, [August 6,] 1866, B2F7, both in SCSVC.

30. Irving to RWC, October 12, 1865, B1F8; and Cordelia Sanders to Newky /Minky [Sarah Ann?], March 16, 1867, B2F7, both in SCSVC.

31. Gadsden, handwritten document, January 17, 1867, B2F4; and Edward Y. Venning to Rev. Richard A. Carden, July 13, 1867, B3F1, both in SCSVC.

32. Cordelia Sanders to RWC, February 10, 1866, B2F7; and undated business card for the carpentry shop of T. S. Denny, B6F4, both in SCSVC. Denny is buried with Robert and Martha in Eden Cemetery, in a plot owned by their brother-in-law William Chew. The Davenports are buried in Mendon, Massachusetts. Anna Davenport's grave (with a photograph of her) can be found on FindaGrave.com (which gives her name as "Ann A. Davenport"), https://www .findagrave.com/memorial/39918045/ann-a-davenport.

33. Daniel Horlbeck to Sarah Ann Sanders, November 24, 1867, B2F7, SCSVC.

34. Second codicil to will dated February 12, 1866, B1, folder between 3 and 4 unlabeled (3½); and RWC to Horlbeck, July 30, 1865, B1F8, both in SCSVC.

35. Sarah Ann Sanders to John Irving, April 13, 1868; and Horlbeck to Sarah Ann, November 24, 1867, both in B2F7, SCSVC.

36. Sarah Ann Sanders's letter quoted back to her, in Horlbeck to Sarah Ann, November 24, 1867; Sarah Ann to Irving, April 13, 1868; and Irving to Sarah Ann, April 14, 1868, all in B2F7, SCSVC. Hassard's pharmacy was at Twelfth and Chestnut.

37. Thomas P. Lockwood Jr. to Harriet R. Palmer, January 7, 1865, in Towles, *World Turned Upside Down*, 426.

38. Horlbeck to Sarah Ann, April 25, 1868, November 18, 1867; and Sarah Ann to Irving, April 13, 1868, all in B2F7, SCSVC. On the 1860 taxes, see *List of the Tax Payers*, 57, 270, 132–33.

39. Horlbeck to Robert Sanders and sisters, December 27, 1866, B2F3, SCSVC.

40. Cordelia Sanders to Newky/Minky [Sarah Ann?], March 16, 1867, B2F7, SCSVC.

41. "Accounts, Estate of R. W. Cogdell," B2F3, SCSVC.

42. Bank book, B2F7, SCSVC. The house, too, had risen in value; in 1869 it was valued at $3,000. The receipt for city real estate taxes was in Cogdell's name; three years after his death and a dozen years after he had signed the house over to his children he—or his estate—continued to pay taxes. Receipt to R. W. Cogdell for 1116 Fitzwater city tax for $55.64, December 31, 1869, B6F34, SCSVC.

43. Cordelia Sanders to RWC, February 10, 1866; Irving to Sarah Ann, December 31, 1868, both in B2F7, SCSVC.

44. Horlbeck to Sarah Ann, November 24, 1867, B2F7; and to Robert Sanders and sisters, December 27, 1866, B2F3, both in SCSVC. The telegram from Horlbeck awaiting Cogdell's body is in B6F34, SCSVC.

45. Irving to RWC, October 12,1865; and A. G. MaGrath to RWC, April 22, 1866, both in B1F8, SCSVC.

CHAPTER SIX

1. Hartman, *Wayward Lives, Beautiful Experiments*.

2. Gordon, *Ghostly Matters*, 20.

3. Some official documents, including the 1860 federal census, misspell his name as Saunders, making identification harder.

4. Venning family Bible, AM 1851, SCSVC. This Bible has several clippings pasted inside it.

5. *McElroy's Philadelphia City Directory* (1860), 1283, 182; *Gopsill's Philadelphia City and Business Directory for 1868–1869*, 1382; LJ to GW, January 20, 1880, in Maillard, *Whispers of Cruel Wrongs*, 57–60.

6. "The Census Not Ended," *Times*, June 22, 1890, 1.

7. This phrase of Cordelia Sanders's is part of a scrap that may be part of a letter dated June 7, 1868, in B2F7, SCSVC.

8. Horlbeck to Sarah Ann, November 18, 1867, B2F7, SCSVC.

9. Newky/Minky [Sarah Ann?] to RWC, [August 6, 1866,] B2F7, SCSVC.

10. Sarah Ann to Horlbeck, April 13, 1868; Sarah Ann to Irving, April 13, 1868; and Irving to Sarah Ann, April 14, 1868, all in B2F7, SCSVC.

11. It was Cordelia who made the final deposit of twenty dollars in their account as executrix. An ad in the *Press* stated: "Estate of Sarah A. Sanders,

deceased. Letters testamentary having been granted upon the above estate, all persons indebted to said estate are requested to make payment, and those having claims or demands against the same to make them known without delay to MRS. CORDELIA S. CHEW, NO. 1116 Fitzwater street, executrix, or to her attorney, JNO. C. REDHEFFER, 128 South 6th St." *Press*, September 19, 1871, B3F6, SCSVC.

12. Biddle and Dubin, *Tasting Freedom*, 421–40, 445, 430.

13. W. E. B. Du Bois, *Philadelphia Negro*, 40 and footnote by Bolivar. See also Cohen, "Honoring Universal Suffrage."

14. Hayashida-Knight, "'Sacrifices and Sufferings,'" chap. 4.

15. Cordelia's scrapbooks are in B2F5 and B2F6, SCSVC. Quotes are from Hayashida-Knight, "'Sacrifices and Sufferings,'" 16, 17.

16. Baumgartner, *In Pursuit of Knowledge*, 4 and elsewhere about the "purpose" of Black women's educational ambitions. On Colored School No. 1 see Woodson, *Education of the Negro*, 152; and Biddle and Dubin, *Tasting Freedom*, 166–67. Historians disagree about the school's origins, but it became part of the Brooklyn public school system in 1845. Baumgartner, *In Pursuit of Knowledge*, 87. In 1887, when legal integration was achieved, it would become PS 67; a folder of material from PS 67's early graduates and teachers is in box 1 (1) SCM90–48/MG400, Colored School No. 1 Records, Schomburg Center for Research in Black Culture, New York Public Library. See also folder 4, "Renaming PS 67 the Charles Dorsey school (1977)," in the same box.

17. Stevenson, *Journals of Charlotte Forten Grimké*, March 16, 1858, 292.

18. Cordelia Sanders to RWC, February 10, 1866; to [Julia Venning?], June 4, 1867; and to Newky/Minky [Sarah Ann?], March 16, 1867, all in B2F7, SCSVC.

19. Stevenson, *Journals of Charlotte Forten Grimké*, June 18, 1857, 230; Cordelia Sanders to Newky/Minky [Sarah Ann?], March 16, 1867, B2F7, SCSVC.

20. These letters contain some scraps, separate pages in lighter ink. Clearly they start in the middle of something and seem to be attached to the letter to Julia dated June 4, 1867, B2F7, SCSVC.

21. *Brooklyn Eagle*, December 24, 1868; Irving to Sarah Ann, December 31, 1868, B2F7, SCSVC.

22. Costa, *Gopsill's Philadelphia City Directory* (1870); quote from [William Bolivar,] "Pencil Pusher Points," *Philadelphia Tribune*, September 13, 1913. On Black barbers, see Bristol, *Knights of the Razor*.

23. Terborg-Penn, *African American Women*, 41.

24. Quoted in Hayashida-Knight, "'Sacrifices and Sufferings,'" 131; *New National Era*, May 22, 1873, 1. The *New National Era*'s subheading reads "The Difficulties between the white and colored ladies of the Philadelphia Centennial Committee" in an article that includes an interview with LeCount.

25. Hayashida-Knight, "'Sacrifices and Sufferings,'" all quotes 143–48. See *New National Era*, June 5, May 22, 1873.

26. Hayashida-Knight, "'Sacrifices and Sufferings,'" 148–50; *Philadelphia Inquirer*, May 12, 1873.

27. Hayashida-Knight, "'Sacrifices and Sufferings,'" 150–52; *New National Era*, June 5, 1873; *Philadelphia Inquirer*, May 23, 1873.

28. Hayashida-Knight, "'Sacrifices and Sufferings,'" 154.

29. Maillard, *Whispers of Cruel Wrongs*, 180n32. Several handwritten receipts from 1875–76: "Rec'd of Mrs. C. S. Chew, $24, $12, $36 for board to Eleanor Jacobs in Cambridge and $12 for piano rental," B2F8, SCSVC.

30. LJ to GW, June 20, 1880, in Maillard, *Whispers of Cruel Wrongs*, 66.

31. LJ to GW, January 20, 1880, in Maillard, *Whispers of Cruel Wrongs*, 57–60.

32. Handwritten note:

Philadelphia November 10th, 1879

Died at 8 o'clock of 5th inst. Funeral of Mrs. Cordelia S. Chew
Carriages:

1st first: William H. Chew, two children & Clara

2nd second Robt. Sanders with Mrs. E. Y. Venning, Edw. Y. Venning with Mrs. Robt. Sanders

3rd Mrs. [Jno?] Chew with Miranda C. Venning, Oliver Venning with Sallie Chew

4th Rebecca Venning with Julie Venning, Thos [Denny] with Eugenia Webb

5th Richard Venning and Mrs. L.[?] Demar, Dr. Bishop with Edith Webb

6th Mrs. Edw. W. Venning with Mrs. Ann Oneill, Mr. Saml [illegible] Demar with Mrs. Robt. Lewis

7th Mrs. Lacombe with Mrs. Ferrette, Mrs. Hanna Brooks with Miss Corinna Barr

8th Mrs L. Bolivar with Mrs. Lindsay, Miss Sarah Smith with Miss Hannah Porter

9th Miss Morris Brown, Chas. G. Ferrette, Julius J. Boisdon, and Worley Bascom, who would serve as Paulbearer.

Someone, in the same writing, has written at the bottom: "Poor Deley's death made a big change in domestic matters." Note in B2F8, SCSVC.

33. Maillard, *Whispers of Cruel Wrongs*, 4, 10.

34. Maillard, *Whispers of Cruel Wrongs*, 22; LJ to GW, dated September 28, postmarked September 30, 1882, and to GW, November 21, 1879, both in Maillard, 93, 53–55.

35. LJ to GW, June 20, August 3, October 4, 1880, from Brockett's Bridge, February 20, 1880, all in Maillard, *Whispers of Cruel Wrongs*, 65–66, 67, 68, 61.

36. LJ to GW, December 20, 1879, [March] 25, 1880, January 4, July 18, 1881, all in Maillard, *Whispers of Cruel Wrongs*, 55, 64, 73, 84.

37. LJ to GW, December 20, 1879, in Maillard, *Whispers of Cruel Wrongs*, 55. Willie Chew was one of six children. John Chew, a successful hairdresser, had

had a personal estate of $300, but his family's security lay mostly in his real estate, which he valued at $5,000.

38. LJ to GW, January 20, 1880, in Maillard, *Whispers of Cruel Wrongs*, 57.

39. [William Bolivar,] "Pencil Pusher Points," [*Tribune*,] n.d., document 9, B4F4, SCSVC. The *Philadelphia Tribune* (April 25, 1914) reprinted a Pencil Pusher column that mentions Miranda Venning and William Chew's lawsuit against the school board. Information (not fully accurate) about William Chew's efforts are in "The Color Line," *Philadelphia Inquirer*, September 6, 1880, and "A Mandamus against the Board of Public Education," *Philadelphia Inquirer*, December 1, 1880.

40. "[Illegible] Education of Colored People," undated clipping soon after Miranda's death, B3F6, SCSVC; undated excerpt, B4F4, SCSVC; "The Color Line," *Philadelphia Inquirer*, September 6, 1880; LJ to GW, October 4, 1880, in Maillard, *Whispers of Cruel Wrongs*, 68. According to the *Philadelphia Inquirer* (December 1, 1880), William Chew brought the case on behalf of his son Charles H. Chew and his niece Sallie Lenning [Venning].

41. LJ to GW, July 18, 1881, in Maillard, *Whispers of Cruel Wrongs*, 84.

42. Advertising in the *Washington Bee*, "Rainey and Chew" promised "2240 pounds to the ton" of coal, guaranteed before "the extreme cold weather." *Washington Bee*, November 21, 1885; Maillard, *Whispers of Cruel Wrongs*, 47.

43. Sallie Venning diary, June 5, 6, 7, 1892, SCSVC. All quotes from Sallie Sanders Venning's diary are from the transcript done by Krystal Appiah, which is now online as part of the Library Company's digital collection. The story of Lebanon Cemetery is a fascinating one. Jacob C. White Jr.'s father, Jacob Sr., owned the cemetery on the city's southern edge, one of two Black-owned burial places in Philadelphia, and his son took over after his death. In 1882 the Philadelphia *Press* reported that bodies buried at Lebanon had been dug up and sold to medical schools. While the veracity of the report remains unclear, African American Philadelphians were outraged, and close inspection of Lebanon revealed disarray and mismanagement. When the city closed Lebanon Cemetery for good in 1902, bodies (including those of Sanderses) were recovered and reburied in Eden Cemetery in Lansdale. McLeary, "Curious Case of Body Snatching." Edward W. Venning owned a plot in Lebanon Cemetery that was later assigned to Eden; a "Proposition to the Lot Holders of the Lebanon Cemetery Company," dated 1902, offered an exchange of land, along with the removal of bodies and headstones to their new location "without any expense to the lot owners." Eden Cemetery Company to Edward W. Venning, for lot no. 41 in Lebanon Section, deed 29, Burial Records, Historic Eden Cemetery.

44. Irving to RWC, October 12, 1865, B1F8, SCSVC.

45. "The Colored Poor," *Philadelphia Inquirer*, August 5, 1875, 2.

46. Martha Sanders obituary (photocopy, no attribution), April 8, 1913, B3F6, SCSVC.

47. Label by archivist on picture, P.9367.32, SCSVC. Pastel based on tintype in Richard DeReef Venning album, p-2012-37-1-p23b, SCSVC. The latter was taken by Joseph Fenton at 729 South Street sometime between 1867 and 1881. See Ries and Ruby, *Directory of Pennsylvania Photographers.*

CHAPTER SEVEN

1. Wright, "Imagining Freedom."

2. W. E. B. Du Bois, *Philadelphia Negro*; Anderson, introduction, quote from Du Bois's *Autobiography* xvi, xxi.

3. A sampling of biographies about these leaders includes Bay, *To Tell the Truth*; Lewis, *W. E. B. Du Bois*; and Parker, *Unceasing Militant.*

4. Higginbotham, *Righteous Discontent*, 188. See Mitchell, *Righteous Propagation.*

5. Cordelia Sanders to Miranda Venning, June 8, 1866; and Miranda Venning to [Rebecca Venning], January 1, 1875; and to Richard DeReef Venning, October 1875, all in B3F6, SCSVC.

6. Receipts, October 2, 1871; "Our Schools and Colored Children," letter to the editor, *Record*, July 3, 1878, on "The Colored Competition" at the Normal School yesterday; and sheets of Miranda Venning obituaries, all in B3F6, SCSVC.

7. Venning autograph book, given to Miranda C. Venning from her uncle R. D'Reef Venning, May 16, 1877, B4F1; and [Oliver Venning] to Helen Lee Pinkett (supervisor, Negro Unit, Federal Writers' Project), typescript on "Life of Miranda C. Venning, 1862–1900," B5F9, both in SCSVC.

8. Robert Vaux Grammar School "Certificate of Attendance, Conduct, and Lessons, &C., of Miranda C. Venning, 'B' Division, Senior Class," 1878; and "[Illegible] Education of Colored People," undated clipping, both in B3F6, SCSVC.

9. Letter to the editor, *Record*, July 3, 1878, in B3F6; and Edward Venning obituary, undated and unattributed, B3F1, both in SCSVC. Similarly, Miranda's grandmother Elizabeth Nixon Venning's obituary of September 23, 1897, mentions two living children and that her grandchildren include Miranda Venning, principal of the Joseph Hill School; in B6F45, SCSVC.

10. [William Bolivar,] "Some of Our First Graduates under Our Public School System, and University of Pennsylvania," Pencil Pusher Points, *Tribune*, n.d. [after 1900], in B4F4, SCSVC; "William Byrd," *Germantown Crier*, Spring 2002, 28; W. E. B. Du Bois, *Philadelphia Negro*, 89; "[Illegible] Education of Colored People," undated clipping, B3F6, SCSVC; "History of the Hill School," *Germantown Crier*, Winter 1983–84, 15. Then as now, the names of schools raised hackles. As one author claimed, the 1913 effort to change the name of the Joseph E. Hill School back to Rittenhouse was further evidence that "the Board of Education has been planning and shaping every means toward segregation."

"Let the Name Remain," unattributed newspaper clipping (photocopy), April 18, 1913, B3F6, SCSVC. Miranda knew Joseph Hill, who had signed her autograph book on September 11, 1877; her brother Oliver suggested that she had come up with the school's name; [Oliver Venning,] "Life of Miranda C. Venning, 1862–1900," B5F9, SCSVC. The record of her employment is confusing: some accounts state that she was a teacher and principal at the Hill School for sixteen years and another that, in 1888, she was the principal of the "Haines colored secondary school" and was "personally teaching six grades"; *Times*, October 28, 1888. Another said that, in 1890, the school board appointed her the principal of the Haines night school; *Times*, September 24, 1890.

11. Sallie Venning diary, May 3, 1891, SCSVC.

12. Funeral notice, *Press*, January 22, 1900, 15; Bolivar to Miranda Venning, January 15, 1900, B4F4, SCSVC; Miranda Venning obituary, *Germantown Guide*, January 20, 1900; *Portland Morning Oregonian*, February 8, 1900. Her mother, Julia Sanders Venning, received a check from the Teachers Annuity and Aid Association; in B3F6, SCSVC.

13. "Concert and Exhibition by the Sabbath School of St. Thomas' P.E. Church," May 30, 1877, B6F11; and "1st Annual Concert of the Young Peoples' Assn of the Chh of the Crucifixion at Liberty Hall," December 26, 1881, B6F15, both in SCSVC; *Christian Recorder*, July 7, 1881. Julie Venning is listed under her married name, Warwick, in the (incomplete) index of students who attended the ICY. See Coppin, *Reminiscences of School Life*.

14. Annie Purvis to GW, September 7, 1885, in Maillard, *Whispers of Cruel Wrongs*, 68.

15. *Official Register of the United States*, 2:585; W. E. B. Du Bois, *Philadelphia Negro*, 342. Du Bois also mentions that the man was once "assistant business manager of a large white religious newspaper in the city," which almost fits with a reference in *The American Baptist Yearbook*, which claimed that the *Christian Banner*, an African American newspaper founded in 1888 in Philadelphia, was edited by a James E. Warwick.

16. *Christian Recorder*, July 7, 1881; "Announcement," Tuesday, December 16 [no year], B6F15, SCSVC; *Christian Recorder*, March 2, 1882. Another concert program listed him as the president of the Young People's Association, working alongside Miranda Venning.

17. Sallie Venning diary, January 30, February 15, 22, 1890, September 23, August 24, 1891, April 3, 1892, SCSVC.

18. Sallie Venning diary, November 18, 20, 21, 24, 1891, SCSVC. In 1900 the forty-year-old widower lived with Florence (fourteen years old) and Elizabeth (twelve), as well as with his sisters Mary (forty-four) and Margaret (thirty-six) Warwick, in a house he (or they) owned on South Eleventh Street. In 1920, Elizabeth Warwick died at age twenty-two; Florence had died the year before, in 1919, at only thirty-three years old. By 1920 James had remarried, as that year's

census includes a wife, one Georgina Warwick, some fifteen years his junior. When he died in 1944, he lived in Chester and left his estate to his "beloved sister" Margaret.

19. Flyer, "Grand Concert: Thursday, Nov, 7, 1918, Musical Fund Hall," B6F8; and clipping of Florence Warwick obituary, B6F28, both in SCSVC.

20. Sallie Venning diary, January 9, 1890, SCSVC. I do not know who this Clara was, though the reappearance of her name (as someone doing domestic labor) is tantalizing.

21. Sallie Venning diary, dancing school October 13, November 10, 17, 1890, and other references November 11, 18, 1890, SCSVC.

22. Sallie Venning diary, March 24, September 14, March 31, 1892, January 6, 1891, SCSVC.

23. Sallie Venning diary, March 19, September 8, 1890, March 10, 1891, and others, SCSVC.

24. Sallie Venning diary, January 16, May 27, October 26, November 30, 1891, April 28, January 3, 1892, SCSVC.

25. Sallie Venning diary, April 10, 11, 15, 25, 1890, March 30, April 20–22, 27, 1891, SCSVC.

26. Sallie Venning diary, February 2, March 2, April 13, 27, September 7, 14, 1891, March 7, 14, April 5, 1892, SCSVC.

27. Scrap dated November 22, 1893, lists Fern Leaf members, in B3F6, SCSVC. Sallie Venning diary, October 5, 8, 29, 1891, February 11, 1892, SCSVC.

28. Sallie Venning diary, e.g., January 20, February 21, 1891; and on fire, see newspaper clipping, February 10, 1902, B6, all in SCSVC.

29. Sallie Venning diary, August 26, 1890, July 15, September 19, 1891, SCSVC: "Went in bathing. Julia went in for the first time."

30. Sallie Venning diary, e.g., February 15, 1892, July 31, 1891, SCSVC. Julia Capps Venning was born and raised in Philadelphia. Her father, Augustus (a waiter), may have taken on summer work at the shore.

31. Scrapbook clipping, B6F9, SCSVC.

32. *New York Times*, June 26, 1887, quoted in Goldberg, *Retreats of Reconstruction*, 149n5; *New York Times*, July 20, 1890, quoted in Goldberg, 60. For histories of the Jersey Shore, see Goldberg; Wolff, *4th of July*; Funnell, *By the Beautiful Sea*; Nelson Johnson, *Boardwalk Empire*; and Simon, *Boardwalk of Dreams*.

33. Duhart, "N.J. Beach."

34. Sallie Venning diary, September 21, 1891, February 19, October 4, 1892, SCSVC.

35. Sallie Venning diary, November 21, 1892, October 13, November 25, 26, 1891, SCSVC. This latter entry was one year since Robert Sanders had appeared in the newspaper as an enumerator. Perhaps his "trouble" from that persisted, or perhaps his health had declined.

36. Sallie Venning diary, July 13, June 28–September 30, 1892, SCSVC.

37. Sallie Venning diary, January 15, February 9, April 22, 1890, SCSVC.

38. Sallie Venning diary, January 1, February 18, October 22, December 1, 1890, January 22, 29, 1891, SCSVC. Perhaps the Duttons had just moved to Fitzwater; in 1880, Sampson Dutton, a waiter, his wife Anna, and their son Frederick lived west of Broad Street, on Wetherill.

39. Wedding invitation, B6F28, SCSVC.

40. Letters of condolence, Holden file, B3F5, SCSVC.

41. I identified the diarist as Sallie Holden based on her reference to her anniversary date. Holden diary, B6F5; and Sallie Holden to Louise Venning, August 28, 1923, B5F4, both in SCSVC.

42. Sallie Venning diary, February 3, 1890; calling card, January 1, 1909, B6F27; and calling card, December 29, 1906, 8–10 p.m., B6F33, all in SCSVC.

43. Louise Venning to Sallie Holden, August 29, 1923, B5F4; and notes and documents including inventory of estate, distribution of personal effects to Venning nieces, "George Edward Venning, in Account with Estate of Louise S. Venning, Dec'd," and an inventory of her estate, B4F90, all in SCSVC. The Star sedan was worth $375.

44. "Institutional Relief Organization presents 'International Congress of Women in Pantomine,' Musical Fund Hall," December 5, 1919, B6F43, SCSVC.

45. "Court of Common Pleas, Sitting in Equity, March term 1937, between city of Phila and Edward W. Venning," B3F2, SCSVC. Quote in W. E. B. Du Bois, *Philadelphia Negro*, 62n.

46. World War I draft registration cards can be found on Ancestry.com.

47. Invitations to Bachelor-Benedict balls include these names variously in 1903, 1907, and 1908. The 1897 invite says only "Bachelors," so apparently the name changed. Invitations, B6F24, SCSVC. Richard Chew is only listed on the 1903 one, about when he went to Lehigh.

48. Program for "Triumphant Return," B6F41, SCSVC. "Chair Covers," the program noted, were "Donated by Williams & Chew."

49. Mary Hinkson to her parents, July 14, 1854, B9F7, SCSVC.

50. University of Pennsylvania, "Program for the 139th Commencement (1895 and 1896)"; catalogue listing course requirements for University of Pennsylvania engineers, Richard Sanders Chew File, University of Pennsylvania Archives; *Philadelphia Inquirer*, June 12, 1895; W. E. B. Du Bois, *Philadelphia Negro*, 353.

51. Review of "An Approximate Measure of Earthquake Effect on Framed Structures" by Richard S. Chew (1938, 165 pages), in Richard Sanders Chew File, University of Pennsylvania Archives.

52. Greenidge, *Black Radical*, 42.

53. Josephine R. Chew, *We Will Meet Again Some Day: Ballad* (San Francisco: Rialto, 1921), 3430.F, Library Company of Philadelphia. People's

expectations, of course, shape the ability to pass racially. The (white) geologist Clarence King was able to pass as Black because he told his future (African American) wife that he was a Pullman porter. See Sandweiss, *Passing Strange*.

54. Richard Chew to Cordelia (Betty) Hinkson, n.d., B9F15, SCSVC.

55. Richard Chew obituary, *San Francisco Examiner*, June 26, 1962.

56. Hartman, *Wayward Lives, Beautiful Experiments*, 157.

57. Elizabeth Palmer Porcher to Harriet R. Palmer, November 12, 1871, May 17, 1870, in Towles, *World Turned Upside Down*, 708, 650.

58. Richard Cogdell's friends and kin who stayed in Charleston barely appear in the remaining sources. John Irving remained in New York until his death a decade later. Daniel Horlbeck lived until 1879. Harry Stevens's daughter (Cogdell's first cousin), Mary Ann Kennedy, now widowed, was the last living grandchild of John and Mary Stevens. Surely she had known, or known of, the Sanders children, although there is no evidence that she and Richard stayed in touch. In 1870, at seventy-eight years old, she lived in Spartanburg, South Carolina, with her daughter Susannah. Her youngest son, Lionel Chalmers Kennedy, a fifty-three-year-old physician, had moved there as well. Lionel valued his real estate at $800 and his personal estate at $790, while his mother's were $900 and $470, respectively.

59. "Paul Stevens, 72," *Sun-News*, December 7, 1969. Basic information about Paul Stevens's children is available through Ancestry.com, which includes birth, death, marriage, and divorce records and some high school yearbooks, and in local newspapers' wedding announcements. Dorothy Lantane Stevens served as a nurse in World War II and married twice. Ann Holladay Stevens attended Goucher College and married S. H. Buckner "at the Stevens' Farm"; *Daily Times-News*, June 14, 1949, August 8, 1951. Eliza Spurr Stevens graduated from Sweet Briar College in 1957, married a sales manager from Missouri, James Perry Jackman, had three children, and divorced.

60. "Niles Stevens," School Yearbooks, 1900–2016 (database), Ancestry.com. Niles Stevens married and had two children.

61. Stevens, *Persimmon*, 143–44; Stevens, "Socialism Is Not for United States," *Daily Times-News*, December 27, 1962; Stevens quoted in Staley A. Cook, "Wind and Confetti," *Daily Times-News* February 21, 1963; "Paul Stevens' File Is Complete," *Daily Times-News*, December 15, 1969. See also Paul Stevens, "Citizen of the World," *Daily Times-News*, March 8, 1862.

62. Their older daughter, Agnes, was two, and four years later a son, Charles, died as a baby.

63. Barnes to Hinkson, July 21, 1941, B9F2, SCSVC. Over the years, Dr. Hinkson would sign his name as the doctor of record on family death certificates, including that of Sallie Venning Holden, the last of Julia Sanders and Edward Venning's children, who died in 1959 at age eighty-seven at 2107 Fitzwater Street.

64. "D. Hinkson, Physician, Civil Rights Leader," *Philadelphia Inquirer*, December 1, 1975, 31; birthday card, B9F2, SCSVC.

65. Typescript of "The Dark Shadow" and Buck to Cordelia Hinkson, June 26, 1942, B9F1, SCSVC.

66. Buck to Cordelia Hinkson, June 26, 1942, B9F1, SCSVC; Milton S. Mayer, "The Case against the Jews," *Saturday Evening Post*, March 28, 1942.

67. Jefferson, *Constructing a Nervous System*, 145–46.

68. Mary Hinkson's letters from Europe, which open up areas of study outside the purview of this book, are simply wonderful. In B9F4-10, SCSVC.

69. Online photos from yearbooks are on Ancestry.com. Sanders descendants maintain an active interest in their family's history, including branches not touched on in this book. For a creative rethinking of Sarah Martha Sanders's daughters' and granddaughters' struggles, see Lora, "Our Whispering Wombs," 32–42.

70. Cogdell Cousins genealogy site, Wayne County, N.C., Biographies, USGenWeb Archives; Greenidge, *Grimkes*, xxvi.

CONCLUSION

1. Chris Ware, "All Together Now," *New Yorker*, January 6, 2014.

2. Haraway, "Situated Knowledges."

3. Barkley Brown, "'What Has Happened Here?,'" 297.

4. Gordon, *Ghostly Matters*, 18.

5. Berlin, *Slaves without Masters*, 388.

6. Nirenberg, *Neighboring Faiths*, 3.

7. Peterson, *Black Gotham*, 208.

8. Richard White, *Remembering Ahanagran*, 13.

BIBLIOGRAPHY

PRIMARY SOURCES

ARCHIVES

Charleston County Public Library, Charleston, S.C.
 City of Charleston Death Records
Charleston Museum, Charleston, S.C.
 Photograph Collection
Historic Eden Cemetery, Collingdale, Pa.
 Burial Records
Historical Society of Pennsylvania, Philadelphia
 Pennsylvania Abolition Society Papers
Library Company of Philadelphia
 Stevens-Cogdell-Sanders-Venning-Chew Collection
 Wood-Webb Family Collection
National Archives, Kew, Richmond, Surrey, England
 Wills, 1384-1858
New York Public Library
 Schomburg Center for Research in Black Culture
 Colored School No. 1 Records
Philadelphia City Archives, Department of Records
 Real Estate Records and Deeds
South Carolina Department of Archives and History, Columbia
 Charleston District Probate Court, Will Books
 Charleston District Courts at Equity, Bills
 Secretary of State, Miscellaneous Records
 South Carolina Deed Abstracts
 South Carolina Will Transcripts (WPA)
South Carolina Historical Society, Charleston
 Cogdell Family History and Genealogy Research Files
 Horlbeck Brothers Records, 1824–1860
 John B. Irving Legal Papers, 1845–1868
South Caroliniana Library, University of South Carolina, Columbia
 Henry Kennedy Stevens Papers
 Manuscripts Misc. (Kennedy, Lionel Henry)
 Paul Stevens Papers
University College London
 Centre for the Study of the Legacies of British Slavery (www.ucl.ac.uk/lbs)

University of Pennsylvania Archives, Philadelphia
 Richard Sanders Chew File
USGenWeb Archives (http://files.usgwarchives.net)
 Wayne County, N.C., Biographies
 Cogdell Cousins genealogy site (http://files.usgwarchives.net/nc/wayne
 /bios/cogdl01.txt)
Winterthur Library, Winterthur, Del.
 John Stevens (Stephano) Cogdell Papers
 Collection 252 (6 vols. of journals)

PERIODICALS

Albion (New York)

Antiques

Atlanta Constitution

Brooklyn Eagle

Carolina Gazette (Charleston, S.C.)

Charleston (S.C.) Courier

Christian Recorder

City-Gazette and Daily Advertiser
 (Charleston, S.C.)

Daily Times-News (Burlington, N.C.)

Georgia Gazette (Savannah)

Germantown Crier (Philadelphia)

Germantown Guide (Philadelphia)

Gleason's Pictorial (Boston)

Newburyport (Mass.) Herald

New National Era (Washington, DC)

New Yorker

New York Times

Philadelphia Gazette

Philadelphia Inquirer

Philadelphia Tribune

Portland Morning Oregonian

Press (Philadelphia)

San Francisco Examiner

Saratoga (N.Y.) Sentinel

Saturday Evening Post

State Journal (Harrisburg, Pa.)

Sun-News (Myrtle Beach, S.C.)

Times (Philadelphia)

Vermont Phoenix (Brattleboro)

Washington (DC) Bee

Weekly Anglo-African (New York)

DIRECTORIES

Census of the City of Charleston, South Carolina, for the Year 1861. Prepared under the Authority of the City Council by Frederick A. Ford. Charleston, S.C., 1861.

Costa, Isaac, comp. *Gopsill's Philadelphia City Directory* [. . .] Philadelphia: James Gopsill, 1870, 1880, 1887.

Directory and Stranger's Guide, for the City of Charleston [. . .] *for the Year 1819.* Charleston: S.C.: Schenck and Turner, 1819.

Directory and Stranger's Guide, for the City of Charleston [. . .] *for the Year 1822.* Charleston, S.C.: James R. Schenck, 1822.

Directory and Stranger's Guide, for the City of Charleston for 1831. Charleston, S.C.: Morris Goldsmith, 1831.

Directory of the City of Charleston, for the Year 1852. Charleston, S.C.: J. H. Bagget, 1852.

Elizer, Eleazer. *A Directory for 1803.* Charleston, S.C.: W.P. Young, 1803.

Folker, Joseph. *A Directory of the City and District of Charleston; and Stranger's Guide.* Charleston, S.C.: G. M. Bounetheau, 1813.

Gopsill's Philadelphia City and Business Directory for 1868-1869. Philadelphia: James Gopsill, 1869.

Jarrell, Lawrence S. *1810 Charleston District South Carolina Census: Complete Transcription of the 1810 U.S. Federal Census for the Charleston District, S.C.* High Point, N.C.: Alligator Creek Genealogy Publications, 1999.

List of the Tax Payers of the City of Charleston for 1860. Charleston, S.C., 1861.

McElroy's City Directory for Philadelphia. Philadelphia: Isaac Ashmead, 1839.

McElroy's Philadelphia City Directory. Philadelphia: E.C. and J. Biddle & Co., 1858, 1860, 1864.

Means & Turnbull, comp. *The Charleston Directory, a Subscribers' Business Directory.* Charleston, S.C., 1859.

Negrin, J. J. *New Charleston Directory, and Strangers Guide for the Year 1802.* Charleston, S.C.: John A, Dacqueny, 1802.

———. *Negrin's Directory and Almanac* [. . .] Charleston, S.C.: J.J. Negrin's Press, 1806, 1807.

Nelson's Charleston Directory, and Srangers Guide [. . .] *1801.* Charleston, S.C.: John Dixon Nelson, 1801.

Pinckney, Elise, ed. *Register of St. Philip's Parish, 1810-1822.* Washington, DC: National Society of Colonial Dames of America, 1973.

Ries, Linda A., and Jay Ruby. *Directory of Pennsylvania Photographers, 1839-1900.* Harrisburg: Pennsylvania Historical and Museum Commission, 1999.

Shackleford, William F., comp. *Directory and Stranger's Guide, for the City of Charleston* [. . .] *1824.* Charleston, S.C.: A. E. Miller, 1824.

South Carolina Writers' Program, Work Projects Administration, comp. *South Carolina: A Guide to the Palmetto State.* New York: Oxford University Press, 1941.

State Free Negro Capitation Tax Books, Charleston, SC, c. 1811-1860. Columbia: South Carolina Department of Archives and History, 1983. Microfilm.

GOVERNMENT, ORGANIZATIONAL, AND MILITARY RECORDS

"American Patents." *Journal of the Franklin Institute of the State of Pennsylvania* 7, no. 2, (February 1831): 74.

"Archives and Library Update." *South Carolina Historical Magazine* 112, no. 3/4 (July–October 2011): 185–91.

A Collection of Ordinances of the City Council of Charleston from the Twenty-Sixth of September, 1818 to the Twelfth of August, 1823. Charleston, S.C.: Archibald E. Miller, 1823.

A Collection of the Ordinances of the City Council of Charleston from the Third of February, 1824, to the Thirtieth of May, 1826. Charleston, S.C.: Archibald E. Miller, 1826.

Colonial Records of the State of Georgia. 25 vols. Various publishers, 1904–16. Online at www.hathitrust.org.

"Company Descriptive Book." Sixth Regiment of the US Colored Troops, Company F. Ancestry.com.

Digest of the Ordinances of the City Council of Charleston, from the Year 1783–July 1818. Charleston, S.C.: Archibald E. Miller, 1818.

Institute for Colored Youth. *Objects and Regulations of the Institute for Colored Youth.* Philadelphia, 1860.

Ladies Union Association. *First Annual Report.* Philadelphia, 1863. Online in "A Great Thing for Our People: The Institute for Colored Youth in the Civil War Era." Falvey Memorial Library, Villanova University. Accessed February 2, 2024. https://exhibits.library.villanova.edu/institute-colored-youth/their-own-words/ladies-union-association-1863-annual-report.

Officers in the Confederate States Navy, 1861–65. Naval War Records Office Memorandum No. 8. Washington, DC: Government Printing Office, 1898.

Official Register of the United States, Containing a List of the Officers and Employees in the Civil, Military, and Naval Service. Vol. 2, *The Post-Office Department.* Washington, DC: Government Printing Office, 1897.

"Poll Lists Charleston Municipal Election 1787." *South Carolina Historical Magazine* 56, no. 1 (January 1855): 45–49.

Ralph, Elizabeth. *Guide to the Bristol Archives Office.* Bristol, UK: Bristol Corporation, 1971.

MEMOIRS, DIARIES, AND CORRESPONDENCE

Coppin, Fanny Jackson. *Reminiscences of School Life, and Hints on Teaching.* With an introduction by Shelley P. Haley. New York: G. K. Hall, 1995.

Drayton, John. *Memoirs of the American Revolution Relating to the State of South Carolina.* 2 vols. New York: New York Times and Arno, 1969.

Emerson, W. Eric, and Karen Stokes, eds. *Faith, Valor, and Devotion: The Civil War Letters of William Porcher DuBose.* Columbia: University of South Carolina Press, 2010.

Fant, Jennie Holton, ed. *The Travelers' Charleston: Accounts of Charleston and the Lowcountry, South Carolina, 1666–1861.* Columbia: University of South Carolina Press, 2016.

Giesberg, Judith, ed. *Emilie Davis's Civil War Diary: The Diaries of a Free Black Woman in Philadelphia, 1863–1865.* University Park: Pennsylvania State University Press, 2014.

Harrison, Eliza Cope, ed. *Best Companions: Letters of Eliza Middleton Fisher and Her Mother, Mary Hering Middleton, from Charleston, Philadelphia, and Newport, 1839–1846.* Columbia: University of South Carolina Press, 2001.

Irving, John Beaufain. *Local Events and Incidents at Home*. Charleston, S.C.: A. E. Miller, 1850.

Jacobs, Harriet. *Incidents in the Life of a Slave Girl*. 1861. Reprint, New York: Signet, 2000.

LeClercq, Anne Sinkler Whaley, ed. *Between North and South: The Letters of Emily Wharton Sinkler, 1842–1865*. Columbia: University of South Carolina Press, 2001.

Maillard, Mary, ed. *Whispers of Cruel Wrongs: The Correspondence of Louisa Jacobs and Her Circle, 1879–1911*. Madison: University of Wisconsin Press, 2017.

Manigault, Peter, and Maurice A. Crouse. "The Letterbook of Peter Manigault, 1763–1773." *South Carolina Historical Magazine* 70, no. 3 (July 1969): 177–95.

Payne, Daniel Alexander. *Recollections of Seventy Years*. New York: Arno, 1969.

Porcher, Frederick Adolphus. "Memoirs of Frederick Adolphus Porcher." Edited by Samuel Gaillard Stoney. *South Carolina Historical and Genealogical Magazine* 47, no. 2 (April 1946): 83–108.

Rainsford, Marcus. *An Historical Account of the Black Empire of Hayti*. London, 1805.

Robinson, Emmett. "Dr. Irving's Reminiscences of the Charleston Stage." *South Carolina Historical and Genealogical Magazine* 52, no. 3 (July 1951): 166–79.

Smith, D. E. Huger. *A Charlestonian's Recollections, 1846–1913*. Charleston, S.C.: Carolina Art Association, 1950.

Stevenson, Brenda, ed. *The Journals of Charlotte Forten Grimké*. New York: Oxford University Press, 1988.

Towles, Louis P., ed. *A World Turned Upside Down: The Palmers of South Cantee, 1818–1881*. Charleston: University of South Carolina Press, 1996.

White, Jonathan W., ed. *A Philadelphia Perspective: The Civil War Diary of Sidney George Fisher*. New York: Fordham University Press, 2007.

SECONDARY SOURCES

BOOKS AND DISSERTATIONS

Appleby, Joyce, Lynn Hunt, and Margaret Jacobs. *Telling the Truth about History*. New York: W. W. Norton, 1994.

Ball, Edward. *Slaves in the Family*. New York: Ballantine, 1998.

Baumgartner, Kabria. *In Pursuit of Knowledge: Black Women and Educational Activism in Antebellum America*. New York: New York University Press, 2019.

Bay, Mia. *To Tell the Truth Freely: The Life of Ida B. Wells*. New York: Hill and Wang, 2009.

Bellows, Barbara L. *Two Charlestonians at War: The Civil War Odysseys of a Lowcountry Aristocrat and a Black Abolitionist*. Baton Rouge: Louisiana State University Press, 2018.

Bennett, Judith M. *History Matters: Patriarchy and the Challenge of Feminism*. Philadelphia: University of Pennsylvania Press, 2006.

Berlin, Ira. *Slaves without Masters: The Free Negro in the Antebellum South*. New York: Vintage Books, 1974.

Berry, Daina Ramey. *The Price for Their Pound of Flesh: The Values of the Enslaved, from Womb to Grave, in the Building of a Nation*. Boston: Beacon, 2017.

Biddle, Daniel R., and Murray Dubin. *Tasting Freedom: Octavius Catto and the Battle for Equality in Civil War America*. Philadelphia: Temple University Press, 2010.

Block, Sharon. *Colonial Complexions: Race and Bodies in Eighteenth-Century America*. Philadelphia: University of Pennsylvania Press, 2018.

Bristol, Douglas Walter, Jr. *Knights of the Razor: Black Barbers in Slavery and Freedom*. Baltimore: Johns Hopkins University Press, 2009.

Brown, George Tindall. *South Carolina Negroes, 1877–1900*. Columbia: University of South Carolina Press, 1952.

Brown, Vincent. *Tacky's Revolt: The Story of an Atlantic Slave War*. Cambridge, Mass.: Harvard University Press, 2020.

Burton, Antoinette, ed. *Archive Stories: Facts, Fictions, and the Writing of History*. Durham, N.C.: Duke University Press, 2005.

Bushman, Richard L. *The Refinement of America, Persons, Houses, Cities*. New York: Vintage, 1992.

Butler, Nicholas Michael. *Votaries of Apollo: The St. Cecilia Society and the Patronage of Concert Music in Charleston, South Carolina, 1766–1820*. Columbia: University of South Carolina Press, 2007.

Carby, Hazel V. *Imperial Intimacies: A Tale of Two Islands*. London: Verso, 2019.

Cooper Owens, Deirdre. *Medical Bondage: Race, Gender and the Origins of American Gynecology*. Athens: University of Georgia Press, 2017.

Cote, Richard N. *Mary's World: Love, War, and Family Ties in Nineteenth-Century Charleston*. Mt. Pleasant, S.C.: Corinthian Books, 2002.

Des Jardins, Julie. *Women and the Historical Enterprise in America: Gender, Race, and the Politics of Memory, 1880–1945*. Chapel Hill: University of North Carolina Press, 2003.

Diemer, Andrew K. *Vigilance: The Life of William Still, Father of the Underground Railroad*. New York: Alfred A. Knopf, 2022.

Dobak, William A. *Freedom by the Sword: The U.S. Colored Troops, 1862–1867*. Washington, DC: Center of Military History, 2011.

Dubois, Laurent. *A Colony of Citizens: Revolution and Slave Emancipation in the French Caribbean, 1787–1804.* Chapel Hill: University of North Carolina Press, 2004.

Du Bois, W. E. B. *The Philadelphia Negro: A Social Study.* 1899. Reprint, Philadelphia: University of Pennsylvania Press, 1996.

Dunn, Richard S. *Sugar and Slaves: The Rise of the Planter Class in the English West Indies, 1624–1713.* New York: W. W. Norton, 1972.

Easterby, J. H. [James Harold]. *A History of the College of Charleston, Founded 1770.* Charleston, S.C.: College of Charleston, 1935.

Egerton, Douglas R. *Thunder at the Gates: The Black Civil War Regiments That Redeemed America.* New York: Basic, 2016.

Eley, Geoff. *A Crooked Line: From Cultural History to the History of Society.* Ann Arbor: University of Michigan Press, 2005.

Emberton, Carole. *To Walk About in Freedom: The Long Emancipation of Priscilla Joyner.* New York: W. W. Norton, 2022.

Finley, Alexandra J. *An Intimate Economy: Enslaved Women, Work, and America's Domestic Slave Trade.* Chapel Hill: University of North Carolina Press, 2020.

Foreman, P. Gabrielle, Jim Casey, and Sarah Lynn Paterson, eds. *The Colored Conventions Movement: Black Organizing in the Nineteenth Century.* Chapel Hill: University of North Carolina Press, 2021.

Fuentes, Marisa J. *Dispossessed Lives: Enslaved Women, Violence, and the Archive.* Philadelphia: University of Pennsylvania Press, 2016.

Funnell, Charles E. *By the Beautiful Sea: The Rise and High Times of That Great American Resort, Atlantic City.* Brunswick, N.J.: Rutgers University Press, 1983.

Gallman, J. Matthew. *Mastering Wartime: A Social History of Philadelphia during the Civil War.* Cambridge: Cambridge University Press, 1990.

Giesberg, Judith. *Army at Home: Women and the Civil War on the Northern Home Front.* Chapel Hill: University of North Carolina Press, 2009.

Ginzberg, Lori D. *Untidy Origins: A Story of Woman's Rights in Antebellum New York.* Chapel Hill: University of North Carolina Press, 2005.

Glymph, Thavolia. *Out of the House of Bondage: The Transformation of the Plantation Household.* New York: Cambridge University Press, 2008.

———. *The Women's Fight: The Civil War's Battles for Home, Freedom, and Nation.* Chapel Hill: University of North Carolina Press, 2020.

Goldberg, David E. *The Retreats of Reconstruction: Race, Leisure, and the Politics of Segregation at the New Jersey Shore, 1865–1920.* New York: Fordham University Press, 2017.

Gonaver, Wendy. "Race Relations: A Family Story, 1765–1867." Master's thesis, College of William and Mary, 2001.

Gordon, Avery F. *Ghostly Matters: Haunting and the Sociological Imagination*. Minneapolis: University of Minnesota Press, 1997.

Greenidge, Kerri K. *Black Radical: The Life and Times of William Monroe Trotter*. New York: Liveright, 2020.

———. *The Grimkes: The Legacy of Slavery in an American Family*. New York: Liveright, 2023.

Hart, Emma. *Building Charleston: Town and Society in the Eighteenth-Century British Atlantic World*. Columbia: University of South Carolina Press, 2010.

Hartman, Saidiya. *Wayward Lives, Beautiful Experiments: Intimate Histories of Social Upheaval*. New York: W. W. Norton, 2019.

Hartog, Hendrik. *Man and Wife in America: A History*. Cambridge, Mass.: Harvard University Press, 2000.

Hayashida-Knight, Christopher H. "'Sacrifices and Sufferings of True Americans': Black Women's Nationalism and Activism in Philadelphia, 1863–1901." PhD diss., Pennsylvania State University, 2017.

Haynes, April R. *Riotous Flesh: Women, Physiology, and the Solitary Vice in Nineteenth-Century America*. Chicago: University of Chicago Press, 2015.

Higginbotham, Evelyn Brooks. *Righteous Discontent: The Women's Movement in the Black Baptist Church, 1880–1900*. Cambridge, Mass.: Harvard University Press, 1993.

Jefferson, Margo. *Constructing a Nervous System: A Memoir*. New York: Penguin Random House, 2022.

Johnson, Jessica Marie. *Wicked Flesh: Black Women, Intimacy, and Freedom in the Atlantic World*. Philadelphia: University of Pennsylvania Press, 2020.

Johnson, Michael P., and James L. Roark. *Black Masters: A Free Family of Color in the Old South*. New York: W. W. Norton, 1984.

Johnson, Nelson. *Boardwalk Empire: The Birth, High Times, and Corruption of Atlantic City*. Medford, N.J.: Medford, 2002.

Jones, Bernie D. *Fathers of Conscience: Mixed-Race Inheritance in the Antebellum South*. Athens: University of Georgia Press, 2009.

Kennedy, Cynthia M. *Braided Relations, Entwined Lives: The Women of Charleston's Urban Slave Society*. Bloomington: Indiana University Press, 2005.

Kilbride, Daniel. *An American Aristocracy: Southern Planters in Antebellum Philadelphia*. Columbia: University of South Carolina Press, 2006.

Lane, Roger. *William Dorsey's Philadelphia and Ours: On the Past and Future of the Black City in America*. New York: Oxford University Press, 1991.

Lerner, Gerda. *The Grimké Sisters from South Carolina: Pioneers for Woman's Rights and Abolition*. New York: Schocken, 1967.

Lewis, David Levering. *W. E. B. DuBois: Biography of a Race*. New York: Henry Holt, 1993.

Litwack, Leon F. *North of Slavery: The Negro in the Free States, 1790-1860*. Chicago: University of Chicago Press, 1961.

Luke, Bob, and John David Smith. *Soldiering for Freedom: How the Union Army Recruited, Trained, and Deployed the U.S. Colored Troops*. Baltimore: Johns Hopkins University Press, 2014.

Luskey, Brian. *Men Is Cheap: Exposing the Frauds of Free Labor in Civil War America*. Chapel Hill: University of North Carolina Press, 2020.

McPherson, James M. *The Struggle for Equality: Abolitionists and the Negro in the Civil War and Reconstruction*. Princeton, N.J.: Princeton University Press, 1992.

Mendez, James G. *A Great Sacrifice: Northern Black Soldiers, Their Families, and the Experience of Civil War*. New York: Fordham University Press, 2019.

Middleton, Lawrence Perry. "John Stevens Cogdell, Charleston Artist." Master's thesis, University of South Carolina, 1973.

Miles, Tiya. *All That She Carried: The Journey of Ashley's Sack, a Black Family Keepsake*. New York: Random House, 2021.

Mintz, Sidney W. *Sweetness and Power: The Place of Sugar in Modern History*. New York: Penguin Books, 1985.

Mitchell, Michele. *Righteous Propagation: African Americans and the Politics of Racial Destiny after Reconstruction*. Chapel Hill: University of North Carolina Press, 2004.

Morgan, Jennifer L. *Reckoning with Slavery: Gender, Kinship, and Capitalism in the Early Black Atlantic*. Durham, N.C.: Duke University Press, 2021.

Myers, Amrita Chakrabarti. *Forging Freedom: Black Women and the Pursuit of Liberty in Antebellum Charleston*. Chapel Hill: University of North Carolina Press, 2011.

———. *The Vice President's Black Wife: The Untold Life of Julia Chinn*. Chapel Hill: University of North Carolina Press, 2023.

Nash, Gary B. *Forging Freedom: The Formation of Philadelphia's Black Community, 1720-1840*. Cambridge, Mass.: Harvard University Press, 1988.

Newman, Simon P. *Freedom Seekers: Escaping from Slavery in Restoration London*. London: University of London Press, 2022.

Nirenberg, David. *Neighboring Faiths: Christianity, Islam, and Judaism in the Middle Ages and Today*. Chicago: University of Chicago Press, 2014.

Nunley, Tamika Y. *At the Threshold of Liberty: Women, Slavery, and Shifting Identities in Washington, D.C.* Chapel Hill: University of North Carolina Press, 2021.

Painter, Nell Irvin. *Southern History across the Color Line*. Chapel Hill: University of North Carolina Press, 2002.

Parker, Alison M. *Unceasing Militant: The Life of Mary Church Terrell*. Chapel Hill: University of North Carolina Press, 2020.

Peterson, Carla L. *Black Gotham: A Family History of African Americans in Nineteenth-Century New York City*. New Haven, Conn.: Yale University Press, 2011.

Poston, Jonathan H. *The Buildings of Charleston: A Guide to the City's Architecture*. Columbia: Historic Charleston Foundation, University of South Carolina, 1997.

Powers, Bernard E., Jr. *Black Charlestonians: A Social History; 1822–1885*. Fayetteville: University of Arkansas Press, 1994.

Rilling, Donna J. *Making Houses, Crafting Capitalism: Builders in Philadelphia, 1790–1850*. Philadelphia: University of Pennsylvania Press, 2001.

Rogers, George C., Jr. *Charleston in the Age of the Pinckneys*. Columbia: University of South Carolina Press, 1969.

Rose, Willie Lee. *Rehearsal for Reconstruction: The Port Royal Experiment*. New York: Vintage, 1994.

Sandweiss, Martha A. *Passing Strange: A Gilded Age Tale of Love and Deception across the Color Line*. New York: Penguin Books, 2009.

Schivelbusch, Wolfgang. *Tastes of Paradise: A Social History of Spices, Stimulants, and Intoxicants*. Translated by David Jacobson. New York: Random House, 1993.

Simon, Bryant. *Boardwalk of Dreams: Atlantic City and the Fate of Urban America*. New York: Oxford University Press, 2004.

Stevens, Paul. *Persimmon: His Story*. Charlotte, N.C.: Heritage House, 1957.

Stuart, Andrea. *Sugar in the Blood: A Family's Story of Slavery and Empire*. New York: Vintage Books, 2012.

Taylor, Brian M. *Fighting for Citizenship: Black Northerners and the Debate over Military Service in the Civil War*. Chapel Hill: University of North Carolina Press, 2020.

Taylor, Frank H. *Philadelphia in the Civil War, 1861–1865*. 1913. Reprint, Glenside, Pa.: J. M Santarelli, 1991.

Terborg-Penn, Rosalyn. *African American Women in the Struggle for the Vote, 1850–1920*. Bloomington: Indiana University Press, 1998.

Tomek, Beverly C. *Pennsylvania Hall: A 'Legal Lynching' in the Shadow of the Liberty Bell*. New York: Oxford University Press, 2014.

Trinkley, Michael, Debi Hacker, Nicole Southerland, Sarah Fick, and Julie Poppell. *Youghal: Examination of an Eighteenth and Nineteenth Century Plantation, Christ Church Parish, Charleston County, South Carolina*. Chicora Foundation Research Series 65. Columbia, S.C.: Chicora Foundation, January 2006.

Trouilliot, Michael-Rolph. *Silencing the Past: Power and the Production of History*. Boston: Beacon, 1995.

Turner, Sasha. *Contested Bodies: Pregnancy, Childrearing, and Slavery in Jamaica.* Philadelphia: University of Pennsylvania Press, 2017.

Twitty, Michael W. *The Cooking Gene: A Journey through African American Culinary History in the Old South.* New York: Amistad, 2018.

Walker, Christine. *Jamaica Ladies: Female Slaveholders and the Creation of Britain's Atlantic Empire.* Williamsburg, Va., and Chapel Hill: Omohundro Institute of Early American History and Culture and University of North Carolina Press, 2020.

Waskie, Anthony. *Philadelphia and the Civil War: Arsenal of the Union.* Charleston, S.C.: History Press, 2011.

Weatherwax, Sarah, Erika Piola, and Kinaya Hassane. *Imperfect History: Curating the Graphics Arts Collection at Benjamin Franklin's Public Library; A Collection of Essays.* Philadelphia: Library Company of Philadelphia, 2021.

White, Richard. *Remembering Ahanagran: A History of Stories.* Seattle: University of Washington Press, 1998.

Wikramanayake, Marina. *A World in Shadow: The Free Black in Antebellum South Carolina.* Columbia: University of South Carolina Press, 1973.

Williams, George Washington. *A History of the Negro Troops in the War of the Rebellion, 1861–1865.* 1888. Reprint, New York: Fordham University Press, 2012.

Winch, Julie. *A Gentleman of Color: The Life of James Forten.* New York: Oxford University Press, 2002.

Wolff, Daniel. *4th of July, Asbury Park: A History of the Promised Land.* New York: Bloomsbury, 2005.

Woodson, Carter G. *The Education of the Negro prior to 1861.* 1919. Reprint, Middletown, De.: Traffic Output Publication, 2018.

Yuval-Davis, Nira, and Pnina Werbner. *Women, Citizenship and Difference.* London: Zed Books, 1999.

ARTICLES AND CHAPTERS

Anderson, Elijah. Introduction to W. E. B. Du Bois, *Philadelphia Negro,* ix–xxxvi.

Barkley Brown, Elsa. "'What Has Happened Here?' The Politics of Difference in Women's History and Feminist Politics." *Feminist Studies* 18, no. 2 (1992): 295–312.

Bender, Thomas. "Wholes and Parts: The Need for Synthesis in American History." *Journal of American History* 73, no. 1 (June 1986): 120–36.

Butler, Nicholas. "The Carolina Coffee House of London." Charleston Time Machine, Charleston County (SC) Public Library website, January 31, 2020. www.ccpl.org/charleston-time-machine/carolina-coffee-house-london.

———. "Stealing Lord Dartmouth's Mail in April 1775." Charleston Time Machine, Charleston County (SC) Public Library website, April 27, 2018. www.ccpl.org/charleston-time-machine/stealing-lord-dartmouths -mail-april-1775.

———. "The Street Numbers of Peninsula Charleston." Charleston Time Machine, Charleston County (SC) Public Library website, August 2010. www.ccpl.org/street-numbers-peninsular-charleston.

———. "A Woman's Progress in Early South Carolina, Part 1." Charleston Time Machine, Charleston County (SC) Public Library website, April 7, 2017. www.ccpl.org/charleston-time-machine/womans-progress-early-south -carolina-part-1.

Cohen, Amy. "Honoring Universal Suffrage and the Election Day Riots of 1871." Hidden City (website), November 4, 2019. https://hiddencityphila.org /2019/11/honoring-universal-suffrage-the-election-day-riots-of-1871/.

Duhart, Bill. "N.J. Beach Was the Only One That Allowed Black Tourists, but They Made It a Hip Place to Be." NJ.com, July 13, 2019; updated June 30, 2020. https://www.nj.com/atlantic/2019/07/nj-beach-was-the-only-one -that-allowed-black-tourists-but-they-made-it-a-hip-place-to-be.html.

Eley, Geoff. "AHR Forum: The Profane and Imperfect World of Historiography." *American Historical Review* 113, no. 2 (April 2008): 425–37.

———. "The Past under Erasure? History, Memory, and the Contemporary." *Journal of Contemporary History* 46, no. 3 (2011): 555–73.

Emberton, Carole. "'Only Murder Makes Men': Reconsidering the Black Military Experience," *Journal of the Civil War Era* 2, no. 3 (September 2012): 369–93.

Fitchett, E. Horace. "The Traditions of the Free Negro in Charleston." *Journal of Negro History* 25, no. 2 (April 1940): 139–52.

Fritzsche, Peter. "The Archive and the Case of the German Nation." In *Archive Stories: Facts, Fictions, and the Writing of History*, edited by Antoinette Burton, 184–208. Durham, N.C.: Duke University Press, 2005.

Haraway, Donna. "Situated Knowledges: The Science Question in Feminism and the Privilege of Partial Perspective." *Feminist Studies* 14, no. 3 (Fall 1988): 575–99.

Harris, Robert L., Jr. "Charleston's Free Afro-American Elite: The Brown Fellowship Society and the Humane Brotherhood." *South Carolina Historical Magazine* 82, no. 4 (October 1981): 289–310.

Hine, William C. "Black Politicians in Reconstruction Charleston, South Carolina: A Collective Study." *Journal of Southern History* 49, no. 4 (November 1983): 555–84.

Inscoe, John C. "Carolina Slave Names: An Index to Acculturation." *Journal of Southern History* 49, no. 4 (November 1983): 527–54.

Lora, Elsa Julien. "Our Whispering Wombs: A Black Family History." *Virginia Quarterly Review* 98, no. 4 (Winter 2022): 32–42.

McLeary, Erin. "The Curious Case of Body Snatching at Lebanon Cemetery." Hidden City (website), April 13, 2015. https://hiddencityphila.org/2015/04/the-curious-case-of-body-snatching-at-lebanon-cemetery/.

Rutledge, Anna Wells. "Cogdell and Mills, Charleston Sculptors." *Antiques*, March 1942.

Silcox, Harry C. "Nineteenth-Century Philadelphia Black Militant: Octavius V. Catto (1839–1871)." In *African Americans in Pennsylvania: Shifting Historical Perspectives*, edited by Joe William Trotter and Eric Ledell Smith, 198–219. State College: Pennsylvania State University Press, 1997.

Welburn, William C. "To 'Keep the Past in Lively Memory': William Carl Bolivar's Efforts to Preserve African American Cultural Heritage." *Libraries and the Cultural Record* 42, no. 2 (2007): 165–79.

Williams, George W. "Eighteenth-Century Organists of St. Michael's Charleston." *South Carolina Historical Magazine* 53, no. 4 (October 1952): 212–22.

Wright, Nazera Sadiq. "Imagining Freedom: Black Girlhood in the Sanders-Venning Family, 1815–1890." In *The Global History of Black Girlhood*, edited by Corinne T. Field and LaKisha Michelle Simmons, 136–50. Urbana: University of Illinois Press, 2022.

INDEX

Page numbers in italics refer to "whispers."

class in Charleston, 1, 45–46, 50, 53–55; and white people in Philadelphia, 92–93. *See also* Chew, Cordelia (née Sanders); Sanders family

"Club House," 104

Coates Row, 21

Coble, NC, 196

Cochran, Thomas, 60

coffeehouses, 12, 20–23

Cogdell, Cecille (née Langlois), 8, 52–55, 58, 60, 65, 67–69, 73, 77, 78

Cogdell, Charles Stevens, 53, 58–59, 119, 141, 147

Cogdell, Clement Burgess, 12, 52, 53, 58, 216n22

Cogdell, George, 12, 23, 37, 51–52

Cogdell, George Burgess, 53

Cogdell, James Gordon, 53, 55–56

Cogdell, John, 51

Cogdell, John Stephano, 38, 41, 51–52, 57, 58, 79, 84, 85

Cogdell, John Walpole, 53, 57–58, 141, 147

Cogdell, Mary Ann (Tolsey) (née Stevens), 36–37, 52; and slavery, 48–49; wills of, 49

Cogdell, Richard Clement, 53, 55, 56–57

Cogdell, Richard Walpole: and Cecille Langlois, 52–55; 68–69; and Cogdell sons, 53–59; decision to leave Charleston, 84–86, 89–90; employment of, 50, 53, 79; as enslaver, 60, 65–66; estate of, 138–42, 151–52; funeral of, 143–44; hiring of enslaved people, 60, 66; investments of, 55, 137; in Philadelphia, 103–4, 113–15; purchases by, 53, 73, 90, 111–12; and Sabina Hall, 65–66; and Sanders children, 66, 74, *74–75*, 112, 118–19; and Sarah Martha Sanders, 60, 69–73, 78–81; travels, 37, 38, 78–80, 85, 217n31. *See also* fathers;

Sanders, Sarah Ann; Sanders, Sarah Martha; Sanders family

Cogdell, Ursula, 53, 216n22

Cole, Rebecca, 159–61

College of Charleston, 53, 216n21

Colored Conventions movement, 94

Colored School No. 1, 117, 154, 156

Condy, Jane, 63

Condy, Thomas D., 50, 63, 65, 78

Confederacy, 5, 115–16, 123–24, *127*, 131, 140, 197; financial losses from, 134–38

Cooper, Addie, 179

Cooper, Parris C., 104–5, 123, 148

Coppin, Fanny Jackson, 102–3, 154, 174

Cornell University, 201

Cosmopolitan Club, 201

Cotton (Confederate ship), 123

Cotton Manufacturing Company, 196

coverture. *See* married women, legal status of

Crouch, Darius, 128

Cummings (schoolmaster), 56

Davenport, Anna A., 136, 137, 167, 229n32

Davenport, Charles, 84, 136

Davenport, Martha Julia. *See* Sanders, Martha J. (née Davenport)

Davenport, Medora, 136

Davis, Emilie, 102, 128–29, 132

Delancey, Peter, 34–35

Democratic Party, 122

Denny, Thomas, 136, 152, 229n32

Denver, Clara, 182

DeReef, Joseph, 45, 105, 107–8, 122, 125, 126, 128, 131

DeReef, Richard Edward, 45, 105, 107–8, 122, 125, 126, 128, 131

Dick (enslaved child), 12, 18, 24–26, 33, 48–49, 60, 206

Diemer, Andrew, 95, 106

Diggs, John H., 129, 131–32, 228n18, 228n21, 229n22

Dorsey, Charles A., 154
Dorsey, Thomas, 128
Dorsey, Tom, 182
Douglass, Frederick, 128
Douglass, Grace, 93
Douglass, Sarah Mapps, 93, 102, 154
draft, military, 129–30, 190
Dred Scott decision, 88, 121
dressmakers, 77, 98, 162, 167
Du Bois, W. E. B., 8, 103, 171–72, 175,
 177, 183, 187, 190–91; *Philadelphia
 Negro*, 171–72
DuBose, William Porcher, 123–24
Ducachet, H. W., 104
duels, 41, 56–57
Duncan, Mabel, 180
Dunn, Richard, 11, 29
Dutton, Fred, 179, 182

Eden Cemetery, 166, 199, 233n43
education: in Charleston, 37, 52–53,
 55, 86–87; in Philadelphia, 2, 101–3,
 154, 165–66, 174–76, 184, 190–91,
 223n22; school lawsuit, 165–66,
 175. *See also* Colored School No. 1;
 Forten, Margaretta; Institute for
 Colored Youth; Philadelphia High
 School for Girls; Venning, Miranda
 Cogdell
elections, 108, 126, 152–53, 183
Ellison, William, Jr., 88
Ellison, William, Sr., 88, 95
emancipation, 2, 49, 61–63; as a
 wartime goal, 126–28, 131; in
 Jamaica, 33; in Pennsylvania, 94;
 and the Sanders family, 135–36.
 See also wills
Emancipation Day, 144
Emancipation Proclamation, 126,
 127, 144
Emlen School, 175
enslaved women: as "concubines," 1,
 48, 66, 67–72, *74–75*, 79–81, 183;
 historical erasure of, 3, 7–8, 10, *13*,
 25, 207; labor of, 73, 78; as mothers,

68, 80–82; sexual abuse of, 1, 66,
 67–68, 74–75, *90*; Lydia Weston,
 68; Nancy Weston, 68. *See also*
 fathers; Sanders, Sarah Martha;
 Sanders family; wills
entertainments, 14, 47–48, 50, 59, 78,
 179–80, 182, 190. *See also* music
Ephrath Cemetery, 80, 144
Erie Canal, 41

fathers: ambitions for children,
 23–24, 28–29, 56–59; of enslaved
 children, 8, 24–26, *57*, 66, 72,
 74–75; unknown, 10, 62. *See also*
 Cogdell, Richard Walpole; Sanders
 family; Stevens, John
Fayssoux, Sarah, 123
Federal Writers' Project, 185
Ferguson, William, 44
Female Medical College of
 Pennsylvania, 159
Finley, Alexandra J., 78
Fisher, Joshua Francis, 92, 125
Fisher, Sidney George, 92,
 125–26, 128
Fitzwater Street, 184, 187. *See also* 1116
 Fitzwater Street
Forten, Charlotte, 108: and racism, 95,
 133, 155; and Sanders family, 105,
 110–11, 136, 153, 154; in Sea Islands,
 124, 126, 154
Forten, James, 94
Forten, Margaretta, 88, 95, 101, 102,
 173, 176
freedom: ambiguity about, 73–74,
 81–82, 87–88; definitions of, 94–95,
 98, 105, 124, 126, 159–61
Free Masons, 53
free people of color, 44–45, 73–74,
 86–89: ambiguity about, 81, *81–82*;
 and capitation tax, 80, 81, 84, 88,
 167; and the Confederacy, 122, 131;
 employment of, 83, 87; legislation
 regarding, 46–48, 86–87; migra-
 tion of, 88; restrictions on, 86–89.

Vanderhorst, Mary, 61
Vanderhorst, William, 61
Venning, Edward W., 99, 106–7, 129, 173
Venning, Edward Y., 152, 195; as carpenter, 111, 113; and Civil War, 129–32; marriage of, 99, 103, 107, 112, 136; and school lawsuit, 165–66, 175
Venning, Elizabeth (née Nixon), 99, 107, 173, 234n9
Venning, George Edward, 165, 180, 184, 187, 10
Venning, John, 107, 235n27
Venning, Julia (née Capps), 180, 181, 187
Venning, Julia E. (née Sanders), 2, 72, 81, 82, *90*, 137, 149, 162; children of, 129, 152, 173–87; death of, 99; marriage of, 99, 103, 107, 112, 136. *See also* Sanders family; Venning, Edward Y.
Venning, Julia E. *See* Warwick, Julia Venning
Venning, Louisa Sanders, 179, 183–85
Venning, Miranda Cogdell (Rannie), 2, 9, 99, 129, 161–62, 164, 173–76, 179, 185
Venning, Oliver Cassey, 165, 178, 185, 187
Venning, Rebecca, 99, 133
Venning, Richard DeReef, 9, 99, 107–8, 146, 152, 173, 180, 184, 187
Venning, Sarah. *See* Holden, Sarah (née Venning)
Venning, Sophia Sanders, 138
Vesey, Denmark, 47
Vigilance Committee, 92, 94

wage-earning, 50, 52–53; by enslaved people, 60, 62–63; by white women, 12. *See also* coffeehouses; *and individual occupations*
Walpole, Sir Edward, 14

Ward brothers, 138
Ware, Chris, 203
Warwick, Abraham, 177
Warwick, Elizabeth Venning, 177, 178, 181
Warwick, Florence Irene, 101, 178, 181
Warwick, James E., 177, 178
Warwick, Julia E. (née Venning), 164, 176–78
Warwick, Martha Clarke, 177
Washington, Booker T., 172
Washington, DC, 99, 108, 135, 156, 162–63, 166
Washington Grammar School, 161, 174, 175
Webb, Genie, 163–64
Weekly Anglo-African, 127, 128
Weld, Theodore, 93
Wells, Ida B., 172
Weston, Lydia, 68
Weston, Nancy, 68
Wharton, Emily, 91–92
whispers: explanation of, 4, 8; examples of, *13, 57, 62–63, 72, 74–75, 79, 81–82, 87–88, 90, 106, 111, 112, 118, 127, 147, 177, 182, 183*
White, Jacob C., Jr., 106, 128, 153, 154, 174
White, Richard, 208
Wigfall, Hampden, 56
Williams, Clarence, 182
Williams, Ed, 182
Williams, John, 187
Williams, Susan (née Saunders), 187
wills: about, 49, 60; lists of enslaved people in, 61; Mary Ann Elizabeth Stevens's, 40; Mary Ann (Stevens) Cogdell's, 37, 49; Mary Stevens's, 49, 51; protecting daughters in, 50–52, 112; Richard Cogdell's, 76, 112, 137; Sabina Hall's, 61–63
woman suffrage, 159, 185
Women's Freedmen's Relief Association, 159